Alberto Giacometti

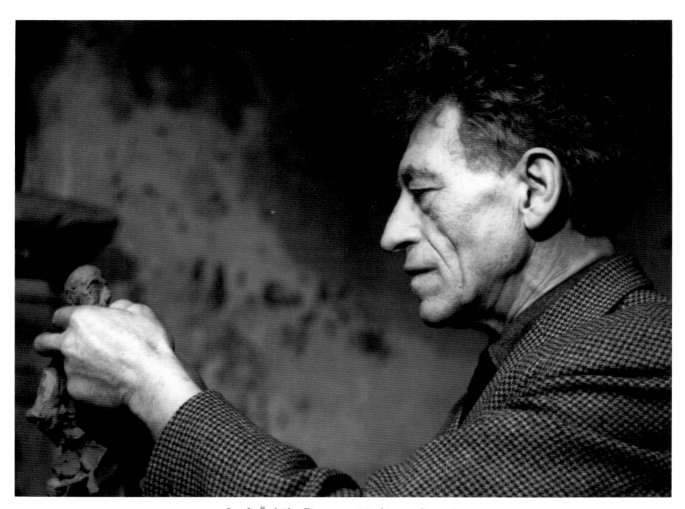

Lutfi Özkök, Giacometti in his studio, 1963

ALBERTO GIACOMETTI

Sculpture · Paintings · Drawings

Edited by Angela Schneider

With contributions by Lucius Grisebach,
Reinhold Hohl, Dieter Honisch, Karin von Maur
and Angela Schneider

Prestel

The essays by Reinhold Hohl, Dieter Honisch,
Lucius Grisebach and Karin von Maur originally appeared in
Alberto Giacometti: Skulpturen, Gemälde, Zeichnungen, Graphik,
published in 1987 in conjunction with the exhibition
of that name held at the Nationalgalerie, Berlin (West),
and the Staatsgalerie, Stuttgart.
They have been partly revised for the present publication.

Front cover: Henri Cartier-Bresson, Giacometti in his studio.
Photo- und Presseagentur GmbH focus
Back cover: Alberto Giacometti, *Palace at Four in the Morning,* 1932 (plate 29)

Translated from the German by Elizabeth Clegg
Copyedited by Michael Robertson

Prestel books are available worldwide. Please contact your
nearest bookseller or write to either of the following
addresses for information concerning your local distributor

Prestel-Verlag

16 West 22nd Street, New York, NY 10010
Tel. 212-627 8199; Fax 212-627 9866
Mandlstrasse 26, D-80802 Munich, Germany
Tel. 089-381 7090; Fax 089-381 70935

Typeset by Interdruck Leipzig GmbH
Offset lithography by ORT Kirchner & Graser, Berlin
and Repro-center Färber, Munich
Printed and bound by Gorenjski Tisk, Kranj, Slovenia

ISBN 3-7913-1371-1 (English edition)
ISBN 3-7913-1335-5 (German edition)

CONTENTS

Chronology

REINHOLD HOHL

1901

Alberto Giacometti was born at one o'clock in the morning on 10 October 1901 at the Cat-Dolf house at 60 Hauptstrasse in the Alpine village of Borgonovo above Stampa (in the canton of Grisons) in the Bregaglia valley, in the Italian-speaking region of Switzerland. His father was the Post-Impressionist painter Giovanni Giacometti (1868–1933), and his paternal grandfather was a pastry-cook and innkeeper, Alberto Giacometti from Stampa (1834–1900). His mother, Annetta Giacometti-Stampa (1871–1964), came from one of the more well-to-do families in the valley.

Giacometti's godfather was the Fauve painter Cuno Amiet (1868-1961), who had been a close friend of his father from the time of their student days in Paris. The Symbolist painter Augusto Giacometti (1877-1947), a figure of some importance in both Swiss and European painting during the transition to abstraction, was a second cousin of both Giovanni and Annetta Giacometti.

1902

Birth of Alberto's brother, Diego Giacometti, whose Christian name was an allusion to that of Velázquez. Diego became a craftsman and designer and served Alberto as a model for over fifty years, from 1925 sharing in his life and work in Paris. He died in 1985. His delicate bronze furniture with modelled animals and leaves brought him international fame. Pieces by him are now highly priced collectors' items.

1903

Birth of his sister, Ottilia Giacometti. In 1932 she married the Geneva physician Dr Francis Berthoud, and died giving birth to their son Silvio on 10 October 1937. Silvio himself became a physician, specializing in medical care in the Third World. As a child, he was looked after by his maternal grandmother in Geneva. From 1942 to 1945, Alberto Giacometti used him as a model for tiny busts and small figures on high pedestals; he died in 1991.

In late autumn, the Giacometti family moved to Stampa, living there for eighteen months at the inn 'Piz Duan', which had been managed since the death of Alberto Giacometti's grandfather by his uncle Otto Giacometti. The gas lighting that had recently been installed at the inn was among the sights of the valley.

1906

The family moved across the road to the first floor of the 'red house' purchased by Otto Giacometti; to begin with, they were without running water and electricity. Giovanni Giacometti extended a nearby barn to use as a studio. From 1910 on, the family spent the holidays and the whole of the summer in Maloja, 2,600 feet higher up from Stampa.

Giovanni Giacometti frequently used his children and family gatherings as the subject of his paintings. Alberto's happy childhood and his growth into an introspective young man can thus be traced year by year in his father's pictures.

Among Alberto's strongest memories of his childhood were the smell of the oil paints in his father's studio and the blissful sense of security he experienced there when drawing and looking through illustrated books. After the death of his father in 1933, Alberto himself, during his annual stay in Stampa, painted and modelled in the low-ceilinged, wood-panelled studio.

1907

Birth of Alberto's brother, Bruno Giacometti. The leading Swiss painter Ferdinand Hodler (1853–1918) was his godfather. Like Diego, Bruno later sat as a model for Alberto; for Bruno, however, the long sittings were agonizing. His two brothers recognized that Alberto was a stubbornly committed, and sometimes peculiar, artist and took over some of his household duties.

Bruno Giacometti became an architect, especially noted in Switzerland for his exhibition and museum buildings and for his designs for schools and hospitals. In 1939 he arranged sculpture commissions for Alberto for the Swiss National Exhibition in Zurich. In 1985 he proposed to install a figure by Alberto, *Walking Man* (*Homme qui marche*, 1960), in the square in front of the city hall in Uster (in the canton of Zurich). Out of respect for public opinion, however, this proposal was not accepted; instead, a work by Max Bill entitled *Schlaufe (Loop)* was purchased, described by Giacometti as 'decorative'. After the deaths of his two brothers, Bruno devoted himself tirelessly and generously to promoting Alberto's work and posthumous reputation.

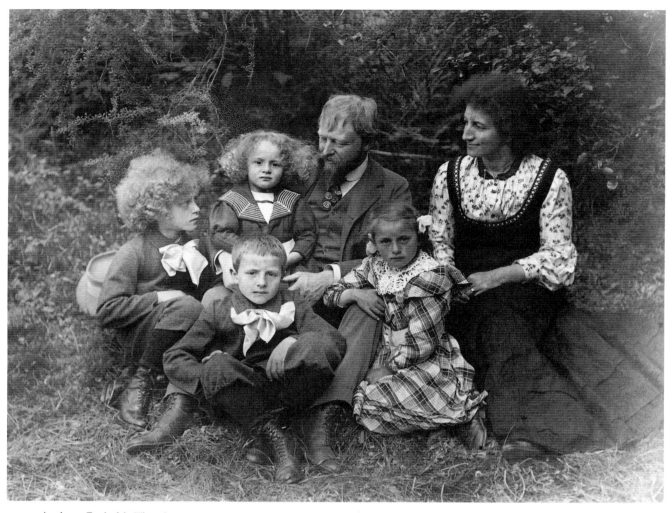

Andrea Garbald, The Giacometti family in 1909. *From left:* Alberto, Diego, Bruno, Giovanni, Ottilia, Annetta

1911–1915

Crayon and pencil drawings have been preserved from almost every year of Alberto Giacometti's childhood. He sent many of these, particularly at Christmas, to his godfather Cuno Amiet in Oschwand (in the canton of Berne). On one visit there, Alberto and his father were drawn by Amiet looking through a portfolio.

In Stampa and also in nearby Maloja, Alberto drew his mother at work in the kitchen and made frontally viewed portraits of her. In 1913 he made his first oil painting, a still life of apples on a folding table in his father's studio.

After Christmas 1914 Alberto Giacometti modelled the heads of Diego and Bruno in plasticine, inspired by illustrations of portrait sculptures. 'They were very restless models,' he wrote to his godfather; he also told him that a very good teacher at school had taught him how to make woodcuts. (The teacher's predecessor at the school in Stampa had been the painter Zaccaria Giacometti, 1856–1897.)

Alberto copied reproductions of art works almost line for line, including Rembrandt's etching *The Good Samar-*

itan, adding his own signature in the form of a monogram of the type used by Dürer. In 1933, in a literary text, *Hier, sables mouvants* (Yesterday, Shifting Sands) he described the games he played in winter and in summer with the children in the village, as well as his childhood dreams and fears.

1915–1919

From 30 August 1915 to 7 April 1919 Alberto Giacometti was a boarder at the Evangelical Secondary School at Schiers (near Chur). On the journey back to Stampa at the start of his first Christmas holiday, he spent the money intended for a night's stay at St Moritz on a book about the sculpture of Rodin. As a result, the fourteen-year-old boy had to walk the rest of the way through the icy winter night.

When he had learnt enough German and caught up with Latin, Alberto established himself as academically above average; but he was especially admired, both by his fellow pupils and by his teachers, for his astonishing artistic skills. He was given his own room at the school to set up as a studio.

In 1916 he made his first sculpted head of his mother, modelled in plasticine; the work was in an impressionistic style.

In his last year at school he entered into a passionate friendship with Simon Bérard, a pupil about two years younger, whom he also drew, painted and modelled. These were almost the only works from these years that Alberto kept for himself; he gave away his other portraits of fellow pupils, as well as his sheets from drawing lessons and designs for stage sets for a school drama production.

1919

Alberto spent the spring and summer of 1919 in Stampa and Maloja, where he was constantly busy drawing, and also produced paintings in a Divisionist (Pointillist) style. It was now clear that he was to become an artist — but whether he was to be a painter or a sculptor was still uncertain.

In the autumn he began studying art in Geneva, at the Ecole des Beaux-Arts and at the Ecole des Arts Industriels. He lived with friends of the family at 79, rue des Eaux-Vives.

He found painting easy in the class of David Estoppey (1862–1952, a Pointillist); and, in the sculpture class, he

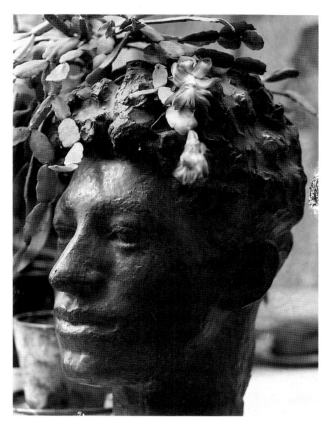

Cuno Amiet, Head of Alberto Giacometti
with cactus flowers, 1920

Cuno Amiet, *Giovanni and Alberto Giacometti, c.* 1912

was allowed to have his own way by Maurice Sarkissoff (1862–1946, a 'modern' working in a style somewhere between those of Rodin and Archipenko). In the life-drawing class, however, there were difficulties because Giacometti insisted on drawing only what interested him: not the whole figure but only the model's feet.

1920

At the end of March Giacometti spent about ten days with Cuno Amiet in Oschwand. He drew portraits in silverpoint, painted still lifes in watercolour in the technique of Cézanne and, working alongside Amiet, composed scenes with the pastures typical of the central Swiss landscape. Amiet modelled a portrait bust of Alberto and later sent a photograph of it to Stampa, in which Alberto's head is wreathed with cactus flowers instead of the laurels that were really intended.

Giacometti began his journey home from Oschwand with a long walking tour to Solothurn, where it is probable, though not certain, that he visited the art collector Joseph Müller. Müller, who had started his collection as a young man with an important picture by Hodler, knew Amiet and Giovanni Giacometti and had bought their paintings. To these he soon added works by André Derain, Matisse, Picasso, Vassily Kandinsky, Fernand Léger

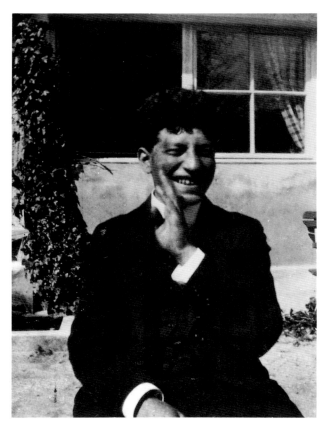

Alberto Giacometti, 1920

and others, and, somewhat later, first-rate sculptures from Africa and the Pacific region.

In May Giovanni Giacometti took Alberto to the *Biennale* in Venice, where the father was inspecting the Swiss section as a member of the Swiss art commission. Among works to be seen that year in Venice were twenty-eight paintings by Paul Cézanne and thirty-five sculptures by Alexander Archipenko.

According to a text Alberto Giacometti published in 1953, *Mai 1920* (May 1920), the most important experience he had in Venice was his discovery of the painting of Jacopo Tintoretto. A few days later, however, his exclusive enthusiasm for Tintoretto's spatial visions was tempered by his reaction to the frescos by Giotto in the Arena Chapel in Padua, which fascinated him with the sculptural power of their treatment of the figure. The impact of the art of both painters was overshadowed in turn the same evening in Padua by a visual experience that—because it was only described much later—appears to anticipate Giacometti's later thoughts and visions: the sight of two or three young girls in the street who, with a quality of reality and directness, seemed to him to be 'gigantic' and 'like a rift in the world'.

From late summer onwards Giacometti again attended the art colleges in Geneva, before leaving for Florence in mid-November. He had planned to take art courses there, but he found nothing suitable and received his

principal impressions of the city in the Museo Archeologico. Here (as he later wrote) the block-like stylization of an eighteenth-dynasty Egyptian head seemed, for the first time, 'life-like'. He must also have seen the two-wheeled Theban war chariot of *c.* 1500 BC there, which was later recalled in his bronze *The Chariot (Le Chariot)* of 1950 (plate 60).

Giacometti then travelled on to Rome via Perugia and Assisi, and was impressed in Assisi by the work of Cimabue. He arrived in Rome on 21 December.

1921

Until returning home in July Giacometti lived in Rome in the villa district of Monteverde on the Gianicolo with the family of a cousin of his parents, Antonio Giacometti (1869–1937; from 1896 he ran the pastry shop Gilli e Bezzola on Via Nazionale 214), and his wife Evelina. Alberto fell in love with the eldest of their six children, the fifteen-year-old Bianca. She, however, had no idea what to make of the young artist, even after his transformation from a youth from the Bregaglia valley into a dandy with new clothes, a walking stick and a cigarette holder.

Giacometti joined the *Circolo Artistico* and took a small studio in Via di Ripetta, well-established for over three hundred years as the city's 'artists' street'. He went to the museums and churches and filled many sketchbooks with drawings copied from mosaics, paintings and sculptures by the Old Masters, from those active in Byzantine Ravenna to those of the Baroque. He went to the opera and to concerts and read the works of both ancient and modern authors, from Sophocles to Oscar Wilde, which inspired him to produce cruel or cynical drawings.

Perhaps in order to impress Bianca, Giacometti also installed a studio in a room in the basement of the villa, and skilfully modelled a portrait bust of Alda, the maid's sister-in-law. This work has survived in a plaster cast (private collection). Things turned out very differently with Giacometti's head of Bianca, on which he started to work at the beginning of March. This provoked a crisis, seemingly both artistic and emotional. In 1947 Giacometti wrote of this first 'failure': 'I was lost, everything escaped me, the head of the model before me became like a cloud, vague and undefined. ... When I left I threw the head in the waste basket.' This experience was to become the archetype of Giacometti's later 'difficulties' and ultimately of an enduring sense of 'inadequacy'. In reality, however, the situation was not entirely as Giacometti described it. Irritated by the demands of her 'artist' cousin, Bianca had kicked the clay head from the modelling stand; and it was the fragments that Giacometti had then thrown in the dustbin. Not long afterwards he brought a prostitute to the house to be his model; and it was with her that he had his first sexual experience.

At the end of March or the beginning of April, Giacometti travelled with a companion to Naples, Paestum and Pompeii. The artistic impressions he received during the journey were accompanied by some deeper lessons that were to shape Giacometti's later work. A meeting with a Dutch fellow-passenger on the train to Pompeii, who took a fancy to the intelligent, lively and good-looking young artist, was to prove fateful.

In July Giacometti went back to Maloja. Bianca, who was travelling on to a boarding school in Switzerland, came with him, and the two spent the night in a hotel in Chiavenna. Here Giacometti's fondest wish was fulfilled: he was allowed to draw Bianca's feet.

In August, at least according to the story that Giacometti later recounted, Antonio Giacometti sent to Stampa an advertisement he had noticed in the personal columns of an Italian newspaper. The Dutchman from the train to Pompeii announced that he would like to meet the interesting young man again. (The advertisement has not so far been traced.) There was an exchange of letters, followed by an invitation to travel with the Dutchman, Pieter van Meurs, through the Tyrol to Venice. The two met at Innsbruck, and on 3 September Giacometti travelled by post-coach with the 61-year-old van Meurs, a state archivist from The Hague, to Madonna di Campiglio, where they stayed at the Grand Hôtel des Alpes. The following day, Van Meurs began to suffer from severe stomach pains brought on by kidney stones. During the night of 4/5 September he died. Giacometti, who was not yet twenty, was never to forget the agony, and the sudden

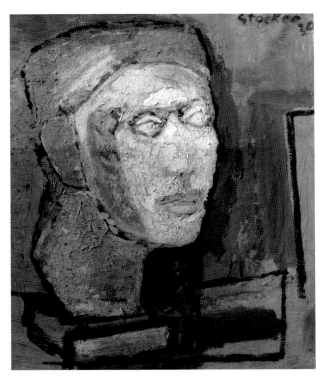

Hans Stocker, *Portrait of Alberto Giacometti*, 1930

reality, of death and he never again slept without a light on. After a day under police surveillance, he was released on 6 September and travelled on to Venice. Here, according to his own later account, he looked again at the work of Tintoretto and also visited prostitutes. On 10 September he returned to Stampa.

During the autumn he painted a great deal: still lifes, landscapes, portraits and self-portraits, some dark in tone, some in a Divisionist style.

On 28 December he left for Basle to obtain a visa allowing him to travel on to Paris.

1922

Giacometti arrived in Paris on the morning of 9 January. His father provided him with 1,000 Swiss francs per month and he stayed, to begin with, in a family-run *pension*, then in a small hotel. He signed up for the life-drawing class and the sculpture class led by Antoine Bourdelle (1861–1929) at the Académie de la Grande-Chaumière. Bourdelle's teaching consisted of weekly correction sessions, during which he would position himself among the modelling stands and talk at great length.

Giacometti used the training facilities offered by the Académie de la Grande-Chaumière until 1927, even though he often stayed away for months on end, and, almost from the start, only worked according to his own principles. From August until well into October he completed basic military training for the Alpine Infantry at Herisau (in the canton of Appenzell Outer Rhodes); he obtained a sharpshooter's stripe but he had a very low opinion of the war games played by the Swiss army. Giacometti lost any patriotic feelings he may have had when his application for a state scholarship was turned down.

During each of his first years in Paris Giacometti returned for many weeks to the Bregaglia valley. He also reported for military exercises on a number of occasions, but he never took part in a political election or a referendum.

1923–1924

The centre of art life in Paris in the 'golden twenties' was the Montparnasse district, and this remained Giacometti's home ground until the end of his life. After leaving the Hôtel Notre-Dame at 1, quai Saint-Michel, he took a hotel room on the boulevard Raspail.

Here he painted and drew for a whole winter from a single human skull. He also worked for a long time at colourful—and now no longer Divisionist—portraits, always after a model or his own reflection in a mirror, and influenced by the 'red-blue style' in the contemporary work of the Basle painter Paul Basilius Barth, which he had seen in Barth's house in Riehen (near Basle).

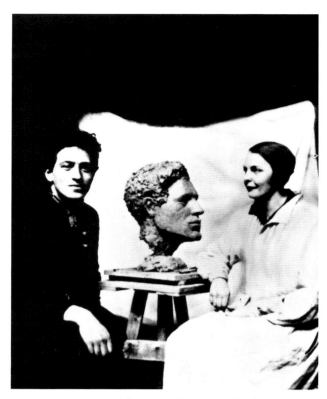

Flora Mayo, Alberto and Flora with Flora's
sculpted head of Giacometti, Paris 1927

In Paris Giacometti initially spent his time with artists
from Basle and other parts of Switzerland: Kurt Selig-
mann, whom he knew from Geneva; Hans Stocker, with
whom he exchanged self-portraits; Leonhard Meissner
from Chur; and Serge Brignoni, with whom he shared an
interest in tribal art and also in Surrealism, to which An-
dré Breton's Surrealist Manifesto of 1924 was drawing
much attention. He took little part in the proverbial
'wild' life of artists in Paris, though he did become a
regular patron of the brothel Le Sphinx at 31, boulevard
Edgar-Quinet, which was legendary for its willingness to
satisfy all desires. Here, Giacometti liked above all to sit
and watch.

For 100 francs a year, Giacometti rented a spacious stu-
dio with light from the north at 72, avenue Denfert-Roch-
ereau, overlooking the garden of the Observatoire.

Both Giacometti's life drawings from the Académie de
la Grande-Chaumière and his portrait drawings of this
period are striking on account of the decisive volume ef-
fect they achieve. This was created by building up an im-
age through a network of lines connecting the most
prominent points in the subject as a perceived mass. The
sculptural works carried out in Bourdelle's class are un-
objectionable. The naturalistically painted plaster forms
were derided by Giacometti's fellow students, even
though the use of colour in sculpture was in keeping
with modern developments and appeared to Giacometti
to be a necessity.

During a stay in Stampa in 1923, Giacometti modelled a
head of his mother, an austere work with much emphasis
on its distinct planes (private collection). In its formal
resolution, this work is the first real evidence of an up-
to-date professionalism, and it stands in marked contrast
to the animated and impressionistic portrait busts of his
youth. Giovanni Giacometti recorded Alberto at work on
this piece and called his painting *The Sculptor (Lo scul-
tore)*.

1925

In January Alberto Giacometti moved into his second,
rather smaller Paris studio, on the second floor at 37, rue
Froidevaux, with windows overlooking the Montpar-
nasse cemetery.

Giacometti's circle of acquaintances from the Acad-
émie de la Grande-Chaumière grew, and now included art-
ists from Italy and the Scandinavian countries as well as a
few Frenchmen, including Pierre Matisse, the son of
Henri Matisse, who was soon to abandon his artistic ca-
reer and become a leading art dealer in New York. Until
1929 Giacometti had an indecisive relationship with the
young American artist Flora Mayo; they made clay por-
trait busts of one other. During the summer months in
the Bregaglia valley, Giacometti's relationship with
Bianca turned into a warm friendship.

A sculpture *Portrait of the Artist's Mother* (*La Mère de
l'artiste,* no longer existent), made at this time, set off a
major creative crisis, perhaps because the demand for re-
semblance always prevailing at Stampa and Maloja
clashed with the modern sculptural forms that Giaco-
metti had come to know in Paris. Giacometti had been
especially influenced by the sculpture of Henri Laurens
(1885–1954), whom he had visited in his Paris studio in the
rue Villa Brune on the edge of Montparnasse. The work
of several Paris sculptors of the early 1920s (Lipchitz and
Brancusi, for example) is also cited by commentators as
having prompted the change in Giacometti's style. In any
case, Giacometti's post-Cubist *Torso* of 1925 (plate 7) sur-
passes the work of these others in its sculptural strength
and its technique of 'harnessing' space.

The fact that Giacometti had now definitively become
a real 'sculptor' is documented in the family portrait that
he painted for his parents' silver wedding anniversary: the
family is seen in front of the house in Maloja (to which a
wooden studio had just been added), with each person
shown at his or her own work (the brothers absent on 4 Oc-
tober appear in a vignette): the father at his easel, the
mother and sister doing needlework, and Alberto with a
hammer and chisel bent over a stone the size of a head. A
few heads sculpted in stone have, in fact, survived, though
their date is uncertain. The later works in stone were
mostly carved by Diego or by a stonemason.

At the Salon des Tuileries in November, Giacometti exhibited a figural composition (a first, artistically as yet unresolved version of his *Torso*) and *Head*, probably a portrait of Diego. From February Alberto's younger brother had shared his life and work in Paris; from this point on he was to remain indispensable to the artist, as his assistant and as his model. The same month Giacometti also took part in an 'Exposition des Artistes Suisses' in Paris.

1926

Giacometti's first portrait of the Swiss art collector Joseph Müller (who lived in Paris as well as Solothurn) had still been academically realistic in form. With *Torso* (plate 7), however, there began the first of the principal periods of Giacometti's mature œuvre—'post-Cubist' and soon also 'Surrealist'. In the winter of 1926/27, stereometrically stylized figural compositions and pictorial symbols derived from the art of 'primitive' peoples both occurred in his work. In his first major sculpture, *Spoon Woman (Femme-cuiller)* of 1926 (plate 8), they were combined.

At the Salon des Tuileries Giacometti exhibited the work *Sculpture*, now known as *The Couple (Le Couple)*, of 1926 (plate 9), as number 865, and *Bust* (probably a portrait bust of Flora Mayo, which he later destroyed), as number 866.

In the spring, Giacometti moved to the studio complex at 46, rue Hippolyte-Maindron, where there was no electricity or heating (except for a small iron stove), and only a small communal tap and toilet in the yard. 'I have acquired a big new studio in Paris where we'll be able to get some work done,' he wrote to a school friend on 10 September 1926. Later on, however, he described the studio as follows: 'It's funny, when I rented this place in 1927, I thought it was tiny. I planned to move as soon as I could because it was so small—just a hole. But the

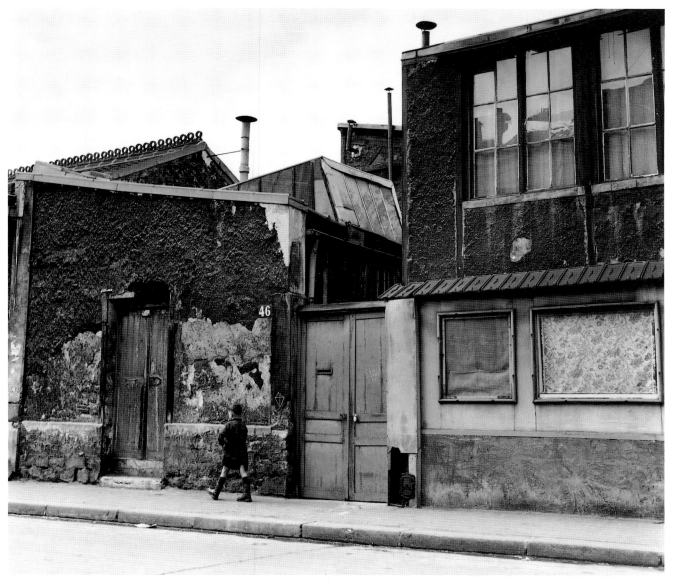

Sabine Weiss, Entrance to Giacometti's studio at 46, rue Hippolyte-Maindron, Paris

longer I stayed, the larger it grew. I've been able to do everything here, even the large standing figures (1959) that belong with the *Walking Man* ... If I'd had a larger studio I wouldn't have used the extra space in it.' Giacometti often sketched the studio together with all the works in it. Diego slept up on the balcony, while Alberto spent the night below in the work room or in the nearby Hôtel Primavera at 147, rue d'Alésia. After the war, he rented the neighbouring rooms as well, and running water, electricity and a telephone were installed.

1927

The second *Portrait of Joseph Müller* heralds an entirely new sort of sculpture, one that reproduces a head 'as one really sees it': as a flat disc, that, for all its symmetry and frontality, renders the face in a three-quarter view. Even more artistically significant were the 'flat' *Head of the Artist's Mother* and a sculpted and coloured *Bust of a Woman*. These works usher in the disc sculptures of the following years.

In Maloja, Giacometti made portraits of his father: alongside fairly naturalistic ones (plate 12), there was also one with facial features scratched on a surface cut across the stone to form the front of the head, as well as a gently domed marble form (plate 13). Julius Hembus, in his memoir of the artist Ernst Ludwig Kirchner, wrote:

> With Kirchner we drove out from Wildboden (in Davos), via the Julier Pass to St Moritz and Maloja to visit Giacometti. But we didn't see him; instead we met his son. [Alberto] Giacometti showed us his works. He described a stone lying on the table, the shape and size of an ostrich egg, as a portrait of his father. On looking more closely, we noticed how characteristically the head had been captured with the simple means employed. He also spoke of a rock high up in the mountains that he had sculpted into its present shape. To create such a monument without the slightest thought of commercial profit is surely the most rewarding achievement an artist can have. (*Frankfurter Allgemeine Zeitung*, 26 May 1970.)

In an exhibition of the works of Giovanni Giacometti held at the Galerie Aktuaryus in Zurich, Alberto showed plaster busts of his father and of one of his brothers (probably Diego) and also that of a young girl. The opening on 23 October was celebrated with the whole family (and the Kunsthaus in Zurich mounted a simultaneous exhibition with works by Augusto Giacometti).

In Paris Alberto Giacometti exhibited his *Spoon Woman* (plate 8) at the Salon des Tuileries.

1928–1929

In February 1928—as the only sculptor and the only Swiss artist apart from Serge Brignoni—Giacometti took part in the exhibition 'Artisti Italiani di Parigi' at the Salon de

First tribute: an essay by Michel Leiris

l'Escalier at the Comédie des Champs-Elysées at 15, avenue Montaigne; he showed six sculptures, including *The Couple* (plate 9) of 1926 and a work called *Figure* that is today known only from its reproduction in the journal *Emporium,* both works being 'primitivist' embodiments of sexuality. From this point onward Giacometti presented himself in Paris as Italian rather than as Swiss.

The following February (1929) Giacometti took part in the exhibition 'Un Groupe d'Italiens de Paris' at the Galerie Zak at 14, rue de l'Abbaye. Again he was the only sculptor, showing alongside the painters de Chirico, Campigli, Savinio, Severini, de Pisis and others.

Giacometti was on the threshold of swiftly increasing renown. A review in *Cahiers d'art* (nos. 2/3, 1929) only mentioned his name in passing, as the critic (perhaps Tériade—see below) was not yet familiar with his work. However, the poet and ethnologist Michel Leiris—who was from then on to be among Giacometti's closest friends—wrote the first essay on Giacometti's recent works, an extremely sensitive piece, in George Bataille's *Documents* (no. 4, September 1929). In the same year, Jean Cocteau added to his diary *Opium* the sentence: 'I've seen sculptures by Giacometti that are so powerful, and yet delicate, that one wants to describe them as snow preserving the footprint of a bird.'

The breakthrough that made him a household name came with the disc sculptures that preoccupied Giacometti in the winter of 1928/29. The principal work in the series is the *Gazing Head* (*Tête qui regarde*; plate 15), a distillation of the flattened head of Giacometti's mother from the previous year, drawing on the example of Cycladic art. From the same stylistic principle, there

evolved upright plaster plates with hollows, convexities and cracks that suggested their titles—*Woman* or *Man*. The works *Reclining Woman* (*Femme couchée*; plate 20) and *Reclining Woman, Dreaming* (*Femme couchée qui rêve*; plate 19), which are also upright forms, initiated the series of Giacometti's Surrealist constructions. In *Man and Woman* (*Homme et femme*; plate 21) the theme of sexual aggression first comes to the fore.

In June 1929 Jeanne Bucher exhibited paintings by Campigli in her gallery at 3, rue du Cherch-Midi along with two works by Giacometti: *Gazing Head* and a work recorded as *Figure*, probably the plaster sculpture *Man (Homme)*. Vicomte Charles de Noailles, patron of the avant-garde and now, above all, of the Surrealists, bought a version of *Gazing Head*.

Even more important for Giacometti than these successes with exhibitions and sales was the respect he now enjoyed among artists. At Jeanne Bucher's gallery, André Masson's attention was drawn to Giacometti's work: the two artists met and talked at the Cafe du Dôme. Shortly afterwards, Giacometti came to know Jean Arp, Joan Miró, Max Ernst, Alexander Calder, Jean Lurçat and soon also Pablo Picasso, as well as the writers Jacques Prévert, Louis Aragon, Michel Leiris, Robert Desnos, Raymond Queneau, Georges Bataille and others, who had already broken with the dogmatic Surrealist circle around André Breton and who warned Giacometti against false prophets.

Giacometti now belonged to the avant-garde both on account of his work and through his distinctive personality. The art dealer Pierre Loeb drew up a contract with him: in return for paying Giacometti a monthly salary, he would take charge of all the work the artist produced for a year, exhibiting it and acting as his agent. In November he issued an edition of five terracotta copies of *Man*, selling one of these to the Vicomte de Noailles.

The art critic (and later art book publisher) Tériade (Efstratios Eleftheriades), who wrote for *L'Intransigeant* and *Cahiers d'art*, came to value Giacometti's sculptures so highly that in the autumn of 1929 he selected two works (again *Man*, in plaster or marble, as well as the bronze *Three Figures Out of Doors, or Two Men, Two Women—Ghosts* (*Trois Personnages dehors, ou Deux Hommes, deux femmes—spectres*) for the large 'Exposition internationale de la sculpture' at the Galerie Georges Bernheim. At the same time, i.e. in November and December, the Galerie Wolfensberger in Zurich also showed, under the title *Production Paris 1929*, Giacometti's *Man and Woman*, a horrifying image of copulation. In 1931 Carl Einstein included five reproductions of Giacometti's works from the years 1926 to 1930 in the third edition of his *Propyläen-Kunstgeschichte des 20. Jahrhunderts*, a popular German art

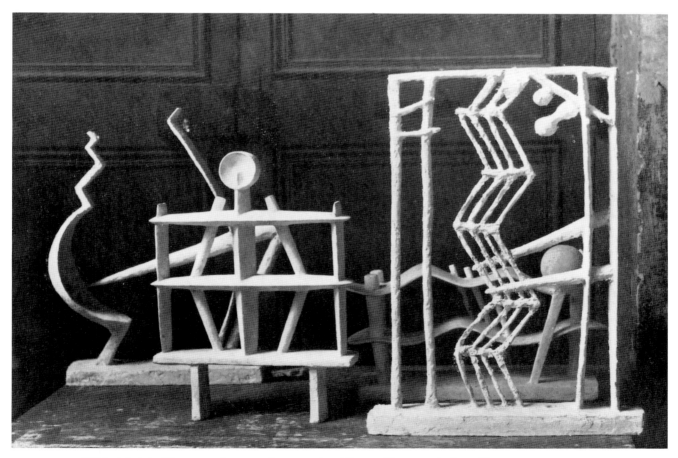

Michel Leiris, Plaster sculptures of 1928–29 by Alberto Giacometti, from *Documents* no. 4, 1929

history book, and added a new conclusion to the chapter on sculpture: 'Giacometti, an Italian Swiss, perhaps goes furthest in breaking away from all the restrictions of traditional imaginative standards. To begin with he produced static, calm images, pale, contemplative faces, tranquilly posed forms. Then he began to introduce movement into his work, so that he is now producing sculptures that are unstable in form; he is now turning resolutely towards the invention of new objects.'

1930

The degree of recognition that Giacometti had now attained in Paris led to new connections and commissions. The American Dadaist and photographer Man Ray, who had lived in Paris since 1921, commissioned Giacometti to make backgrounds and props in plaster for his fashion photographs.

More important, however, above all for the period beginning in 1935, when Giacometti worked for many years without any success, Man Ray introduced both Alberto and Diego to Jean-Michel Frank who, from his office at 140, rue Faubourg Saint-Honoré, commissioned artists to make furniture for his exclusive interior decoration schemes. Giacometti modelled small female heads for bronze standard lamps and attachments, and made wall lamps and vases in plaster. For the fashion designer Elsa Schiaparelli he designed pieces of jewellery from bronze gilt. For the banker Pierre David-Weill, whom he had met through André Masson, he created two bronze andirons and a spider-like wall relief. Other pieces of this sort—a combination of fine and applied art—followed for other clients.

This additional and highly needed income was generously supplemented from February onwards by occasional cheques from the Vicomte de Noailles, in payment for a garden sculpture commissioned for his summer house, Saint-Bernard, which had been built in 1925 by the architect Robert Mallet-Stevens in Hyères on the Côte d'Azur.

In the spring Pierre Loeb organized the exhibition 'Miró—Arp—Giacometti' at his gallery at 2, rue des Beaux-Arts, commissioning the Basque cabinet-maker Ipústegui to make a wooden version of Giacometti's plaster *Suspended Ball* (*Boule suspendue*; plate 18). The work unleashed a furore in André Breton's circle, and Breton himself purchased it. Giacometti's work gave fresh stimulus to Surrealist object art.

Breton visited the artist at rue Hippolyte-Maindron and invited him to join the Surrealist group. Giacometti took part in their activities and meetings until the winter of 1931/32 (and then again in 1933), but he did not submit to Breton's doctrinaire and dictatorial manner. When Giacometti had his appendix removed at the beginning

of July in the hospital at Samedan in the Engadine, he sent postcards to his new friends (to Jacques Prévert, for example), and a letter to André Breton that was almost tender in its tone.

In August, working in a mountain meadow near Maloja, Giacometti made three plaster stele figures (*Man, Woman, Child*?) as a model for the 'mysterious beings', as Vicomte de Noailles was now describing the sculptural commission for Hyères. On his journey back to Paris Giacometti checked the proposed location for these in the garden of the Villa Saint-Bernard.

He was back in Paris before 27 September. This was the period of the 'hot nights of Montparnasse' that Giacometti spent with artists and Surrealist poets at the Coupole, the Rotonde and the Dôme. All we know about his female companion during these adventures is that she was called Denise. She was the mistress of an itinerant fruit-seller called 'Dédé le Raisin', so that Giacometti, in his own way, got his money's worth. According to Giacometti's account, his nights with Denise were incorporated into his construction *Palace at Four in the Morning* (*Palais de quatre heures*; plate 29), a major work of this period.

Towards the end of December, Henri Laurens called on Giacometti at his studio. In 1928 Laurens had created a female figure in marble, over six feet high, for the summer residence of the Vicomte de Noailles. He now saw for the first time the plaster cast for Giacometti's final, monolithic figure for Hyères (just as large as his own).

Man Ray, *Palace at Four in the Morning*, 1932

16

Man Ray, Alberto Giacometti, 1932

Giacometti's Surrealist sculptures now became even more aggressively sexual. There were phallic objects without pedestals, *Unpleasant Object (Objet désagréable)* and *Unpleasant Object to Throw Away (Objet désagréable à jeter)* and constructions like board-games, *Circuit, Man, Woman, Child (Homme, femme, enfant)*. In October, at the exhibition 'Jeunes Artistes d'aujourd'hui', at the Galerie Georges Petit at 8, rue de Sèze, these works met with little enthusiasm among the conservative clients and art critics who were regular visitors there.

In the third issue of Breton's magazine *Le Surréalisme au service de la révolution*, which came out in December, a double-page spread headed *Mobile and Dumb Objects (Objets mobiles et muets)* contained a poem by Giacometti as well as seven drawings based on some of his own constructions and objects. From the years 1930 and 1931 there were: *The Cage (La Cage), Suspended Ball (Boule suspendue), Unpleasant Object to Throw Away (Objet désagréable à jeter), Model for a City Square (Projet pour une place;* plate 22) and *Unpleasant Object (Objet désagréable)*. There were also sketches of two apparently no longer surviving multi-part compositions, one of which is the first version of *Spike in the Eye (Pointe à l'œil)* and the other the construction *Palace at Four in the Morning*.

Before the end of the year it was decided that Giacometti, on Laurens's recommendation, should carve the final version of the figure from the pale Burgundian limestone available from the quarry at Pouillenay.

1931

At the end of February and in the first half of March, working at Pouillenay with Diego's help, Alberto carved out a rough version of the figure's intended shape. On 13 March he sent it by rail to Hyères. He himself returned to Paris, but travelled to the Côte d'Azur for a few days at the end of April in order to do more work on the figure. At the end of May and the beginning of June 1932 he was again in Hyères, together with Diego, in order to give the stone stele the exact form of the plaster model (Diego did most of the work on this), and in the summer or autumn of 1933 he completed it there. This *Large Figure (Grande Figure)* now stands in a private park in Fontainebleau.

In May Giacometti signed the Surrealist pamphlet against the 'Exposition coloniale internationale'. From 22 May to 6 June the Galerie Pierre Loeb showed Giacometti's work in its exhibition 'Où allons-nous?', although the artist had cancelled their business arrangement the previous November in favour of an association with the art dealer Pierre Colle.

1932

Giacometti now became more closely associated with the politically engaged 'left' wing of the Surrealist group, led by Louis Aragon. Until 1935, he contributed a number of caricatures—attacking the Church or commenting on the class war—to its journals *La Lutte* and *Commune*.

In May the Galerie Pierre Colle at 2, rue Cambacérès mounted Giacometti's first one-man show. Picasso was one of the first to arrive at the opening. Christian Zervos published an essay on Giacometti's sculptures, 'Quelques Notes sur les sculptures de Giacometti', illustrated with photographs by Man Ray, in his magazine *Cahiers d'art* (nos. 8/10, pp. 337–42).

The themes of sexual aggression, cruelty and death were pursued in sculptures placed directly on the floor, without a pedestal, such as *Woman with her Throat Cut (Femme égorgée)* of 1932 (plate 32), or that looked like models for stage sets for psychodramas: *The Game is Over (On ne joue plus), Life Goes on but the Bridges are Rotten (La vie continue mais les ponts sont pourris), Palace at Four in the Morning*. Other sculptures, insistently three-dimensional and executed on a larger scale, indicate that Giacometti also saw such compositions as models for large-scale sculptures or even for a monument for a public square (notably the elements for *Model for a City Square*), and that he was feeling his way towards life-size figures such as *Walking Woman (Femme qui marche)*.

LE SURRÉALISME
AU SERVICE DE LA RÉVOLUTION
Directeur :
André BRETON

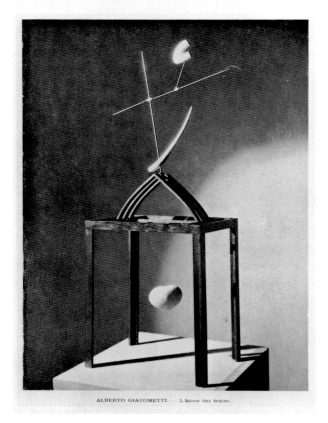

ALBERTO GIACOMETTI. L'heure des traces.

Anonymous, *The Hour of the Traces*, 1930–31,
from *Le Surréalisme
au service de la révolution* no. 6, 1933

For a Roman countess, Madina Visconti, Giacometti made two large-format views of his studio (plates 30 and 31) that provide a complete inventory of his work at the time. He had met the Countess at a smart evening party, and she had visited him at least twice at rue Hippolyte-Maindron, where he had made three portrait drawings of her. Giacometti gave the studio scenes to her in December, hoping that he would meet her again.

In Stampa and Maloja Giacometti modelled realistic portrait busts of his father, of his brother and of his sister Ottilia. Here he also painted portraits in a more conventional and fashionable style. The difference between his working methods in Paris and in Switzerland is remarkable. In Basle on 2 November Giacometti learnt just how provincial Switzerland was in artistic matters. He had been invited to be a member of the jury assembled by the Art Fund of the Canton of Basle *(Staatlicher Kunstkredit)* to select a sculpture for the garden of one of the city's hospitals. The majority of the jury voted for a waddling goose by Carl Bauer, and Giacometti went straight back

to Paris. While he remained well-disposed towards everyone from Switzerland until the end of his life, and especially towards young artists who met him or who wrote to him, he never again agreed to be a member of a jury sponsored by a Swiss cantonal or federal government.

1933

In February and March Giacometti took part in the Surrealist sessions led by André Breton and Paul Eluard, during which leading questions of the type posed in 'depth psychology' were used to produce the texts later gathered under the title *Recherches experimentales sur la connaissance irrationelle d'un objet* (Experimental Research on the Irrational Knowledge of an Object). This was the title given to the report of these events, with Giacometti's answers to the questions, in the May issue of *Le Surréalisme au service de la révolution*. The same issue (no. 5, p. 15) contained Giacometti's *Poème en 7 espaces* (Poem in Seven Spaces), *Le Rideau brun* (The Brown Curtain), and the text *Charbon d'herbe* (Burnt Grass), in which he mentioned Bianca, who married in 1933. On page 41 there appeared Giacometti's drawing of a sculptural project, *Meeting in a Corridor (Rencontre dans un couloir)*. Issue number 6, published simultaneously, contained his surrealistically stylized report on his childhood, *Hier, sables mouvants* (pp. 44–5).

In the engraving workshop Atelier 17, at 17, rue Campagne-Première established by the Englishman Stanley William Hayter (who exhibited in 1933 with the Surrealists), Giacometti learnt the techniques of engraving and etching. During this year and the following one he made three or four prints based on his own sculptures. For a de luxe edition of poems by René Crevel, *Les Pieds dans le plat*, Giacometti provided an engraving relating not only to the poems, but also to Crevel's interpretations of works by Paul Klee (1929, published 1930) and to Raymond Roussel's stories in *Locus solus* (1914). In 1934 there appeared Giacometti's four engravings, called 'etchings', for André Breton's volume of poems, *L'Air de l'eau*. In 1938 these early prints by Giacometti were shown for the first time in Maastricht at the exhibition 'Groupe de l'Atelier 17'.

On 20 June at the 'Exposition surréaliste' at the Galerie Pierre Colle, the Vicomte de Noailles bought Giacometti's *The Surrealist Table (La Table surréaliste)* in plaster for 6,000 francs. At the auction of works owned by the magazine *Cahiers d'art* on 12 April, however, the marble *Caress (Caresse)* sold for only 2,100 francs—a consequence of the increasing economic crisis and the retreat of art dealers to more conventional, and predominantly representational, works. Giacometti's other sculptures in the exhibition at Pierre Colle's gallery were: *Palace at Four in*

the *Morning, Mannequin, The Hour of the Traces (L'Heure des traces), Sugar Lump (Sucre minéral)* and perhaps the large plaster cone from *Model for a City Square*.

Along with Jean Arp, Victor Brauner, Max Ernst, René Magritte, Joan Miró, Meret Oppenheim, Man Ray and other Surrealists, Giacometti exhibited in a separate section in the Salon des Surindépendants, presenting a version (now enlarged to almost two metres, and made from wooden slats and plaster) of the construction *The Cage (La Cage)* of 1931. This unwieldy object was eventually placed on the balcony of Max Ernst's apartment, and one day it smashed to pieces on the paving of the courtyard.

In the garden at the villa Saint-Bernard in Hyères, Giacometti completed the *Large Figure (Grande Figure abstraite;* private collection, Fontainebleau). It was probably during this visit that he constructed a mobile giraffe together with Luis Buñuel.

On 25 June Giovanni Giacometti died in a private clinic at Valmont in Glion (above Montreux). Alberto and Diego arrived there the next day. Alberto fell ill, and it was only after his father's funeral in Borgonovo on 28 June that he was able to return to the Bregaglia valley, where he spent the summer without his usual enthusiasm for his work. During the rest of the year in Paris only a few pieces were made. On his father's death, Giacometti's interest in Surrealist objects and constructions apparently came to an end.

1934

With the year 1934 came the international spread of Surrealism through exhibitions offering a survey of the movement ('Exposition Minotaure' in Brussels and 'Was ist Surrealismus?' in Zurich, for example), in every case with works by Giacometti, even if he was not present in person. However, the year also marked the end of Giacometti's Surrealist phase: in Paris, too, he now started modelling portrait heads from life.

Giacometti now strove to do justice to the theme of death and the continuing of life in a large, perhaps monumental, figural composition. According to Robert Goldwater, the stereometrically stylized *Skull Head (Tête crâne)*, mistakenly called 'Cubist', is partly a living face, and partly a dead man's skull. The monumental dodecahedron *The Cube (Le Cube)*, a quotation from Dürer's engraving of 1514, *Melencolia I*, is a stylized head. Giacometti carved a self-portrait into one of the two plaster versions of the work.

His principal work during this period was the sculpture *The Invisible Object—Hands Holding Emptiness (L'Objet invisible—Mains tenant le vide)*, 1934–35 (plate 35), which can be interpreted as a figure for a tomb. It was elaborated in the spring, with several versions of the head, drawing on

both Kolbe's bronze *Assunta* (1921) and a Polynesian tomb figure. André Breton published a very misleading account of the work in *L'Amour fou* (1934).

On the occasion of the exhibition 'Minotaure' in Brussels in May and June, the Belgian journal *Documents 34* published a question-and-answer dialogue between Giacometti and Breton.

During the summer in Maloja, Giacometti and Max Ernst worked on objects found in a glacier that had been smoothed round by the forces of nature. It was from this type of granite that Giacometti produced the stone for his father's grave in the cemetery of San Giorgio in Borgonovo (still in situ): on the front there is a relief with early Christian symbols of life after death, while, seen from the rear, the stone takes on the form of a torso. Here Giacometti also made, from plaster, his last Surrealist figure: a cone about one and a half metres in height with the pencil inscription $1 + 1 = 3$, suggesting the figure might be identified with that of a pregnant woman. In 1947 he wrote of this work that he had been unable to get it right and had therefore had to make several studies from nature, in the process restricting himself to the rendering of the head.

In Paris, from the autumn onwards, Giacometti in fact worked on only two heads, initially without, and then with models, and always the same ones: his brother Diego and the professional model Rita Gueffier. Among the Surrealists this change of approach was perceived as a betrayal of the avant-garde, in view of the fact that figural, and often reactionary, art was now encouraged both politically and commercially. 'A head—but everyone knows what a head is', Breton is said to have exclaimed, in-

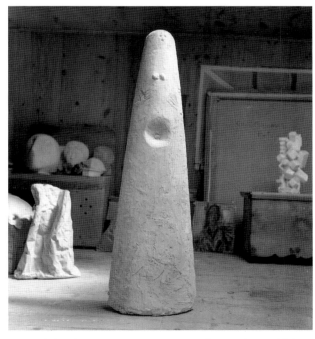

Ernst Scheidegger $1 + 1 = 3$, 1934, in the studio at Maloja

censed. From this point on, however, Giacometti was to prove that no sculptor before him had shown how the human head is seen in space.

At Giacometti's prompting, the Kunsthaus in Zurich dropped the plan for an exhibition with free-standing sculptures by Arp, Laurens, Lipchitz and a disproportionately large number of works by Giacometti. Instead, it mounted in October a more balanced Surrealist exhibition with twelve sculptures each by Giacometti and by Arp, six iron sculptures by Julio González, three paintings by Miró and fifty-one pictures and collages by Ernst, who contributed a preface, 'What is Surrealism?', to the catalogue.

In December, in issue number 3/4 of *Minotaure*, the new magazine published by Tériade and Albert Skira, there appeared Brassaï's photographs of Giacometti's *Woman with her Throat Cut* (plate 32) and *Palace at Four in the Morning* (acquired by the Museum of Modern Art, New York, in 1936); and, alongside them, Giacometti's text connecting *Palace* with his earliest childhood memories of his mother and with a magical experience of love and death with Denise two years earlier.

From 1 December until 1 January 1935 Julien Levy's gallery at 602 Madison Avenue, New York, presented Giacometti's first one-man show in the USA, entitled 'Abstract Sculpture by Alberto Giacometti'. According to Levy's memoirs, published in 1977, Giacometti himself proposed the exhibition, but this hardly seems credible. The New York dealer naturally knew all about the Paris avant-garde. The twelve works exhibited, in marble, wood and plaster and priced at between 150 and 250 dollars, included *The Game is Over*, which the art dealer retained to pay for his expenses (since 1986 it has been in the Nasher collection in Dallas), and *The Invisible Object* (plate 35), later acquired by Roberto and Patricia Matta. During the exhibition itself no sales were made, and the critics were at a loss as to what to say about Giacometti's sculptures.

In December Giacometti was invited to supper by André Breton and Benjamin Perret and afterwards to the apartment of Georges Hugnet. This had been prearranged so that Giacometti could be formally accused (on account of his work for the interior decorator Jean-Michel Frank) of disloyalty to Surrealism. Giacometti abruptly brought the 'hearing' to an end by voluntarily and definitively leaving Breton's circle. In 1938, on the occasion of an international Surrealist exhibition held at the Galerie Charpentier, Breton was to term Giacometti a 'former Surrealist'.

1935–1936

As a result of this 'excommunication', Giacometti lost his connections with the Paris Surrealists and with many of

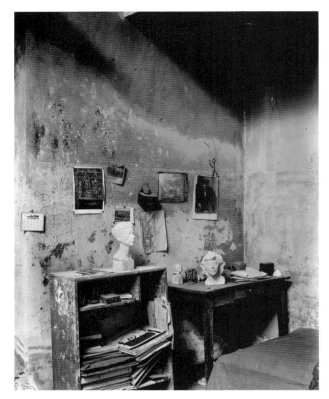

Pierre Bruguière, Giacometti's studio, 1936–38

his friends at one stroke. An exception was René Crevel, and it was therefore all the more distressing for Giacometti when Crevel (a homosexual who had been ostracized on this account by Breton) killed himself on 18 June 1935. Giacometti became closer to other artists: to André Derain, who was now aged and had lost much of his artistic importance; to Jean Hélion; and, above all, to a number of artists working figuratively—Balthus, Francis Gruber, Tal Coat and Francis Tailleux. Each of these had something personal, usually anecdotal, to express through objective representation. Giacometti's own work from life was, however, to prove the beginning of something quite new, something universal and absolute.

In 1935 the art critic and writer Anatole Jakovski included a composition by Giacometti among the twenty-four etchings by artists discussed in his volume *24 Essais*. Another, non-representational etching (of 1936) was to be included in the album *Repères*, along with a text by Tristan Tzara.

From 24 February to 31 March 1935 the Kunsthaus in Zurich showed the exhibition 'These—Antithese—Synthese', a review of contemporary art organized by Hans Erni, a Lucerne painter working in Paris. In addition to Giacometti's two plaster 'Heads' of 1934, the exhibition included his *The Cube*, designated *Part of a Sculpture (Partie d'une sculpture)*; to judge from the relative sizes, it would seem that another 'part' was the plaster cone *1 + 1 = 3*, also produced in 1934.

In Paris Giacometti, Laurens and Lipchitz were the only sculptors to participate in the exhibition of the Union of Revolutionary Writers and Artists at the Communist Maison de la Culture at 12, rue de Navarin. Giacometti showed two heads, on this occasion calling them *The Two Oppressed Ones (Les Deux Opprimés)*.

In the spring of 1935 Giacometti met in a cafe the 23-year-old Englishwoman Isabel Nicholas, whom the sculptor Jacob Epstein had used as a model. She became an important friend for Giacometti, and, from 1936, also his model. After the war she lived with him for three and a half months at the studio in rue Hippolyte Maindron.

Giacometti spent the later 1930s in isolated, dogged work on heads, using his few trusted models. Comparisons between specific works show that Giacometti's new start (in his drawings as well) was based on stereometric basic forms, and led him to increasingly vivid frontally gazing faces that were animated in their surfaces, but were also becoming constantly smaller.

Alberto and Diego Giacometti now supported themselves financially more than ever before by designing and making lamps and furniture for Jean-Michel Frank, through whom they also met new friends (including Christian Bérard). Giacometti worked as conscientiously at such objects as at his sculpture, but he did not regard them as works of art.

In June and July 1936 two pieces by Giacometti were included in the exhibition 'Zeitprobleme in der Schweizer Malerei und Plastik' (Contemporary Questions in Swiss Painting and Sculpture) at the Kunsthaus in Zurich: the phallic 'Objects' (in marble and wood). From December 1936 to January 1937 the Museum of Modern Art in New York showed the exhibition 'Fantastic Art, Dada and Surrealism', including works by Giacometti: the wooden *Unpleasant Object* from a private collection, the plaster *Head Landscape, or Life goes on (Tête paysage, ou La Vie continue)*, the *Fall of a Body on to a Diagram*, cited as a loan from the artist, and *Palace at Four in the Morning*, cited as an anonymous gift to the museum. Other Giacometti works to be found in New York by this time were *Walking Woman*, owned by the art dealer Pierre Matisse, and *Figure* of 1927 in the Gallatin collection.

1937

Now that the first, brilliant half of Giacometti's life had come to a close he attained the human maturity, artistic integrity and preoccupation with the absolute that were eventually to make him into a legend. In the short term,

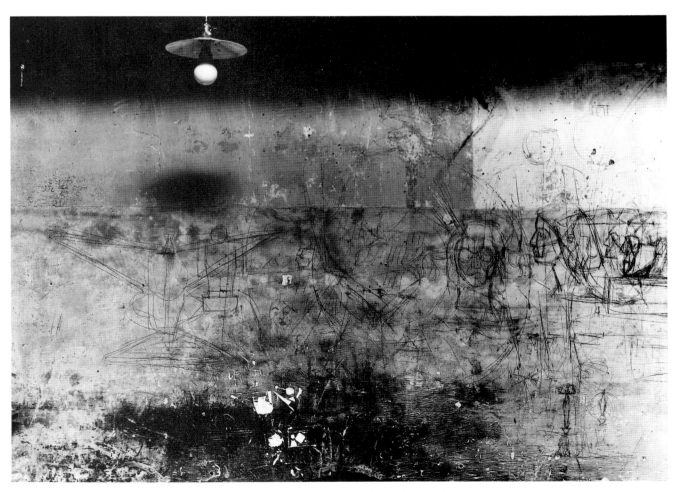

Pierre Bruguière, Giacometti's studio, 1936–38

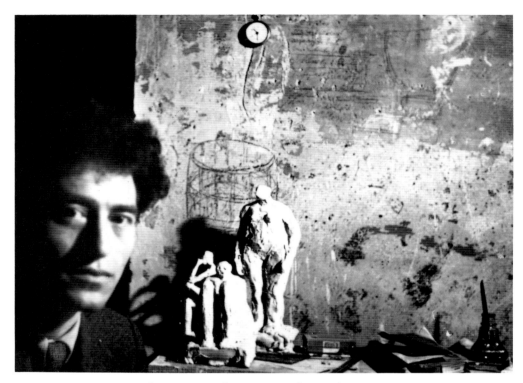

Anonymous, Giacometti in his studio, 1937

however, these qualities were to ensure that the artist became a demanding and stimulating interlocutor for Picasso, Samuel Beckett and soon also for Jean-Paul Sartre.

At the end of October 1937 Beckett settled in Paris for good; and in December his first major work, *Murphy,* was accepted by a publisher, after forty-five rejections. Giacometti struck up a conversation with Beckett one evening at the Café de Flore, and their discussions were to continue (sometimes with prolonged mutual silences) through innumerable aimless nocturnal strolls through the streets of Montparnasse till the break of dawn.

Though Giacometti could never take Picasso's painting and sculpture wholly seriously, he nonetheless visited Picasso in his 'Guernica studio' at 7, rue des Grands Augustins. Picasso, in turn, visited Giacometti in the studio in rue Hippolyte-Maindron, observing Giacometti's apparently hopeless and impossible attempt to reproduce individuals in sculptural form as he saw them—as small particles within the field of vision. Picasso understood that Giacometti was wrestling with an entirely new concept of sculpture, just as he himself had wrestled with Cubism from 1907 to 1910. It was only in Picasso's characteristic fits of malevolence that he would say, behind the back of his almost despairing friend: 'Giacometti wants to make us feel we're missing the masterpieces he will never make.'

For the time being, Giacometti was still always at work on two heads, one male and one female; later—as he said at the beginning of July to the Swiss sculptor Karl Geiser—he wanted to make 'realistic' figures: a standing woman and a walking man. These were probably connected with his idea for 'Compositions with Figures'. It had been for the sake of this project, as he was to write to Pierre Matisse in 1947, that he had again started working from life in 1934.

But a visual experience that Giacometti had made him realize that he was striving for something other than 'realism'. Around midnight in the boulevard Saint-Michel he saw his friend Isabel walking further and further away, diminishing in size between the rows of houses, even though he lost nothing of his sense of the indivisible totality of her identity. He wanted to reproduce in sculpture what a painter or draughtsman could attain by means of perspective: a figure that was not a replica but a visual reminiscence.

His current difficulties with his modelling were more than compensated for by success in his painting. In Stampa Giacometti produced the two pictures *Apple on a Sideboard* (*Pomme sur le buffet*; plate 36) and *The Artist's Mother* (*La Mère de l'artiste*; plate 37); few of his works had anticipated the style of these in any way, nor had any previous work matched their masterly execution.

1938

During the first few months of the year, Giacometti produced, on commission from the Communist Party, the only political sculpture he made that has survived: a monument to the photojournalist Gerda Taro (1911-37), who was killed during the Spanish Civil War. The monu-

ment was unveiled at the Père Lachaise cemetery in Paris on 30 May 1938, during a demonstration by the *Front populaire,* which was repeated on the same date the following year. The work, first recognized and reported on in a publication by Casimiro Di Crescenzo in 1991, is still accessible to the public, although its position was rotated 180 degrees in 1953. None of the monuments Giacometti designed after 1945 for the French Communist Party or for the City of Paris were executed.

Giacometti made heads of Diego, Rita and Isabel, the size of a child's fist, without necks and initially without pedestals. The facial features were extraordinarily full of energy and the eyes were gazing intently. These, however, were studies. Giacometti was like an explorer who had set out for the North Pole without knowing for sure whether or not there really was a North Pole.

This difficult work was interrupted for several weeks because of an accident on 18 October. After dinner in Saint-Germain-des-Prés, Giacometti accompanied Isabel across the Seine to her hotel in the rue Saint-Roch. On his way back, while looking for a taxi in the place des Pyramides, he was hit and knocked down on the pavement at the monument to Joan of Arc by an uninsured car hired by a Mrs Nelson from Chicago. A police patrol took them both to the Bichat hospital, where the unhurt American woman was then released. The following day an X-ray of Giacometti's right foot revealed that the instep was crushed in two places. From 20 to 25 October Giacometti was given specialist treatment at the Rémy-de-Goncourt clinic by the surgeon Dr Raymond Leibovici, though without undergoing an operation. He was released on 26 October and advised to look after his foot, which was in plaster, until the fracture had healed, so that there should be no lasting damage. Giacometti neglected these instructions and, as a result, was to walk wih a limp from this time onwards. For several years he used a support when walking, at first crutches, then a walking stick. There was never any danger that his foot might be amputated (as has been suggested by commentators as a trauma that might explain the oversized feet and pedestals of Giacometti's later bronze figures). While he was in the clinic Giacometti drew the trolley with the bottles that rattled as it moved along. From this, he was to derive the sculpture of 1952, *The Chariot* (*Le Chariot*; plate 60); the original drawing has not survived. Giacometti repeatedly described the accident to his friends as being an experience that had far-reaching consequences for his life. In 1964 Jean-Paul Sartre gave a garbled account of it in his autobiography *Les Mots (The Words)*.

1939–1941

In 1939 Sartre came up to Giacometti in the Café de Flore and asked him to pay his bill. After his successful novel of 1938, *La Nausée (Nausea)*, Sartre was just completing his studies for a phenomenological psychology (*Sketch for a Theory of the Emotions,* 1939). Sartre and his companion Simone de Beauvoir regarded Giacometti as a fascinating conversational partner and as an artist who was engaged in a 'search for the absolute' (in 1947 Sartre was to use this as the title for an essay on Giacometti), someone who was, as it were, re-inventing the art of sculpture. A number of Giacometti's thoughts found their way into Sartre's principal philosophical work, *Being and Nothingness,* of 1943.

During these years the most important French phenomenologist, Maurice Merleau-Ponty, was still pursuing behavioural research; yet, between 1942 and 1945, he was to establish an approach to epistemology—the phenomenology of perception—that paralleled what Giacometti was searching for between 1938 and 1945 in sculpture.

The portrait busts and heads modelled by Giacometti had now shrunk to the size of a nut. They were intended to reproduce a remembered image that incorporated the sense of space and distance. Also intended to introduce the element of distance were the square pedestals, larger than the small figures and becoming ever larger, while the busts and heads themselves became ever smaller. For the first time, a diminutive bust of this sort on a high, broad pedestal was reproduced in the second year of Tériade's magazine *Verve* (1939, nos. 5/6, p. 131: *Portrait Bust of Dr Théodore Fraenkel*), together with the portrait of Giacometti's mother painted in 1937 (plate 37).

Giacometti's brother Bruno secured two sculptural commissions for him for the Swiss National Exhibition, held in Zurich from May to October 1939: one for the covering for the façade of the pavilion 'Textiles and Fashion', and another for a sculpture for one of the glazed inner courtyards of the building, each six metres square. For the first Giacometti proposed a monumental plaster 'drapery' that it was not possible to execute for technical reasons. For the second he began by ordering in advance a large pedestal, and this was already in position when he arrived in Zurich. He had brought the sculpture intended for it with him—in a small suitcase. It was one of his new small figures; and if the first would not do, then another of those he had with him might serve. Any of these, he insisted, would appear monumental when viewed from any side. This proposal was perceived, however, as a mockery of the other Swiss sculptors taking part in the exhibition, and none of Giacometti's tiny figures was used. Instead, the pedestal was removed and *The Cube* from the Lucerne exhibition of 1935 was placed on the ground directly.

At the outbreak of war on 1 September 1939 Alberto and Diego Giacometti were in Maloja. On 2 September they reported to the military authorities in Chur. Alberto

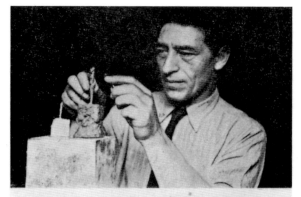

labyrinthe

JOURNAL MENSUEL DES LETTRES ET DES ARTS

ALBERTO GIACOMETTI CHEZ LUI

Strambin, Three photographs of Giacometti's garret
in a Geneva hotel, from *Labyrinthe* no. 1, 15 October 1944

was found unfit for military service; Diego was assigned to a transport battalion. By mid-November Alberto had returned to Paris; at the end of December Diego was there too.

In spring 1940 the American heiress and art collector Peggy Guggenheim returned to Paris from London, where she had opened the Guggenheim Jeune gallery. In Paris she planned to buy one work of art a day. In 1938 she had proposed to Giacometti an exhibition of his Surrealist work, but he had wanted only to exhibit his new pieces. In the Galerie Jeanne Bucher, Peggy Guggenheim

now saw Giacometti's plaster sculpture of 1932, *Tormented Woman in her Room at Night (Femme angoissée dans sa chambre la nuit)*, and wanted to buy it if Giacometti would restore the broken parts. Giacometti, however, did not sell her this work, but, instead his second version of the subject, *Woman with her Throat Cut* (plate 32), and had it cast in bronze for her. Peggy Guggenheim also bought the wooden version of *Model for a City Square* (plate 22). To begin with, she deposited these and other acquisitions in the Musée des Beaux-Arts in Grenoble and then shipped them back to New York, where in October 1941 she bought the plaster *Walking Woman* from Pierre Matisse. In October 1942 she was to establish a private museum, Art of This Century, and put the *Woman with her Throat Cut* on show at once. At the start of 1945 she was to organize a one-man show for Giacometti there with these three works as well as loans from American private collections (those of Julien Levy, Roberto Mattà and Philip Johnson).

In May 1940 Giacometti buried his recent, tiny sculptures in a corner of his studio. On 13 June—just before the entry of the German army into Paris—Alberto, Diego and the latter's companion Nelly joined the general exodus to the south: by bicycle and without the walking stick. On 14 June they saw the shelling of Etampes and the aerial machine gunning of the streams of refugees. Of all the gruesome sights he saw during those days, Giacometti was haunted, above all, by a stinking burnt arm and hand with spread fingers. In 1947 he evoked this memory in *The Hand* (*La Main*; plate 46). On 17 June the refugees reached Moulins, only to be overtaken, the next day, by the German advance. They turned back and were once more in Paris by 22 June. On the same day a ceasefire was agreed; and from then on Giacometti again started using his walking stick.

On 10 December 1941 Giacometti applied for a travel permit for Switzerland in order to visit his mother in Geneva. On 31 December (after midnight on that day the visa would have run out) Giacometti left Paris. Diego looked after the studio in rue Hippolyte-Maindron until September 1945.

1942–1945

From 1 January 1942 until 17 September 1945 Giacometti lived and worked in Geneva. At first he stayed with his brother-in-law, Dr Francis Berthoud, at 57, route de Chêne, where his mother was bringing up his nephew, now over four years old. Giacometti then rented, at 60 Swiss francs a month, a scantily furnished room, without heating or running water, in the sleazy Hôtel de Rive on the corner of the rue de la Terassière and the rue du Parc. He went to see his mother every day, if only just to

24

collect the meagre sum of pocket money she granted him (even though he was entitled to part of the money left by his father). Wealthy Swiss acquaintances, whom Giacometti asked for a loan, refused him. Giacometti did drawings for little Silvio and had the boy pose for him naked in the bathroom 'for hours on end' (or so it seemed to the boy). The outcome was a series of even smaller figures and heads on even larger pedestals. Giacometti's mother did not think much of this curious form of sculpture, her principal experience of it being through the traces of plaster she saw on Alberto's clothes and shoes when he came to the apartment. She knew nothing of his bohemian life in Geneva.

This took place after Giacometti had finished work in his hotel room, mainly at the Café du Commerce on the place du Molard or in the Grand Café de la Couronne on the Grand Quai at the place du Lac, as well as in a number of bars and *hôtels de passe* in the rue Neuve du Molard. At the Café du Commerce Giacometti regularly met with Albert Skira who, initially together with Pierre Cailler, was establishing an art book publishing company in his native city. From October 1944 to December 1946 Skira was to publish the journal *Labyrinthe* (illustration on p. 24), to which Giacometti contributed ideas, drawings and texts; Skira also paid Giacometti for the decorative vases that he ordered from him. Other members of the invariably lively circle were the sculptor Hugo Weber, the painters Charles Rollier, Roger Montandon and, for a while, Balthus, the photographer Eli Lotar, the actor Michel Simon, the philosopher Jean Starobinski and the writer Ludwig Hohl; a particularly close friend of Giacometti was the geologist Charles Ducloz.

Giacometti lugged plaster up to his hotel room by the sackful. He knew precisely what he wanted to achieve: the remembered image of Isabel, as he had seen her at midnight in 1937 in the boulevard Saint-Michel, or equivalent figures and heads seen 'in perspective'. As Giacometti was to write and draw in his autobiographical letter of 1947 to Pierre Matisse, despite his intentions, these figures became so small that they crumbled to dust at the last squeeze with his thumb or at the last nick with his knife. But he persisted in spite of this.

Giacometti continued to spend the summer months, and also some time each winter, in Stampa and Maloja. In summer 1942 he made in Maloja the only plaster sculpture from this period that provides a provisional embodiment of his other main sculptural project of this time, *Woman on a Chariot (La Femme au chariot)*, 1942 (plate 41), reminiscent of a cultic figure from a funeral procession in antiquity who is destined to live on in the realm of the dead.

In October 1943, at dinner at the Brasserie Centrale, Giacometti met Annette Arm (1923–93), who had just come of age a few days before. She was full of high spirits and wanted to get away from her parents' house in the suburb of Grand-Saconnex. After taking a secretarial course, she worked in one of the offices of the International Committee of the Red Cross. Her colleague there, Yvette Z'Graggen, was to describe Annette's affair with Giacometti, the limping artist twenty-two years her senior, in her *roman à clef* of 1950, *L'Herbe d'octobre*.

After the liberation of Paris in the summer of 1944, Giacometti secured the papers needed for his return. At the end of December, Skira organized a farewell supper for him, but Giacometti did not leave. In the fourth issue of *Labyrinthe*, appearing on 15 January 1945, he wrote about the sculptor Henri Laurens and also, in a text on Jacques Callot (1592–1635), on the importance of the subject in a picture. Was it Annette Arm who kept Giacometti in Geneva? He was absolutely determined that she should not feel tied to him, and he certainly did not want to take her back with him to Paris. Eventually, he borrowed the money for the journey to Paris from her and left Geneva, alone, on 17 September. On the afternoon of 18 September, after an absence of over three and a half years, Giacometti again set foot in his Paris studio. Diego

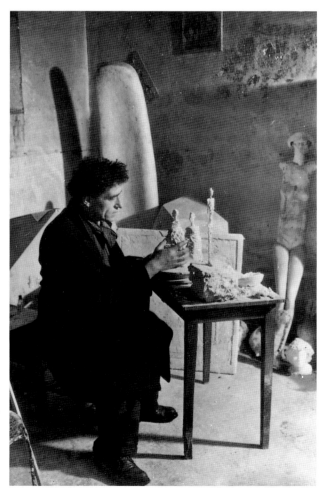

Emile Savitry, Alberto Giacometti in his Paris studio, *c.* 1946

had left everything exactly as it had been before. Giacometti continued with his work. Living conditions were difficult, and there was less money than ever before.

Soon Giacometti met Isabel Nicholas (who had returned from London) in a café on the Champs-Elysées, and asked her to come and live with him. Isabel lived for three months in an extra room that Giacometti rented in the studio complex in the rue Hippolyte-Maindron. On 25 December she left him. Their relationship was over for good, although they saw each other again occasionally.

1946

By the winter of 1945/46 Giacometti had not only resumed his lonely work, but had also returned to his gregarious night life in Montparnasse, and now also in Saint-Germain-des-Prés. Picasso acknowledged his artistic seriousness, and the friendly relations between the two went so far that Picasso was prepared to accept Giacometti's objections to his own sculptural ideas. The conversations between Giacometti, Sartre and Simone de Beauvoir, recorded by de Beauvoir, revolved around what was most fundamental in sculpture and on the relation between the image of the body and the void of the surrounding space. Among the writers, it was Louis Aragon and Georges Bataille and his wife Diane, who now belonged to a self-contained circle of friends. Giacometti drew them and modelled portraits of them. There was also the psychiatrist Jacques Lacan, to whom Giacometti left his early painting of a skull (1923). Among the painters, Giacometti started to see Balthus, Gruber and Tailleux again.

From now on Giacometti once again felt able to walk without his walking stick.

Giacometti now sketched people in the street, and in a new way: they formed elongated stick-figures, and he worked as if in 'shorthand', drawing sketchy, loosely intersecting lines across the whole sheet. In the portraits he drew at this time the subject was very small at the centre of the sheet, without precise outlines, with the face often smeared over to form a blackened blur. On one occasion, at the cinema Actualité Montparnasse, he saw the film images in a newsreel as black and white specks shifting over a flat surface and then suddenly noticed how different the reality of the people sitting around him was. Later, out in the street, he noticed how different that, too, was from the images in the film. The reality around him suddenly seemed entirely unknown, as if bewitched, and above all with its component parts distanced from him in irreducible space.

This important experience, along with what Giacometti had learnt through the process of drawing, altered his sculptural style. His aim in modelling heads and busts was now no longer to evolve an image that would correspond to the image preserved in his memory, but rather to achieve a phenomenological reproduction of the reality he observed in front of him: an entity that was small and slight in relation to the whole field of vision, incorporeal and weightless.

The difference is apparent in the portrait of the Resistance leader Colonel Henri Rol-Tanguy, still placed on a cube-shaped pedestal, and the tall, slender bust of Diane Bataille. Another work, in Giacometti's new style, was a design for a monument to the French victims of war: *The Night (La Nuit)*: a figure of a walking woman, thin as a wire, on a base resembling a sarcophagus.

Some of the new drawings (and perhaps also paintings) were exhibited at the Galerie Pierre Loeb. Sculptures the size of pins were also exhibited (at this gallery, or perhaps another), but no one showed any interest in them. In May, Pierre Bruguière, who had known Giacometti and his work before the war, organized an exhibition of modern art in the Musée des Beaux-Arts in the city of Tours, including several works by Giacometti: an old drawing after *Palace at Four in the Morning*, other old drawings and also some that were quite new, as well as two sculptures, *The Skull* of 1934 (of which several casts were made) and a plaster *Head* of 1944 (private collection, Paris). The only item that was sold was a portrait drawing of Aragon (plate 65).

At Easter, Giacometti travelled to Geneva, where Annette Arm sat as a model for him for the first time. On 6 July Annette arrived in Paris, intending to stay. She adapted herself to the extraordinarily frugal living conditions at the rue Hippolyte-Maindron. Giacometti, instead of buying household articles, painted a still-life for her on the wall. For over a year they had to borrow money from friends to be able to eat.

Because of the imminent closing of the brothels in Paris, Giacometti once more visited the 'Sphinx' and picked up an infection there.

On 25 July the eccentric caretaker of the studio complex at rue Hippolyte-Maindron, Tonio Pototsching, died. This, together with the disease contracted at the 'Sphinx', Annette's mocking reaction to it, and Giacometti's nightmare about Pototsching's corpse in the next room, was worked into the skilfully narrated text, *Le Rêve, le sphinx et la mort de T.* (The Dream, the Sphinx and the Death of T.) that Giacometti wrote for Skira's journal *Labyrinthe* (nos. 22/23).

In the first post-war issue of the magazine *Cahiers d'art* (1946, pp. 253–68) sixteen pages with reproductions of Giacometti's recent and latest sculptures and drawings documented the change of style that had taken place during this year: the shift from the pin-like figures on high pedestals to the 'beanpole' women more than a metre tall (without their pedestals) here described as 'en voie d'ex-

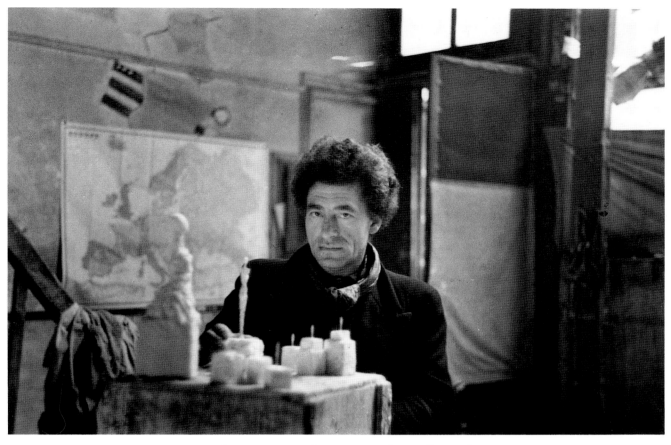

Henri Cartier-Bresson, Giacometti in his studio, 1946–47

ecution' (work in progress). Admittedly, most of the standing figures—figures of women, though only barely characterized as such—were still only hand-high forms on tall pedestals, no more than studies. None the less, like the new portrait busts of Simone de Beauvoir and Marie-Laure de Noailles (plate 43), they had the directness and vitality of an apparition perceived all at once and as an integral whole. Probably for the first time in the history of sculpture, a sculptural figure was not a copy of a body in real space, but an imaginary form (as the objects of a painting always are) in its own space, a space that was simultaneously real and imaginary, tangible and yet impossible to enter.

1947

Giacometti's new figural form retained its integrity and became a style—the 'Giacometti style' of the figures thin as a rod with indeterminate anatomy (but exact proportions) and vaguely suggested heads (but keenly staring eyes). The stock-still frontality of the 'Standing Women' lifts them into the hieratic. The summary representation of movement turns the 'Walking Men' into hieroglyphs of this particular action. The gristly surfaces, with their blurred modelling of details, always evoke the figures' 'containment' in space, lending them a closeness to real-

ity (despite their incorporeality), plausibility, and presence.

Giacometti now embarked upon the realization of the 'Compositions with Figures', in which the almost life-size 'Standing Women' (see plates 48, 50, 51) and 'Walking Men' (see plate 47) still remained isolated, but were related to the scenes of streets and squares that he drew. In *The City Square (La Place)* of 1948, he recorded such scenes in the form of a sculptural model. Giacometti still termed all these works 'studies'. *The Hand* (plate 46) and *Head on a Rod* (*Tête d'homme sur tige*; plate 45), above all in the versions that Giacometti also coloured, convey with immense power experiences that were personal but also express the universal experience of the preceding war years.

Giacometti pursued in his now numerous paintings the new style achieved in the drawings but also heralded in *The Artist's Mother* of 1937 (plate 37): a representation of the human figure that emphasized the positioning of the individual within the surrounding space.

Art dealers turned up: Louis Clayeux, who still worked for Louis Carré's gallery in the Avenue de Méssine, and Pierre Matisse from New York who, during two visits to Giacometti's studio, bought both Surrealist and new works, the latter no longer seeming too small for his taste.

In the summer Christian Zervos organized an exhibition of contemporary painting and sculpture in the Palais des Papes in Avignon. This brought together a well-known early work by Giacometti—*Woman with her Throat Cut (Femme égorgée*; plate 32)—with three plaster sculptures of 1947 in the artist's still unfamiliar 'new' style.

At André Breton's 'Exposition internationale du Surréalisme' at the Galerie Maeght at 13, rue de Téhéran, Giacometti refused either to be present himself or to show his *The Invisible Object* (plate 35).

Giacometti prepared for the one-man show that Pierre Matisse was planning for his gallery in New York, completing new works to present in it. By the end of the year he had written an eight-page autobiographical letter, interspersed with sketches of works, describing his career as an artist. With some pithy last-minute corrections that he made, this emerged as a striking literary text.

1948

From 19 January to 14 February the Pierre Matisse Gallery at 41 East 57th Street, New York, mounted Giacometti's first post-war one-man show. It included sculptures in plaster, wood, marble and bronze dating from 1925 to 1947 with the two paintings *Apple on a Sideboard* (plate 36) and *The Artist's Mother* (plate 37) of 1937 (mistakenly dated as '1945' in the catalogue, although this was an understandable error from the point of view of style) and two drawings. The catalogue itself, original in design, contained photographs by 'Patricia' (Patricia Echaurren Mattà, soon to be Mrs Matisse) of many very recent sculptures, some of which have not been preserved, in Giacometti's studio, as well as an English translation of Sartre's essay 'La Recherche de l'absolu'. Giacometti's autobiographical letter was also published in the catalogue, both in fascimile and in English translation, and there was a reproduction of a six-page list of works from 1925 to 1936, with sketches. The plaster for the sculpture *Spoon Woman* (plate 8) appears in it as *Large Woman (Femme grande)* with the date given as 1932–33, though Giacometti later wrote to Pierre Matisse that he had actually made the figure in the winter of 1926/27.

Giacometti's very thin, life-size figures from 1947 were seen in public for the first time at this exhibition. They had a notable success with American collectors and artists, although the press and the general public were less enthusiastic. It was this exhibition that initiated the spread of Giacometti's fame in the post-war period in the English-speaking world, where he was established before he became a familiar figure in Europe.

From February to May the Kunsthalle in Berne showed the exhibition 'Sculpteurs contemporains de l'Ecole de Paris'. Arnold Rüdlinger had grouped six figures and heads by Giacometti (from the artist's own col-

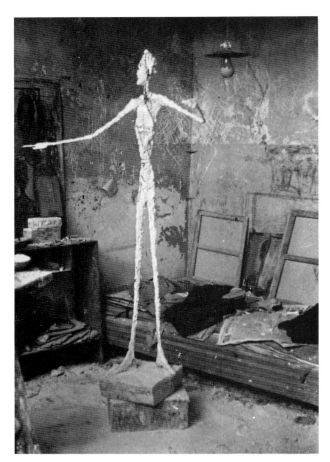

Patricia Matisse, from the catalogue *Exhibition of Sculptures, Paintings, Drawings,* Pierre Matisse Gallery, New York, 1948

lection and that of his brother in Maloja and Zurich) with works by eighteen other sculptors. The exhibition was then shown at the Stedelijk Museum in Amsterdam under the title '13 beeldhouwer uit Paris'.

Giacometti rented the studio next to his own in the rue Hippolyte-Maindron, and equally shabby, and furnished it frugally as a bedroom for Annette and himself. Annette sat as a model for him for hours on end, initially for nude paintings.

1949

In Paris the fame of the 'new' Giacometti spread. The dealer Pierre Loeb persuaded the artist to start making etchings again. Among Giacometti's new friends, now all younger than himself, was the poet Olivier Larronde. Giacometti lent him his support—as he was later to do with the poet Léna Leclercq—by making prints for the de luxe editions of his books. More prints—to begin with, etchings—accompanied publications of Giacometti's old friends Tristan Tzara and Georges Bataille.

Giacometti's principal sculptural work during the winter of 1948/49 was the composition *The City Square (La Place)* in two versions. On account of the still small scale of the figures standing on the shared platform (four walk-

ing men and a standing woman) this could be seen as a model for a much larger work intended for a public square. As so many bronze statues had been melted down and their pedestals left standing, the city of Paris, after the war, was commissioning new sculptures. For the square in front of the town hall of the 19th arrondissement, on the Buttes Chaumont, Giacometti designed a frontally viewed standing female figure poised above the axis of two large chariot wheels. The work was turned down by the authorities, but it was to become *The Chariot* (*Le Chariot*; plate 60) in 1950. Further walking men on shared platforms, in groups or alone, were probably similarly conceived as large street sculptures, but they remained as models.

On 19 July Annette Arm and Alberto Giacometti married at the registry office of the 14th arrondissement. From now on Giacometti was able to take Annette with him to stay with his mother in Stampa and Maloja, and so was able to carry on there with his work from the model.

In September and October Peggy Guggenheim mounted an exhibition of contemporary sculpture from

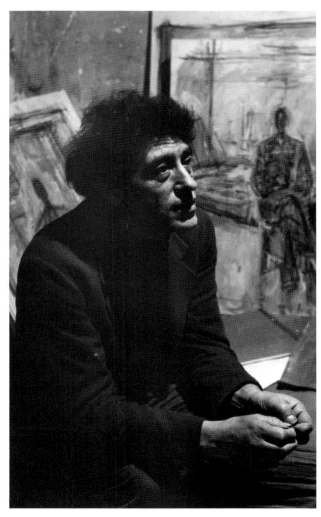

Anonymous, Alberto Giacometti in his studio, *c.* 1950

her own collection at the Venetian palace she had acquired—the Palazzo Venier dei Leoni on the Grand Canal. Of works by Giacometti, she showed the bronze *Woman with her Throat Cut* of 1932 (plate 32), the original plaster version of *Walking Woman* of 1933, together with the bronze cast made by the sculptor Pietro Consaga after the plaster version had been repaired. In addition, there was *The City Square* of 1948, in bronze. Giacometti went to see the exhibition. In 1957 he was to give Peggy Guggenheim his 1947 *Standing Woman*, known from then on as *Leoni Woman* (*Femme debout Leoni*; plate 50).

1950

From 24 January to 13 February works by Giacometti were to be seen at the Paris exhibition 'Quelques aspects de l'art d'aujourd'hui'. Apart from the New York art dealer Pierre Matisse, it was now with Aimé Maeght's gallery—opened in 1947 in great style at 13, rue de Téhéran, in a fashionable district of Paris—and its director Louis Clayeux that Giacometti had his principal business arrangement. In view of planned exhibitions, he made a splendid and varied series of compositions with individual figures or figural groups on pedestals that were intended to be seen as part of the subject. He had now found the right stylistic form for the standing women, walking men and watching heads. His new task, and one at which he worked with particular intensity in March and April, consisted of addressing the question of the interaction evoked by the respective placing and individual significance of each of these elements.

Invited by the French commission for the Venice *Biennale* to exhibit alongside Henri Laurens, Giacometti travelled with a few works to Venice in order to set them up in the French section of the exhibition. However, when he saw how Laurens's works were presented much less prominently than those of Ossip Zadkine, who was to receive the *Biennale* sculpture prize instead of Laurens, he packed his figures up again and left.

For an exhibition running from 6 May to 11 June, the Kunsthalle in Basle installed three rooms with works by Giacometti—fifteen sculptures, ten paintings and twenty-five drawings. The series of his sculptures here began with three works from the years 1932 to 1935: *Woman with her Throat Cut* (Plate 32), here again called *Objet-Figure*; *The Invisible Object* (plate 35), here with the title *Large Figure of a Woman (Grande Figure femme)*, both in bronze; and, with the title *Head*, the cubic *Skull-Head* in marble. These were accompanied, without any examples to serve as connecting elements, by major works from the years 1947 to 1950, the most recent being one here called *Composition 8 Figures* (probably the work *Seven Figures, One Head [Sept Figures, une tête]*, later called *The Forest*; plate 57).

Georg Schmidt, director of the Kunstmuseum in Basle, used money from the Emanuel Hoffmann Foundation, supported by the Basle patron Maja Sacher, to purchase the paintings *Portrait of Annette* (in reality a portrait of Marie-Laure de Noailles) and *The Table (La Table)*, both of 1950, for, 1,500 and 600 Swiss francs ($300 and $120), respectively. He also bought a bronze version of *The City Square* for 3,800 Swiss francs ($960; in 1993 its market value exceeds $2 million). These were the first post-war works by Giacometti to be acquired for a public art collection. The total price of 5,900 Swiss francs was knocked down to 5,500 ($1,100).

In November the second Giacometti exhibition at the Pierre Matisse Gallery in New York took place. It contained sixteen of the complex compositions from 1949 and 1950, now all cast in bronze. All were sold. Also in the show were six paintings and a drawing. For the catalogue Giacometti wrote the so-called 'Second Letter to Pierre Matisse' (in reality two letters written on consecutive days) with sketches of works and observations on the evolution of the works, presented in biographical terms. This is the principal source for the titles used since then for works made up to this date: *The Forest (La Forêt*; plate 57); *The Glade (La Clairière*; plate 59); *Man Walking in the Rain (Homme qui marche sous la pluie)*. In *The Chariot (Le Chariot*; plate 60), Giacometti recalled the Theban war chariot seen in Florence in 1920. In connection with *Four Figures on a High Base (Quatre Figurines sur base*; plate 56) and *Four Women on a Pedestal (Quatre Femmes sur socle*; plate 55) he cited visual impressions in 'Le Sphinx' and in a brothel on the rue de l'Echaudé.

1951

Aimé Maeght persuaded Giacometti to make lithographs with sale editions of seventy or ninety. Giacometti initially selected subjects from his studio full of sculptures, like those he had also frequently shown in his paintings. A number of lithographs served as illustrations for the periodical published by Maeght's gallery, *Derrière le miroir,* of which the issue number 39/40 accompanied the large exhibition held in the Galerie Maeght. Michel Leiris contributed the text *Pierre pour un Alberto Giacometti* (Monument to One Alberto Giacometti) written with shrewd insight into the artist's work. In contrast to the previous year in Basle and New York, small figures from the years 1940 to 1944 in plaster and bronze were now also exhibited, though the show also included *The Invisible Object* (plate 35). In addition, there were works from 1951—*The Cat (Le Chat)* and *The Dog (Le Chien*; plate 86)—as well as two plaster horses, each 1.60 metres in height *(Deux Chevaux)*, that belonged to a life-size team of six, together with a coach, that stood in the yard of the foundryman Alexis Rudier. (They were destroyed

after his death.) The total of thirty-six sculptures was accompanied in the show by eighteen paintings, a sculpture-to-painting ratio never before seen in exhibitions of Giacometti's work.

In November, on their return journey from Stampa to Paris, Giacometti and Annette visited Henri Matisse in Nice. They also went to see Picasso in Vallauris. The two artists had seen each other only rarely for some time; this meeting turned into an ill-tempered argument and brought their friendship to an end.

At the end of November, the Federal Art Commission inquired whether Giacometti would like to take part in setting up the new Swiss pavilion at the Venice *Biennale* exhibition; he was to take the place of Max Bill, whose name had been deleted from the list of suggested participants. Giacometti declined, suggesting it would be preferable to use a Swiss artist (he nominated Hermann Haller). (The irony of this response lies in the fact that it was his own brother, Bruno Giacometti—a Swiss like himself—who was to build the exhibition hall in 1952, and that Hermann Haller's best sculptures had been produced before the First World War.)

1952–1953

In February 1952 the American writer James Lord met Giacometti in the Café des Deux Magots. Through increasingly frequent visits to Giacometti's studio and, in time, numerous visits to the cinema, to bars, dinner in restaurants, and conversations in the circle of Giacometti's friends, as well as friendship with Diego, he became an intimate witness of Giacometti's work and private life. Lord kept a diary, also making notes on his conversations with Giacometti and the often bizarre fate of his artist and poet friends. Starting in 1970, using these and thousands of painstakingly researched further details, Lord was to write the life story of Alberto and Diego Giacometti. His book, *Giacometti: a Biography,* was published in New York in 1985; the author appears in it as 'a friend' or 'Giacometti's companion on that occasion'.

After the era of the significant post-war sculptures of 1947 to 1950 and renewed recognition in Paris, Giacometti turned now to the task of modelling and painting portraits from life as he saw the heads of his models in front of him, at an exactly plotted distance during the long sittings. He strove to get away from slightness, to make figural sculpture that was more naturalistic in scale and, in the paintings, to replace the graphic use of line with a broader, more bright and painterly use of colour. The paintings none the less invariably turned out grey.

From now on exhibitions on the theme of 'Art in the Twentieth Century' almost without exception included sculptures, paintings and drawings by Giacometti: in London (Royal Academy of Arts and Battersea Park), in

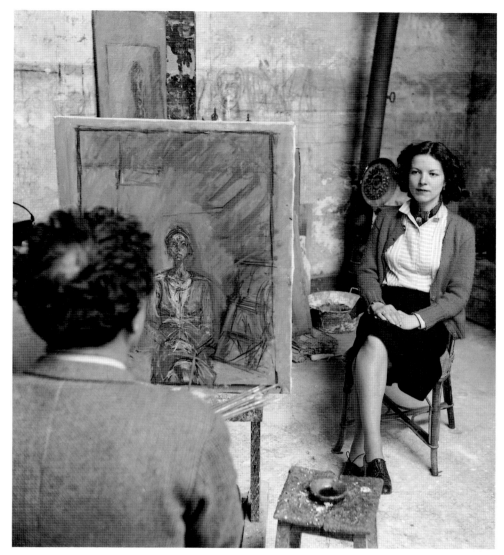

Sabine Weiss, Giacometti painting Annette, 1954

Paris (Musée d'art moderne), in Zurich (Kunsthaus), in Basle ('Phantastische Kunst des 20. Jahrhunderts' at the Kunsthalle, with three works dating between 1947 and 1950), in the USA (the travelling exhibition 'Sculpture of the Twentieth Century' in Philadelphia, Chicago and New York, 1952/53), in Antwerp and in Hamburg (1953).

The Institute of Contemporary Arts in London dedicated two discussion sessions to Giacometti ('Points of View on Alberto Giacometti' on 13 May 1952; 'Recent Trends in Realistic Painting' in July 1953), the art critic David Sylvester serving as their driving force and as a knowledgable interpreter of Giacometti's work. The artist made an oil portrait of Sylvester and also one of another English art critic, Peter Watson (plate 101).

In September 1952 the Wittenborn Gallery at 1018 Madison Avenue, New York, organized the first exhibition of Giacometti's lithographs of his studio. In November 1953 the Arts Club in Chicago showed a really substantial one-man show.

1954

In spring an American steel magnate from Pittsburgh, G. David Thompson, called on Giacometti in his studio at the rue Hippolyte-Maindron. Thompson's enormous collection of modern art, in which there were about a dozen works each by Matisse, Picasso, Léger and Miró and several dozen by Klee and Schwitters, included several sculptures by Giacometti that he had bought from Pierre Matisse in New York. Now he wanted to gather together the biggest Giacometti collection of all, if possible by acquiring works from the artist himself—or to provide him with so much money that he need no longer work for Pierre Matisse and Maeght or, even better, need not work at all. Giacometti gave him original works in plaster from the 1920s and 1930s and twice painted his portrait (see plate 102). At the end of 1962 the Basle art dealer Ernst Beyeler was to buy Thompson's Giacomettis, which had, in the meantime, grown even more numerous, so that they could be acquired, in 1963, by a private syn-

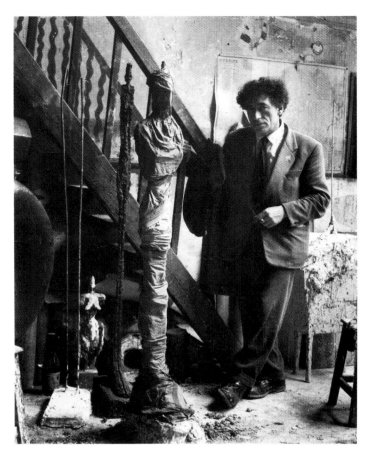

Denise Colomb, Alberto Giacometti, 1954

dicate and, from 1966, be assured of remaining in Switzerland as the 'Alberto Giacometti Foundation'.

Giacometti and the writer Jean Genet met and, from now on, were to see each other often. Giacometti was fascinated by Genet's outlandish life, but also by his bald head, as is clear from the drawings and paintings he made of the writer. Genet thought intensively and shrewdly about Giacometti's sculptures and in 1958 his notes were published as *The Studio of Alberto Giacometti*. This is one of the most discerning texts on Giacometti, and more generally one of the best books ever written by one artist about another.

The principal sculptural works of this year were the portraits of Diego, for which Giacometti found a new style: the chest and shoulders became a substantial foundation for the (anatomically 'too small') head that is thereby displaced into the distance. Alternatively, the heads were life-size but strikingly thin, with a more lively effect in their narrow frontal view.

In May the Galerie Maeght in Paris organized its second Giacometti exhibition, containing very many paintings as well as new sculptures and drawings. This show made clear that Giacometti was of equal significance as a painter and as a sculptor. In the sixty-fifth issue of *Derrière le miroir*, Jean-Paul Sartre published an essay on Giacometti's paintings.

From 30 June to 7 July, and again in September, Giacometti stayed with the bed-ridden Henri Matisse in Nice. He made half a dozen portrait drawings of the still lucid, but elderly, man, so as to prepare a medallion commissioned by the French mint (which was never struck). Matisse died on 3 November. On 8 September Giacometti had been present, as the only artist of stature, at André Derain's funeral. He also revealed his respect for the masters of the previous generation on other occasions, for example at Henri Laurens's death (1954) or that of Braque (1963), whom Giacometti drew on his deathbed.

1955

The first museum exhibition dedicated to Giacometti in Germany, with fifty-eight works, travelled between May and October, from Krefeld, via Düsseldorf, to Stuttgart. In June and July the first extensive Giacometti retrospective exhibitions were mounted simultaneously by the Arts Council in London, with David Sylvester's catalogue text 'Perpetuating the Transient', and by the Solomon R. Guggenheim Museum in New York.

In the autumn Giacometti was invited to exhibit the following year in the French pavilion at the Venice *Biennale*. He was happy to accept. In 1960, by contrast, he again turned down an invitation, personally delivered by a member of the Swiss Federal Council (equivalent to a government minister), to exhibit in the Swiss pavilion. This is in fact the only possible way for an artist from Switzerland not to be measured by mediocre standards. Twenty years after Giacometti's death, yet another member of the Swiss government was to put forward the idea of using Giacometti's annual stay in the Bregaglia valley to promote tourism.

On 8 November at the Café des Deux Magots Giacometti arranged to meet with a Japanese professor of philosophy, Isaku Yanaihara, who was preparing an article on the artist for a Japanese journal. Through Yanaihara's subsequent frequent visits to Giacometti's studio, a close friendship with the artist evolved, and from November 1956 this also included Giacometti's wife. Until 1961 Yanaihara came back to Paris every year (except for 1958). He made notes on his meetings and his conversations with Giacometti, drawing on these for a monograph he published in Japanese in Tokyo in 1958. The volume showed intimate knowledge of the artist. Excerpts were published in French in 1961 in *Derrière le miroir*, and in Japanese in 1965 in The journal *Dojidai* (Contemporaries).

1956

Specifically for the *Biennale* in Venice Giacometti prepared a standing figure of a woman, over a metre in height, that he modelled in many versions. On each occa-

sion he used the same armature and mass of clay (every morning Diego took a plaster cast of the previous night's work) but the figures were always different in expression and height (from 1.05 to 1.56 metres). In all, there were more than fifteen states of this *Woman for Venice (Femme de Venise)*; nine of the plaster figures were later cast in bronze. At the beginning of June, Giacometti went to Venice to set up 'Women for Venice' (see plates 108-114) in two groups of four and six figures, alongside six other sculptures, in the French pavilion. He saw his selection as a whole as a 'work in progress' and told the jury that he would not be a candidate for their sculpture prize.

He then travelled on immediately to Berne. The first Giacometti retrospective to be held in Switzerland opened at the Kunsthalle on 16 June, organized and installed by Franz Meyer. The sculptures shown dated from works made in the 1920s to five figures that have not survived—plaster versions of *Woman for Venice*, titled from *Figure I* to *Figure V*. There were also twenty-three paintings and sixteen drawings, dating from between 1918 and 1956. Although the selection of the works shown was not made by Giacometti alone, he did make a contribution to the way in which it documented his development from his youth to the present.

In September Isaku Yanaihara sat for the first time as a model for Giacometti, initially for drawings and paintings, and his departure for Japan was put off again and again. Giacometti could not get the painting right. He went through one of his 'crises'—on this occasion it was to last until 1958—not because he no longer felt able to paint portraits but because he was striving for both a new attitude towards reality and a new type of content in his work.

1957

Giacometti was now not only a world-famous artist but also one who was receiving very large sums of money from sales of his work through the dealers Pierre Matisse and Aimé Maeght. He passed banknotes by the bundle on to his mother, his brother Diego and his companions of the night, but he allowed his wife only modest comforts. A second adjoining room was rented in the studio complex in the rue Hippolyte-Maindron, and a telephone was installed. Giacometti's own demands were always the same, as were his clothes—always the same in style and always covered in plaster. Giacometti's habits never altered. His first meal of the day, and the only one he had until midnight, consisted of hard-boiled eggs and many cups of coffee in the early afternoon at the *café-tabac* Le Gaulois at the intersection of the rue d'Alésia and the rue Didot. At midnight, however, he had his regular table at the Coupole.

Giacometti's third exhibition at the Galerie Maeght in Paris had so many sculptures, paintings and drawings, and from all periods, that it became the first complete retrospective of Giacometti's work to be held in France. It was also perceived as a triumph by the artist himself—as a brief moment of elation in a period in which artistic work presented him with particular difficulties. The background to all this is described by Jean Genet in his text 'L'Atelier d'Alberto Giacometti' in the 98th issue of *Derrière le miroir*, which preceded its publication in book form later the same year.

Giacometti now turned down many other offers of exhibitions because he could not yet solve the problem of how to represent the figure in the way that he now wanted to show it: busts and portraits that united the unique and individual of the here and now with the timeless universal significance of the figure that one found, for example, in the statues and busts of antiquity.

Igor Stravinsky, who had come to know Giacometti's work in America, met the artist in Paris at the Hôtel Plaza-Athénée. They immediately found they had a deep mutual understanding. Giacometti made portrait drawings of Stravinsky, and in later works he was to show the composer conducting.

1958

From 1956 Giacometti (like Alexander Calder) had been invited to make a sculpture for the square in front of the skyscraper then being built for the Chase Manhattan Bank in New York. The architect Gordon Bunshaft from the firm Skidmore, Owings and Merrill had a cardboard model of the project delivered to Giacometti and went to see him in Paris, as the artist could not, or would not, travel to New York. Giacometti had at last been offered a commission of the kind that he had wanted for twenty-five years: a sculpture for a public square, for which he had the 'Composition with Figures' in mind. He made small figures (6-10.5 centimetres in height) of a walking man and a standing woman, each only on a plinth so that they could then stand without a pedestal on the surface of the square, and also a large head (see plates 119-123). He then tried out the placing of these, as an integral group, on the architectural model.

Through the daily process of modelling, and above all of painting portraits of Annette, Diego and Yanaihara, Giacometti's 'crisis' was resolved in the artist's now incipient late style, in which the sculpted figures acquired a tightly centred core of volume, and the painted ones achieved a hieratic dignity.

Sculptures, paintings and drawings from the years 1956 to 1958 were exhibited in May at the Pierre Matisse Gallery in New York. It was from New York that Giacometti

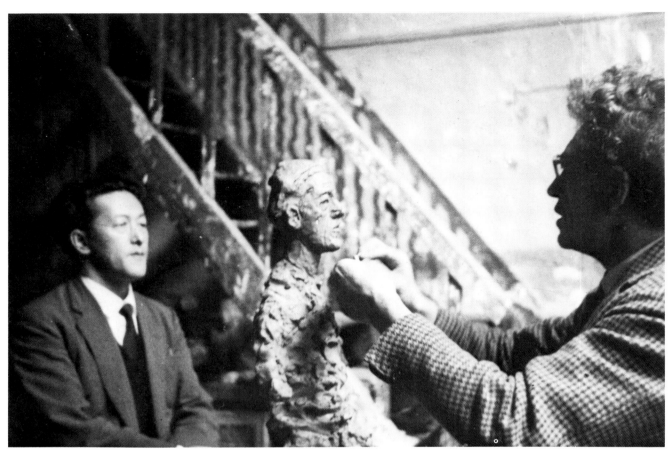

James Lord, Isaku Yanaihara sitting for Giacometti, 1960

received his first formal prize, an 'Honourable Mention' in the Guggenheim International Awards for 1958, for an oil painting of 1957.

The Zurich photographer Ernst Scheidegger had photographed Giacometti's studios in Maloja, Stampa and Paris since 1943, and in particular his sculptures. In 1958 he published his photographs in a now valuable little book in French and German, *Alberto Giacometti: Essais, photos, dessins* (Verlag der Arche, Zurich, 1958; reissued 1985), which reprinted the list of works illustrated with Giacometti's sketches as well as Giacometti's autobiographical and poetic texts: from 1933 *Poème en 7 espaces* (Poem in Seven Spaces), *Le Rideau brun* (The Brown Curtain), *Charbon d'herbe* (Burnt Grass), *Hier, sables mouvants* (Yesterday, Shifting Sands); from 1945 there was *Le Rêve, le sphinx et la mort de T.* (The Dream, the Sphinx and the Death of T.), and from 1947 the *Lettre à Pierre Matisse* (Letter to Pierre Matisse).

1959–1960

In 1959 the group composition for the Chase Manhattan Plaza had taken its definitive form in several large individual figures. These were cast in bronze in 1960, although the agreement with New York had by then fallen through. The group now consisted of two 'Standing Women' ('Femmes debout'; plates 120, 121, 2.70 and 2.78 metres in height respectively), soon supplemented by two 'Walking Men' ('Hommes qui marchent'; plates 119, 122, 1.83 and 1.87 metres in height respectively) and *Large Head* (*Grand Tête*; plate 123, 96 centimetres in height, including its base).

In the summer and autumn of 1959 Yanaihara again became Giacometti's favourite model. In 1960 Giacometti made his first portrait busts of him (illustration above). The circle of Giacometti's literary friends now included Jacques Dupin and André du Bouchet, for whom, as well as for Michel Leiris and Iliazd (Ilya Zdanevich), Giacometti made etchings for the de luxe editions of their books published between 1959 and 1961. These were tokens of the loyalty that Giacometti maintained towards his friends. He was also notable, however, for his kindness to people unknown to him—young artists who called on him, or photographers and journalists who earned their living by reporting on his life and work. This is all the more remarkable in that Giacometti was now chronically overtired, looked much older than his age, and was troubled by constant bronchitis that was aggravated by his excessive smoking.

In October 1959 Giacometti met a 21-year-old woman from the underworld in the bar Chez Adrien in the rue Vavin. She called herself 'Caroline' and she appears with this name in Giacometti's paintings until November 1965.

It was for Caroline's sake that Giacometti once kept Marlene Dietrich waiting in vain (he had been meeting her frequently since her visit to him at the studio at the rue Hippolyte-Maindron at the end of November 1959), and he stopped seeing her altogether in mid-December. It was also for Caroline's sake that, during the last years of his life, Giacometti became involved in a number of shady escapades and spent large amounts of money; he saw in her a degree of living reality that was a match for his art or that even surpassed it. At the end of 1960, when he bought the house at 54, rue du Moulin Vert for his brother Diego, and an apartment at 2, rue Léopold-Robert for Annette (and in 1963 another apartment for her at 70, rue Mazarine), he bought for Caroline a much more luxurious apartment on the avenue du Maine. The circumstances of Giacometti's last years, and the good and bad sides of his value standards, can only be understood in relation to the personality of 'Caroline', who vanished from history after Giacometti's death.

1961

In March Samuel Beckett asked Giacometti to design the set for Jean-Louis Barrault's new production of *Waiting for Godot* (first staged in 1953) in May at the Théâtre de l'Odéon in Paris. After much indecision on both sides, Giacometti produced a barren plaster tree.

In June the last Giacometti exhibition at the Galerie Maeght took place. It showed twenty-two sculptures from the years 1957 to 1961, including the 'Standing Women' as well as the two 'Walking Men' and the large head of the Chase Manhattan group. Among the twenty-four paintings, six were of Yanaihara (dating from 1956 to 1960, as Giacometti wanted to show both his 'crisis' and its resolution). Others were of Giacometti's mother, of Annette and of Diego; while the six biggest pictures (up to 1.85 by 0.86 metres) showed a 'Seated Woman' ('Femme assise'), i.e., Caroline. The 127th issue of *Derrière le miroir* contained Olivier Larronde's text, 'Alberto Giacometti dégaine' (Alberto Giacometti Draws his Sword), Léna Leclercq's impressions of Giacometti's studio entitled 'Jamais d'espaces imaginaires' (Never Imaginary Spaces)—Giacometti in return provided eight lithographs for her volume of poems, *Pomme endormie* (Apple Asleep)—and pages from Yanaihara's diary. Only two of Giacometti's fourteen lithographs in the issue showed the sculptures in his studio; the others were astonishingly directly viewed frontal portraits of Annette and of the couple's friends.

Giacometti had his lithographs printed in Paris by Mourlot. The publisher Tériade wanted to issue an album of Giacometti's work. Giacometti thought of using views of places of particular significance for him in Paris, for example those seen on his way to Mourlot, or street scenes that he had more recently seen from the passenger seat of the dark red MG roadster he had bought for Caroline (who would have preferred a Ferrari). The album appeared posthumously in 1960 with the title, chosen by Giacometti, *Paris sans fin* (Paris Without End).

In August and September Yanaihara visited Paris for the last time.

In the second half of October, Giacometti was in Venice to see the rooms in the main building of the *Biennale* complex in the Giardini, in which he was to exhibit both paintings and sculptures the following year. He had been invited by the *Biennale* directors, rather than being chosen to represent any particular nation.

Another award came from America: the Carnegie Sculpture Prize of the International Painting and Sculpture Exhibition in Pittsburgh.

1962

With Giacometti's consent and assistance, the poet Jacques Dupin, who worked for the Galerie Maeght, pre-

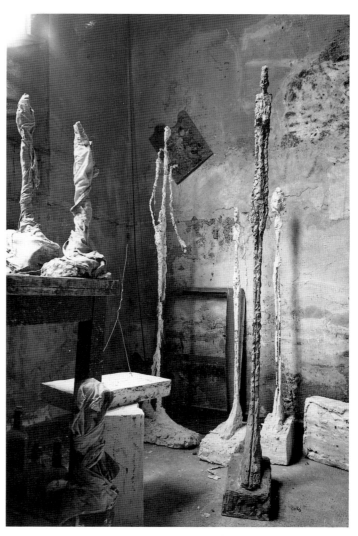

Ernst Scheidegger, The studio, with various finished sculptures and works in progress, *c.* 1960

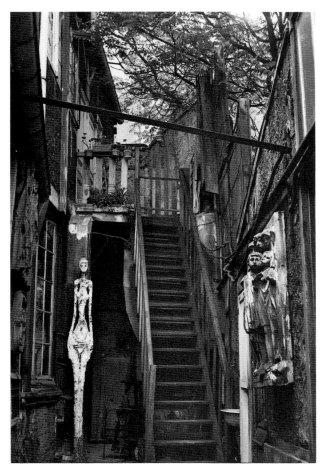

Henri Cartier-Bresson, The courtyard of Giacometti's studio, 1960–61

Biennale exhibition building in which, in 1920, Alberto had seen paintings by Cézanne in the original for the first time. Alberto tirelessly altered the positioning and height of the pedestals of the sculptures and presented the figures of the Chase Manhattan group in such a way that each was effective on its own, even though all of them clearly belonged together as a 'Composition with Figures'. In the night before the opening, he intensified the power of other sculptures by adding colour.

Giacometti received the Prize of the Presidency of the Italian Council of Ministers, but only for his work as a sculptor. He was therefore only half satisfied, since in his view this meant that the historical significance of his new concept of the portrait—the object of a representation as the subject of an encounter—had not been fully appreciated. The new degree of fame Giacometti had now attained brought with it many further interviews, as well as a swiftly-produced and superficial book published in Italian, English and French by Palma Bucarelli.

Giacometti spent the summer months in the Bregaglia valley, but in Stampa rather than in Maloja, as his mother, now ninety-one, was no longer able to leave the house. Here Giacometti made the most affecting portrait drawings of the old woman, whom he now began to resemble more and more.

In the autumn a planned one-man show at the Tate Gallery led to Giacometti's first trip to London. There, Isabel (now Mrs Rawsthorne), who had visited him in Paris many times since the end of their close relationship in December 1945, introduced him to the painter Francis Bacon, who often painted portraits of Isabel. Giacometti's impression was that, compared to Bacon's paintings, his own looked like the work of an old maid.

In October Giacometti's stomach pains prompted Dr Remo Ratti (a native of Maloja based in Paris) to urge the artist to have X-rays taken. They were carried out by the same surgeon, Dr Raymond Leibovici, who had put Giacometti's foot in plaster and treated it in the Rémy-de-Goncourt clinic in 1938. The X-rays showed that a ten-year-old gastric ulcer had developed into a cancerous tumour. The doctor did not tell Giacometti of these findings but said that he would need an operation soon. Through a series of indiscretions, however, Giacometti's family and several friends heard about his stomach cancer, though they did not pass this information on to him; only his wife, Annette, thought that a man so radical in his thinking and his living as was Giacometti had the right, and the strength, to know the truth about his condition. None the less, Giacometti was only to learn of this later; and he was highly offended by this failure to inform him at the time.

It was in this state, therefore, that on 2 December Giacometti attended the opening of the retrospective exhi-

pared the first monograph on the artist. It appeared at the beginning of 1963 (though dated '1962'), published by Maeght. Up to this point Giacometti had resisted the publication of a book about himself, even though, from 1951, he had given many interviews for the press and for radio and had recounted the development of his work as an autobiographical epic, all of which had made him into an almost legendary figure in his own lifetime. His complete œuvre was now presented, with over two hundred reproductions: 90 plates of his paintings, from 1917 to 1962, and 125 of his sculptures from 1914 (when he was thirteen) to 1962, together with photographs of his studio.

With the same notion of providing a 'general survey', Giacometti agreed to prepare an exhibition for the Kunsthaus in Zurich. First, however, he concentrated on the exhibition for Venice, working despite physical pain and with hardly any sleep. He knew that he was intended to receive the principal prize, and he wanted to receive this most important international recognition not only as a sculptor but also as a painter. Above all, he wanted to show the position he had reached in his painting and in his sculptural style.

At the start of June, Alberto and Diego Giacometti travelled to Venice to install the *mostra personale* in the same

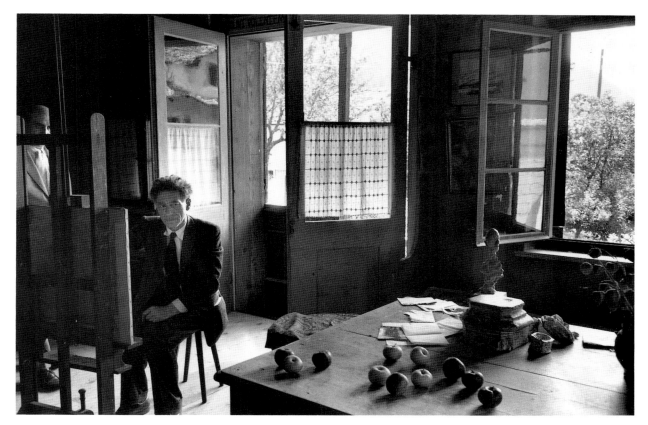

Henri Cartier-Bresson, Giacometti in Stampa, 1960

bition at the Kunsthaus in Zurich, organized by its Director, René Wehrli, and installed by Bruno Giacometti. The exhibition started with a painting from 1912, a drawing from 1915 and a stone relief from 1919, and ended with the intensively sculpted and painted portraits of Annette from 1962. The general survey, with a total of three hundred works spanning fifty years, served as a summing up of Alberto Giacometti's contribution to the art of his time. It convinced art experts and the Swiss federal authorities of his importance, but public opinion remained sceptical. The negative popular reaction was evident in a controversy that continued until 1965, when the municipality of Zurich finally decided against spending 250,000 Swiss francs on a 'Giacometti Foundation' containing works valued at a total of 3,000,000 Swiss francs.

1963

On 6 February, in Paris, Dr Leibovici performed a three-hour operation on Giacometti's stomach, removing four-fifths of it, including all the cancerous tissue. Giacometti spent fourteen days in the Rémy-de-Goncourt clinic, where he worked on small clay figures, subsequently recovering relatively quickly at the Hôtel Aiglon at 232, boulevard Raspail, where he could be more comfortable than in his studio. He then travelled to Stampa. His first long outing after the serious operation was to Milan, on

7 April, where he went to look at Michelangelo's *Rondanini Pietà*.

Back in Paris again, Giacometti not only got back to work but also resumed his exhausting daily and nocturnal routines and—in spite of chronic bronchitis— his immoderate smoking. He expected further possible signs of cancer (which failed to appear), so that each day and each work was marked by a sense of impending death. For Giacometti this could only mean continuing to work every night, struggling to record the reality he found in front of his eyes—a face, the back of a chair, a tree. In this way, too, he made the series of lithographs for the volume *Paris sans fin*.

In February and March the Phillips Collection in Washington mounted a Giacometti exhibition with fifty-four works. From July to September the 143 works by Giacometti acquired from the collection of G. David Thompson were exhibited in the Galerie Beyeler in Basle, and efforts to establish a public 'Giacometti Foundation' in Switzerland were inaugurated.

1964

Giacometti spent the first weeks of the year in Stampa, prior to his mother's death on 25 January.

In Giacometti's studio in Paris, a new model was seen regularly from the end of 1963 onwards: Eli Lotar, whose career as a photographer had long since finished. With

Henri Cartier-Bresson, Alberto Giacometti in
rue d'Alésia, Paris, 1961

solidarity with Louis Clayeux, the director of the gallery, who had been unfairly treated at the opening celebrations for the Fondation Maeght at Saint-Paul-de-Vence on 28 July, and who had resigned. The new museum, built near Nice by Josep Lluís Sert, contained a significant collection of sculptures and paintings by Giacometti; in its courtyard there was the group of bronze figures originally intended for the Chase Manhattan Plaza in New York, in extremely impressive, painted versions set up by the artist himself (plates 119–123).

From 8 to 11 September Giacometti was in London, where David Sylvester recorded a BBC interview with him that was later published under various titles with various extracts.

From 12 September to 1 October, in eighteen sittings, Giacometti painted and repeatedly re-painted the portrait of James Lord, who photographed eleven of the changing states of this work, and made notes on his conversations with the artist. Lord was to publish both in 1965 as *A Giacometti Portrait*.

In October an examination in the cantonal hospital in Chur revealed that no further signs of cancer had appeared, but also that Giacometti was suffering from a state of extreme exhaustion.

In November and December the Pierre Matisse Gallery in New York mounted the first exhibition exclusively devoted to Giacometti's drawings (with a catalogue text by James Lord).

him, with Diego, and with Annette, Giacometti developed the style of his last portrait busts, though he also worked without a model to achieve this. The resulting works were distinguished by heads that had their own 'independent' volume in space and faces with keenly gazing eyes. Caroline also sat for Giacometti, and his paintings turned her portraits into secular icons.

Twenty-five years after the fiasco with Giacometti's works at the Swiss National Exhibition in Zurich, the Federal Exhibition organized in Lausanne had nine bronzes and four paintings by him. With the exception of *Portrait of Joseph Müller* of 1926, they were all post-war works in the 'Giacometti style' (which by now had become a figure of speech, used to signify an exceptionally thin individual).

When Giacometti read the garbled account of his accident of 1938 in Jean-Paul Sartre's autobiography *The Words*, he broke off all contact with the writer. Giacometti also now had hardly any contact with Picasso; and when Picasso, knowing that Giacometti was on the Côte d'Azur at the end of July, asked him to visit him at Mougins, Giacometti sent back a cool reply.

In August, while in Maloja, Giacometti also broke off his relations with the Galerie Maeght. He did this out of

1965–1966

As if the whole world knew that this was to be Giacometti's last year of life (the state of his health was, of course, well known, and leading newspapers were already preparing to commission his obituary), exhibitions, honours and publications came thick and fast. It would have been a year of triumph for Giacometti had he not been distressed by a sense of inadequacy—measured, that is, against his aim to create in the work of art both a duplicate of reality and a promise of permanence—and, in addition, by tensions in his immediate circle and the intrusions of Caroline's associates from the world of crime.

In the last busts of Diego and Eli Lotar sculptural corporeality gives way to the fragmentary, as if Michelangelo's *Rondanini Pietà* (on which Michelangelo was still at work in the last year of his life in 1564) had now really become Giacometti's yardstick. Yet the glance of the raised heads of both sitters is refined to a visionary gaze, creating around the sculpted figures a privileged space that evokes the 'sacred'. The Caroline portraits, meanwhile, now always left apparently unfinished, turn the whore into a saint. The drawings for the planned

book *Paris sans fin* became varied and intimate witnesses to Giacometti's life in the city.

From 9 June until 10 October the Museum of Modern Art in New York showed a large retrospective which subsequently travelled to Chicago, Los Angeles and San Francisco, where it closed on 24 April 1966.

On 17 July the retrospective 'Alberto Giacometti: Sculpture, Paintings, Drawings 1913–1965' opened at the Tate Gallery in London. Giacometti had made a replica of *Suspended Ball* of 1930 for the exhibition, and, the week before the opening, he repaired, touched up and painted more recent sculptures in a makeshift studio set up in the museum's basement. The exhibition catalogue contained David Sylvester's essay 'The Residue of a Vision'.

The Louisiana Museum at Humlebaek near Copenhagen held a Giacometti exhibition from 18 September to 24 October, with eighty-nine sculptures dating from 1914 to 1965 and fifty-four paintings dating from 1913 to 1965. From 5 November till 19 December the Stedelijk Museum in Amsterdam also showed an exhibition of Giacometti's drawings.

In September, Ernst Scheidegger and Peter Münger made the film *Alberto Giacometti* in Paris and Stampa: Giacometti was shown painting Jacques Dupin's portrait and then talking to the poet while modelling a bust from memory. In 1986, an extended version of this film was produced, including an excellent interview made in 1962, at the Kunsthaus in Zurich.

From 1 to 6 October Giacometti travelled, with Annette and Diego and with Pierre and Patricia Matisse, to New York on board the *Queen Elizabeth*. He got through the obligatory receptions there and made many visits not only to the exhibition of his work at the Museum of Modern Art, but also, at night, to the Chase Manhattan Plaza in the Wall Street district, where he had Annette, Gordon Bunshaft and James Lord stand in various places in order to reconsider his group composition. He finally came to the conclusion that he could do justice to the situation with a single figure of a standing woman, 6 to 8 metres in height. He asked Diego to prepare the armature for this and was confident of being able to execute the work in a short time after his return to Paris. (It was not executed, however; and, since 1974, Jean Dubuffet's sculpture *Four Trees* has stood in the plaza.)

After a week Giacometti returned, with Annette, on board the *France*. During the journey he told the sculptor Hugo Weber that he wanted to start all over again as he had back in those days with Bourdelle at the Académie de la Grande-Chaumière. In the margins of a journal he wrote the poem that is reproduced at the end of this chronology.

On 4 and 18 October, during his journeys to New York and back to Europe, Giacometti had written two summar-

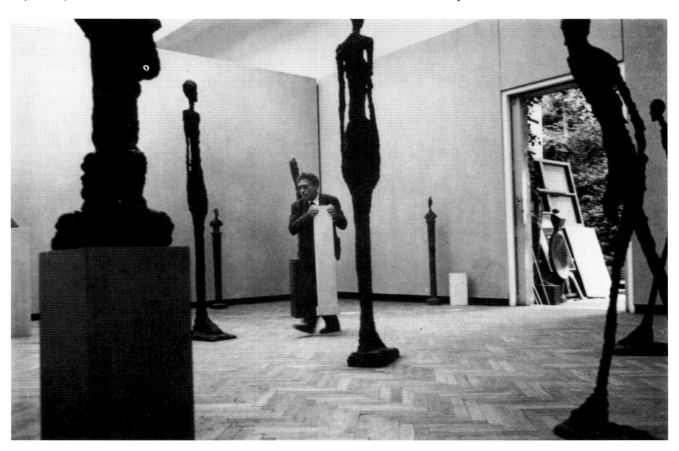

Ugo Mulas, Giacometti installing his exhibition at the Venice *Biennale*, 1962

ies of his life and career to serve as texts to accompany the book *Begegnungen mit der Vergangenheit: Kopien nach alter Kunst* (Encounters with the Past: Copies of Older Works of Art) being prepared by Luigi Carluccio and containing his copies of older works of art.

Hardly had Giacometti returned to Paris than he left again, this time for Copenhagen, to visit the exhibition of his work at Humlebaek. Once back in Paris, he sorted the sheets for Tériade's album of lithographs and then attempted to finish the text to accompany this collection (which he had started on 16 May 1964). It remained unfinished, however: of the sixteen pages intended for it, six remained empty. Giacometti's last sculptural work was a life-size half-figure of Eli Lotar, seated. This, too, remained 'unfinished', though the word here has no meaning, since, for Giacometti, no work was ever really 'finished' and, by the same token, might be regarded as 'finished' at any stage.

On 20 November the French state honoured Giacometti with the *Grand Prix National des Arts*.

Giacometti then travelled to Berne, where, on 27 November, the philosophy faculty of the university awarded him an honorary doctorate, and the President of the Swiss Federation gave a banquet.

On 1 December, again back in Paris, Giacometti was persuaded by Annette, Diego and close friends to visit a doctor. He did so and was urged to go to hospital as soon as possible. Giacometti therefore arranged to be admitted to the cantonal hospital in Chur, in his native canton.

From 2 to 4 December Giacometti continued to work on the bust of Eli Lotar and on a painting of Caroline; he also bought more material for modelling and painting. On 5 December he left Paris, by the night train, for the last time.

Giacometti arrived in Chur on the morning of 6 December and, after a short visit to his cousin Renato Stampa, went into the cantonal hospital, where the doctor in charge, Professor N. G. Markoff, began by giving him oxygen on account of the apparent disturbances to his heart and circulation. He then once again carried out an examination for cancer. The negative findings from this gave Giacometti hope, and he began to think of being able to return to Paris, after a period of rest, if only for a week, in order to complete the two works he had had to leave.

For the time being he resigned himself to hospital life, spoke with friends on the telephone and had visits from his brothers, from Annette and from Caroline. He slightly remodelled one figure of the work of 1950, *Four Figures on a High Base* (plate 56), which had been damaged in London.

Before Christmas his condition worsened. Congestion of the lungs and liver indicated serious damage to the heart muscle. Appropriate medical intervention led to a

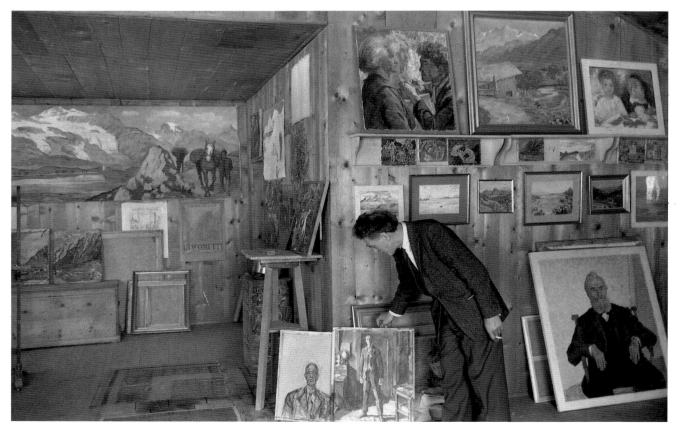

Henri Cartier-Bresson, Giacometti in his studio at Maloja with pictures by his father Giovanni, 1964

Kurt Blum, Alberto Giacometti in Berne, November 1965

temporary improvement. Visitors from Paris and Zurich came and went.

On 6, 9 and 10 January 1966 it was again necessary to drain the thoracic cavity. The doctor and his patient recognized the seriousness of this new development. Giacometti lost his joy in working and the will to go on living. The next day Diego arrived from Paris. When Giacometti saw his whole family gathered around him (Annette, Diego, Bruno and Bruno's wife, Odette) and Caroline too, he knew what this meant.

On 11 January 1966 at ten past ten in the evening, Alberto Giacometti died in the cantonal hospital at Chur of heart failure, and specifically from an inflamed thrombosis of the heart muscle caused by chronic bronchitis (which he had had for years).

On 12 January Diego travelled back by the night train to spend a day in Paris. Here he carefully heated the ice-cold studio at the rue Hippolyte-Maindron, thawed out the rags wrapped around the clay figure of Eli Lotar and made a plaster cast of this last work. He was to place the bronze version, which he inherited, on his brother's grave in the cemetery of San Giorgio in Borgonovo.

On 15 January the body of Alberto Giacometti lay in a coffin in his studio in Stampa. At two o'clock in the afternoon, it was taken from there on a horse-drawn carriage to the artist's place of birth, Borgonovo, passing through the snow-covered winter landscape at the head of a long funeral procession. At Borgonovo, Alberto Giacometti's funeral took place, attended by his family and the inhabitants of the Bregaglia valley, but also by representatives

Herbert Maeder, Giacometti's funeral on 15 January 1966, Borgonovo-Stampa

of the cantonal and Swiss authorities and of the French state, by friends from Switzerland and Paris, and by museum directors and art dealers from around the world.

The poem Giacometti wrote in October 1965 while crossing the Atlantic:

Tout cela n'est pas grand'chose,
toute la peinture, sculpture, dessin,
écriture ou plutôt littérature,
tout cela a sa place
et pas plus.

Les essais c'est tout,
Oh merveille!

It all means little,
all the painting, sculpture, drawing,
writing, or rather literature,
it all has its place
and nothing more.

An attempt is everything,
How marvellous!

Compiled from information provided in the book by James Lord, *Giacometti: A Biography* (New York, 1985; London, 1986).

Herbert Matter, Giacometti, Paris 1965

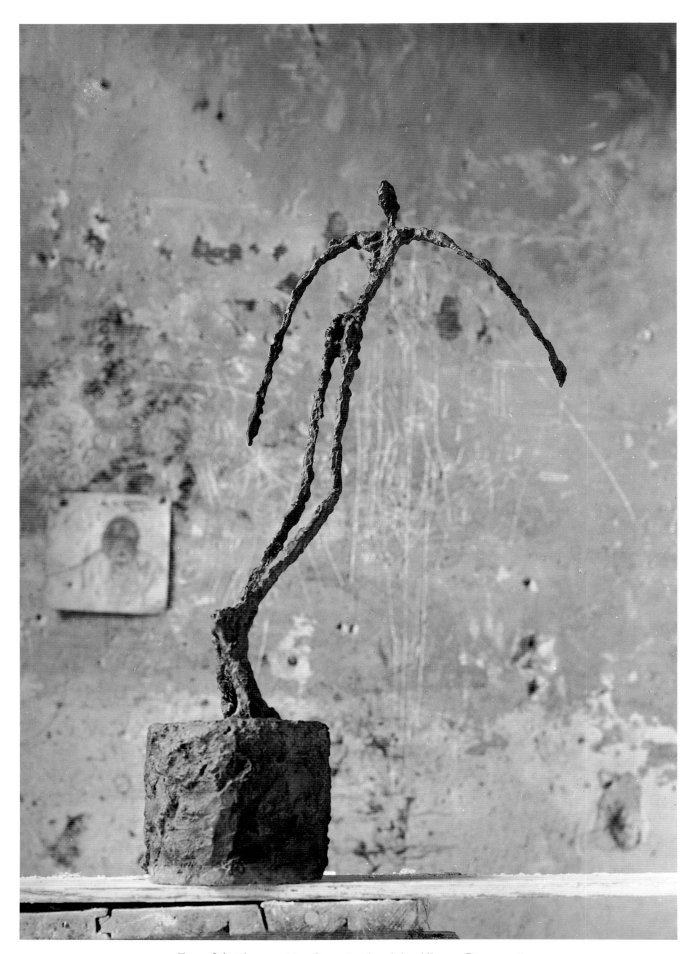

Ernst Scheidegger, *Man Staggering* (1950) by Alberto Giacometti

Giacometti and his Century

REINHOLD HOHL

Giacometti's century is, of course, the twentieth, the one in which he lived, from 1901 to the start of 1966; but was the twentieth century, as we now perceive it, the century in which, and for which, he produced his work? That is to say, was he really a contemporary of his age—an artist who bore witness to it or even shaped it?

Of course, as far as one can tell today, there is only one artist in the twentieth century who has dominated ninety of its hundred years both through the power of the work he produced and through his enduring influence. That artist is Picasso. Yet a total of fifty productive and influential years is itself an unusually large one for a painter, a sculptor or an architect. Matisse achieved it, albeit not as a continuous sequence, and so did Le Corbusier. Braque and Chagall, to take a generous view, had ten years each, even though the former lived to be eighty-one and the latter to the age of 97. For our own contemporaries, five years in the limelight appears to be a more appropriate sum; though, naturally, we cannot know what a precocious artist of today may bring forth in his late work—as no one could have guessed of the 35-year-old Giacometti.

Within his lifetime, Giacometti's work was not in the limelight for long. From 1930 to 1934 his objects and constructions brought real form and substance to Surrealist sculpture—so much so that artists such as Max Ernst and Henry Moore continued to find new stimulus in these works until the end of their lives. From 1948 to 1965, Giacometti produced sculptures and paintings that not only impressed his contemporaries but that, even today, retain their creative power. His appeal is still as great as it used to be, yet his work—unlike that of, say, Cézanne—has had little significant influence on the progress of painting and sculpture since his death. He has imitators, but there are no artists who can really be said to carry on his work. For the generation born after him—both artists and others—Giacometti embodies what they demand both of a work of art and of their lives as a whole. Today, every encounter with Giacometti's work, whether in a permanent collection or an exhibition, provides an opportunity to assess, before the end of the century, what degree of strength and sincerity a work from this era may embody.

Such thoughts, and those that follow, naturally record personal reactions and are not to be understood as object-

ive statements on the history of art in the twentieth century. We know, after all, that art history is merely the sum total of the more or less felicitous ideas of a few influential art critics and the useful contributions of competent and assiduous art historians. The present comments, then, are the subjective considerations of a writer on art who recognizes that his own life is reaching its end along with that of the century, and who thus feels entitled to ask which artists truly represent the period in which he has lived.

During the first half of the twentieth century, despite the First World War, there still endured some hope for a better future; as an artist representative of this period, I would point to Fernand Léger. During the second half, after the Second World War, all that has mattered is the mere probability of surviving; the most significant representative of this period seems to me to be Joseph Beuys. Naturally, I recognize, as does a much younger generation, that the art produced during the twentieth century as a whole is a treasure created by these and, say, five hundred others, including artists active today. It is a treasure that has upheld, borne witness to, enriched and often brought delight to life in this century; and, among its five hundred creators, Giacometti has a special place. In my view, this is because his work may be perceived as a 'plumb-line' that registers what is essential in the art of all centuries.

The history of art in the first two thirds of the twentieth century now appears in textbooks as a canonic sequence of styles and tendencies: Post-Impressionism—Fauvism / Expressionism—Cubism—Dada →Surrealism, on one hand; Abstraction →Constructivism, on the other; then, a new classicism, objective Realism, Magic Realism, and state-sponsored Realism; and finally, in the post-Second World War period, non-formal art, Abstract Expressionism, *tachisme,* and conceptual art. Those are the stages that Giacometti might have passed through during the fifty years of his artistic career, from 1915 to 1965. There were some at which he did, indeed, linger (until 1925 while catching up with others, from 1926 to 1934 as a participant); after that, however, he continued, for thirty years, to oppose his own sequence of development to the one we have outlined. From 1935 to 1945 he was absorbed in researching and establishing a phenomenological basis for representational art; from 1946 to

1956 he was engaged in realizing his own 'view of the world', in both the literal and the figurative sense of that term; while from 1957 to 1965 he was active as a 'portraitist', that is to say, as the painter and modeller of an image of the human figure that is to be measured not only in twentieth-century terms, even though it is entirely of its time.

Until 1925, as we have noted, Giacometti was engaged in catching up: at first, with Rodin's style of portrait sculpture, then with the academic 'tightening' of representational sculpture after Rodin. As a young painter, Giacometti initially worked in a Post-Impressionist manner; he then adopted the practice of constructing an image from planes of colour in the post-Cézanne fashion and, for a short while in the early 1930s, his work was even characterized by a certain stylish elegance. He appears to have bypassed Cubism and Dada.

Giacometti entered the history of modern sculpture in 1926. From then until 1929 he produced figure compositions that drew simultaneously on 'post-Cubist' stereometry and on 'Primitivism' derived from both the art of the Neolithic period and that of 'primitive' peoples. From 1930 to 1934 Giacometti created constructions and objects that were to prove the most original and the strongest examples of Surrealist sculpture. Constructivism, abstraction and object art all played a part in these pieces, which have become an inseparable part of modern art history not only because they reflect up-to-date artistic concerns of the time, but also on account of their outstandingly high quality. They combine, that is to say, a maximum of sculptural power and of forceful subject matter with a minimum of formal and illustrative content.

In the years 1926 to 1929 Giacometti achieved what came to be seen as his most significant innovation, one that revolutionized modern sculpture and was to have important consequences for his own, quite different later work: he made the position of the beholder an integral part of free-standing sculpted portrait heads. The artist was determined that such heads be perceived only in a three-quarter view. This intention could easily have been realized in reliefs or paintings; but how was one to model a head standing free in space, and seen from all sides, that would, none the less, present only one of these? The answer was provided in the following sequence of sculptures: *Portrait Head of Joseph Müller I* (1925) and *Portrait Head of Joseph Müller II* (1927) (both private collection, Geneva), *Portrait of the Artist's Mother (Portrait de la mère de l'artiste)* of 1927 and *Gazing Head (Tête qui regarde)* of 1927–29 (plate 15). Artists in Paris in 1929 recognized what Giacometti had achieved in these works, and from this point on he was an acknowledged member of the avant-garde.

The special status of Giacometti's work within the three-dimensional creations of Surrealism is due to the fact that, from 1930 to 1934, he gave sculptural form to the irrational, provocative and mystifying notions advanced in Surrealist doctrine and, above all, that he did so in such a way as to bestow a sense of permanence on the ephemeral and to convert the sensual thrill of the private into a virtual 'memorial' of universal significance. His work thus went beyond what could be derived from the inspiration of a moment, however striking this might prove—as in Meret Oppenheim's matchless fur-covered cup, saucer and spoon of 1936 (*Object*; Museum of Modern Art, New York) or Hans Bellmer's double-sided dolls, without head, arms or legs (also 1936). Many of Giacometti's Surrealist compositions and constructions may also be understood as small-scale models for large-scale public sculpture, or they may look like models for the stage sets of suprapersonal psychodramas. In the course of these years he produced much that was new in the history of sculpture: the boxes and cages dramatizing sculptural space; the game-boards and table-top pedestals, some of them with mobile symbolic forms; the sculptures without bases, detectable only through their

Auguste Rodin, *The Burghers of Calais,* 1884–95

Auguste Rodin, *The Burghers of Calais,* 1884–95 (detail)

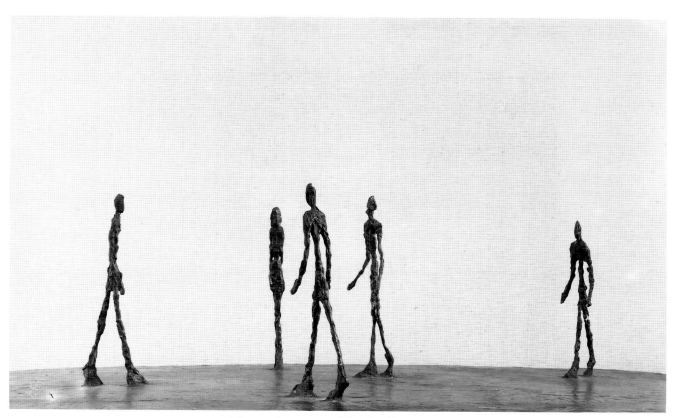

Alberto Giacometti, *The City Square,* 1948

distinct 'presence' among everyday objects on a table or on the floor at one's feet (though this had been anticipated in the work of Degas, Rodin and Brancusi).

At no earlier or later period was Giacometti so much a part of the history of art in his century as he was in the early 1930s. Until the late 1940s he was politically also a genuine contemporary of his era, albeit very much on the margins. In 1935, however, he withdrew from the history of modern art and, after ten years of solitude, entered the history of art in general with a series of radical innovations.

The motive for this break was, as he once wrote, the desire to create 'compositions with figures' and to prepare for these by making a number of studies from life. Behind this wish, however, there probably lay the intention of going beyond the merely modern and the purely personal, and of creating sculpture of public significance that would arrest the attention of Everyman—in the manner, for example, of Rodin's *The Burghers of Calais* (illustration, p. 46). Giacometti had in mind something quite different from Pevsner's *Developable Column of Victory (Colonne developpable de la victoire)* of 1946; and two years later he produced his figural composition *The City Square (La Place;* illustration above) though this did not progress beyond the stage of a model. It shows four walking men and the immobile figure of a woman on a shared platform representing the square. The figures bear witness to the bustle and exertions of everyday life, but the

work as a whole conveys an atemporal conception of life and nature. (Giacometti's female figures soon came to resemble, and indeed to be termed, trees or figures of worship from Antiquity.) This sort of monument to human existence was not intended as an anecdotal illustration (as with Rodin); nor did Giacometti wish it to be perceived simply as a mass of bronze (as in the case of Maillol's work), or as an abstract construction (as with Pevsner's sculpture). Rather, the beholder was to be confronted with direct visual evidence of reality as it appeared in the street.

This, at least, is how we may formulate it in retrospect. We have no record of Giacometti's aims as he embarked on his new start in 1935, unless we treat as such his *Model for a City Square (Projet pour une place)* of 1931 (plate 22), a work that appears to allude to this sort of 'mythology of humanity' through the use of three-dimensional symbols. Such references backwards and forwards within Giacometti's œuvre are justified in that they help us to illuminate his situation in 1935.

Nothing could be more mistaken than to interpret Giacometti's resumption of work from the model in 1935 as a 'return to figuration' (such was the title of a Giacometti exhibition held in Geneva and Paris in 1986/87). Neo-conservative art historical writing has done so, and with uncalled-for satisfaction, as if non-representational and Surrealist art were done for, and as if humankind (as idealized as possible) were the only possible subject mat-

ter for art. It is true that there is still so very much to be said about the nature of human beings (about their illusions, their sexuality, their brutality) that figurative artists in the next century will certainly not run out of material; but neither will there be any lack of tasks for sculptors and painters working non-representationally.

Initially, Giacometti's study from the model was, in any case, applied not to matters of content, but to a stylistic problem. Giacometti sought to establish whether or not it was possible for the artist to capture in his work how he actually sees a figure, or even just a head. André Breton is supposed to have exclaimed, *à propos* of Giacometti's new work on heads: 'But everyone knows what a head is.' Ever since portraits were sculpted in Antiquity, all sculptors have, of course, known what a head 'is' and how it is shaped: a compact, ovoid volume with individual proportions and features. Yet hardly any sculptor—unless it be Medardo Rosso—has reproduced how he *sees* a head. As Giacometti discovered in the course of time, it is perceived as a small, blurred object in space, seen always from a distance, as if it were a mere particle in the field of vision; but the artist is also aware of it as a partner returning his gaze, as his subject—an intense core of a life, an existing individual.

Such insistent flourishes on the part of the writer anticipate what was to come, in order to make quite clear what Giacometti had embarked upon in 1935. We should bear in mind the general artistic circumstances at the time: the thriving of Surrealism, the self-assertion of Constructivism (in the work of the Paris group *Abstraction-Création*) and the rise of totalitarian state-sponsored art (for example, in the form of Brancusi's triumphal arch *Gate of the Kiss*, conceived for the patriotic memorial at Tîrgu-Jiu in Romania and executed in 1938 in the crude neoclassical style typical of the fascist era).

Elsewhere in this volume, it is recorded year by year how uncertainly and slowly Giacometti's new concept of the portrait was elaborated over the period of a decade. From 1938 onwards the difficulties of realization were increased by the advent of a new concern. Giacometti decided that a sculpture should not capture only what had been gleaned by the artist through his contemplation of the model, but also his memory of that model. The sculptor, that is to say, had to give form to an imaginary reality that could neither be measured nor touched. This image from memory was, furthermore, to 'occupy' a remembered, imaginary space that was to supplant the real space in which the sculpture was located, just as the depicted space of a landscape painting could be said to annul that of the living room or museum gallery in which it hangs. In other words, Giacometti sought in free-standing sculpture the sort of representation of the figure and of space that had previously been the prerogative of paint-

ing (and, in an incomplete form, also of work in relief). Before Giacometti, Medardo Rosso had attempted something similar in his 1893 'impression', *Conversation in a Garden* (Museo Medardo Rosso, Barzio); but Giacometti was determined on a far more rigorous investigation into the problem of rendering purely visual appearances in sculpture. In the period 1938 to 1945 this resulted in his portrait heads becoming smaller and smaller and their pedestals ever larger—a means, not dissimilar to perspective in painting, of placing the heads in a spatial context.

One can certainly describe as 'heroic' this ten-year period of research into the possibility of a fundamentally different style of sculpture. It is significant within the artistic production of the twentieth century not only on account of the results eventually attained—the narrow heads and the stick-like figures of 1947 onwards in the by now proverbial 'Giacometti style'—but also as an impressive example of discipline and integrity. It offers a compelling image of the artist, in isolation, engaged in continuing creative work and undistracted by success in terms of either sales or shows.

In his paintings, Giacometti responded to much the same task—that of representing a person or an object in a spatial context—by using the traditional means of perspective and a novel *grisaille* style, derived from drawing. In 1937 he created two masterpieces (apparently with little effort, for we know of only a few previous works in which he approached comparable solutions): *Apple on a Sideboard* (*Pomme sur le buffet*; plate 36) and *The Artist's Mother* (*La Mère de l'artiste*; plate 37). It is clear how much Giacometti's study of Cézanne had contributed to the success of these works, but it is also clear that Giacometti had surpassed the modernist painting that had followed Cézanne. Giacometti's apple, unlike Cézanne's, does not consist of volume constructed out of flat, coloured shapes, and it is not an object resplendent with the most intense presence. It is, rather, the existential residue of an apple, exposed on every side to the surrounding space, an object that can be compressed no further and that dominates a picture surface four hundred times larger than itself for precisely that reason. In the second painting, the frontally viewed half-figure of Giacometti's mother does not blend in with the picture plane like the figure in *Madame Cézanne with a Coffee Pot* (Musée d'Orsay, Paris). Rather, she clearly sits in front of it, though at the same time appearing to be placed behind a layer of air, evoked with shades of grey, that renders the distance between painter and model.

In 1946 Giacometti made the transition in his sculptural work from 'phenomenological' proportions to the slight, thin, insubstantial and, as it were, weightless sculptures that possessed even more strongly the charac-

ter of intangible apparitions in an inaccessible 'pictorial' space. This shift was connected with Giacometti's determination, after the war, when public memorials were a major concern, to elaborate his studies into finished works of art—that is to say, to give them a form in terms of style. Giacometti's efforts in finding a style may have been based on the notion, mentioned above, of the object appearing to the artist as if surrounded by space, yet the decisive factor in the realization of his intentions from 1947 onwards was the insight that the power of Oceanic or Egyptian or Etruscan sculpture lay in its artifice, in its hieratic and sacred significance—in its style.

There had been an Egyptianizing vogue in European sculpture at the start of the twentieth century, when followers of Rodin had sought a stabilization of volume and the tension of a highly polished surface in order to appear 'modern'. Giacometti, on the other hand, strove for a sculpture that would prove a match for the 'old' art in terms of both form and content. It is this ambition, the strength of the images and their style, redolent of timeless idols—without, let it be noted, a hint of the religious—that give Giacometti's individual figures and paintings their status and their distinct character among twentieth-century works of art.

The effect of earnestness, importance and timelessness, with which a work by Giacometti captivates the spectator, is, of course, the consequence of specific decisions regarding form. These included the 'hieroglyphic'-figures of men walking without their legs bending at the knee and the canonic form of female figures standing stock still, with arms held close to their sides. None of Giacometti's standing figures is shown in contrapposto—that distinction between the weight-bearing and the 'free' leg which, credited as an invention of the Greek sculptor Critius in 480 BC, lent the traditional Egyptian and pre-Classical type of statue a semblance of living reality. In eschewing contrapposto, Giacometti is entirely a sculptor of his century. Ever since Matisse's bronze group of 1908, *Two Negro Girls,* contrapposto has been 'impossible' in modern figural sculpture, rejected as outdated or even as a concession to the totalitarian policy of combatting the 'degenerate' in art. However much Giacometti's sculptures otherwise owed to Matisse, it was the influence of 'post-Cubist' compositions and tribal art that first led him, in 1925/26, to dispense with contrapposto. His avoidance of it later was a means of achieving the hieratic effect he sought.

Another of Giacometti's formal devices is the frontality of his standing figures and gazing heads. This constrains the beholder to place himself frontally in relation to the sculpture in order to comprehend it as a pictorial presentation and not merely as a gristly bronze surface (this is the crucial difference between Giacometti's work

and Etruscan stick figures). In the case of the portrait paintings, this feature draws the viewer in line with the central axis of the canvas. Giacometti's works thus generate the kind of hierarchical relationship enforced by sacred images in all religions and by the ceremonies attending every form of authority: the beholder always assumes the role of a 'petitioner'. (In the last four lines of this essay the reader will learn the true significance of this.)

The 'compositions with figures' that Giacometti made between 1947 and 1950, with various groupings of walking men, standing women and gazing heads, presented on pedestals or in boxes, play an undeniably crucial part in the sculpture of the twentieth century. One will have to forget the anecdotes that used to be told about them if one is to do them justice as sculptural creations in space and to grasp their significance. While it is true that they express an intense awareness of life at mid-century, after the experience of war and hardship, they suggest a timeless, rather than a historical or specifically modern, situation. Similarly, one would also have to find another title for the 'Women for Venice' ('Femmes de Venise'; plates 108–114) in order to see these figures, grouped together for the *Biennale* exhibition of 1956, as they really are. The upright poses of the women and the sense of solidarity in their alignment constitute a compelling image of human self-assertion. One could imagine them as a public monument that would represent the twentieth century, as opposed to the nineteenth, on account of the many differences between them and Rodin's *The Burghers of Calais.* However, it is perhaps symptomatic of Giacometti's century that he was not able to execute a single project for a monument.

The extremely high prices now paid for Giacometti's work—in 1987, for example, three of the large 'Standing Women' ('Femmes debout') from the projected group for the Chase Manhattan Plaza in New York fetched around three million dollars each—fix the 'rating' of Giacometti's art no less than the frequent citing of a 'Giacometti' in contemporary light fiction signifies the artist's 'standing', or than the selection of works by Giacometti for reproduction on book jackets indicates an 'existential' or eschatological content. This status of Giacometti's work as a secure financial investment, and as an expression of an elevated life-style or a non-transcendent way of thought, certainly tells us something about prevailing notions of his œuvre at the end of our century, but it expresses nothing of the historical significance of that œuvre. This we are now beginning to discover in the late works, those of the years 1958 to 1965: in each modelled bust of Diego or Annette, in each painting of Yanaihara or Caroline. They show that Giacometti was as great a painter as he was a sculptor; that in both fields he was at his strongest as a

portraitist (in this respect he had no rivals among his contemporaries); and that he created a new concept of the portrait in terms of both form and content.

This last achievement is more readily apparent in the paintings than in the bronzes. The position of the painter and the model in the studio—seated opposite each other and with the canvas angled in such a way that the artist, with minimal movement of head or arm, could note his observations on it with great exactitude—leads as a matter of course to a frontally presented head, bust or half-figure. The great period for the frontally viewed portrait and self-portrait was around the turn of the century, in the work of Munch, Picasso and Hodler—but never in that of Cézanne.

Giacometti modelled volume with various specific painterly procedures and freed it both from the background and from any sense of immediate proximity to the spectator. It is a mistake to believe that the result was intended to express isolation; the painter and his model were, after all, themselves together, and reports indicate that Giacometti's endless exchange of glances with Yanaihara and with Caroline during their sittings was also a form of erotic communication. Thanks to Giacometti's skill, it is the model that possesses the greater power in this partnership. That is what was new in Giacometti's concept of the portrait.

Yet this innovation had ancient precedents. If, when portraying his wife, Cézanne was concerned, above all, to produce a 'good painting', then Giacometti, in his images of his wife, Annette, restored to the model her reality, both in the here-and-now and in the form of a timeless presence—and that is the ancient concept of portraiture embodied in icons. No religious connotations are intended here; I merely wish to point out that Giacometti's portraits share with icons, among other stylistic features, the frontal and symmetrical presentation, the fixed gaze staring out at the viewer and the 'supernatural' area of paint 'behind'—in reality, above and alongside—the head. In any case, all interpretations of images, including icons, as holy stem from the beholder. And yet...and yet Giacometti created for the twentieth century a painted image of humankind for which I know of no better term than the 'secular icon': the profane idol.

The power that emanates from the bronze busts, created late in life, of his brother Diego and of his model Eli Lotar derives from their gaze. Portrait sculpture in the twentieth century has almost always been commissioned work, a satisfactory result being assessed in terms of how correctly reproduced were the sitter's proportions, the hair style and the collar. Prestige busts of this sort certainly have eyes with pupils, but these are not supposed to look at the spectator in the manner of Bernini's busts of cardinals with their marble flesh and their 'animated' glance. The Expressionist portrait sculpture of the twentieth century, on the other hand, has regarded style itself as the sole source of eloquence, bearing witness not to the life of the sitter, but to the modernity of the sculptor. Hence, in Giacometti's century, portrait busts are expected to be—and to remain—either memorial objects or art objects, providing either decoration for conference rooms or examples of a specific style in art collections.

Giacometti, however, makes of the object a subject. And he does this in two ways: he bestows on the art object the effective power of a subject and he allows the 'victim' of the artist's activity—the sitter—to be him- or herself, to possess his or her own intrinsic value, thus surpassing the work of art and its value as such. Giacometti himself testified to this latter aspect, which was also affirmed in the sums of money that he paid his models. Caroline would otherwise have continued to earn her living by assuaging male desires at top prices, while living it up with a band of crooks. Eli Lotar would have done nothing at all, or would simply have got drunk; his good years as a photographer were in any case over.

It is this respect for the artist's object as an individual subject that we sense as being the real content of Giacometti's portrait busts; and this is naturally the consequence of their form. I return, then, to my earlier assertion—that, with his late bronze busts, Giacometti made the art object into a subject. The act of looking is the subject's most succinct expression of being alive, for it involves the whole head and the whole upper body, while the eyes, the pupils, are only gristly lumps or vague recesses. The more the presentation of the body and the shoulders is fragmented, in the very last works, the stronger is the impact of the bust as a subject—that is, it registers a more powerful claim to be acknowledged other than as a work of art. It is probably only insensitive people—or perhaps art dealers—who can share a living room or an office with one of the late busts of Diego.

Here, for once, Walter Benjamin's catchphrase about the 'aura' of a work of art is appropriate. For Benjamin was not, of course, referring to the prestige accorded a famous work by art historians who feel compelled to inflict on it a dose of art-obscuring prose (a crime to which the present writer pleads guilty!); rather, he was giving expression to that sense of irreducible 'distance' that we feel even in spite of the greatest proximity to a work. This was a quality that Giacometti strove for and achieved. Precisely how he was able, in the last period of his career, to make distance and surrounding space, as the subject matter of his work, an integral part of a sculpture I do not know. The result—the 'aura'—is, however, difficult to deny. The heads and busts (even when Giacometti worked without a model) dominate a space

created by them and emanating from them, a space that may be compared to that of a holy precinct. (We should note that the effectiveness of such a space, even in a recognized place of worship, also depends on an elaborate, artificial and artistic setting, as well as on generations of indoctrination.)

Giacometti's modelled image of humanity thus involves a concept of respect not otherwise familiar in twentieth-century art. Indeed, the only comparable work I can cite is Michelangelo's unfinished *Rondanini Pietà*. This, is the one *Pietà* among the hundreds in the history of art that allows one to forget the form of worship connected with it, on account of the silence it provokes in its setting in the Castello Sforzesco in Milan. It is the same silence in which Giacometti's *Eli Lotar III* (plate 157) looks at us, while also keeping his distance.

Could Giacometti's contribution to the art of the twentieth century, both as a painter and as a sculptor, therefore be described as a 'secular art of the sacred'? If so, this would be no small achievement, for it would at least have returned nobility of being, in the form of an effigy, to a humanity controlled by its century, battered by society, brutalized by the crowd, subjugated by the cult of the state and by that of established religion, terrorized by the police, tortured in prisons and ravished by psychoanalysis.

The art of the twentieth century presents humanity as the object it has indeed become. Only Giacometti's image of man reminds the spectator that he was once a subject.

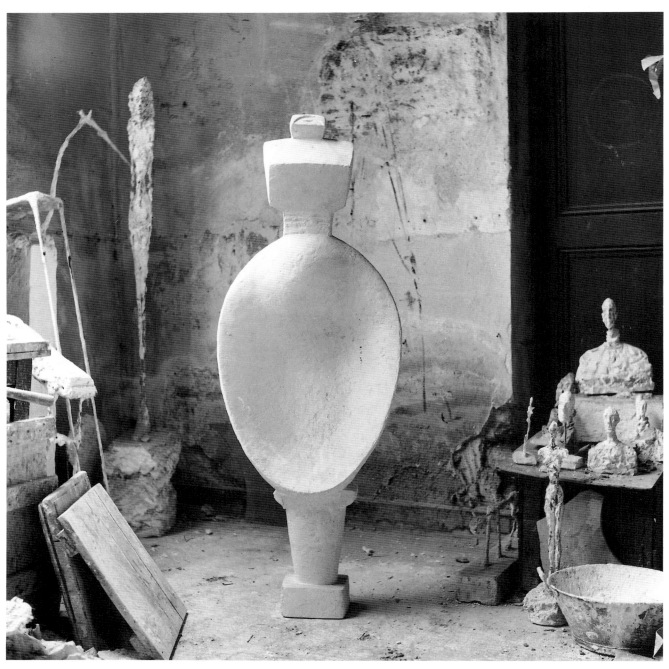

Ernst Scheidegger, Giacometti's studio in 1957 with the plaster for *Spoon Woman*, 1926

Giacometti and the Parisian Avant-Garde, 1925–1935

KARIN VON MAUR

When people talk about Alberto Giacometti, we tend to see in our mind's eye the tall, gaunt forms of his post-war work, figures that seem to embody the spirit of the Age of Existentialism. This direct identification of the artist with his creations—there was even a physical resemblance—long obscured the view of Giacometti's entirely different early work. This was boldly innovative and its vexing ambiguity was quite in contrast to the insistent modelling of form of the artist's later years. Giacometti himself contributed in no small measure to the 'eclipse' of his works from the period 1925 to 1935, in which both Cubist and Surrealist elements are to be found, for he later dismissed these as pure self-gratification. None the less, for some time now, the originality and significance of the work from this period has begun to claim the attention of both scholars and the general public, a development encouraged by such international exhibitions as '"Primitivism" in 20th-Century Art' (New York, 1984) and 'Qu'est-ce c'est que la sculpture moderne' (Paris, 1986).

At the time of Giacometti's arrival in Paris, in 1922, the momentous upheavals brought about by Cubism, Futurism and Orphism had already given way to the more tempered evolution of neo-classical figuration and Purist abstraction. It was in 1922 that the Dadaists disbanded, some of them later to become Surrealists. Inventions such as *collage* and *assemblage*, the *objet trouvé* and the ready-made, especially important for sculpture, had been tried and tested before the First World War. Now, around 1920, an urge to break with the constraints of a system made itself felt in the prevailing post-Cubist trends. Under the wings of the Romanian Constantin Brancusi, who had lived in Paris since 1904, other emigrants from eastern Europe—the 'Russians' Alexander Archipenko from Kiev, Jacques Lipchitz from a small town in Lithuania, and Ossip Zadkine from Smolensk, the Hungarian Josef Csaky and the Pole Elie Nadelman—had adopted the formal language of Cubism, in each case further developing it with marked individuality. In the work of the French artists Raymond Duchamp-Villon and Henri Laurens, however, there was clear evidence of a striving for homogeneity and 'finish'. Thus, at the start of his career, the Swiss artist Giacometti, considerably younger than all those mentioned, was confronted with the overwhelming superiority of a generation of pioneers.

Not until three years after his move to Paris did Giacometti receive from his teacher, Emile-Antoine Bourdelle, an invitation to exhibit two sculptures at the Salon des Tuileries. His *Torso (Torse)*, shown in an early, as yet unresolved version, alongside a head of his brother Diego, aroused the displeasure of Bourdelle, who was also acting as vice-president of the Salon. Angrily, he told Giacometti: 'One does something like that at home, for oneself, but one does not exhibit it.'[1]

Although *Torso* as we know it today (plate 7) has probably been re-worked, it is clear that Giacometti was not merely 'experimenting': the piece already reveals a sure grasp of the structure of the body, which is reduced to a few, angular blocks. For once, a Cubist vocabulary is not employed in order to effect an analytical dissection of form; rather, it is used to create a sculptural formula for the very concept of the torso. Giacometti can thus be said to have provided a female counterpart to *Torso of a Youth*, a work of 1917–22 by the doyen of avant-garde sculpture, Brancusi, itself fashioned out of three cylindrical forms (illustration, p. 54). In comparison with the detached and absolute quality of Brancusi's solution, the torso made by the 24-year-old 'newcomer' is admittedly more massive, more 'archaic', and less perfectly polished; but it is also imbued with a restrained expressiveness that is closer to the compact formal language of Lipchitz, as manifest, for example, in his sculpture of 1917, *Seated Bather* (Marlborough International Fine Art; estate of the artist).

In its extreme simplification, *Torso* goes beyond Lipchitz's sculptures, but Giacometti's block-like structures of 1926–27—though most of these are considerably smaller—point more clearly to the example of the older artist. Lipchitz had emigrated to Paris in 1909 and Giacometti had occasionally visited him in his studio there. The Swiss artist's increasing success led, however, to a cooling of the relationship.[2]

Giacometti's *Cubist Composition—Man (Composition cubiste—homme*; illustration, p. 54) consisting of squared blocks and cylinders piled on top of each other, recalls, in its sharp contrasts of mass and space, Lipchitz's figure of eight years earlier, *Man with a Guitar,* but also the sculpture *Harlequin* (illustration, p. 54) made in 1917 by Juan Gris with advice from Lipchitz, who was his friend. *Man and Woman (Homme et femme)* of 1926–27 also embodies a

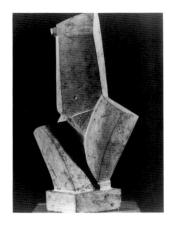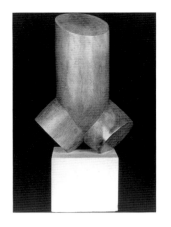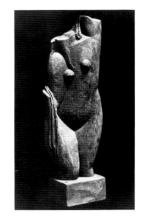

principle of organization demonstrated by Lipchitz in, for example, *Musical Instruments* of 1925 (illustrations below): the concentrated dynamism of the play between bands of undulating forms and fractured zig-zags. None the less, the interaction of elements in the younger artist's piece is intensified to the point of lending them the character of opposites.

In contrast to his feelings for Lipchitz, with whom he was linked only as a temporary acquaintance, Giacometti nurtured a life-long admiration for Laurens, which he was to express in an essay of 1945 on that artist's work.[3] What linked the two was, in essence, a similar intellectual attitude, a striving for purity and veracity. This was manifest in the urge towards a clarifying simplification of form, but could also extend to questions of workmanship—for example, the neat finishing of edges or the treatment of a pedestal. Comparison between works by the two artists—Laurens's *Torso* of 1925 and Giacometti's *Torso,* for instance (illustrations above)—reveals differences, too: despite the similar tendency towards enclosed block shapes, the Swiss artist elaborates the tectonic structure of the trunk and the thighs, and their interrela-

tion, in terms of contrapposto, while strengthening the angularity and fragmentary character of the forms.

In the mid-1920s Giacometti's approach to sculpture was crucially influenced through his preoccupation with prehistoric non-European art, above all the African, Oceanic and Cycladic figures that he had been able to study closely in the Musée de l'Homme, but also in periodicals such as *L'Esprit nouveau* and *Cahiers d'art* and, from 1929, Georges Bataille's *Documents.* There were also books such as Carl Einstein's *Negerplastik* (Negro Sculpture), which appeared in a French edition in 1922, and events such as the 'Exposition de l'art indigène des colonies d'Afrique et d'Océanie' of 1924/25 at the Musée des Arts Decoratifs.[4]

In 1926 Giacometti exhibited at the Salon des Tuileries—together with a portrait bust of the American sculptress Flora Mayo—the sculpture *The Couple* (*Le Couple;* plate 9)—a work clearly stamped by the shock of the encounter with 'primitive' art. Even though this particular group was apparently not derived from specific models, several details are striking in this context: the schematized indications of the woman's hands recall the sym-

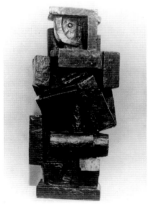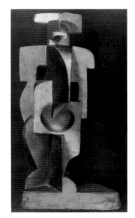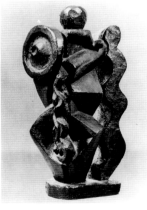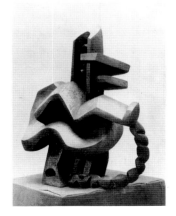

Alberto Giacometti,
*Cubist Composition—
Man,* 1926–27
Private collection, Zurich

Juan Gris,
Harlequin, 1917
Philadelphia
Museum of Art

Alberto Giacometti,
Man and Woman, 1926–27

Jacques Lipchitz,
Musical Instruments, 1925
Marlborough International
Fine Art; estate of the artist

54

metrical placing of hands over the stomach or the sexual organs in African sculptures, and the schematic patterning of the relief elements could be connected with the raised tattoos on the bodies of figures carved by various tribes. On the other hand, the frontal, relief-like presentation contrasts markedly with the solid rotundity of African sculptures, as does the very skilfully suggested relation between the two forms. Despite their apparently unrelated co-existence, they are united into the quintessence of a couple. The overall outline of each of the figures is reduced to a basic geometric shape indicative of gender—an almond form reiterating the vagina, a trapezoid standing for the phallus. In addition, the female form resembles a shallow, rimmed shell, while the male has a marked convex shape. These characteristics emphasize the elemental, but also complementary, opposition of man and woman. Within these sexually symbolic shapes, moreover, significant individual characteristics of form and gender are engraved or applied (in a form evoking runic inscriptions) to attest to a relationship based on reciprocity. The horizontal almond shape of the man's single eye thus corresponds to the vertical mandorla of the female vagina, just as the attached oval of the female eye corresponds, in turn, to the cylindrical form of the male member.

The symmetrical internal structure of the female form certainly stands in opposition to the asymmetry of the male; but the contrast is less strict in the placing of the woman's hands, for here there is some similarity to the play of hands found in the male figure. Such compositional details mark this group out as the work of a European, that is to say, of an artist who does not proceed on the level of a pseudo-naive primitivism, but absorbs, rather, only those conceptual features that may lead to an effect as charismatic as that of 'primitive' figures. Giacometti was fascinated, above all, by the 'magic ability to charm possessed by certain images'.[5]

These raids into exotic territory always alternated, however, with periods when Giacometti confronted the model directly. Thus, in the summer of 1927, in Stampa, he produced portrait busts of his father (plates 12, 13), mother and brother and later, in Geneva, of the collector Joseph Müller. These exhibit a striking tendency to treat the face as a surface with features engraved upon it.

Then, towards the end of the year, Giacometti showed, at the Salon des Tuileries, a figure over a metre in height, the celebrated *Spoon Woman* (*Femme-cuiller*; plate 8). The idea for this sculpture was probably sparked off by the anthropomorphous grain scoops of the Dan tribe of the Ivory Coast, which Giacometti might have seen at the colonial exhibition of 1924/25 mentioned above.[6] In replacing the given metaphor (spoon as woman) with its reverse (woman as spoon), Giacometti succeeded in

ennobling the utensil into an idol, an object of worship. The treatment of certain body parts as independent entities and their extreme size as an expression of the significance allotted to them:[7] these are further aspects of African sculpture that Giacometti has here made his own. The oval shell of the body becomes the determining formal motif; dominating the other parts, especially the diminutive head, it lends the 'Spoon Woman' the aura of a fertility goddess.

The rendering of the female body as a concave, hollowed-out form was, of course, a sculptural concept that Archipenko had already employed in 1913 in female figures such as *Concave, Green*. (Archipenko Archives, Woodstock, NY). While the individual body parts of Giacometti's *Spoon Woman* (plate 8), despite their high degree of abstraction, are fused to form an organic being, in his *Reclining Woman (Femme couchée)* of 1928–29 he proceeds to a radical isolation of individual anthropomorphic motifs, an approach rehearsed by Archipenko in his *Seated Geometric Figure* of 1913 (illustrations, p. 56). The spoon shape is now employed as a double abbreviation for the whole body: set on its edge, its handle end is aligned with a standing skittle form that represents the head and a propped arm. Whereas *Seated Geometric Figure* has an air of artificiality, of constructedness, Giacometti absorbed influences from archaic idols to arrive at a new synthesis of extreme simplification, anthropomorphic suggestion and mythical aura.

With *Reclining Woman, Dreaming (Femme couchée qui rêve)* of 1929 (illustration, p. 56), probably made in connection with *Reclining Woman*, Giacometti takes a step beyond anything achieved in his work thus far. The principal form—reduced to nothing more than a pair of undulating bands—is held in a hovering position by vertical supports; a scoop leaning at an angle against one end represents the reclining figure's raised head and neck. This bold construction makes of the space between its solid components an equal partner in the whole, and so transposes the rhythm of the contours of the body into a drawing in space. Rhythmic abstraction also formed the basis of Lipchitz's appreciably larger *Reclining Woman with Guitar* of 1928 (illustration, p. 56); yet, in contrast to the heaviness of this figure, Giacometti's small *Reclining Woman, Dreaming*, with its few, delicate linking rods, is removed into a sphere of airy weightlessness.

For a while, Giacometti continued to make scaffold-like, transparent structures; and, in the figure *Man (Apollo)* his work again appears to reflect that of Lipchitz, in this case the transparent metal structure of, say, *Fleeing Harlequin* of 1926 (illustrations, p. 57). The principal connection between the investigations pursued by each artist was a knowledge of the African manner of organizing form: many tribes, for example,

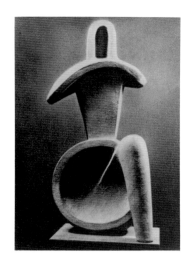

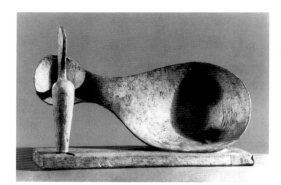

evince a tendency towards the use of perforated rectangular shapes.[8] In *Man (Apollo)* Giacometti developed this into an uncompromising, symmetrical treatment of the figure organized around the body's axis, this last formed by a scoop. These transparent constructions already embody that virtual 'X-ray vision' which Giacometti experienced, throughout his life, when in the presence of the model: he did not see it as a compact body, but, as he stated in his famous letter of 1948 to Pierre Matisse, as 'something skeleton-like in space'.[9]

In June 1929 Giacometti exhibited at the Galerie Jeanne Bucher, showing for the first time two of his disc sculptures, *Gazing Head* (*Tête qui regarde*; plate 15) and *Figure—Man* (*Figure—homme*; illustration, p. 57). These at once attracted the attention of the Paris avant-garde and won Giacometti his first mentions in the press, including an article on his work by Michel Leiris in *Documents.* Then, the most committed collectors of contemporary art, the Vicomte Charles de Noailles and his wife Marie-

Laure, acquired *Gazing Head* from Jeanne Bucher for their already choice collection. After years of working in Paris in isolation and obscurity, Giacometti suddenly became much sought after.

Among the first to come to the opening of the exhibition was Picasso, who proved to be especially impressed by *Gazing Head*. Giacometti's thin slabs, with their occasional hollows, were, in fact, of an astonishing novelty. While Oskar Schlemmer had made an entirely concave relief, *Half-Figure with Accented Forms* (lost), in 1923, Giacometti can hardly have known of this; moreover, Schlemmer's work is much more strongly conceived in terms of conventionally recognizable entities than is Giacometti's. The Swiss artist's hollowed reliefs evoke random natural phenomena—such as footprints in the snow. Jean Cocteau immediately noted the latter association in his diary, *Opium*: 'I've seen sculptures by Giacometti that are so powerful, and yet delicate, that one wants to describe them as snow preserving the footprint of a bird.'[10]

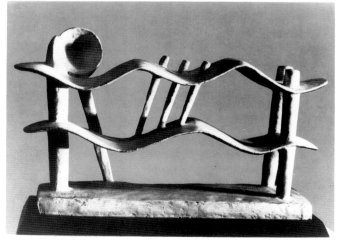

Alberto Giacometti,
Reclining Woman, Dreaming, 1929

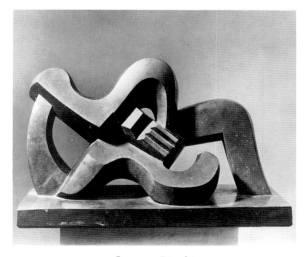

Jacques Lipchitz,
Reclining Woman with a Guitar, 1928
Hirshhorn Museum and Sculpture Garden, Washington

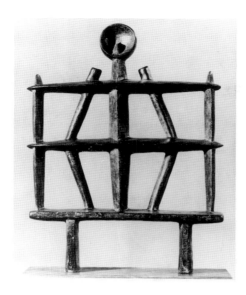

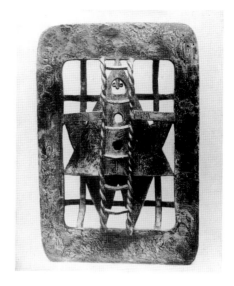

Alberto Giacometti,
Man (Apollo), 1929

Extreme right: Jacques Lipchitz,
Fleeing Harlequin, 1926
Kunsthaus, Zurich

One vertical and one horizontal hollow are enough to suggest the gazing head; the flat, rectangular disc, as Leiris observed, is in part derived from the head forms of Cycladic idols. The play with lit and shaded parts across a white surface, in spite of its tactile effect, recalls painting, and it was probably this that fascinated Picasso, especially as he was preoccupied at this time with a similar manipulation of light and shadow—for example, in his lithograph *The Face* (Marie-Thérèse Walther).[11]

At the 1930 spring exhibition of the Galerie Pierre Loeb, where Giacometti showed alongside Joan Miró and Jean Arp, the Swiss artist came up with a new sensation: *Suspended Ball* (*Boule suspendue*; plate 18). With this work, made in wood by a cabinet-maker after the original plaster version, Giacometti effected a transition not only to mobile sculpture but also to object art. 'There was a third element that concerned me in reality: movement', he later explained in his letter to Pierre Matisse. 'In spite of all my efforts, I found it impossible at that time to tolerate a sculpture that feigned movement—a leg walking, an arm raised, a head turning to look sideways. I could only make such movements [in my work] if they were real and actual; I also wanted to convey the feeling that they might be unleashed.'[12]

What was new here was not so much the way shapes were combined—such combinations were also to be found in Picasso's sketches for sculptural monuments—but the in-built possibility of movement and the inducement to the beholder to set the sphere swinging to and fro. The appeal to the sense of touch and the feeling of movement were integral to the erotic lure emanating from the suggestion of imminent contact as the notched sphere hovered over a horizontal crescent-shape resembling a slice of melon. The vividly evoked notion of a gliding contact of sphere and crescent at the unleashing of the swinging motion constituted a tactile, and erotic,

provocation that was, of course, of enormous fascination to the Surrealists. André Breton bought *Suspended Ball* and went to see Giacometti in order to induce him to take part in the activities and exhibitions of his circle. In 1931 Salvador Dalí, in his essay on Surrealist objects published in *Le Surréalisme au service de la révolution,* cited this sculpture as a perfect example of the genre.[13] In the same year, René Crevel, in his publication on Dalí, emphasized the erotic thrill of Giacometti's 'Ball':

Take a close look at this wooden ball in action. Giacometti had equipped it with a female indentation so that it could glide over the edge of an elongated fruit made from the same material, but of a male shape. Both forms [were] imbued with the utmost nervous tension and [were] so fixated on each other that they conveyed this state of excitement to every beholder. This was something

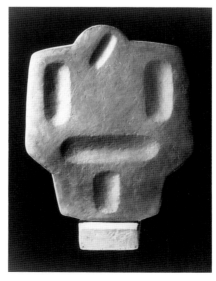

Alberto Giacometti,
Figure—Man, 1929
Centre Georges Pompidou, Paris

Oskar Schlemmer,
Half-Figure
with Accented Forms, 1923

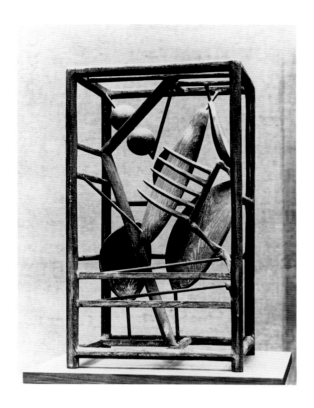

Left: Alberto Giacometti, *The Cage,* 1930–32
Moderna Museet, Stockholm

Pablo Picasso, *Figures on a Beach,* 1931
Musée Picasso, Paris

that one would, *a priori,* hardly have thought possible on seeing these two polished boxwood pieces, and yet it could no longer be disputed—except that a thread checked the momentum of the sphere so that it could not fall into the Nirvana of gratification.[14]

Connected with the sexual symbolism of the two sculptural elements and their erogenous stimulus, there was, at the same time, a sense of hurt, conveyed by means of the cleft—recalling a gash—in the sphere. It is extraordinary that both Dalí and Crevel should have failed to recognize this element of ambiguity in the sphere. They considered it only as a female sexual symbol, whereas it more readily recalls the emotionally charged sequence from the 1928 film by Dalí and Luis Buñuel, *Un Chien andalou,* in which a woman's eye is sliced by a razor.

The connection of love with violence, of sexuality with the desire to kill, was indeed one of the central subjects of the discussions, books, pictures and periodicals of the Surrealists. Aspects of Giacometti's early life seem to have granted him an affinity for such themes, as becomes clear from accounts of his experiences and his childhood dreams, in which sexual desire is associated with a homicidal craving.[15] Investigation into the dark side of the human psyche, into an environment of aggression and instinctive reaction, of violence and torture, play a decisive role in Giacometti's work from the early 1930s, and it was encouraged by the circle of friends around Georges Bataille—Leiris, André Masson and Max Ernst—who likewise tackled such themes.

Giacometti had already presented the sexual act as the thrust of a dagger in the sculpture *Man and Woman* (*Homme et femme*; plate 21) of 1928–29; after this the motif of violence emerged in his work in particular connection with cage constructions. *Suspended Ball* had been preceded by *The Hour of the Traces* (*L'Heure des traces*; plate 28), a filigree case with a 'roof' that distantly recalls the mechanical-looking constructions of the Russian Vladimir Stenberg,[16] although Giacometti's work inhabits a wholly different dimension. While a rounded heart hangs in its interior, over the ridge of the roof there hovers, supported on a fragile wire rod, a mask-like head with a wide-open mouth bearing witness to the pangs of death. The dangling heart and the impaled head enter into a dramatic relationship with one another that evokes thoughts of the human sacrifices carried out by the Aztecs. This bizarre, static 'mobile' of 1930/31, combining an oscillating hanging form with a hovering 'balancing act', is close to the wire constructions with mobile elements made a little later by Alexander Calder.

In *The Hour of the Traces,* with its weightless equilibrium, the element of the unfathomable in the hint of human sacrifice, or the fantasies on the torments of love, are offset by being treated ironically. In *The Cage* (*La Cage*; illustration above), however, the limbs of a man and a woman in the interior of a wooden structure are dismembered and reduced to a series of interlocking forms—threateningly pointed forks and sticks, spheres and coniform husks—so as to evoke a pitiless psychological drama. The arrangement 'paraphrases' that of the curious bone forms wedged into each other in Picasso's

Max Ernst, *Anatomy as Bride,* 1921
Private collection

paintings of these years—for example, *Figures on a Beach* of January 1931 (illustration p. 58).

The Cage derives from the plaster sculpture *Woman, Head, Tree (Femme, tête, arbre),* published as *Jone* in the July 1930 issue of *Bifur*. This second work, though, resembles a strange cactus plant rather than a woman, and it points to the influence of Arp. The box construction in *The Cage*, by severely circumscribing the dismembered limbs of the couple, intensifies the theme of the battle of the sexes to the point where it appears to be without hope of resolution. Rosalind Krauss has pointed to the connection between this work and the motif of the praying mantis which, after mating, swallows the male.[17] This phenomenon assumed so much symbolic significance for the Surrealists that Breton, Dalí and Paul Eluard kept whole collections of these insects in cases, while Roger Caillois published an article on them in *Minotaure*.[18]

The cage sculptures give rise to various, and contrary, associations: with prisons and the notion of confinement, but also with out-of-bounds rooms and secret, taboo zones that are suddenly opened to view, releasing in the beholder the thrill felt by a voyeur. These 'showcases of a fruitless amorous mechanism'[19] culminate, in 1932, in *Palace at Four in the Morning* (*Palais de quatre heures*; plate 29). In contrast to the cramped cages, Giacometti here erects a frail castle in the air—in memory of his nights with Denise (see p. 16), where the two would try for hours on end to build fantastical palaces out of matches, which then always collapsed. Giacometti's castle calls to mind the weightless *palazzi* in the pictures of Paul Klee, but also the bare constructions characteristic of the stage sets in Vsevolod Meyerhold's Moscow theatre.[20] The skeleton of a bird and the spine of a small animal in the cage on the right are opposed to a conical statuette on the left, while, at the centre, a hollow, husk-like form and a sphere are placed on a pedestal. Giacometti himself, in an essay published in *Minotaure* in 1933, drew attention to the autobiographical sources of certain motifs: the bird's skeleton is explained in terms of Denise's dreams before the couple parted, while the spine is the one that Denise sold him on the street at one of their first meetings. He identifies the standing figure on the left with early childhood impressions of his mother in a long, black dress that seemed to form an inseparable part of her body.[21] Between these symbolic motifs—some, like the husk-shaped form, relating to Giacometti himself—the motionless arrangement of objects within the fragile scaffolding propmpts the 'spectator' to see an 'event' taking place. Like all Giacometti's works from the 1930s, *Palace at Four in the Morning* may be regarded as a form of exorcism, carried out by means of an obsessive concentration on specific anxieties and spiritual crises. In 1929 Leiris had already emphasized this as a particular mark of Giacometti's work: 'everything he makes is like the fixing of one of those moments we experience as crises, [mo-

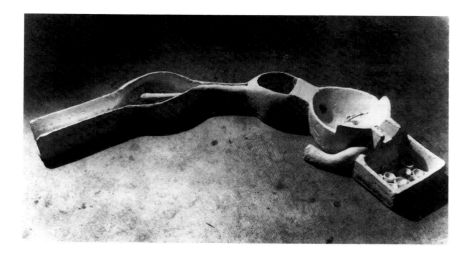

Alberto Giacometti,
Model for a Passageway,
1930–31
Alberto-Giacometti-Stiftung, Zurich

ments] imbued with the intensity of a quickly perceived and immediately internalized adventure'.[22] *Palace at Four in the Morning* may be compared to Antonin Artaud's 'theatre of cruelty' and to the nightmarish visions and transformations in Kafka's novels and stories. Such resemblances are even more striking in Giacometti's other images of those years, such as the expressive skeleton in *Tormented Woman in her Room at Night (Femme angoissée dans sa chambre la nuit*, 1932; lost) or the gruesome, free-standing *Woman with her Throat Cut (Femme égorgée*; plate 32), its form evoking that of a dangerous crustacean.

After 1930 Giacometti's œuvre is dominated by horizontal sculptures, in which, to begin with, motifs of torture and torment again play a part. This is the case, for example, in the almost dadaistic *Captive Hand (Main prise*; illustration, p. 61), in which the thumb of a wooden hand is tied to a mechanical wheel drive (significantly, the work was acquired by Man Ray), and in *Flower in Danger (Fleur en danger)*, where a head hung on a sort of gibbet faces a catapult.

The most aggressive of these objects, *Spike in the Eye (Pointe à l'œil*; illustration, p. 61) of 1931, has been connected by Jean Clair with Bataille's book *Histoire de l'œil* of 1928 and with the notion, beloved of the Surrealists, of the eye as a metaphor for the vagina. According to Bataille's cultural, historical and mythological interpretation, the eye is also an instrument with a reversible function, and can be a weapon of both defence and attack, both a shield and a spear. This notion may have influenced *Spike in the Eye*.[23] There is, however, a more direct, autobiographical source for this motif: the shock of Giacometti's younger brother Bruno, in Stampa, when Alberto—probably not without a certain sadistic pleasure—came very near to Bruno's eyes with the point of his compasses while measuring the size of his brother's head during the frequent sittings for portraits.[24] This attack on the eye as one of the body's most vulnerable organs again recalls the famous 1928 film sequence in Dalí and Buñuel's *Le Chien andalou*, and the scene is repeated with variations in Dalí's paintings and graphics—very clearly in one etching of 'Les Chants de Maldoror' of 1933 (published in 1934).

The extraordinarily innovative game-board sculptures *Man, Woman, Child (Homme, femme, enfant)* and *Circuit*, exhibited by Giacometti in October 1931 at the Galerie Georges Petit, incorporate movement in another way. Following one's impulses, one can perceive that they contain a network of allusions to human existence: life and death as an eternal, meaningless cycle, like that of the sphere which orbits *ad infinitum* along its prescribed track. In 1932 these implications grow stronger in a further game-board sculpture, *The Game is Over (On ne joue plus)*, which is suggestive of a mysterious necropolis. In these works Giacometti has, as it were, placed his vertical disc sculptures horizontally and replaced a frontal view with a bird's-eye view. There is a logical progression from this change of approach to Giacometti's models of architectonic arrangements for squares. This process is especially clear in the sculpture *Fall of a Body on to a Diagram (Chute d'un corps sur un diagramme*; destroyed), also known as *La Vie continue (Life Goes On)*, the horizontal arrangement of which transforms the features of a mask-like face into elements of a landscape.

The highly original *Model for a Passageway (Projet pour un passage*; illustration, p. 59) is still connected with the idea of a game-board, though it is in fact made up of a long, tube-like structure partly open, in the manner of a shell, and ending in a rectangular vessel containing small bowl-like forms. On close scrutiny, this 'passageway' takes on the form of a woman's body, the head represented by the rectangular vessel, and the other basin shapes, linked by closed passages, standing for the breast, belly and legs. A rod leading from between the legs to the sexual parts makes clear the erotic symbolism that turns the object as a whole into a schematized embodiment of the mechanics of the sexual act. Similar passage motifs, recalling a system of distillation flasks, are to be found in the painting of 1912 by Marcel Duchamp, *The Passage from Virgin to Bride* (Museum of Modern Art, New York) and, even closer to Giacometti's work, in Max Ernst's 1921 collage *Anatomy as Bride* (illustration, p. 59);[25] yet Giacometti's idea of fashioning a passageway in so ambiguous a form—part reclining woman, part curious game of *boule*—was both novel and prophetic. Not until 1966 was a comparable project carried out, albeit with quite different symbolic implications: for the Moderna Museet in Stockholm, Niki de Saint-Phalle produced a gigantic reclining female figure, named *Hon*, that could be entered through its genitals.

While *Model for a Passageway* exists only in plaster, at a length of 1.25 metres, Giacometti executed the six sculptural elements of his *Model for a City Square (Projet pour une place*; plate 22), on a larger scale. The monolithic parts of this work, which was intended to be suitable also as a garden 'environment', may have been prompted by Picasso's designs for multi-part sculptural monuments; yet in Giacometti's work, grouped on a rectangular base, they assume, despite their high degree of abstraction, a metaphorical significance. The head-high stele stands for a tree, the hollow hemisphere for a head, the cone for a woman, and the zig-zag form for a snake.[26] Our thoughts are automatically drawn to the Garden of Eden, the Tree of Knowledge and the Fall that fatally divided the sexes. The individual elements are so simply shaped that, were the work executed on a large scale, one could walk be-

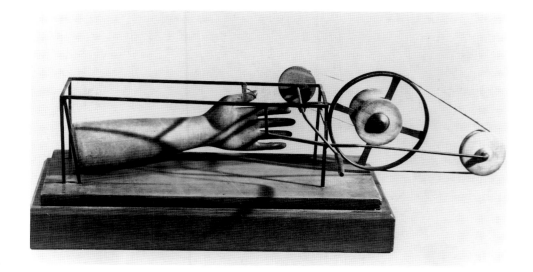

Alberto Giacometti, *Captive Hand,* 1932

tween them, sit on them or lean against them, as had been Giacometti's wish.[27] Giacometti made large-scale plaster models of the individual elements of the work, such as the stele, the hemisphere and the snake (cf. plate 31 and illustration, p. 25), but they were never executed in full as an ensemble. Nevertheless, they can be seen as the forerunner of the projected group for the plaza in front of the Chase Manhattan Bank in New York, the stele-like standing and walking figures of which were not carried out on a large scale until 1960.

For all the apparent discontinuity in Giacometti's œuvre, certain concepts retained their power, to be developed further in the late work. The cage constructions are a case in point. They initially return, again in connection with hanging forms and oscillating movements, in sculptures such as *The Nose* (*Le Nez*; plate 44) of 1947 or *Cage—Head and Woman* (*Cage—Tête et femme*; Alberto-Giacometti-Stiftung, Zurich) of 1950. They are also to be detected in the tectonic inner framework of the paintings, where—signifying both an internal and an external boundary—they contribute to the expression of existential hopelessness, isolation and alienation.

The furniture sculpture *The Surrealist Table* (*La Table surréaliste*; plate 33), devised by Giacometti in 1933 for the exhibition of Surrealist objects at the Galerie Pierre Colle, looks rather like a sculptural realization of a picture by René Magritte. We see the head of a young girl on a pedestal, which stands on the table. The face, half covered by drapery, looks out over the table, its mouth opened in an expression of alarm. This face faintly recalls those of the adolescent girls, surprised in the dark by their private fantasies, encountered in the paintings of Balthus, with whom Giacometti was friendly at this time. On the rhomboid table-top, which is supported by four quite differently turned legs, there lie a number of objects related to the image of the girl, but as if not belonging to her: on the left, for example, a polyhedron and on the right a detached hand pointing outwards. Both these objects were the subject of individual sculptures by Giacometti, the latter echoing *Captive Hand* of 1932 and the former recurring, in a more fully developed form, as the monumental *Cube—Night Pavilion* of 1934. This polyhedron, which refers to Dürer's engraving of 1514, *Melencolia I*,[28] also appears in a pen and ink drawing of the same

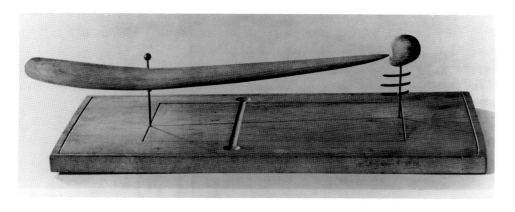

Alberto Giacometti, *Spike in the Eye,* 1931

time, entitled *Lunar Events (Lunaire)*—here, too, in connection with the head of a girl with an alarmed facial expression.[29] However anecdotal *The Surrealist Table* (plate 33) may appear, the presence of the mysterious polyhedron suggests a modern allegory of melancholy.

The figural canon of Egyptian art assisted Giacometti in taking a further step towards capturing human form. In the slightly less than life-size *Walking Woman (Femme qui marche)* of 1932, which, in its side view, still recalls both the slenderness of Cycladic idols and Giacometti's incorporeal disc sculptures, the artist again approaches natural proportions. While Archipenko's small torso of 1915 may well have served as godfather to this figure, the walking woman, with her tall legs, her rectilinear statuesqueness and her virginal severity, is still very much Giacometti's own creation. The figure is raised to the level of an idol by the indentation below the girlish breast, a hollow that stands for the heart but, at the same time, suggests an empty reliquary shrine. It is possible that Giacometti was inspired here by the plate-shaped hollow in an Egyptian statue of the god Min of Coptos that was illustrated in 1931 in *Cahiers d'art*.

A direct, if arduous, path led from *Walking Woman* to *The Invisible Object (L'Objet invisible*; plate 35), the culmination of Giacometti's early work. André Breton describes the genesis of this sculpture in his memoir of 1937, *L'Amour fou*. In its still apparently unresolved stage, which we know from a later photograph of Giacometti's studio (illustration, p. 25) the head and, in particular, the eyes were a problem yet to be overcome. Since, for Giacometti, these features determined the essence, and formed the centre of the life, of any figure ('The rest of the body is reduced to the role of antennae')[30] the completion of the sculpture was delayed. The head stubbornly opposed every process of individualization and so remained, for the time being, in a state of indeterminate stylization. Giacometti was helped, however, by a chance find at the flea market during a walk taken with Breton one spring day in 1934. Both men were fascinated by a late medieval iron visor, and Giacometti bought it on the spot. The visor acted as a catalyst, leading a little later to a mask-like form as the definitive solution for the head.[31]

The unsettled, semi-seated posture of the woman in *The Invisible Object* is reminiscent of Oceanic ancestor fig-

ures, but the sculpture also includes motifs derived from Egyptian art. The position of the hands, at breast height, recalls the figure of Queen Karomama presenting an object sacred to Isis in a sculpture in the Louvre that Giacometti copied.[32] The panel attached to the legs may also be traced to Egyptian models.[33] The tall back of the chair transforms this into a throne, its rectangular 'frame' embracing the figure like a halo and granting it the aura of a ritual object.

In this unusually compelling figure, Breton glimpsed 'the emanation of the desire for love and reciprocal affection in man's search for the truly human and in his [state of] painful ignorance'.[34] Its alternative title, *Hands holding Emptiness (Mains tenant le vide)*, indicates, however, that there is a further dimension to the work. It would seem to allude to that distance from the person 'close' to one that Giacometti felt deeply throughout his life and that, with this sculpture, he finally succeeded in making an integral part of his figures. In its dialectic—the human desire for a counterpart expressed in the upper part of the figure, and the notion of hindered desire rendered by means of the panel holding back the legs—*The Invisible Object* embodies Giacometti's search for that Archimedean point from which he could bring about a reconciliation between objective reality and his own spiritual reality.

A review of Giacometti's work from the years 1925 to 1935 draws attention to a wide diversity of formal exploration, with results ranging from block-like Cubist sculptures to structures that are fragile and almost 'dematerialized', from the static sculpture to the movable object, from the individual piece to the architecturally orientated 'environment'. Above all, such a review enables us to recognize an intensity of effect without parallel in the sculpture of the time. Giacometti renders perceptible a terror concealed within the world of appearances, a sense of the alien and a 'continual violence', 'without which man could not exist, and which sustains him', and which is expressed, in particular, in the tension of a sculptural work.[35] The new awareness of life conveyed by Giacometti's often confusingly ambiguous and abstract sculptures of the 1920s and early 1930s derives from his success in tracking down this primary moment of terror, the moment that reveals the vulnerability and 'emotionality' of the artist in the face of reality, and in transforming it into a seamless artistic creation.

1 Quoted in Reinhold Hohl, *Alberto Giacometti: Sculpture, Painting, Drawing,* London, 1972, p. 247. Quotations from this volume, a translation from the German (Stuttgart, 1971), have been revised slightly for the present publication.

2 See James Lord, *Giacometti: A Biography,* 3rd edn, London and Boston, 1986, p. 99.

3 Alberto Giacometti, 'Un sculpteur vu par un sculpteur', *Labyrinthe,* no. 4, 15 January 1945, p. 5.

4 On the reception of African art in France around 1925, see Rosalind Krauss, 'Giacometti', in *'Primitivism' in 20th-Century Art: Affinity of the Tribal and the Modern,* exhibition catalogue, 2 vols., ed. W. Rubin, New York, Museum of Modern Art; Detroit, Detroit Institute of Arts; and Dallas, Museum of Art, 1984/85, vol. 2, p. 507.

5 Stefanie Poley, 'Alberto Giacomettis Umsetzung archaischer Gestaltungsformen in seinem Werk zwischen 1925 und 1935', *Jahrbuch der Hamburger Kunstsammlungen,* vol. 22, 1977, p. 175.

6 Nine years later, in *L'Amour fou* (1937, p. 45, plate 8), André Breton illustrated a rustic wooden spoon in which the association with a woman is produced by a shoe carved at the end of the handle.

7 See Carl Einstein, *Negerplastik,* 2nd edn, Munich, 1920, p. xxi.

8 See the examples from Zaïre, South Africa and Cameroon illustrated in Krauss, 1984/85, pp. 526 and 532.

9 Quoted in E. Scheidegger (ed.), *Alberto Giacometti: Schriften, Fotos, Zeichnungen,* Zurich, 1958, p. 34.

10 Quoted in Hohl, 1972, p. 248. In this connection, it is perhaps worth noting that Giacometti later described a snow cave of his in the mountains near Stampa and expressed a longing for the snowy wilderness of Siberia; see the autobiographical 'Hier, sables mouvants', published in May 1933 in the periodical *Surréalisme au service de la révolution,* no. 5, p. 44f.

11 Hohl, who now dates the disc sculptures to the winter of 1928/29 (see Chronology), claimed, in his essay 'Giacomettis Atelier im Jahre 1932', that Picasso was inspired by Giacometti's *Gazing Head* to make his lithograph *The Face;* see Reinhold Hohl, in *Alberto Giacometti: Zeichnungen und Druckgraphiken,* exhibition catalogue, Tübingen, Kunsthalle, etc., 1981, p. 45. With the later dating of Giacometti's disc sculptures, priority may now probably be awarded to Picasso as the source of inspiration.

12 Quoted in Scheidegger, 1958, p. 34.

13 Salvador Dalí, *Unabhängigkeitserklärung der Phantasie ... Gesammelte Schriften,* ed. Axel Matthes and Diego Stegmann, Munich, 1974, p. 161. What is more, in 1933 Dalí integrated Giacometti's *Suspended Ball* into his sketch for a Surrealist 'environment'; see Karin von Maur, *Salvador Dalí 1904-1989* (Stuttgart, 1989), pp. 132-3, with illustration.

14 René Crevel, *Dalí ou l'Anti-Obscurantisme,* Paris, 1931, pp. 23-4.

15 See Giacometti, 1933, and Lord, 1986, pp. 14 and 77ff.

16 See Hohl, 1981, p. 48.

17 Krauss, 1984/85, p. 517f.

18 See 'La Mante religieuse', *Minotaure,* no. 5, 1934, pp. 23-6.

19 Hohl, 1981, p. 45.

20 See Hohl, 1972, p. 83.

21 *Minotaure,* nos. 3/4, 1933, p. 46.

22 Quoted in Hohl, 1972, p. 249.

23 See Jean Clair, 'Alberto Giacometti: La Pointe à l'œil', *Cahiers du Musée national d'art moderne,* no. 11, 1983, pp. 54-89.

24 See Bruno Giacometti, 'Souvenirs fraternels', in *Alberto Giacometti,* exhibition catalogue, Martigny, Fondation Gianadda, 1986, pp. 37-43.

25 See Hohl, 1972, pp. 81 and 293, fig. 40.

26 See ibid., p. 79ff.

27 See his letter to Pierre Matisse, quoted in Scheidegger, 1958, p. 35.

28 See Hohl, 1981, p. 50.

29 See Peter-Klaus Schuster, 'Das Bild der Bilder: Zur Wirkungsgeschichte von Dürers Melancholiekupferstich', in *Idea: Jahrbuch der Hamburger Kunsthalle,* vol. 1, 1982, p. 97.

30 Georges Charbonnier, *Le Monologue du peintre,* Paris, 1959, p. 167.

31 See André Breton, *L'Amour fou,* Paris, 1937, chapter 3, plate 7.

32 See *Alberto Giacometti: Begegnung mit der Vergangenheit – Kopien nach alter Kunst,* ed. Luigi Carluccio, Zurich, 1966, p. 30.

33 See Bernard Lamarche-Vadel, *Alberto Giacometti,* Paris, 1984, p. 71.

34 Breton, 1937, chapter 3, p. 23.

35 See Charbonnier, 1959, p. 164.

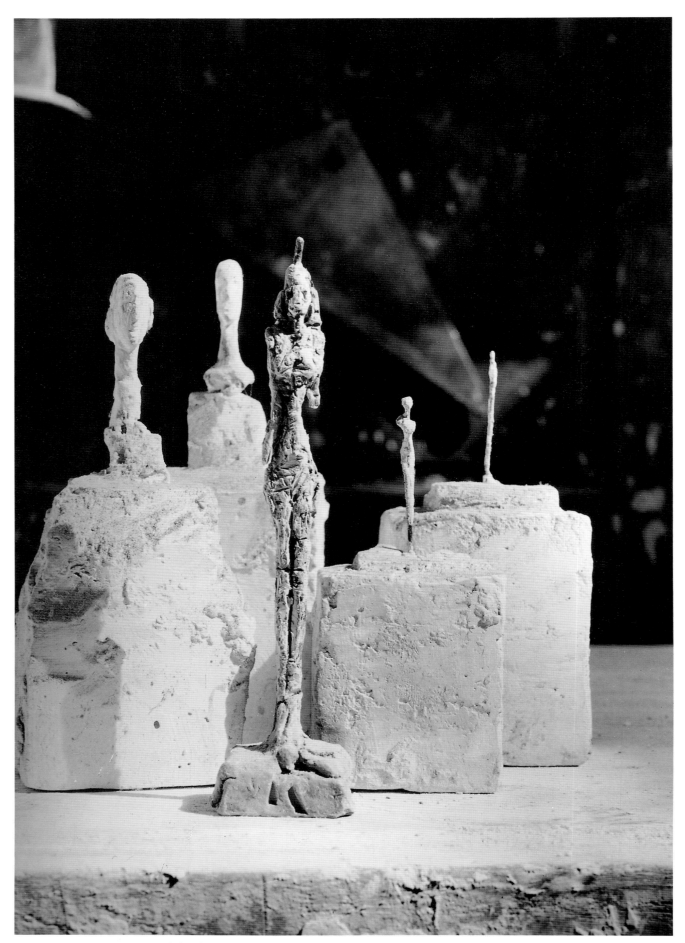

Ernst Scheidegger, Various sculptures by Giacometti from the period 1949–58

Scale in Giacometti's Sculpture

DIETER HONISCH

Yet, when I wanted to create from memory what I'd seen, the sculpted figures became, to my dismay, smaller and smaller; a likeness was there only when they were very small, but all the same their size infuriated me and I tirelessly started over and over again, only to end up, several months later, at the same place. I found a large figure untruthful even though I found a small one intolerable; apart from that, they often became so small that they crumbled to dust at a single touch of my knife.[1]

These remarks hint at a dilemma, a crisis in which Giacometti found himself between 1935 and 1945. All the work he produced from 1942 to 1945 in Geneva could be kept in the six matchboxes he took back with him to Paris. In 1935 Giacometti had parted company with the Surrealists, in whose circle his important and largely non-representational early work had evolved. What now prompted him to reduce so drastically the scale of his sculptural work?

The search for truth and the daily studies after various models on which Giacometti abruptly embarked had branded him a renegade in the eyes of the Surrealists; but, on the other hand, this new approach produced no compelling results. 'To my horror', Giacometti reported,

my statues got even smaller after 1940. It was a real disaster. I remember, for instance, that I wanted to sculpt a girl I loved, from memory, as I had seen her in boulevard Saint-Michel. I wanted to make her about eighty centimetres high. To cut a long story short: she became so small that I couldn't put any more details on the figure. It was a mystery to me. All my figures stubbornly shrank to a height of one centimetre. Another touch of my thumb and oops!—no more figure.[2]

In the same context he admitted:

It was only later that I began to think about it. At first I had instinctively made the sculpture so small to indicate the distance from which I had seen the model. From a distance of fifteen metres, that girl was for me not eighty centimetres high, but a little over ten. And then, too, in order to convey the appearance of the whole and not lose myself in details, I had to choose an even greater distance. But even then, when I put in details, they seemed to con-

tradict the whole. ... So I moved further and further back, until at last everything disappeared.

In these studies, which paved the way for his late work, Giacometti was not concerned with opposing a figurative form of sculpture to his metaphorical and symbolist early work. Rather, he wished to find a form that was able to convey his experience of seeing. Here, for the first time, sculpture is measured against reality: not against what we know about an object, but against how it appears to us. In this process, it was not the traditional concepts of the object, of mass and of proportion, that were significant to Giacometti, but those of distance and the sense of totality. 'I'm trying', he once admitted to François Stahly, 'to give the head the right size, the actual size it appears to someone who wants to see it all at once, with complete visibility. What impresses us about its appearance can be seen only from a certain distance.'[3] Simone de Beauvoir recorded the artist's remark: 'A face [is] an indivisible whole, a mood, an expression.'[4]

Giacometti dated to a day in 1945 his key experience in this new awareness of distance and totality. It occurred after he had left a cinema in Boulevard Montparnasse:

That day, reality took on a completely new value for me; it became the unknown, but an enchanted unknown. From that day on, because I had realized the difference between my way of seeing in the street and the way things are seen in photography and film,—I wanted to represent what I saw. Only from 1946 have I been able to perceive the distance that allows people to appear as they really are and not in their natural size.[5]

Obviously, in seeking to make sculpture into an equivalent of the experience of reality, Giacometti discovered a phenomenon known to painters since at least the time of Piero della Francesca: the need to reduce the scale of figures in accordance with the laws of space and to the advantage of the pictorial conception as a whole, without thereby incurring a loss of significance.

It is possible that the fascination exerted on the young Giacometti by the work of Jacopo Tintoretto also played a role here.[6] Although one should not overestimate this, the fears of the abyss that Simone de Beauvoir reports as characteristic of Giacometti do call to mind the visions of space in the work of the great Venetian painter:

For a long time, when he was walking down the street, he had to test the solidity of the house walls with his hand, to resist the abyss that had opened up next to him. Then again, he had the impression that nothing had weight; that in the streets and squares the passers-by were floating through the air.[7]

Yet the evidence of Giacometti's own paintings, in which there is little sense of distance reducing the size of the figures, and in which a single subject is often shown from very close in a vast space, argues against such direct outside influences on his sculpture. In a characteristic way, the pictorial vision embodied in the sculpture is opposed by a sculptural procedure in the act of painting. In this respect, only the work of Francis Bacon offers an exactly contemporary analogy, one that Giacometti tacitly acknowledged: 'Compared with Francis Bacon's, my paintings look as if they had been done by an old spinster.'[8]

It would be entirely wrong to interpret Giacometti's use of large and small forms in the sense that these have in traditional sculpture, signifying, respectively, more or less important, public or private, monumental or intimate; or, in the sense they can have in painting, signifying the near and the distant. 'Until the war I believed I saw people in the distance life-size. Then, little by little, I realized that I was seeing them much smaller—and even when they were near to me, not only when they were far away. The first few times this happened, I was just walking somewhere.'[9] Here Giacometti would seem to mean that an impressive or significant appearance in a particular object or person is invariably also connected with a particular experience of distance that bestows visual presence on the object or person. Distance thus becomes a precondition of experiencing the reality of a thing; seen excessively close up—from not far enough away—the thing would dissolve into a merely arbitrary appearance. Reinhold Hohl has spoken of Giacometti's 'subjective experience of the object'. One could find no more apt description of the phenomenon in question, which probably constitutes the very respect in which Giacometti differs from every other sculptor of his time.

Science has established that we store in the central part of our brains notions of 'standard' size. If what we encounter in the world around us exceeds this, or falls below it, there ensue warning signals that lead to a state of increased alertness. In the case of Giacometti's work, this evidently happens because, in his presentation of human beings or of human appearances, his forms fall below generally accepted units of volume. In the case of Pop Art, on the other hand, it occurs because we are confronted with utensils or consumer goods that are oversized. Giacometti is concerned with the perception of things in space, the Pop artists with our mental notions of things. Asked to conjure up an image of Giacometti's figures in our mind's eye, we would no doubt envisage them as slender, shooting straight up, spatially distorted and incorporeal. Hardly anyone would be able to say exactly how tall they are, although, for Giacometti, that was clearly the most important aspect. I believe one would imagine them—unlike the artist—to be tall or even too tall, monumentalizing them and thus dispensing with the precision of perception that Giacometti desired the beholder to exercise.

In 1959, when Giacometti received a commission from the architect Gordon Bunshaft to make a group of figures, each eighteen metres high, for the square in front of the skyscraper of the Chase Manhattan Bank in New York, he turned it down.[10] Nevertheless, the commission continued to haunt him. He visited the square repeatedly and had friends station themselves at various places in it. His last idea was for a larger than life-size female figure (seven or eight metres in height) as an expression of the 'totality of life'; but this work was never executed.[11]

Between Giacometti's heads of the 1940s, which, the size of peas, could be kept in matchboxes, and his period of intensive thought, in the 1960s, about a monument to life for the Chase Manhattan Bank, lay experiences of reality that led the sculptor in those final years of his life, when he was permanently dissatisfied with himself and plagued by the notion that he had failed to achieve his real goal, to feel an urge towards the monumental—that monumentality which also dertermines they way we imagine his work. We think of Giacometti's sculptures as large, yet their scale in our imagination does not correspond to their actual size. If we look at his works and find them to be too small—'I don't know', declared a friend of the artist, 'it's all so small'[12]—this is the expression of a conventional notion of sculpture. It may well have been this prevailing conception of the medium that finally led Giacometti to stop producing works that fell below a certain size.

It is altogether characteristic that, as Giacometti's work became more widely known, it was not the thread-like form of his sculptures, but rather their size, that irritated people:

The tiny figures that Giacometti sent to various exhibitions in France [in 1947] were almost completely overlooked—the critics considered them to be studies only. But the moment he began to apply the principles of phenomenological sculpture that he had worked out during the war to pieces of a more normal size—resulting in figures that, though certainly tall, were slender—he was all at once acknowledged as the representative of French … post-war sculpture.[13]

It was not the intensity of a perception determined by distance and attuned to totality that was found to be the qualifying factor; Giacometti's sculptures attracted attention only when they were of a normal size. Convention proved stronger than experience of reality, and continued to do so. Max Bill, for example, determined the size of an object according to its position, not—as in the case of Giacometti—according to the visual impression that the object made on him. And in the non-representational sculpture of Minimalism (which, despite its name, was an art of large rather than small objects) the exact positioning of the viewer was also a prime concern. It would none the less be true to say that art with a beholder-determined view of the object had its starting point in the work of Giacometti. Inasmuch as Frank Stella, for instance, bases his art on the maxim 'What you see is what you see', one could term him a follower of Giacometti. After the latter's first exhibition at the Pierre Matisse Gallery in New York in 1948, the Americans were quick to appreciate him. Barnett Newman noted: 'Giacometti made sculptures that looked as if they were made of spit—new things with no form, no texture, but somehow filled; I took my hat off to him.'[14]

The sculptures shown in New York had nothing to do with the largeness of scale so important to American artists at the time, but this concern with outsized dimensions may have had a reverberation in Giacometti's work—at least in the project for the Chase Manhattan Plaza. Why else should an artist who, using his experience of distance, created new qualities of perception out of a particular smallness and the sense of proximity this conveyed, resolve on a process of monumentalization that was beyond his experience? After the intended height had been reduced, Giacometti felt certain that the female figure inspired by the Plaza commission could be executed; but it was not, and so nothing definitive can be said about the size of the figure in relation to his sculptural work as a whole. He alone could have been relied upon to give this female idol the measure of reality and truthfulness that in every respect characterizes his other sculptures. The size we imaginatively impute to Giacometti's sculpted figures is linked to the inner monumentality that distinguishes them. Even when they are small, they attain a degree of exaltedness that enlarges them in our minds.

With Giacometti, the problem of a lack of height is accompanied by the problem of a lack of volume: 'After 1945 I swore to myself that I wouldn't allow my statues to keep getting smaller, not one iota smaller. But what happened was this: I was able to keep the height, but they became thin, thin ... tall and paper-thin.'[15] It looks as if this extreme reduction of volume in terms of height, breadth and depth was not merely the result of Giaco-metti's experience of distance, tested daily while working from the model, but occurred as a form of compulsion, entirely against his will. Friends have spoken of his feeling of despair about the situation.

David Sylvester enquired into this phenomenon in two radio interviews broadcast in September 1964, extracts from which were published in a catalogue produced in 1977 by Thomas Gibson Fine Art Ltd of London.[16] Sylvester had noticed that the forms of Giacometti's sculptures were more slender than those in his paintings and drawings. The artist explained this by stating that the paintings proceeded from an illusion and the sculptures from reality, from perception itself. For Giacometti, the most significant sculptures produced by ancient civilizations, by the Egyptians, the Sumerians, the Chinese, and prehistorical cultures, were small, or at least appeared thus on account of their location in an architectural setting and their distance from the beholder. Large sculptures were simply extensions of smaller ones: 'If I look at a woman on the opposite pavement and I see her all small, I feel the wonder of a small figure walking in space, and then, seeing her still smaller, my field of vision becomes much larger. I see a vast space above and around that is almost limitless.' If a person came nearer, increasing in size until he or she occupied the artist's entire field of vision, then his interest in the act of seeing that person waned: 'I want to touch them, don't I? There is no longer any interest in looking.' This observation is also of interest in that Giacometti (albeit unconsciously, and drawing solely on the lessons of his own perception) applies to sculpture the categories of close and distant view that have played an important role in European landscape painting, in particular that of the Romantic era. The way in which Giacometti saw a figure as standing or walking in a vast and unbounded space—the experience that intensified his vision of space—might indeed be termed a pictorial way of seeing.

Giacometti felt that there was something imagined, rather than seen, about figures that approached life size, and he criticized this feature not only in the sculpture of Rodin and Houdon, but also in the paintings of Cézanne, Courbet and even Titian. He himself felt closer to Van Eyck. For Giacometti, it was more important, and also more realistic, to work in terms of how an object appeared to the eye—and the more surrounded by space it was seen to be, the smaller it had to be and the more energy and concentration it had to have—than in terms of what one knew about it and what connected it with models in nature. He did not wish to create reproductions of reality, but equivalents of it. What was important for him was not what one thought, but what one saw. In the interview with Sylvester he observed that his experience of the figure was not tactile, not sculptural, but pictorial: 'If

I make a sculpture I'm unable to walk around the model. ... Even the sculpture I'm working on becomes almost as illusory [*sic*] as a painting on a canvas.'

Seen from a distance, Giacometti's sculptures assume the 'illusory' appearance of pictures, which, constituting 'a certain position in certain surroundings', contrast with that which sculpture signified to him—that is, 'working with actual mass'. This cannot be taken to mean, however, that he conceived of his sculptures as 'living' pictures, rather that they were to be experienced pictorially, albeit without the exact position in a particular setting that also distinguished his own two-dimensional work. His father, who was a painter, may have served as a model for this approach. Of far greater importance, though, was Giacometti's interest in great painters of the past, such as Tintoretto, Van Eyck and Giotto, whose work preoccupied him more than that of sculptors. Like Michelangelo, he had rather unkind comments to make about these.

Only with Picasso did Giacometti have a closer relationship. Picasso, uniquely, asked him for advice regarding his own sculptures—and surely not always to Giacometti's delight, for he could hardly have found the Spaniard's playful treatment of objects and forms congenial. The flattened bodies produced by Picasso in the multiple views characteristic of Cubism had not especially impressed Giacometti and had scarcely influenced his work. Unlike Picasso, Giacometti did not start from the image, from the total representation of a thing on a surface, but from how bodies in space appeared to the beholder. Also, he no longer had any confidence in what artists, in an essentially arbitrary fashion, displayed of their own imagination in works of art; he had put behind him his experiences with the Surrealists. In 1965 Robin Campbell reported on a visit that Giacometti made to the British Museum: 'The T'ang figure led him to say that, more and more, he preferred to anything else the impersonal and objective quality in early art: he had less and less liking for the kind of art where the artist puts his own feelings and attitudes into what he is doing.'[17]

That war and Fascism had destroyed people on a previously unimaginable scale must have had an influence on Giacometti, however slight his interest in politics. As early as 1934, one commentator observed: 'Giacometti is probably the most sincere witness to the current catastrophe. No one else has expressed the anxiety of the present as he has.'[18] It is true that no recorded statement by the artist testifies to the effect of contemporary events on his work; but his difficulties, in Geneva and later in Paris, in establishing a new and adequate image of humankind surely cannot be explained only in artistic terms. The fact that his figures ran through his fingers, that their bodies disintegrated; the grey atmosphere of his studio; the dust out of which there slowly rose a vision of the intact totality of humanity and the dignity of all existence: these enabled Giacometti to express an awareness of life that was attuned to post-war sensibilities. The sense of personal exposure; the meaninglessness of individual existence and, in spite of that, its dignity; the unrelatedness of human beings, their isolation and their aimlessness; the inability to believe and to accept ideals; the desire to survive, to find one's place—all this is especially forcefully expressed in the figures created in connection with the group envisaged for the Chase Manhattan Bank Plaza, the only larger than life-size figures of his entire career. If Giacometti himself saw a meaning in this enlargement of scale, we can only assume this to have been the desire to create a monument that was not a memorial in the traditional sense: not an exaltation of the victors, but of the victims, the maltreated and the nameless.

The pictorial distance of Giacometti's figures, which rendered them thin and small, automatically raised the question of how they were to be granted the tactile proximity that is essential to sculpture. Giacometti solved this problem in a two-fold way. Firstly, he gave his figures a large base or pedestal. Secondly, as his friends report, he generated a sense of proximity by incessantly fingering the clay models, hence giving the impression of surfaces seen from close up. As a result, no one figure ever looked similar to another, because the final state emerged only from a continuous series of innumerable sculptural actions. Thus, for example, the 'Women for Venice' ('Femmes pour Venise'; plates 108–114), made in 1956 for that year's *Biennale,* are various states of a single figure, each of which Giacometti's brother Diego had to record in the form of a plaster cast. These nine, less than life-size bronze figures (between 110 and 113 centimetres in height) reveal, like no other pieces, the artist at work on one and the same subject. Accordingly, this 'work in progress' also provides a unique demonstration of Giacometti's working method: how he wrestled with a particular presence, with a particular expression, and how these were attained not in the individual figures, but only in the sum of them.

Large and small are relative values in Giacometti's sculpture. With the exception of the few monumental, larger than life-size figures, they signify no more and no less than the positioning in space of perceived objects, which attain a significant appearance only at varying distances. In so far as Giacometti firmly assigned to the figure a reality within the space surrounding it, he released it from the relative proportions the beholder had imagined and made it into a concrete object of perception, tying it to the eye of the viewer. From this nearness to the beholder, the figure acquires its reality, just as it

draws from distance the totality of its appearance—the suggestion of its being 'intact'. In Giacometti's work, differences of scale do not alter meaning; rather, they are aimed at the identity of the figure, which is to be experienced as a reality in space only in its distance from the viewer. Giacometti models the figure not as an objective value, but as one dependent on the beholder. We are ourselves included in these sculptures.

If Giacometti found a large figure 'untruthful' and a small one 'intolerable', he none the less needed a certain smallness, so as to be able to establish the distance required for the overall appearance of his figures. This was an appearance that, freed from details, and guaranteed to be 'impressive', could be perceived from a distance as well as in proximity, so that there in fact arose an image of 'reality' that had to become an image of the 'unknown'. The relativity of large and small, the interchangeability of near and distant, the demand for distinctness and, at the same time, for comprehensibility at a glance, produces an object that is as perfectly artificial as it is also rooted in our experience of the real, an object in which illusion and reality combine to form a unified manner of looking. This object of cognition, which Giacometti had to wrench from less 'serious', life-size sculpture, from the conscious sense of correct proportion, and from the 'illusory' imagery of the picture (itself distant from reality), is not an object of nature, but rather one that is to be achieved visually and that has, repeatedly, to be defined anew. In this we can grasp that 'difficulty in realizing' that Giacometti sensed as a form of perpetual failure. It also makes clear the spiritual exertion and the intensity implicit in Giacometti's work, and equally the feeling of personal insecurity with regard to results that the artist understood more or less as approximations, thus forcing him to a permanent and never ending process of work. The danger of ceasing to be visible was a potential consequence as much of a figure that was too large as of one that was too small. Giacometti's work, dedicated not to the visible but to making visible, is therefore poised perpetually between the poles of the too large and the too small, both of which contradict perception. True meaning lies somewhere between the sublime and the void; and it draws its credibility from both.

In Giacometti's work, large and small, near and distant, clarity in detail and comprehensibility at a glance are constituents not of one figure, but of every figure. Each category brings the next into play and thus divests the beholder of that sense of correct scale derived from his experience of perception, ordering him, as an observer, back into the realm of his own imagination. To this extent, the space that Giacometti's figures generate around themselves, and which they need, is really not to be entered by those looking on. The boundary is invisible, but one can feel it.

1 Quoted in Ernst Scheidegger (ed.), *Alberto Giacometti: Schriften, Fotos, Zeichnungen,* Zurich, 1958, p. 36.
2 Quoted in Reinhold Hohl, *Alberto Giacometti: Sculpture, Painting, Drawing,* London, 1972, p. 275. Quotations from this volume, a translation from the German (Stuttgart, 1971), have been revised slightly for the present publication.
3 Quoted ibid., p. 207.
4 Quoted ibid.
5 Quoted ibid., p. 277.
6 See ibid., p. 189.
7 Quoted ibid., p. 277.
8 Reported by Robin Campbell; quoted ibid., p. 285.
9 Quoted ibid., p. 207.
10 See ibid., p. 282.
11 See ibid., p. 143.
12 Simone de Beauvoir; quoted ibid., p. 275.
13 Ibid., p. 277f.
14 Quoted ibid., p. 278.
15 Quoted ibid., p. 277.
16 *Alberto Giacometti: Thirteen Bronzes,* exhibition catalogue, London, Thomas Gibson Fine Art Ltd, 1977, pp. 7-19.
17 Quoted in Hohl, 1972, p. 286.
18 Anatole Jakovski; quoted ibid., p. 187.

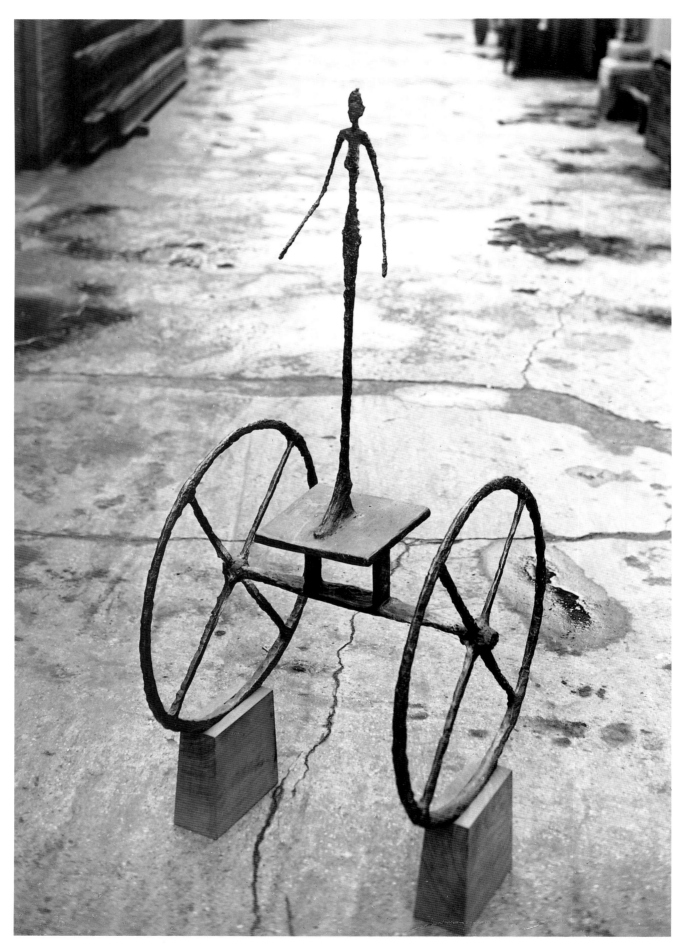

Ernst Scheidegger, *The Chariot* (1950) by Alberto Giacometti

As if from Afar: Constants in the Work of Alberto Giacometti

ANGELA SCHNEIDER

'I no longer know what to think about anything.' [1]

In the photograph by Cartier-Bresson on the cover of this book, Giacometti is glimpsed between a majestic, standing female figure in plaster and a restless, striding male figure in bronze; and he looks like one of his own sculptures. Beyond its anecdotal quality, this image gets to the core of Giacometti's work, work that derives its intensity from the irresoluble contradiction between art and life. In spite of all the abrupt stylistic changes to be found in his work, Giacometti was committed throughout his career to a single idea—that art might portray the reality of life. In this connection, it may have been significant that Giacometti's father, the painter Giovanni Giacometti, had for his son signified both life and art, combined in a single person. Models and friends speak repeatedly—particularly with reference to Giacometti's later career—of his sense of despair, of his Sisyphean task, of his destroying each night what he had made the day before and of starting again the following morning, as if these figures, as Jean-Paul Sartre wrote, citing Giacometti's own words, had only been made to exist for a few hours.[2] Giacometti told Pierre Schneider, 'I sometimes think I'm capturing the phenomenon, but then I lose it again, so that I have to start from the beginning. This is what makes me hurry, makes me work.' In response to Schneider's question, 'But don't you have the feeling you're running on the spot?', Giacometti replied,

> 'Not at all, I think that I make a little progress every day. Oh yes, I really believe that, even if this progress is hardly visible. And, increasingly, I believe that it's not only every day that I make some progress, but every hour. This spurs me on more and more, and, on this account, I'm now working more than ever. I feel certain that I'm doing something that I've never done before, and that will make everything I've produced in sculpture till yesterday evening, or even till this morning, irrelevant.[3]

Giacometti later described the beginnings of this crisis in his famous letter to Pierre Matisse:

> 'Impossible [at the Academie de la Grande Chaumière] to grasp the whole of a figure (we were much too close to the model, and if one started on a detail, a heel, or a nose, there was no hope of forming a whole. But if, on the other hand, one began by analyzing a detail, the tip of a nose, for example, one was lost. One could have spent a lifetime doing that without achieving any result. The form became distorted, it was little more than specks moving in a deep black emptiness. The distance between one side of the nose and the other was like the Sahara. There was no fixed point, no boundaries, everything escaped.'[4]

A year after the death of his father in 1935. Giacometti gave up working on his Surrealist constructions—showpieces informed by the opposed qualities of sexuality and cruelty—in order to turn to a new model from life, the 'Compositions with Figures'.[5] For these, he thought he would need about fourteen days' work from the model; but nothing went right. The figures that he made from memory in the years 1938-44 were no more than two to seven centimetres in height. Resemblance, according to Giacometti, was only achieved 'when they were very small; yet their dimensions infuriated me, and tirelessly I started over and over again, only to end up, several months later, at the same point.'[6]

On their over-sized and often stepped bases, the figures appeared as if seen from afar. They were marks made in space recalling exactly the way we perceive a person from a distance—as a whole, but as alien; with the details indistinct, but surprising us with their presence. Giacometti was not concerned here with conventional resemblance, with the recognition of habitual expectations. He was interested, instead, in the accurate reproduction of the act of seeing, an act that encompasses the distance between the viewer and the viewed, and thus makes space itself visible. Giacometti had in mind a very specific situation: he had seen his friend Isabel walking away down the boulevard Saint-Michel one night, and he wanted to reproduce the image of her that he had retained in his memory, and at the correct size. 'I saw the vast blackness above her, the houses; so, in order to reproduce my impression from that time, I would have had to produce a painting, not a sculpture.'[7]

In formal terms, as Gottfried Boehm has pointed out, these figures conceived in terms of the view from a distance belong in the tradition established by Adolf von Hildebrand and Auguste Rodin.[8] Unlike either of these artists, however, Giacometti did not shape the various parts of his bodies after the model of nature. A cheek or

a breast was not intended to exist in its own right; matter was not regarded as infinitely divisible, but was seen to correspond to the indivisibility of the phenomenon. In this process, however, the figures became so small that they broke into pieces in the artist's hands, and crumbled into shapeless chips of plaster. It was only after the end of the war that Giacometti found a way out of this dilemma: after returning to his Montparnasse studio, he allowed his figures to shoot upwards. Here, too, the material element was reduced to a minimum, but it none the less held its own in ensuring the size that was necessary for a 'real' figure. Now Giacometti was able to introduce the details he had earlier sought in vain;[9] but on no occasion do the cracked, split, jagged surfaces function as descriptions of individual parts of the body, or enter into any conceptual identification with them. Sartre wrote,

> One has to study a classical statue, or approach it; at each moment one grasps new details, the parts appear separately, and then the parts of the parts, and one ends up getting lost. One cannot approach a sculpture of Giacometti. Do not expect this breast to swell as you move towards it: it will not change, and you, while approaching, will have a peculiar impression of standing still. The nipples: we have intimations of them, we guess at them, now we are on the point of seeing them: another step or two, and we still have only an inkling of them; one more step, and everything vanishes, only the folds in the plaster remain.[10]

There is a tension between the apparently shapeless and—despite its treatment—apparently natural surface, and the appearance as a whole; and it is this that has led to there being such a diversity of interpretations of Giacometti's work, the most well-known being those offered by Sartre and by Genet.

> But something has happened to these bodies: do they come from a concave mirror, from a fountain of youth, or from a punishment camp? At first glance, we seem to be confronted with the emaciated martyrs of Buchenwald. But the next moment we have changed our minds: these tender, relaxed figures are ascending to heaven, in each of them we see an Ascension or Assumption; they dance, they are dances, they are made of the same weightless matter as the transfigured bodies that are promised to us; and yet, while we are still contemplating this mystical uplift, these starving bodies blossom, and all we have left are flowers of the earth. This martyr here was only a woman. But a complete woman, glimpsed, secretly desired, a woman who passes us by with the strange dignity of a willowy, delicate girl striding carelessly in high-heeled slippers from her bed to her bathroom; a woman who passes us by with the tragic horror of a victim of fire or famine; a complete woman, devoted to us, refused us, near, far; a woman whose exquisite body betrays a hidden emaciation, and whose horrifying emaciation conceals a soft, physical roundedness; a complete woman, ever endangered on this earth, and yet already not entirely of this earth; a woman who lives, and who tells us of the astonishing adventure of the flesh, our own adventure.[11]

Even if nowadays we can no longer see Giacometti's sculptures as embodying misery and humiliation—those topoi so effusively embraced in the Existentialist era—the fascination nevertheless remains of the way in which they succeed, in equal degrees, in being effectively hieratic in appearance and apparently shapeless in their surface structures.

Death and Sexuality

Giacometti's own confession of faith from these years was the story 'The Dream, the Sphinx and the Death of T.', written in 1946, at the request of Albert Skira, for the journal *Labyrinthe*. This autobiographical text revolves around the death of T. (Tonio Pototsching), who lived next door to Giacometti's studio, and the artist's visit to the brothel 'Le Sphinx' the day before it was to be closed; and it therefore takes up again the themes of death and sexuality that are crucial to Giacometti's work. As a result of these two events, Giacometti had a new and deeply disturbing experience: 'There was no longer any relationship between objects, they were separated by insuperable abysses of emptiness. I looked at my room with horror, and cold sweat ran down my back.' He went on, 'I confronted a bewildering mixture of time, events, places and feelings. I began the search for a solution.'[12]

Now—in Giacometti's work from 1947 on—the bases have become smaller, in comparison with the figurines produced during the war years. These later bases anchor the figures to the ground, and are firmly attached to their large feet, which—and one could not express this better than Genet—'have taken upon themselves the figure's whole materiality.'[13] A field of energy arises between the bases and the figures' heads; lines of force flow incessantly back and forth. As Gottfried Boehm put it, the figures 'seem to want to withdraw from their own figurativeness onto a fluid underlying layer that is on the point of dissolution itself.'[14]

Head on a Rod (*Tête d'homme sur tige*; plate 45) and *Four Figures on a High Base* (*Quatres figurines sur base*; plate 56) are both sculptures that can be directly related to Giacometti's text of 1946. The head fixed to a rod is situated at the dividing line between life and death, between a living mass and a hollow skull. The surface is jagged like a mountain range. The flattish head is gently rounded towards the back and below; but at the front its chin, open

mouth and nose form a zig-zag staircase like unattainable, awe-inspiring mountain peaks. The face is turned upwards and is looking at something we can only guess at. It embodies the sort of horror that Giacometti speaks of in his text, which had earlier come over him on witnessing the death of his travelling companion Pieter van Meurs, and which had recurred in a curious fashion on the death of his neighbour T. Giacometti describes the precise moment in which the living man has died and the dead man is disturbingly present:

And then, though not believing it, I had the vague impression that T. was everywhere, everywhere but in the pitiful corpse on the bed, this corpse that had appeared to me so insignificant. T. no longer had any limits, and I crossed the corridor only with a very great effort and in an absolute dread that an ice-cold hand might reach out and touch my arm … I had just experienced, in reverse order, what I had felt several months earlier when confronted with living creatures. At that time I had started to see heads in a void, in the space that surrounded them. As I saw quite clearly, for the first time, how the head I was looking at froze, and then in an instant became immobile, definitively, I shivered with terror as I had never done in my life before, and a cold sweat ran down my back. This was no longer a living head, but an object that I was looking at just as I looked at any other object—no, that's not quite it, not like any object, but like something simultaneously both living and dead.[15]

In a 1951 interview with Georges Charbonnier, Giacometti repeated this insight. 'On the other hand, when I am working from a live model, I find I am able—almost to my own horror—to recognize the skull beneath the skin without difficulty … This happened to me once with a young girl who was posing for me and whom I wanted to draw.'[16] This insight does not mean that Giacometti allowed his sculptures to become skeletons. It was a matter, rather, of capturing the living quality of the moment, as each moment is unmistakable and unique, and can only be recognized when contrasted with the timelessness of death. This was why the struggle was one to achieve a rigid, definitive form.

Four Figures on a High Base was made in 1950. In his second letter to Pierre Matisse, Giacometti recalls the situation: 'Several nude women, seen at the 'Sphinx' while I sat in the background. The distance that separated us (the shining parquet floor) and that appeared impassable, despite my desire to cross the floor, made as strong an impression on me as did the women themselves.'[17] A tapering trapezoid base bearing four dainty female figures, each only twelve centimetres in height, stands on a tall modelling stand. While the base imitates the perspectival foreshortening of the reception room at the 'Sphinx', the

majestic, self-contained figures are the prostitutes, who show themselves off to their customers with all the seductive charms that a nude woman can muster. The diminutive scale of these figures indicates the distance from which they are seen, and their unattainability. This spatial distance is accompanied by a temporal distance. Through the severe frontality of their pose, their arms placed at their sides, and not least through the large base, the figures recall the Egyptian sculptures that had struck Giacometti, from his youth onwards, as being 'lifelike'.[18] Beat Wyss detects in *Four Figures on a High Base* the monument to a recollection scintillating with the evocation of both a brothel scene and a shrine. While these small figures, seen from afar, are suggestive of the *penates* of a household altar, they also reveal themselves, as we approach, to be graceful women on a catwalk, only to end up by becoming, in immediate close-up, little more than scabby stalks whose reddish-ivory surface displays the venereal disease which those who have come too close to these goddesses can expect.[19]

Giacometti had, in fact, caught an infection himself on his last visit to the 'Sphinx', through carelessness, but also almost wilfully; and the following week he found traces of an ivory-coloured suppuration. There are two references to this colour in 'The Dream, the Sphinx and the Death of T.': in the description of the skin of the dying T. and in the account of the 'shell' of the slithering spider which, like the ladies at the 'Sphinx', elicits both hope and fear. It is also found on both the painted plaster version of the *Head on a Rod* and on the bodies of the *Four Figures on a High Base*. If we look carefully, then, their initial, sublime appearance is revealed as an injured, nauseating corporeality. In making this connection between terrifying, all-engulfing sexuality and formal innovation, Giacometti was, however, able to draw on a celebrated model—Picasso's *Demoiselles d'Avignon* of 1907.

In order to make his 'Compositions with Figures', Giacometti had abandoned his Surrealist compositions. Between 1947 and 1950, after some ten years of 'basic research', as Reinhold Hohl describes it elsewhere in this volume,[20] Giacometti made about ten such compositions, various versions of which are preserved. *The City Square* (*La Place*; illustration, p. 47) of 1947–48 is one of the first of these. It shows four men and one woman. The archetypal figure of the striding man, always engaged in a quest, and of the standing woman who is always already there, were to remain, with a few exceptions, key features of Giacometti's work. Developed in this form during the war, and present as a full-scale work in his *Woman on a Chariot* (*La Femme au chariot*; plate 41), produced in Stampa in 1942, this archetype was already hinted at in his first monumental figure, the *Spoon Woman* (*Femme-cuiller*; plate 8) of 1926. Taking its formal inspiration from Afri-

can grain scoop sculptures, this is similarly presented both hieratically and frontally, although in a timeless, distant manner, without any trace of animation. In *The City Square,* the female figure is placed towards the back of the base, approximately at its mid-point, while the men walk past her, following in her tracks without encountering her. It looks like a chance situation, such as one might observe any day. But we can go on to compare the sculpture *The City Square* with the work of 1931-32 called *Model for a City Square (Projet pour une place*; plate 22). This board sculpture was a draft for a sculpture in public gardens that were ultimately not created. Among other interpretations, the work has been seen as a depiction of Paradise, as the Garden of Eden including the Tree of Knowledge and the serpent.[21] In this context, Giacometti's second city square could be seen as the continuation of the same subject, as a description of the division between man and woman. Freed from any symbolism, this process is presented as an ordinary event; the male figures, as Giacometti was to express it in 1961, are 'a little like ants, each one looks as if he is going about his own business, quite alone, in a direction of which the others know nothing. They encounter each other, or they walk past without seeing each other, without looking at each other, don't they? Or they move around a woman. A woman who stands still, and four men who walk around more or less in relation to her.'[22]

While the figures in *The City Square* were approximately equal in size, their scale varied in Giacometti's next sculptures—*The City Square (Composition with Three Figures and a Head) (Place [Composition avec trois figures et une tête]*; plate 58), *The Forest (La forêt*; plate 57) and *The Glade (La Clairière*; plate 59). As a result, despite sharing the same base, each figure has its individual appearance; the figures are thus perceived by the spectator to be standing at varying distances. Their arrangement in relation to each other, that is to say their composition, is, in fact, a matter of chance. Giacometti simply brought them together on several panels exactly as he found them standing in his studio. In his second letter to Pierre Matisse, he described the procedure he had followed: 'A few days later'—after the completion of the Square—'when I looked at the other figures that had been placed haphazardly on the floor when I had cleared the table, I noticed that they formed two groups, and that these seemed to correspond to what I was searching for. I mounted the two groups on base plates without making the least alteration in either, and although I did do some further work on the figures, I altered neither their location nor their scale.'[23] Giacometti then felt reminded by both groups of his native Bregaglia region, of the tall trunks of the trees, without branches, that seemed to him like people talking to each other.[24] As Max Frisch observed, what is acci-

dental [*das Zufällige*] is simply what falls to someone's lot [*einem zufällt*]. From the chaos of Giacometti's studio, there had emerged an arrangement perceived spontaneously at a single glance.

The 'Women for Venice' ('Femmes de Venise'; plates 108-114) made by Giacometti on the occasion of his exhibition in the French Pavilion at the 1956 *Biennale,* was also presented as a flexible grouping. The figures' installation was not permanently fixed by the artist, but could be altered according to the place and the context; and each figure could also be regarded as an individual element. This characteristic is connected with their distinct statuesqueness. The flattened body forms in *The Forest* really resembled tree-trunks; they looked like pieces of bark darkened by rain, banishing the women to a sphere of natural, unreflective existence. The 'Women for Venice', however, retain all their eroticism behind their cracked and bony surfaces. With their large, emphatically distinct breasts swelling above their slender waists and rounded hips, they entice the spectator, only to draw back into the severity of their upright pose. This, like their gaze directed into the distance, is an expression of their unattainability. 'It's perhaps that, in spite of everything,' Genet said to Giacometti, 'the woman naturally appears to you further away … or perhaps you want to make her recede.' 'Yes, perhaps that's it,' answered Giacometti.[25] This notion of distance would also have been the theme of the female figure, eight metres in height, that Giacometti planned for the Chase Manhattan Plaza in New York after viewing the site in November 1965. This project remained unrealized through Giacometti's death in January 1966.

The Hallucinatory Gaze

The special quality of Giacometti's late works has been described often enough: their hallucinatory gaze. Giacometti often stressed that a work of art must have a gaze, particularly in the interview with Georges Charbonnier mentioned above:

A living person is distinguished from a dead one only by the gaze. So I asked myself—and I've often thought about this since then—if it would not basically be better to produce a skull. One wants to sculpt a living head, but the only living element is undoubtedly the gaze. This leads me to the sculptures of the New Hebrides and to Egyptian sculptures. The sculpture of the New Hebrides seems authentic to us, and even more than authentic, because it has a gaze. It is not a matter of imitating an eye, it is really a question of the gaze. All the rest is there only as a bearer of the gaze.[26]

It is striking that Giacometti's late sculptures—the

busts of Annette (plates 143-145), and of Diego (plates 151-153) and the figures of Eli Lotar (plates 155-157)—are presented as torsos. Here, however, the torso is not to be understood as the 'Classical topos of mourning and completion, of destruction in the light of perfection';[27] it is, rather, to be viewed simply as the bearer of the gaze. For, according to Giacometti, 'if the gaze, that is to say the life, is the most important aspect of a figure, there is no doubt that it's the head that really counts. The other parts of the body are reduced to playing the role of antennae making the life of the individual possible—the life that is found in the skull.'[28]

It was above all in painting, however, in the portraits of Diego, Annette and Yanaihara, and later of Caroline, that Giacometti elaborated his conception of the gaze. Giacometti's models, mute and immobile, had to endure sittings lasting for hours because Giacometti always wished to reproduce the 'totality of life',[29] the sum total of all of life's moments. His endlessly repeated brushstrokes seek to capture the liveliness of one of those moments; they are concentrated on the sides of the nose and the area of the eyes; they circle around the cheeks, the forehead and the hair; they draw lines down to the chin and then grow stronger once again around the eyes. The gaze emerges from the concentric tangle of lines, and embraces the spectator. It fills out the whole head so that it seems to float in front of the canvas.

Giacometti's late sculptures, too, are marked by this prominence of the head. The ferocity of the gaze in the case of the *Bust of a Man (Diego) New York I* (plate 152) is already heralded in the dramatically turbulent and, as it were, seething surface of this upper body that has been reduced to the shape of a cross. As a support, Giacometti uses the head perched on a slender neck, its vehement, protruding eyes, short, distinctive nose and slit-like mouth seeking to wrest a human life from out of this chaos of material.

In Giacometti's last work, *Eli Lotar III* (plate 157), which he left unfinished in his Paris studio, we can discern a further instance of this process of clarification. The neck and head, more delicately treated than the rest of the figure, seem to be shown casting off the kneeling torso as its surface assumes the form of a frozen waterfall; and the gaze, pleading for deliverance, emerges from the gentle tension of the egg-shaped head. In the small *Figure from London* of 1965, however, everything once again seems to merge into the material; and 'in December 1965, Giacometti said he would never attain the goal that he had set himself; for thirty years he had gone on thinking that he would get there the next day.'[30]

1 Alberto Giacometti, 'Notes sur les copies', rptd. in Alberto Giacometti: *Ecrits* (Paris, 1990), p. 97.

2 Jean-Paul Sartre, 'La recherche de l'absolu', in *Les Temps modernes,* January 1948, p. 1156; adapted from the English translation, 'The Search for the Absolute', published in the exhibition catalogue, *Exhibition of Sculptures, Paintings, Drawings,* New York, Pierre Matisse Gallery, 1948, p. 6.

3 Alberto Giacometti, 'Ma longue marche' (interview with Pierre Schneider), in *L'Express* no. 521 (8 June 191), rptd. in Alberto Giacometti: *Ecrits* (see note 1), p. 159.

4 Alberto Giacometti, 'Lettre à Pierre Matisse' in Alberto Giacometti: *Ecrits* (see note 1), p. 38; adapted from the English translation, 'Letter to Pierre Matisse', published in *Exhibition of Sculptures* (see note 2), p. 30.

5 Alberto Giacometti, 'Lettre à Pierre Matisse' (see note 4), p. 44; English translation, p. 42.

6 Alberto Giacometti, 'Lettre à Pierre Matisse' (see note 4), p. 44; English translation, p. 44.

7 Cited from Yves Bonnefoy, *Alberto Giacometti: Biographie d'une œuvre,* Paris, 1991, p. 272.

8 Gottfried Boehm, 'Das Problem der Form bei Alberto Giacometti', in Louis Aragon et al.: *Wege zu Giacometti,* Munich, 1987, pp. 50ff.

9 See Reinhold Hohl, *Alberto Giacometti: Sculpture, Painting, Drawing,* London, 1972, p. 275.

10 Jean-Paul Sartre, 'La recherche de l'absolu', (see note 2), p. 1159; English translation, p. 11, corrected and adapted.

11 Jean-Paul Sartre, 'La recherche de l'absolu' (see note 2), p. 1162; English translation, pp. 19-20, corrected and adapted.

12 Alberto Giacometti, 'Le rêve, le "Sphinx" et la mort de T.', in *Labyrinthes* nos. 22-23 (15 December 1946), rptd. in Alberto Giacometti, *Ecrits* (see note 1), p. 31.

13 Jean Genet, *L'Atelier d'Alberto Giacometti* (Saint-Just-la-Pendue, 1986), unpaginated [p. 47].

14 Gottfried Boehm, 'Das Problem der Form bei Alberto Giacometti', in *Wege zu Giacometti* (see note 8), p. 43.

15 Alberto Giacometti, 'Le rêve' (see note 12), p. 30.

16 Georges Charbonnier, 'Le Monologue du peintre', rptd. in Alberto Giacometti, *Ecrits* (see note 1), p. 246.

17 Cf. Alberto Giacometti, *Ecrits* (see note 1), p. 56.

18 Cited from Reinhold Hohl, *Alberto Giacometti* (see note 9), p. 232.

19 Beat Wyss, 'Porträtskizze: Alberto Giacometti als Sujet', in *Wege zu Giacometti* (see note 8), p. 105.

20 See p. 45 above.

21 Cf. Karin von Maur's essay, 'Giacometti and the Parisian Avant-Garde, 1925-1935', p. 60 above.

22 Alberto Giacometti, 'Ma longue marche' (see note 3), p. 266.

23 Alberto Giacometti, *Ecrits* (see note 1), pp. 58-59.

24 Ibid., p. 59.

25 Jean Genet *L'Atelier d'Alberto Giacometti* (see note 13), unpaginated [p. 31].

26 Georges Charbonnier, 'Le monologue du peintre' (see note 16), pp. 19-20.

27 Gottfried Boehm, 'Das Problem der Form bei Alberto Giacometti', in *Wege zu Giacometti* (see note 8), p. 39.

28 Georges Charbonnier, 'Le monologue du peintre' (see note 16), p. 247.

29 Cited from Reinhold Hohl, *Alberto Giacometti* (see note 9), p. 278.

30 Peter Schifferli (ed.), 'Alberto Giacometti: Was ich suche', in Georges Charbonnier (ed.), *Le Monologue du peintre,* Zurich, 1973, p. 47.

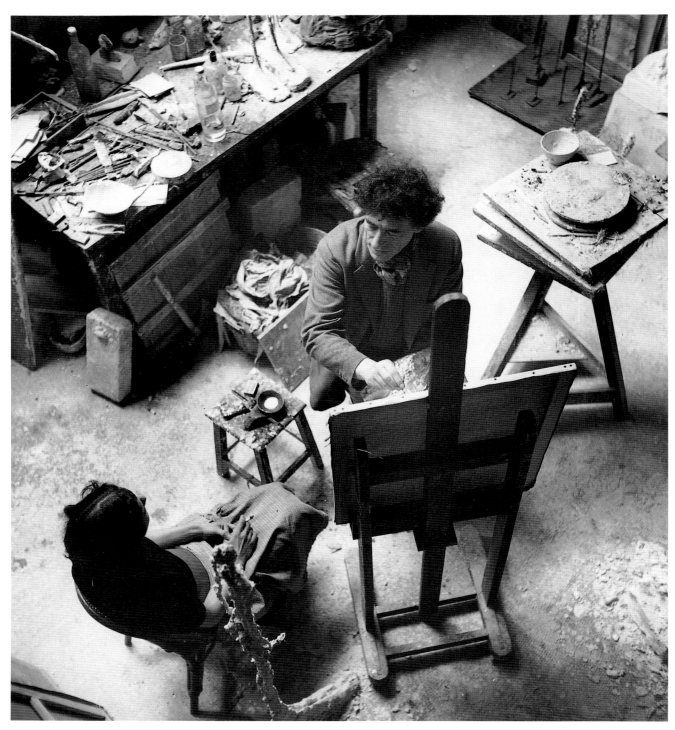

Ernst Scheidegger, Giacometti painting Annette

The Paintings

LUCIUS GRISEBACH

Two opposing schools of thought exist today on the subject of artistic genres and their interrelation: the art historical tradition of dividing artists' work strictly according to genres and of granting these the status of natural categories, and the modernist endeavour, reformulated again and again, to overcome these genres, to free the creative powers of art by allowing them to come into operation without regard to the boundaries of the categories.

Alberto Giacometti, though a modernist, assumed a remarkably unmodern attitude towards this problem. From the start, he saw himself as a representative of one of the classical genres—as a sculptor— and he always adhered to that view. He worked in the three genres of drawing, painting and sculpture, but he never attempted to merge them with one another or even to go beyond the bounds of each. Even when he painted his sculptures, he remained within sculptural tradition, for polychromed sculptures have been a feature of the genre since Antiquity; and not even in his Surrealist period did he employ some of the means most favoured at that time, such as *assemblage* or *collage.* He adhered entirely to traditional categories and techniques, modelling his sculptures from plaster or clay, painting his pictures with a brush in oils on canvas and executing his drawings with a pencil. Evidently, he did not see his task as that of redefining these media. The task set by the subject itself was for him so overpowering and so absorbing, even within the parameters of the traditional genres, that the question of surmounting these never arose.

Giacometti was the son of a painter and thus, from birth, at home in a studio. The significance of this is illustrated succinctly by a photograph taken in 1964 by Henri Cartier-Bresson (illustration, p. 40). It shows Giacometti in his family's summer house in Maloja, where the studio of his father, Giovanni, had been preserved, unchanged, along with many of Giovanni's pictures. The photograph shows the son, now in his sixties, displaying some of his own paintings—both early and late—alongside those of his father. It allows us to discern what a determining influence the domestic milieu and the presence of the father must have had, and to understand that, for Alberto Giacometti, painting was an innate, or inherited, language.[1]

It is entirely in keeping with this situation that Giacometti never drew or painted in the manner of a child. His surviving childhood works are adult in intent and, indeed, in appearance. From the start, Giacometti was at a high artistic level—not in the sense of being a consummate infant prodigy, but in the sense that, as the child of his father, he was able to start from a point of considerable artistic professionalism and up-to-dateness. He did not need to work his way through the vast obstacle of academic training towards the position of modernism, but was already there as the son of a painter who was himself allied to this movement. A number of paintings from Giacometti's youth have repeatedly been exhibited (illustrations, p. 78). The artist produced his first paintings during his childhood in the parental home and when attending the *Gymnasium* at Schiers. He painted more regularly from 1919, while studying in Geneva, and he stopped when his attention turned definitively to sculpture in Paris in the mid-1920s. There is much evidence to suggest that, subsequently, Giacometti painted above all when he was staying in one or other of his parents' house—in Stampa or in Maloja.

Giacometti's father, and the artistic environment of his parents' house, did not only supply the artist with a fertile soil in which to develop; the father also offered his son a stylistic starting point. Giovanni Giacometti had initially been strongly influenced by Giovanni Segantini, to whom he had been closely linked as a friend-cum-pupil. From 1900, though, responding to the challenge of the work of the Divisionist painters of Italian Post-Impressionism, of Van Gogh and, finally, of Matisse and the *Fauves* in France, he had evolved a manner of painting with patches of fresh, luminous colour. When Alberto Giacometti started painting, he took his father's more recent work as his model. He employed the same Divisionist style, the images built up from spots of pure colour.[2] However closely related stylistically, the work of father and son none the less betrays a fundamental difference of focus. While the father aimed principally at unifying and enlivening the picture surface, the son's attention appears to have been directed, from the start, towards the object and its solidity.

The series of Giacometti's early paintings came to an end in 1924. During the years that followed, sculpture supplanted painting almost entirely. The few exceptions include: a portrait of his father, done in two versions

around 1930[3] (illustration, p.79); a further such work from 1932;[4] a female portrait on 1934;[5] three paintings—two still lifes, each of an apple on a sideboard (plate 36), and a portrait of his mother (plate 37)—created in the summer of 1937 in the homely atmosphere of Stampa or Maloja; and lastly, a female portrait from 1944.[6] Not until 1946 did Giacometti again start to produce a steady stream of pictures; painting and sculpture then both continued to preoccupy him until the end of his career.

Looked at on their own, and in ignorance of the time that elapsed between their execution, Giacometti's early paintings would evince a marked stylistic continuity. Removed from the context of his œuvre as a whole, and linked with each other across large intervals, they would convey the impression of a steady, homogeneous stylistic development; and there would be no hint of the Surrealism that was so marked a feature of Giacometti's sculptures betwen 1925 and 1934. This impression, however, blatantly contradicts the image offered by Giacometti as a sculptor. Every consideration of his artistic development has, after all, been dominated by the sudden change of direction sparked off by the crisis connected with his radical rejection of Surrealism in the mid-1930s.

We can note a new and striking devotion to painting at the very time when Giacometti was going through the deepest crisis of his artistic career; from now on, his work as a painter is wholly removed from the rather innocuous context of the father-son relationship. In 1937, three years after parting company with the Surrealists and resuming sculptural work from the model, he painted the three pictures mentioned above (plates 36, 37). Stylistically, they are distinct from all Giacometti's previous pictures and are now regarded as the first examples of his mature work as a painter, even though that did not get fully underway until 1946. Compared to these works, Giacometti's earlier painting pales into relative insignificance.

The crisis of 1934, which persisted into the 1940s, is the central issue in all attempts at interpreting Giacometti's work. Giacometti himself repeatedly spoke of it, and there can be no doubt about how fundamental were the matters that so troubled the artist, even if the reaction of commentators has varied according to their different points of view. In a nutshell, this crisis had to do with the confrontation of art, or style, with reality. The turn away from 'art' signified a turn towards directly absorbed life and immediate experience.[7] Yet the individual and concrete experience is so complex that it leaves one bewildered. Even partial aspects of it are so multifarious as to elude a definitive record; the task of conveying its nature and significance thus presents difficulties that are often insurmountable. General theories and rules may be learned and passed on, but the concrete particular cannot be grasped with the intellect. It is against this background that one has to understand the keynote of enduring failure that sounds throughout Giacometti's own remarks on the problems possed by his work.

That painting again became of immediate interest to Giacometti—and without any external stylistic stimulus, but as a logical consequence of his development—at precisely that moment when he turned to addressing the direct experience of reality without the mediation of the forms of art, suggests that the special opportunity painting offered him had to do with this very process of rendering reality. In relation to his principally sculpture-orientated endeavours, painting was assigned a 'pioneering' role, being sent ahead to reconnoitre the terrain.

In Giacometti's famous letter of 1947 to Pierre Matisse, in which he traced the decisive stages of his development, the artist wrote of his crisis:

Nothing was as I had thought. A head (I soon discarded whole figures, they were simply too much) became for me an entirely unknown thing, without any secure dimen-

Alberto Giacometti,
Self-Portrait, 1921

Alberto Giacometti,
The Artist's Father,
c. 1930

sions. Twice a year, I started work on two heads, always the same ones, without ever reaching my goal; then I put the work away … In the end, so as to achieve at least some concrete result after all this, I started to work from memory again, above all in order to see how much of what I had done remained with me. (In all those years I also drew, and painted a few things, and almost always from life).[8]

There are other remarks to the same effect. It is clear that, for Giacometti, the central problem of these years lay in sculptural work; but from the sentence in brackets we also learn that drawing and painting were granted an auxiliary role within the process of approaching reality. While Giacometti worked at his sculpture from memory, he drew and painted from life. This would continue to be the case.

In the three pictures from 1937 there is already a clear indication of most of the features that were to characterize Giacometti's later painting. First and foremost, the subject matter: the portrait, or to put it more neutrally, the individual man or woman, and the still life, in each case in the spatial context of an interior. Next, the austere, monochrome colouring, from which the characteristic grey would later emerge. And, finally, the specific approach to rendering space on a two-dimensional surface and—as one of the most essential stylistic characteristics of Giacometti's work—the extensive use of line.

Giacometti's manner of painting constituted a continuation and an extension of drawing. This is probably the key to understanding his pictures. As already noted in connection with the earliest paintings, in contrast to the painterly approach of his father, Giacometti never followed the path of generalization; rather, he adhered closely to the object confronting him and, in doing so, proceeded primarily like a draughtsman. In the paintings of 1937 this draughtsman's approach plays a more deter

mining role than before: they are drawings executed in oils on canvas. Both the definition of the subject and the tension in the disposition of details across the picture plane are achieved in the manner of a drawing, through the creation of a web of lines.

Let us look at the still life *Apple on a Sideboard* (*Pomme sur le buffet*; plate 36) in these terms. The sideboard, on which the single small apple lies, stands in front of a wood-panelled wall. The sections of the panelling, the sideboard, its drawers and doors, its top—all are drawn as if with a pencil in continually repeated, increasingly bold strokes. This creates a strong surface arrangement in which nothing is left indistinct. Yet the whole composition is slightly tilted in relation to the rectangular format; if that were not the case, one might almost take the painting for a *De Stijl* composition in disguise. In addition, there are combinations of strokes and lines that have nothing to do with the delineation of the objects. They anchor spatial relationships in the picture plane. Vertical strokes run through the knobs on the sideboard drawers, through the top of the sideboard at a point corresponding to the space between the drawers and, in each case, behind these features, through the panelling of the wall. More importantly, the edge of the picture is reiterated by lines on all four sides, forming a frame within the picture. This was to become a hallmark of Giacometti's paintings and drawings. Such an inner frame recurs in the portrait of 1937 (plate 37). In does not take the place of the real picture frame, since it allows us still to glimpse the fringes of the subject beyond its edges; but it serves to demarcate a frame of reference apart from that provided by the real picture frame. Within this frame of reference, all spatial relationships are marked on the picture plane and so rendered visible.

Once again, viewed only in the context of Giacometti's œuvre as a painter, the three pictures from 1937 supply a solution to a pictorial problem. If Giacometti had ever

79

Alberto Giacometti, *Self-Portrait*, 1921

seen himself only as a painter, he would now have had before him a path that he could have followed with confidence. It is even conceivable that he might have given up sculpture in favour of painting for, while in the latter he had arrived at solutions, he continued for years to reject the fruits of his work as a sculptor. It was in sculpture, however, that Giacometti found the crucial problem to reside; and that explains why, during the next nine years, until 1946, he painted virtually nothing at all. The sculptures at which he worked during the war years in Geneva became smaller and smaller as he handled them, shrinking as he strove for a true rendering of appearance. The size of each of Giacometti's sculpted figures is dependent on the spatial context in which it appears, but it must itself create that context. It must itself generate the space that it occupies and in which it can be grasped as an object of a particular size. Without the sculpted figure, this space does not exist. On the other hand, drawings and paintings, by their very nature, already possess a frame, which needs to be filled with a system of spatial relationships. Since the frame—that is, the format of the sheet of paper or of the canvas—does not alter in the course of the artist's work, his subject has only to evolve within this format. Its size, and its appearance, can be defined by being spatially connected to all four sides of the support. The particular significance of the edge of the support as a container for the system of spatial relationships is revealed, in Giacometti's work, by the drawn or painted frame. Employed, to some degree, as an exten-

sion of drawing, painting serves as a suitable training ground for the artist's attempts at overcoming problems associated with the treatment of space.

Giacometti's work as a painter after 1946 may be divided into two phases, the years up to 1956 and the period from 1957 until his death in 1966. The subject matter of the pictures always remained the same. It centred on the frontal image of an individual, for the most part that of his wife, Annette (see plates 79, 150), or of his brother Diego, though Giacometti also painted his mother, some of his friends and, in the 1960s, his lover, Caroline. Intermittently, he painted the occasional studio interior, individual figure, still life or landscape. The artistic means employed—the graphic painting style and the colouring, henceforth grey—also remained consistent, changing only in degree. There were, however, important differences. In the first phase, the central figure (or the central object) is encountered in a vast surrounding space; and this came to be rendered in so much detail that it was possible to reconstruct the interiors in which Giacometti used to paint—above all his studio in Paris—and identify all the objects to be found there. The pictures of the second phase, however, focused on the figure alone, with the distinguishing characteristics of the surrounding space only hinted at.

The figure forms the central axis of these paintings. The sitter is positioned as if ready to be painted, and assumes an attentive, upright pose. Around the figure there unfolds the space of the interior, as a rule that of the Paris studio with its walls and windows, its furniture and sculptures. The figure is elongated, although never in so extreme a fashion as in the sculptures of the same period. It materializes along an axis which is not only that of the body, but also the central axis of the picture. The body's proportions are frequently foreshortened towards its upper part: the legs appear inordinately long, the upper body becomes gradually narrower and the head appears small. All the pictures have a painted frame within the picture plane, and all the objects surrounding the figure (next to, and behind it) are connected with this frame, either through its cutting across them or by their being placed parallel to it. The painted frame, and the connection of every detail to it, creates a tense scaffolding across the picture plane, directing the viewer's eye towards its edges. The central placing and axial alignment of the principal figure engender, for their part, a sense of movement towards the centre. The degree of give and take, the sense of movement to and fro, outwards then inwards, is such that the viewer's gaze follows it unremittingly. In doing so, the beholder retraces the action of the painter, whose brush had moved repeatedly to and fro between the component parts of his image, covering the surface with a dense network of marks.

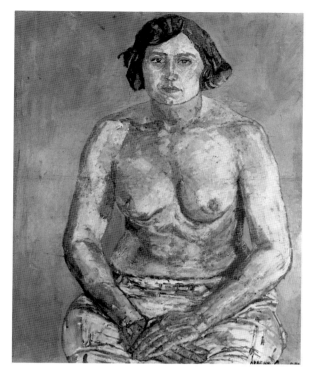

Alberto Giacometti, *Seated Nude*, 1923

Giacometti built up his pictures layer by layer. A variety of tones is to be found worked into the web of black, white and grey strokes and lines. The graphically applied paint evolves at length into a thick skin of colour.[9]

A fundamental principle of these pictures is that everything should appear only within a fixed system of spatial relationships. The subject can be perceived only in this way, and it can be presented only in this way. We know from a variety of accounts how precisely Giacometti calculated and then fixed the position of the model and the easel at the start of his work on a painting.[10] He marked these positions on the floor, in order to be able to retain, at every sitting, the same spatial relationship between himself and the model. Perception was determined by spatial relationships and would have been altered by any modification of them. Accordingly, work on the picture started with the fixing of the spatial reference points. The first layer of the picture as always a drawing. This established the compositional scaffolding of the image within the frame that outlined the surface and anchored the figure, or the central object, within that scaffolding.

The relationship between figure and space in Giacometti's paintings is determined wholly by the problem of perception and its representation. Thus, the connection between the figure and its surroundings is insignificant in terms of traditional portrait iconography: they have little to do with each other on any other level. Individuals sat for Giacometti because they were known to

him, and they sat where he was used to working—in his studio—and never in their own environment. Even the resemblance to any given sitter is slight; the face is insufficiently detailed to permit identification. Nevertheless, each of the figures is an unmistakable individual, but it is not really important who he or she is. What made Giacometti's sitters worthy of being portrayed was neither their notability nor their beauty, but rather their connection with the artist and his interest in them. Even when the person concerned can be identified as one of Giacometti's famous friends, this makes no difference. Jean Genet and Jean-Paul Sartre are certainly far more famous than Annette and Diego Giacometti, but in these pictures all men are equal. The sitters each possess the highest degree of individuality and the highest particularity, but only in the existential sense, as individuals, not as writers, philosophers or other such celebrities.[11] From being a portrait of an individual person each picture became an image of humankind in general. No process of standardization or generalization could have attained such universal validity as did this confrontation with the particular individual.

Analysing Giacometti's pictures in terms of their means of presentation and composition, one finds that one has accounted for all of them in describing just one. In a sense, Giacometti painted the same picture over and over again. No new motifs appear, both figures and accessories always remaining the same. However, each image is new in that it comprehends and conveys an individual situation that is itself new and unique every time. The real concern of these pictures, the personality, the unmistakable identity of the sitters regardless of insignificant external details—that always offers something unique, and so the artist's task was a fresh one in each case, despite external conditions that remained constant. The decisive aspect was not the individual and the objects as sources of new visual information, but Giacometti's confrontation with them as a whole. This ensured that there was always something to be discovered in the same things in the same space.

Apart from a gradual loosening of the brushwork, there was no stylistic alteration in Giacometti's painting until 1956. His work retained its emphatic relationship between figure and space and its draughtsman-like approach. A change set in towards 1957. Suggesting an analogy with the fundamental crisis of 1935, Reinhold Hohl speaks of the advent of a new artistic crisis when Giacometti began painting the portrait of his Japanese friend Isaku Yanaihara.[12] Jean Genet reports:

During all the time he was struggling with the portrait of Yanaihara [presumably, the face presented itself, and then refused to allow its resemblance to be transferred to

the canvas, as if protecting its identity], I followed the troubled actions of a man who never deceives himself and yet always loses his way. He penetrated further and further into the realm of the impossible, from which there was no escape. Sartre told me: 'When I met him at the time of the Japanese fellow, he really wasn't getting anywhere.' I replied: 'He always says that. He's never satisfied.' Sartre: 'But he was really in despair then.'[13]

As a consequence of this second crisis, in the late 1950s Giacometti's attention began to shift from the surrounding space to the figure itself, and a more painterly approach came to outweigh that of a draughtsman. The figure became larger and more dominant, while there were only hints at the nature of the space surrounding it. Increasingly, the aura of the sitter's personality seemed to occupy that space. In principle, the pictures were still developed out of a system of spatial relationships, but this was no longer so thoroughly registered on the surface. Instead, everything was focused on the figure and, in particular, its head. While the pictures of 1946 to 1956 had been formed from a web of lines and strokes spread out evenly over the picture plane, later ones were less densely worked towards the edges. The figure placed along the central axis of the picture was drawn and painted clearly, but the greatest concentration of painting and drawing was attained in the head. All the energy in the picture gathered there. The facial features were re-modelled again and again with the brush, as if they were actually those of a sculpture that had to be kneaded into shape. In these pictures the heads are black and firm, their forms established by lines 'engraved', over and over, with the brush. Within the looser and, by comparison, often almost colourful painting of the surrounding area, they stand out like images inscribed on black slate. It is above all in the heads that the artist seems to have sought the essence of each sitter. Under the merciless hand of the painter, these heads turn into gaunt skulls, approaching ever closer to a basic type, with a slender overall form, a large mouth and eyes opened wide. The more penetrating Giacometti's gaze, the more the outwardly different individuals resembled a single archetype.

Even if Giacometti had produced no sculpture, he would have been assured a place in art history as one of the most important painters of the twentieth century. Yet he was a sculptor and, however natural painting was to him, and however splendid the results, it accounted for only one part of his work. Not only were there phases in his development in which painting was virtually insignificant, but the relationship between painting and sculpture was of varying closeness. With drawing, the situation was different again, but it is probably safe to say that, for Giacometti, painting always remained something of an extension of drawing.

As noted above, when seen in relation to Giacometti's development as a sculptor, painting, alongside drawing, was evidently the medium that the artist preferred to use when wrestling with problems resulting from his direct confrontation of concrete reality. When this became the determining factor in his work as a whole, painting emerged as the equal of sculpture. In the period between 1946 and 1956 this equal status also entailed a measure of independence of the two media from each other: painting had its own subject matter and pursued other paths than those followed by sculpture, ones that brought it closer to the visible world. Important basic themes of Giacometti's sculpture, such as the group of figures in a square, had no direct equivalent in his painting. His sculpture was developing along more fundamental lines, being less directly tied to the individually experienced situation than were his pictures. After 1957, however, and above all towards the end of his life, the paths followed by sculpture and paintings met. Painting then perhaps even took the lead.

Giacometti's painting cannot be associated with a particular school. It stands alone among the various stylistic positions found in modernism. Commentators have resorted to the formula of the 'portrayal of humanity', aligning Giacometti's work with that of other 'loners' in the realm of figurative painting—for example, Francis Bacon. Yet this did not constitute a school. Any painter who had tried to derive a learnable style from Giacometti's artistic 'handwriting' would have remained stuck in the fashionable superficiality of a Bernard Buffet. The style of Giacometti's painting is thus inseparable from his person and cannot be subsumed in general categories. What makes each individual picture a masterpiece is that which emerges from the act of painting itself, that reality, that unique and concrete life which we have discussed above. This is not to be found in the 'style' of these works, nor is it to be grasped in terms of stylistic concepts. It is to be characterized indirectly in the process of striving and wrestling, from which these pictures evolved and which is immediately apparent in them:

Yes, I make pictures and sculptures, and I have always done so, from the time I first started drawing or painting, in order to denounce reality, in order to defend myself, in order to become stronger in those things with which I can the better protect myself and the better carry out my assaults; in order to have something to hold on to, in order to advance as far as possible in every field and in every direction, in order to fend off hunger, cold and death; in order to be as free as possible, free to strive, with the means that today appear to me as the most suited to this

task, to see and to understand my environment better, to understand it better so that I have the utmost measure of freedom; in order to squander my powers, in order to expend all my energy as far as I can into that which I create, in order to have adventures, in order to discover new worlds, in order to wage my battle—for pleasure? out of joy?—a battle for the sake of the pleasure in winning and losing.[14]

1 Curiously, Giovanni Giacometti's first experience of, and essays in, art were in the realm of sculpture (see Elisabeth Esther Köhler, 'Leben und Werk von Giovanni Giacometti 1868-1933', Ph. D. diss., Zurich, 1968, p. 5). The talent for sculpture would thus appear to have been present in the family at this stage, but in the case of the father it was supplanted by a gift for painting.

2 'When I was sixteen years old, I painted with the technique of the Divisionists. I held the opinion that Cézanne and the Impressionists had come the closest to nature', remarked Giacometti in the 1950s. Quoted in Reinhold Hohl, *Alberto Giacometti: Sculpture, Painting, Drawing,* London, 1972, p. 231.

3 *The Artist's Father,* 1930 (Kunsthaus, Zurich; inv. no. 1963/42); *The Artist's Father, c.* 1930 (Kunsthaus, Zurich; inv. no. 1963/41). The oil painting *Study,* illustrated by Reinhold Hohl in his introduction to the catalogue of the Giacometti exhibition held at the Solomon R. Guggenheim Museum in New York in 1974 (p. 34) as a work from the mid-1930s, has since been shown, by Hohl himself, to be a fake. Striking similarities, in the composition and the figure, with a photograph taken by Ernst Scheidegger of Giacometti's studio in Maloja (see *Von Photographen gesehen: Alberto Giacometti,* exhibition catalogue, Chur, Bündner Kunstmuseum, and Zurich, Kunsthaus, 1986, p. 40) lead one to suppose that the forger was inspired either by this photograph or by the arrangement of the studio in Maloja that it records. Against the studio wall stands the plaster version of *The Chariot I (Le Chariot I);* behind this, the figure of a female nude, in the same pose and proportions, is painted on the wall.

4 *The Artist's Father* (private collection, Switzerland). See *Alberto Giacometti,* exhibition catalogue, Martigny, Fondation Gianadda, 1986, cat. no. 62, colour plate p. 57.

5 *Portrait of Maria,* 1934 (private collection, Paris). See *Alberto Giacometti: Plastiken, Gemälde, Zeichnungen,* exhibition catalogue, Duisburg, Wilhelm-Lehmbruck-Museum, and Mannheim, Städtische Kunsthalle, 1977-78, cat. no. 60, illustration p. 174.

6 *Portrait of Madame D,* 1944 (private collection, Geneva). See *Alberto Giacometti: Retour à la figuration 1933-1947,* exhibition catalogue, Geneva, Musée Rath, and Paris, Musée national d'art moderne, 1986-87, p. 25, with illustration. An oil sketch for this picture is also illustrated.

7 The frequently used concept 'perception' would seem to be inadequate here, as it could give rise to the misconception that a problem of optical perception only was involved. The 'perception' practised by Giacometti certainly included an element of existential philosophy.

8 Quoted in Ernst Scheidegger (ed.), *Alberto Giacometti: Schriften, Fotos, Zeichnungen,* Zurich, 1958; p. 36.

9 David Sylvester has commented similarly on the relationship between space and mass (that is, the figure) in Giacometti's pictures: 'In the paintings, space is like a cloudy heavy liquid that is seen no less than the mass at the heart of it is seen, and is hardly less tangible. The mass has an energy that is turned inward upon itself, violently compressed around a central core, so that it seems to have a highly concentrated density; the space has an energy that is turned outwards, sometimes as if exploding out of the picture, and at the same time often seems held back, drawn in, by the mass at its centre, as if this were the centre of a whirlwind. Where the one meets the other there is an interpenetration. The boundary between them is not fixed. … There is either no outline or a multiplicity of outlines in the paintings to mark the transition of mass to space.' David Sylvester, 'The Residue of a Vision', in *Alberto Giacometti: Sculpture, Paintings, Drawings 1913-65,* London, Tate Gallery (The Arts Council of Great Britain), 1965, unpaginated.

10 See, for example, James Lord, *Giacometti: A Biography*; cited here in the German paperback edition: *Alberto Giacometti: Ein Porträt,* Frankfurt am Main, Vienna and Berlin, 1984, p. 11.

11 There are certainly more people who have become famous on account of being painted by Giacometti than there are celebrities who appear in his work.

12 Hohl, 1972, pp. 170-4.

13 Quoted ibid., p. 281 (translation from the original German publication revised here).

14 Alberto Giacometti, 'Ma Réalité' (1957), in Scheidegger, 1958, p. 6.

Plates

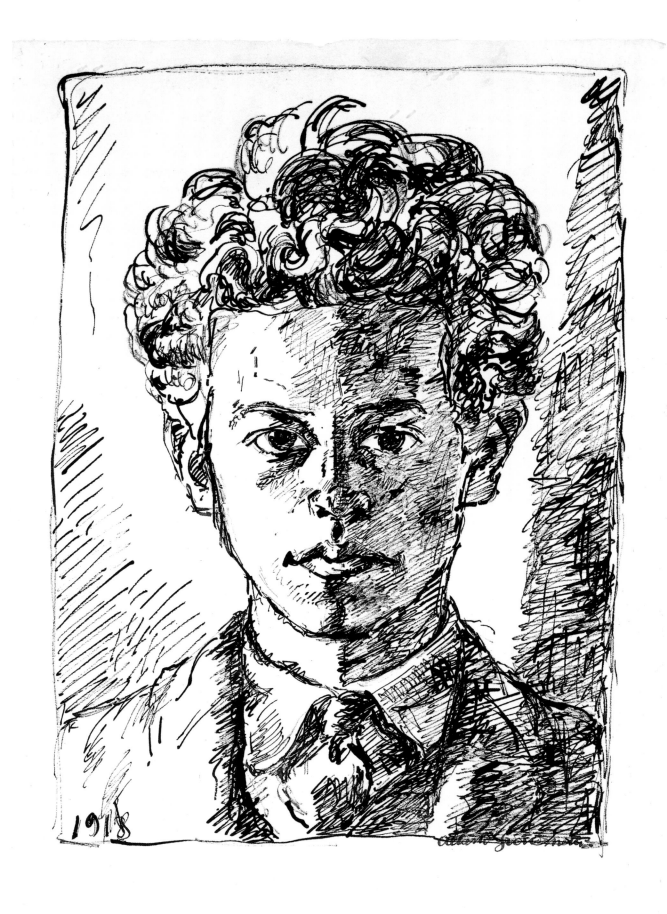

1 SELF-PORTRAIT 1918, AUTOPORTRAIT. Pen and wash, 14⅜ x 10⅛" (36.6 x 25.8 cm)
Inscr. lower right in ink: Alberto Giacometti. Öffentliche Kunstsammlungen (Kupferstichkabinett), Basle

6　SELF-PORTRAIT 1925, AUTOPORTRAIT. Plaster, 16⅛ x 8⅝ x 11″ (41 x 22 x 28 cm)
Signed in pencil on the base: Alberto Giacometti. Private collection

Preceding page:

2　THREE NUDES 1923–24, TROIS FEMMES NUES. Pencil, 17½ x 11″ (44.5 x 28 cm)
Inscr. lower right: Alberto Giacometti 1923–24. Alberto-Giacometti-Stiftung, Zurich

3　STANDING NUDE, TURNED TO THE LEFT 1922–23, FEMME NUE DEBOUT, TOURNÉE VERS LA
GAUCHE. Pencil, 19 x 12⅜″ (48.5 x 31.5 cm)
Inscr. lower right: Alberto Giacometti 1922–23. Alberto-Giacometti-Stiftung, Zurich

4　SEATED WOMAN 1922–23, FEMME ASSISE. Pencil, 15⅛ x 11″ (38.5 x 28 cm)
Inscr. lower right: Alberto Giacometti 1922–23. Alberto-Giacometti-Stiftung, Zurich

5　SEATED NUDE SEEN FROM THE BACK 1922–23, NU ASSIS, DE DOS. Pencil, 19 x 12⅜″ (48.5 x 31.5 cm)
Inscr. lower right: Alberto Giacometti 1922–23. Alberto-Giacometti-Stiftung, Zurich

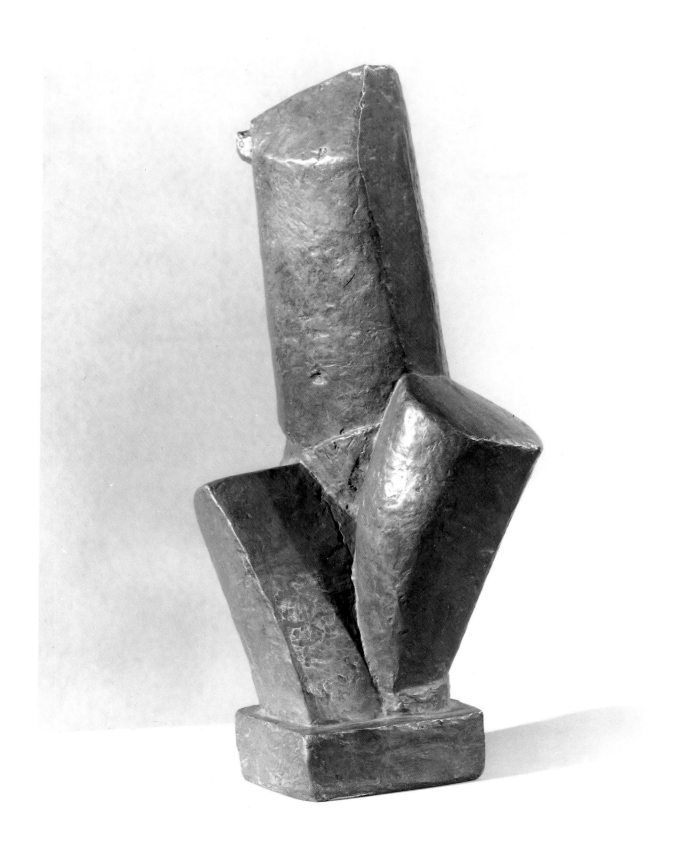

7 TORSO 1925. Bronze, 22¼ x 9⅝ x 9″ (56.5 x 24.5 x 23 cm)
Inscr. on back of base: 5/6 Alberto Giacometti 1925. Alberto-Giacometti-Stiftung, Zurich

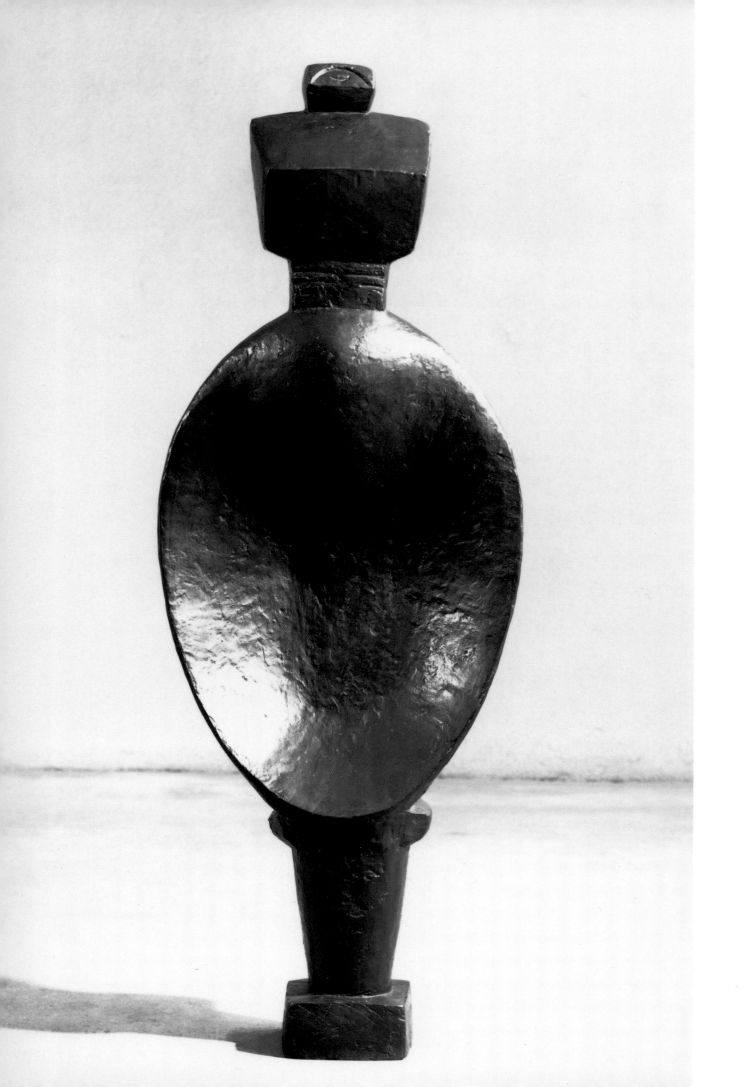

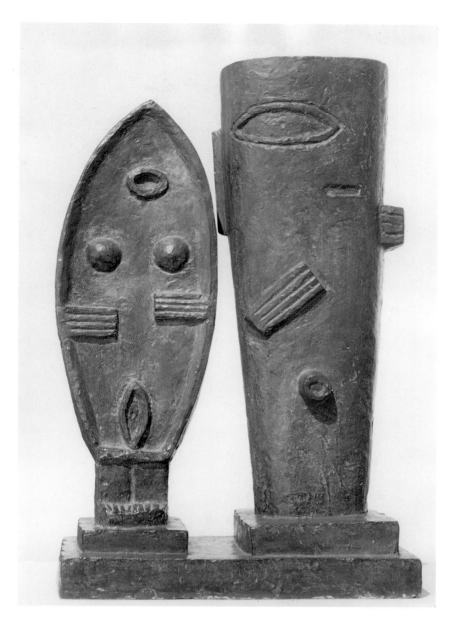

9 THE COUPLE (MAN AND WOMAN) 1926, LE COUPLE (HOMME ET FEMME)
Bronze, 23⅝ x 14½ x 7″ (60 x 37 x 18 cm)
Inscr. at right on back of base: A. Giacometti 1/6; at left on back of base:
Susse Fondeur Paris. Alberto-Giacometti-Stiftung, Zurich

Left:
8 SPOON WOMAN 1926, FEMME-CUILLER. Bronze, 57 x 20½ x 9⅞″ (145 x 52 x 25 cm)
Inscr. at right on base: Alberto Giacometti 1/6; on back of central plate: Alberto Giacometti
1/6; at left on base: Susse Fondeur Paris. Alberto-Giacometti-Stiftung, Zurich

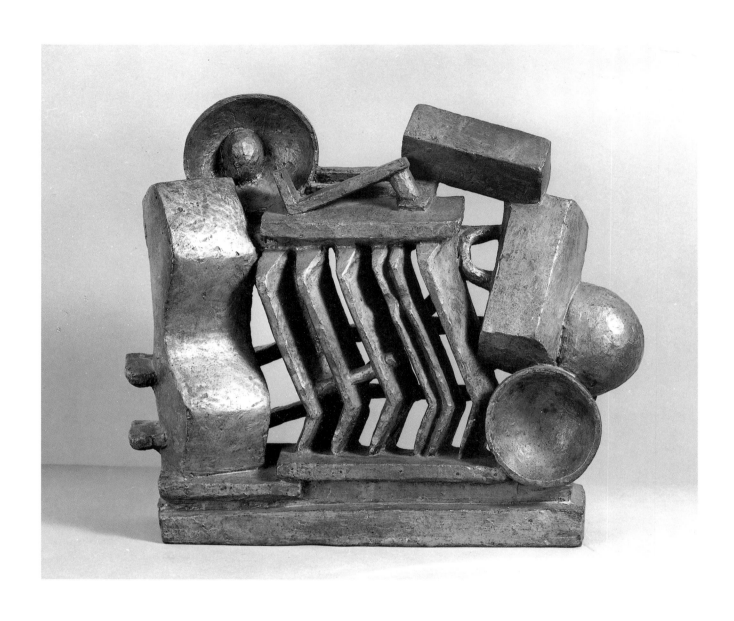

10 THE COUPLE (RECLINING) 1927, LE COUPLE (COUCHÉ). Bronze, 15½ x 17⅞ x 5⅞″ (39.5 x 45.5 x 15 cm)
Inscr. Fonte Pastori E/I. Private collection, Switzerland

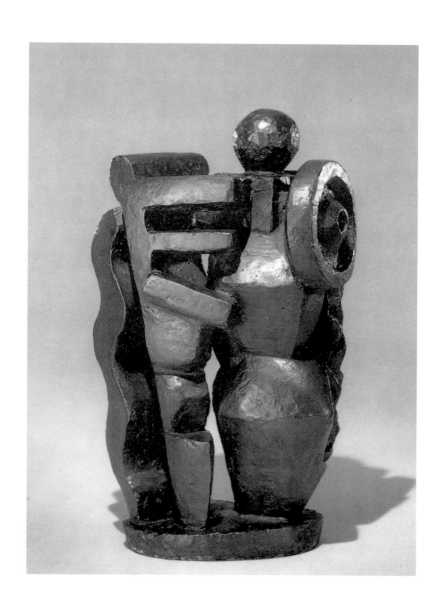

11 MAN AND WOMAN 1926–27, HOMME ET FEMME.
Bronze, 12⅜ x 7⅝ x 5″ (31.5 x 19.3 x 12.9 cm). Inscr. 1/6
The Hirshhorn Museum and Sculpture Garden
Smithsonian Institution, Washington, D.C.
Gift of Joseph H. Hirshhorn, 1966

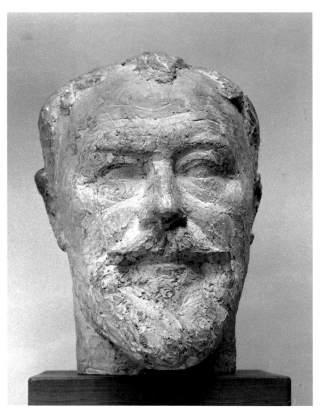

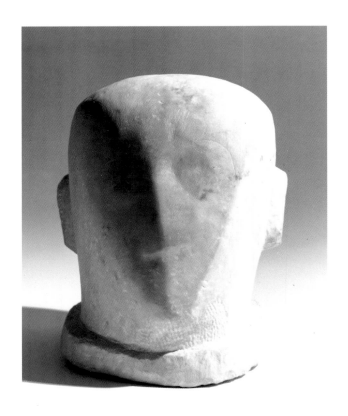

12 THE ARTIST'S FATHER I 1927, LE PÈRE I.
Plaster, 10⅝ x 7⅞ x 9⅞″ (27 x 20 x 25 cm)
Private collection, Switzerland

13 HEAD OF THE ARTIST'S FATHER 1927,
TÊTE DU PÈRE
Marble, 11⅞ x 9 x 8¼″ (30 x 23 x 21 cm)
Private collection, Geneva

14 BRUNO GIACOMETTI 1929–30. Plaster,
12¼ x 7½ x 9½″ (31 x 19 x 24 cm)
Private collection, Switzerland

Right:
15 GAZING HEAD 1927–29, TÊTE QUI REGARDE
Marble, 16⅛ x 14½ x 3⅛″ (41 x 37 x 8 cm)
Inscr. at left on back of base: Alberto Giacometti
Marble version created by Diego Giacometti
Alberto-Giacometti-Stiftung, Zurich

16 WOMAN 1928, FEMME. Marble,
13⅛ x 12¼ x 3½″ (33.5 x 31 x 9 cm)
Inscr. at left on back of base: A. Giacometti
Marble version created by Diego Giacometti
Alberto-Giacometti-Stiftung, Zurich

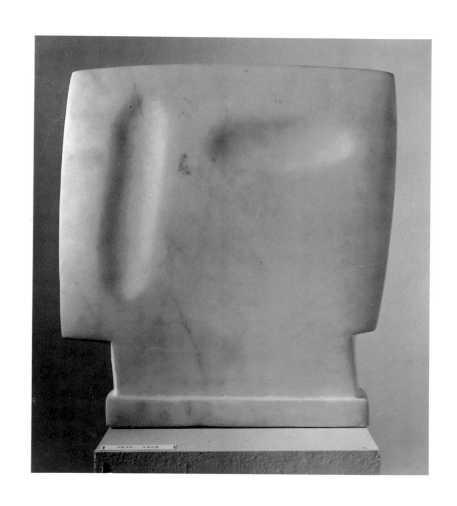

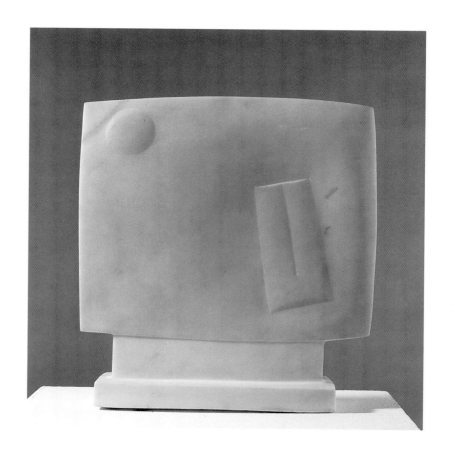

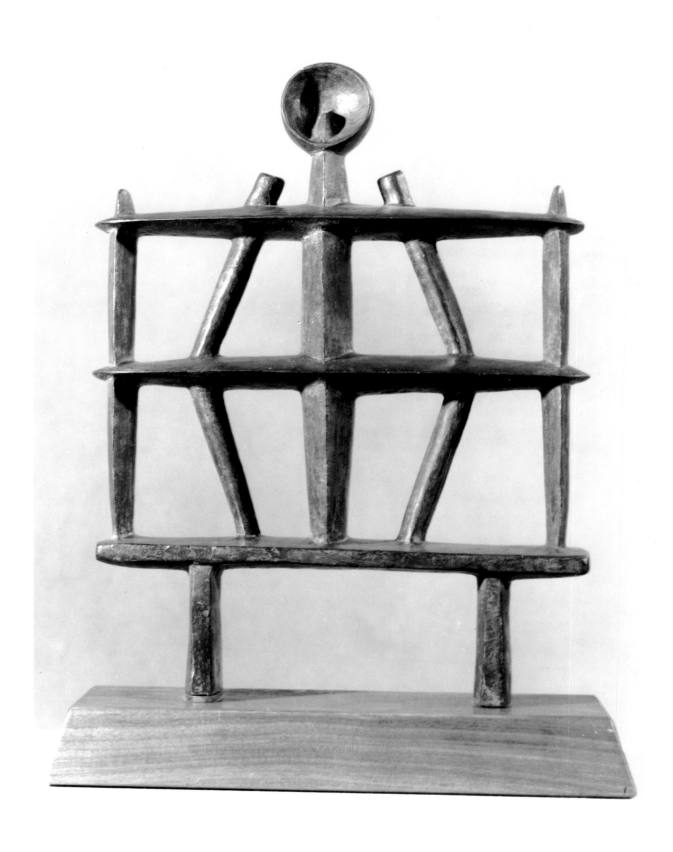

17 MAN (APOLLO) 1929, HOMME (APOLLON). Bronze, 15¾ x 11⅞ x 3⅜″ (40 x 30 x 8.5 cm)
Inscr. on back of the lowest cross-beam: 2/6 Alberto Giacometti 1929. Alberto-Giacometti-Stiftung, Zurich

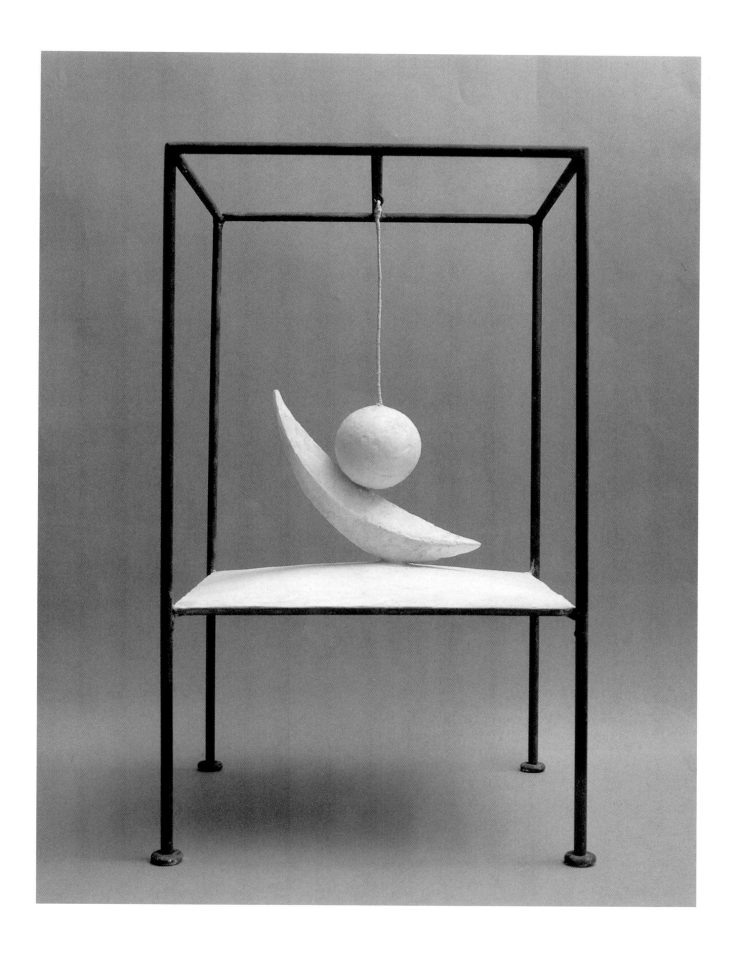

18 SUSPENDED BALL 1930–31, BOULE SUSPENDUE. Plaster and metal, 23¾ x 14¼ x 14″ (60.3 x 36.2 x 35.5 cm)
(Variant executed in 1965.) Private collection

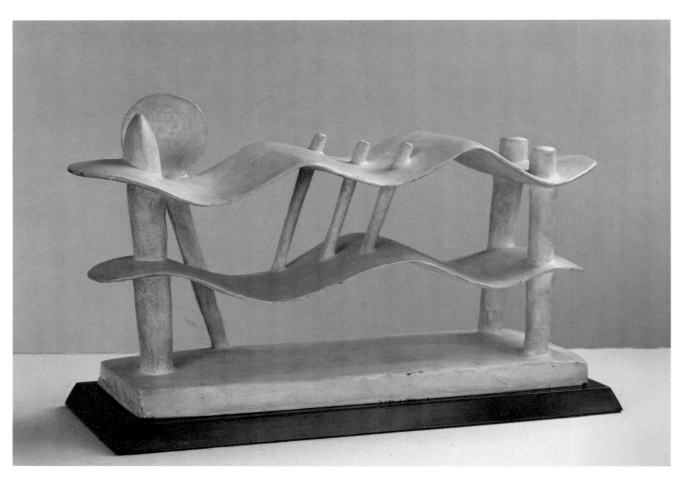

19 RECLINING WOMAN, DREAMING 1929, FEMME COUCHÉE QUI RÊVE
Painted bronze, 9⅝ x 16⅞ x 5½" (24.5 x 43 x 14 cm)
Inscr. at left on back of base-plate: Alberto Giacometti 0/6. Alberto-Giacometti-Stiftung, Zurich

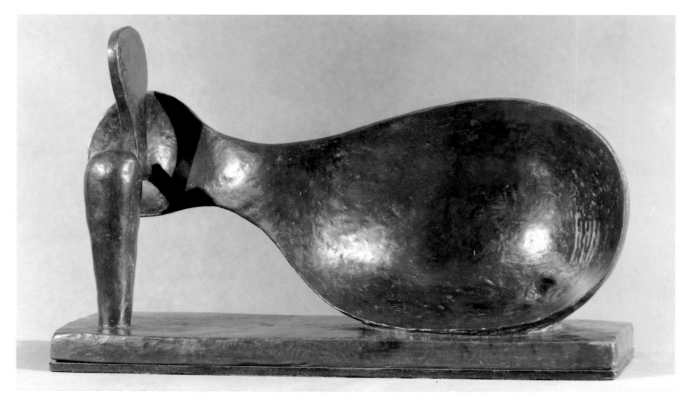

20 RECLINING WOMAN 1929, FEMME COUCHÉE. Bronze, 10⅝ x 17⅜ x 6¼" (27 x 44 x 16 cm)
Inscr. at right on back of base: Alberto Giacometti 1929, 1/6. Alberto-Giacometti-Stiftung, Zurich

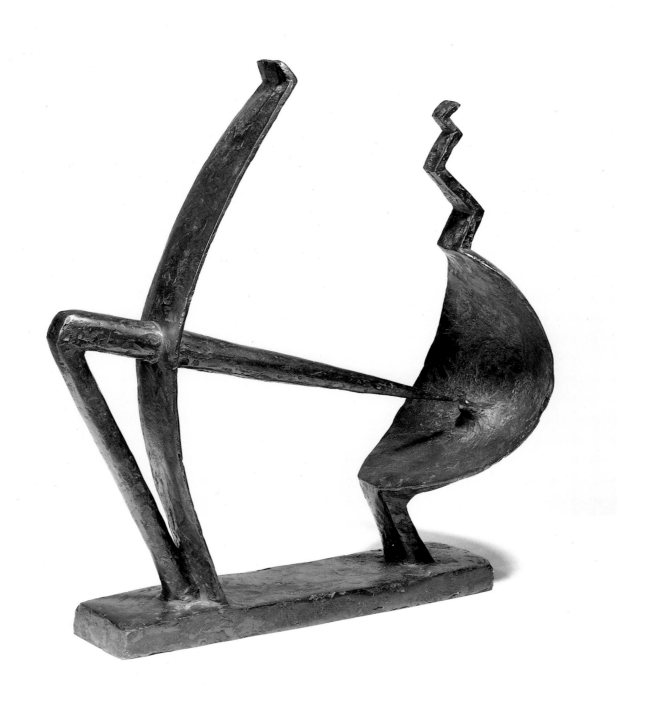

21 MAN AND WOMAN 1928–29, HOMME ET FEMME
Bronze, 15¾ x 15¾ x 6½″ (40 x 40 x 16.5 cm)
Musée national d'art moderne, Centre Georges Pompidou, Paris

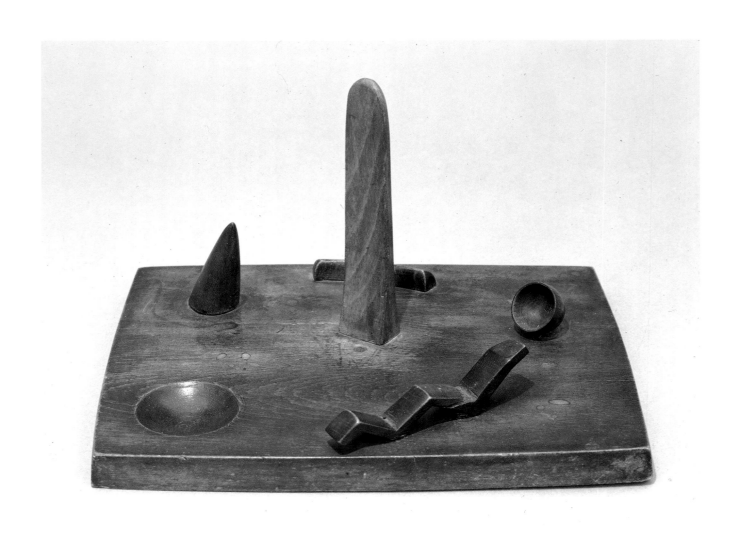

22 MODEL FOR A CITY SQUARE 1931–32, PROJET POUR UNE PLACE
Wood, 7⅝ x 12⅜ x 8⅞″ (19.4 x 31.4 x 22.5 cm)
Peggy Guggenheim Collection, Venice (The Solomon R. Guggenheim Foundation)

23 MODEL FOR A PASSAGEWAY 1930–31, PROJET POUR UN PASSAGE (LE LABYRINTHE)
Plaster, 6¼ x 49¼ x 16½" (16 x 125 x 42 cm)
Inscr. in bowl at front right: Alberto Giacometti plâtre original (in
pencil), and in bowl below right: Alberto Giacometti (scratched in).
Alberto-Giacometti-Stiftung, Zurich

24 SPIKE IN THE EYE 1931, POINTE À L'ŒIL. Plaster and metal, 5¼ x 23½ x 12¼″ (13.5 x 59.5 x 31 cm)
Inscr. on edge of base at front left: Plâtre original; at front
right: Alberto Giacometti (with brush). Alberto-Giacometti-Stiftung, Zurich

25 THE GAME IS OVER 1932, ON NE JOUE PLUS
Marble, wood, and bronze, 15¾ x 11⅞ x 2″ (40 x 30 x 5 cm). Private collection, USA

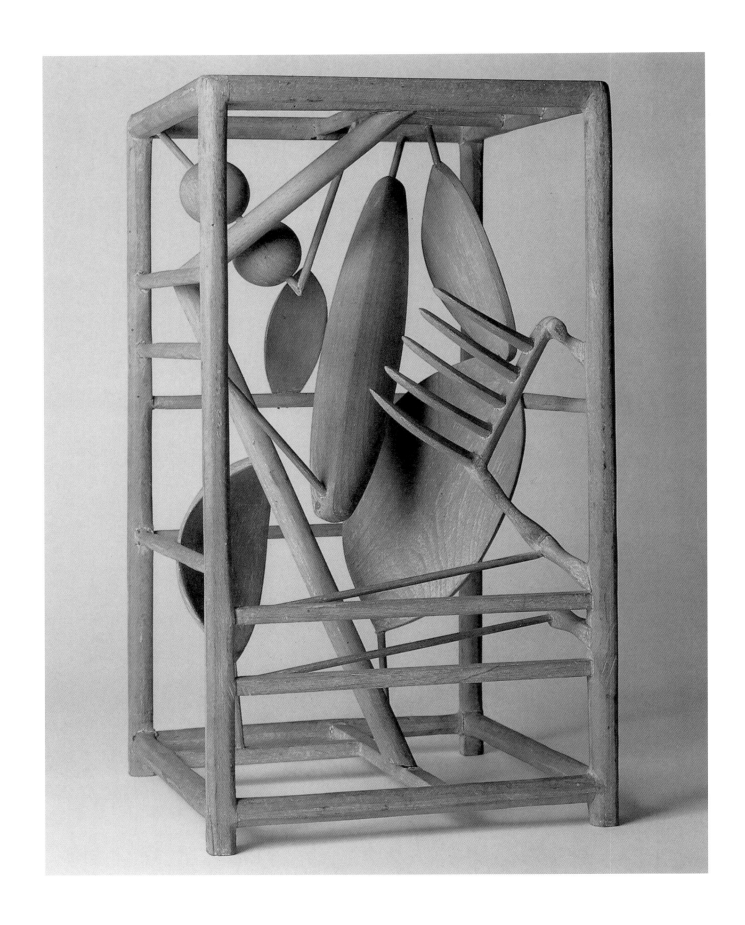

26 THE CAGE 1930-31, LA CAGE. Wood, 19¼ x 10½ x 10½″ (49 x 26.5 x 26.5 cm)
Moderna Museet, Stockholm

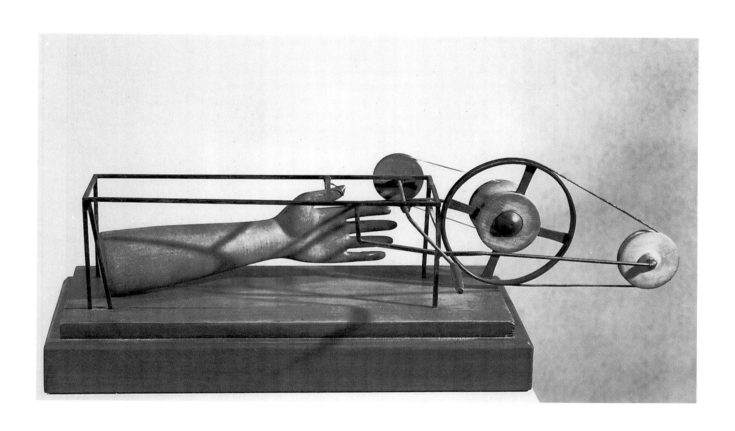

27 CAPTIVE HAND 1932, MAIN PRISE. Wood and metal, $7\frac{7}{8}$ x $23\frac{1}{2}$ x $10\frac{5}{8}$″ (20 x 59.5 x 27 cm)
Inscr. on edge of base: Alberto Giacometti 1932 (in pencil).
Alberto-Giacometti-Stiftung, Zurich

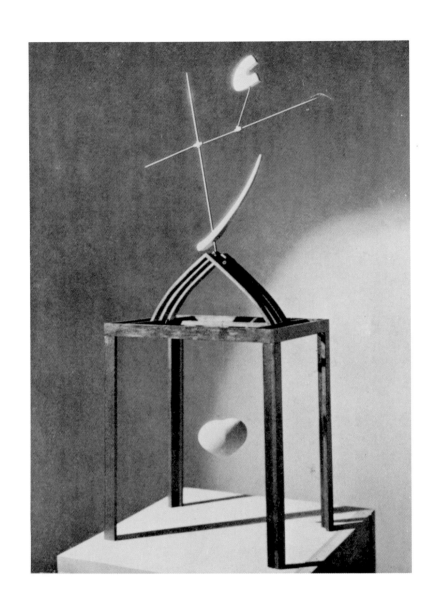

28 THE HOUR OF THE TRACES 1930–31, L'HEURE DES TRACES
Painted plaster and metal, 27 x 14¼ x 11¼" (68.6 x 36.2 x 28.6 cm)
Purchased by the Friends of the Tate Gallery, London

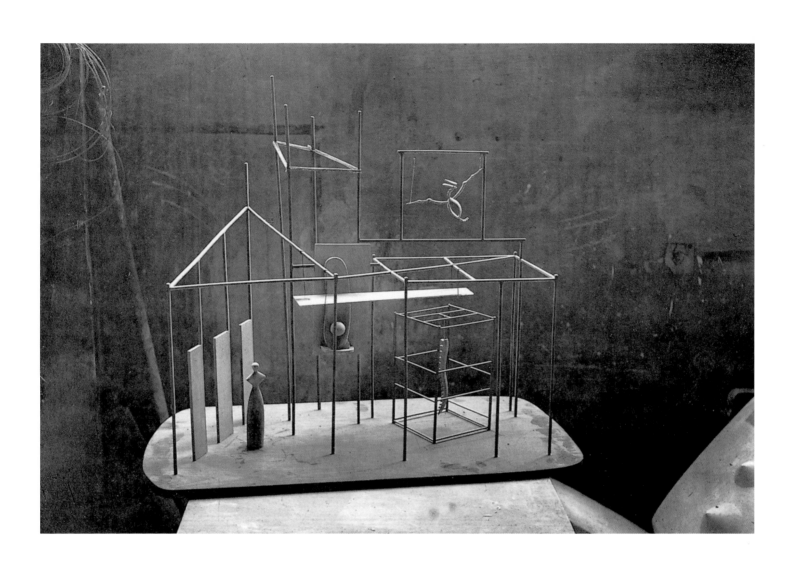

29 PALACE AT FOUR IN THE MORNING 1932, PALAIS DE QUATRE HEURES DU MATIN
Wood, glass, metal, 24⅝ x 27¾ x 15½″ (62.5 x 70.6 x 39.5 cm)
Museum of Modern Art, New York

30 STUDIO, TOWARDS THE REAR 1932, ATELIER. Pencil, 12½ x 17¾" (31.8 x 45 cm)
Inscr. in pencil at lower right: Alberto Giacometti 1932
Öffentliche Kunstsammlung (Kupferstichkabinett), Basle

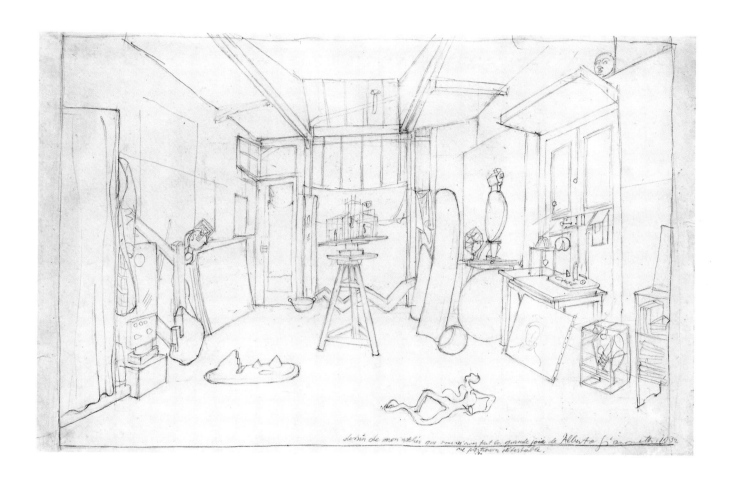

31 SKETCH OF MY STUDIO 1932, DESSIN DE MON ATELIER. Pencil, 12⅞ x 12½ x 19⅜″ (32.7 x 31.9 x 49.3 cm)
Inscr. in pencil at lower right, above the framing line: Alberto Giacometti 1932; on right, above and below the
framing line the dedication: Dessin de mon atelier que vous m'avez fait la grande joie de / ne pas trouver
détestable. (Dedication added after the signature). Öffentliche Kunstsammlungen (Kupferstichkabinett), Basle

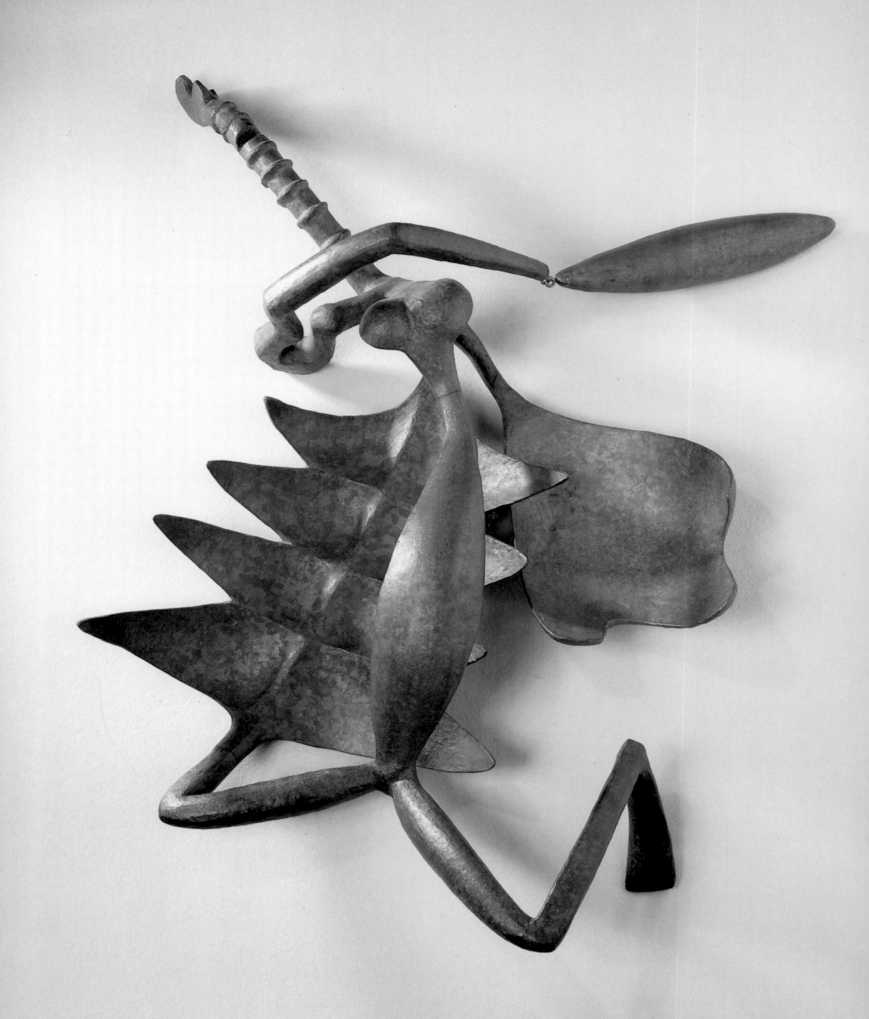

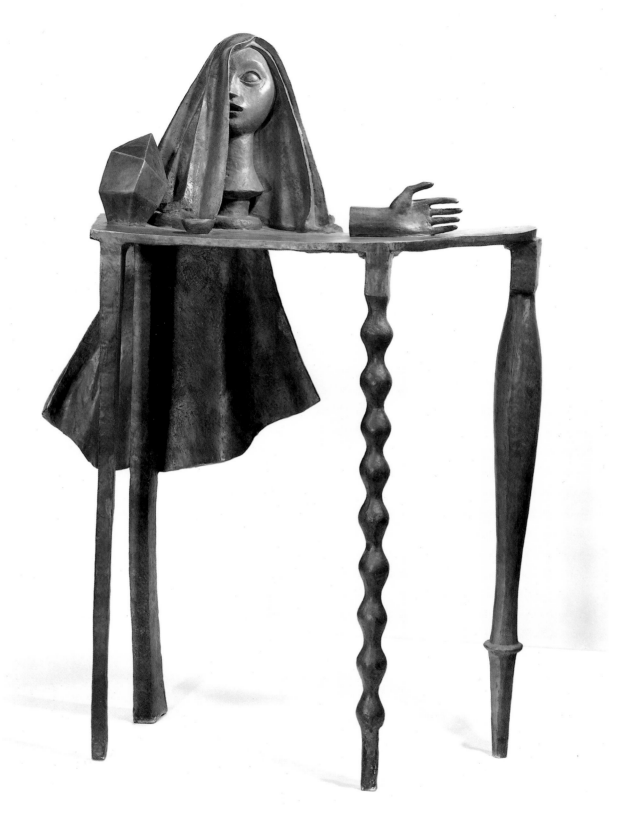

33 THE SURREALIST TABLE 1933, LA TABLE SURRÉALISTE. Bronze, 56¼ x 40½ x 17″ (143 x 103 x 43 cm)
Musée national d'art moderne, Centre Georges Pompidou, Paris

Left: 32 WOMAN WITH HER THROAT CUT 1932, FEMME ÉGORGÉE. Bronze, 7⅞ x 29½ x 22⅞″ (20 x 75 x 58 cm)
Inscr. under the scoop-shaped element on left: A. Giacometti 1932, 3/5
Alexis Rudier Fondeur Paris. Alberto-Giacometti-Stiftung, Zurich

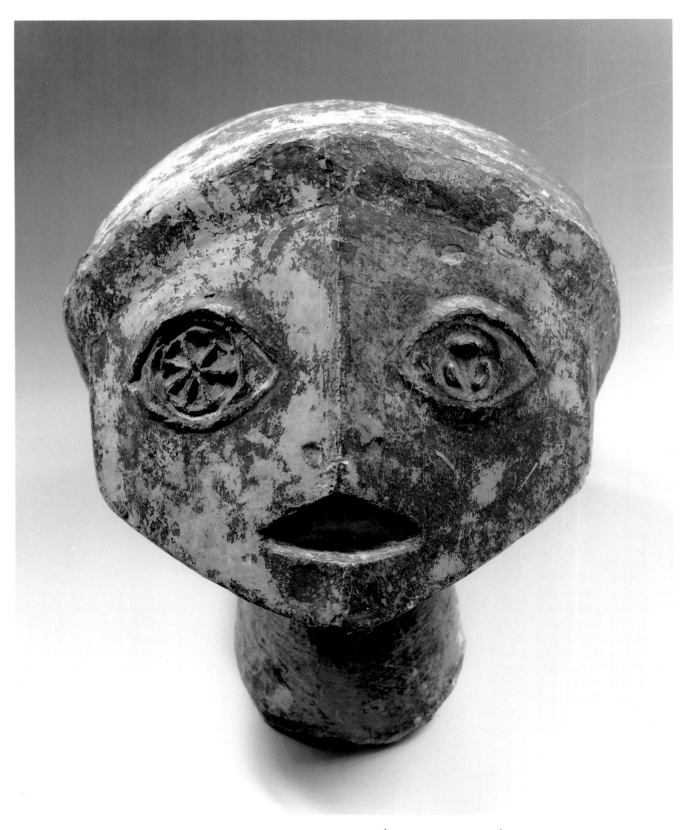

34 FEMALE HEAD FOR: THE INVISIBLE OBJECT 1934, TÊTE DE FEMME POUR: L'OBJET INVISIBLE
Plaster, 6¾ x 5½″ (17 x 14 cm). Ny Carlsberg Glyptotek, Copenhagen

Right:
35 THE INVISIBLE OBJECT—HANDS HOLDING EMPTINESS 1934–35, L'OBJET INVISIBLE—MAINS TENANT LE VIDE
Bronze, height 60¼″ (153 cm). Inscr. on upper back of base: Alberto Giacometti;
at right on back of base: 3/6 Alexis Rudier Fondeur Paris. National Gallery of Art,
Washington, D.C., Ailsa Mellon Bruce Fund 1974

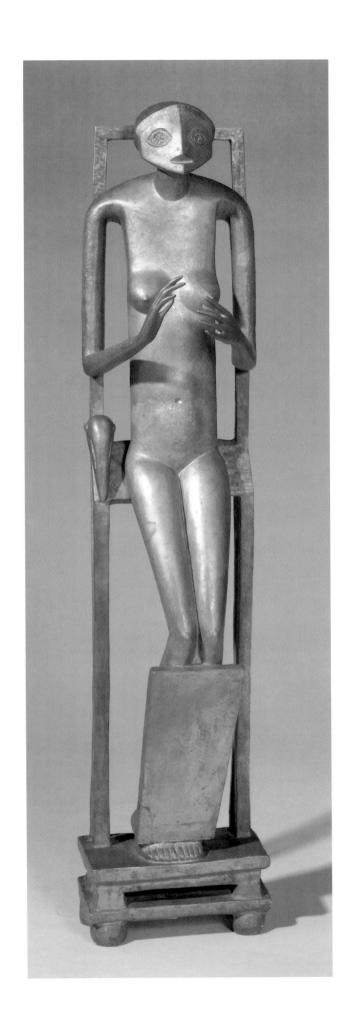

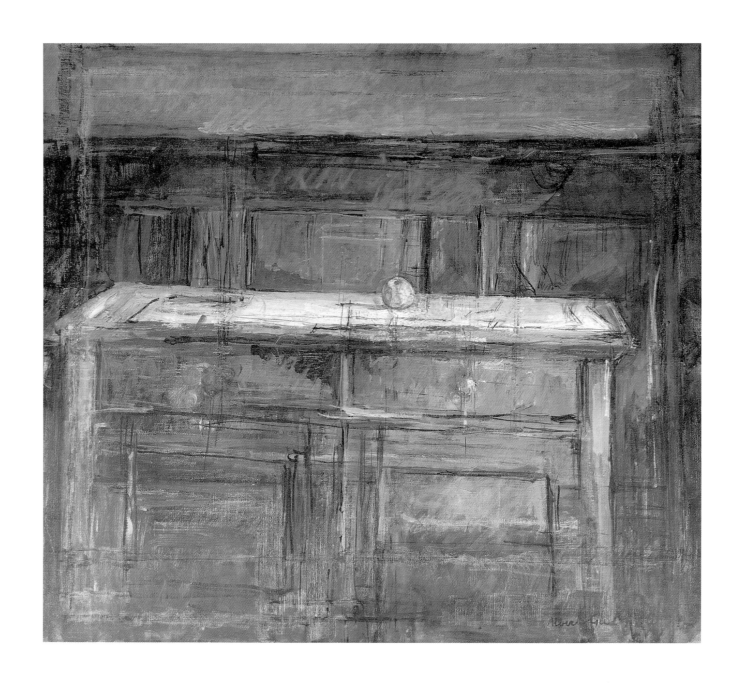

36 APPLE ON A SIDEBOARD 1937, POMME SUR LE BUFFET. Oil on canvas, $28\frac{3}{8}$ x $29\frac{3}{4}$" (72 x 75.5 cm)
Inscr. lower right: Alberto Giacometti 1937. Private collection

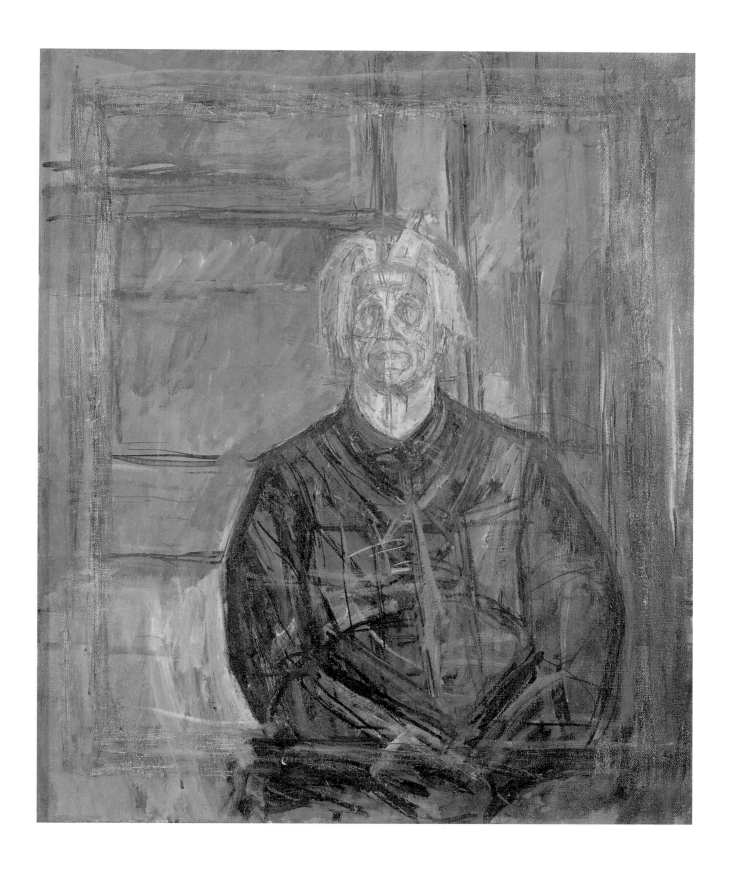

37　THE ARTIST'S MOTHER　1937, LA MÈRE DE L'ARTISTE. Oil on canvas, 25⅝ x 19⅝″ (65 x 50 cm)
Private collection

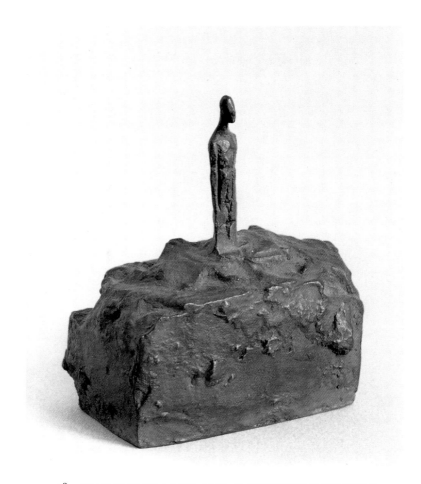

38 SMALL MAN ON A BASE 1940-41, PETIT HOMME SUR SOCLE
Bronze, height 3¼″ (8.4 cm). Inscr. on the base
Private collection, Paris

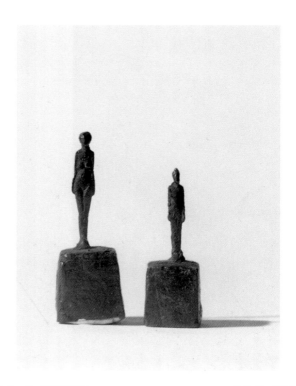

39 SMALL FIGURE 1940-41, FIGURINE
Bronze, height 16⅛″ (41 cm). Bequest of Christian
and Yvonne Zervos
Commune de Vézelay

40 SMALL FIGURE 1940-41, FIGURINE
Bronze, height 1⅜″ (3.5 cm). Bequest of Christian
and Yvonne Zervos
Commune de Vézelay

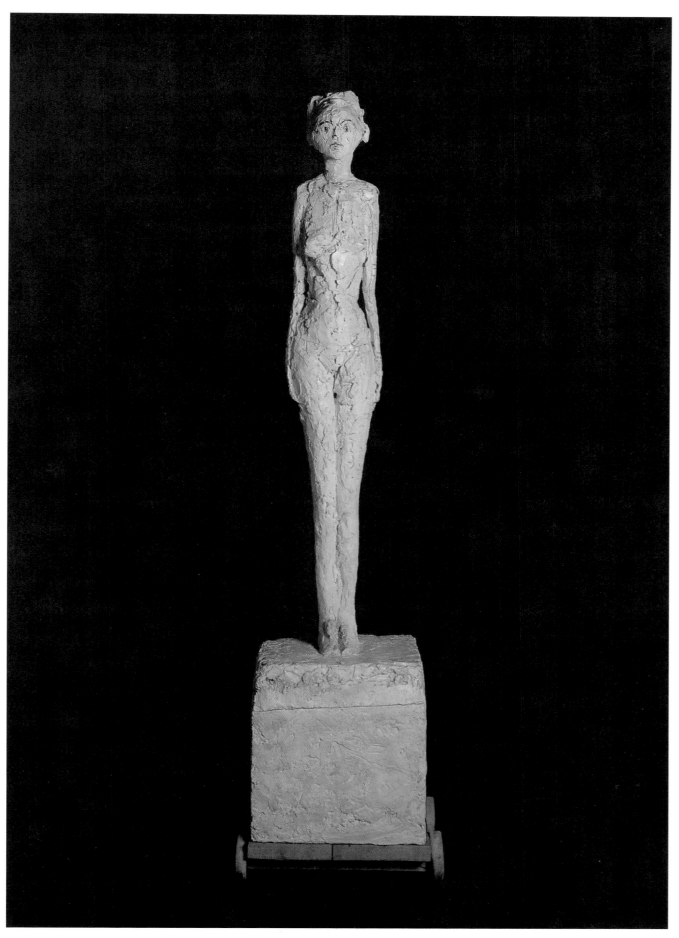

41 WOMAN ON A CHARIOT 1942–43, LA FEMME AU CHARIOT
Painted plaster, height 64½″ (164 cm), Wilhelm-Lehmbruck-Museum, Duisburg

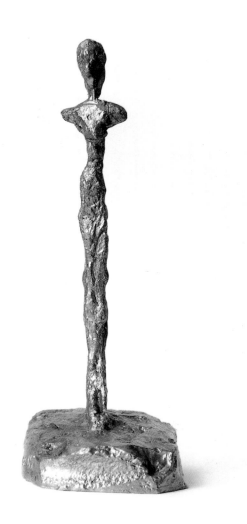

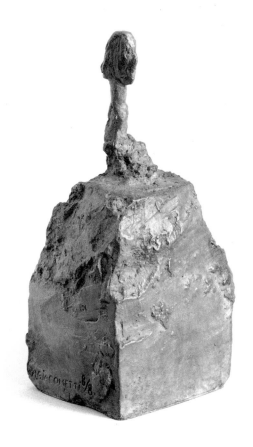

42 SMALL FIGURE (WITHOUT ARMS) 1946–47,
FIGURINE (SANS BRAS)
Bronze, height 4¾″ (12 cm)
Signed on the base. Private collection, Paris

43 SMALL BUST OF A WOMAN ON A BASE (MARIE-
LAURE DE NOAILLES) 1945–46, PETIT BUSTE DE FEMME
SUR SOCLE (MARIE-LAURE DE NOAILLES)
Bronze, height 4¾″ (12 cm)
Signed on the base. Private collection, Paris

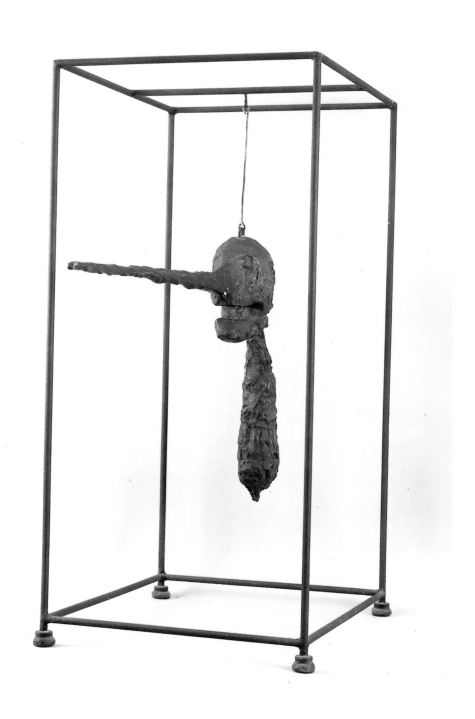

44 THE NOSE 1947, LE NEZ. Bronze, $32\frac{1}{4}$ x $28\frac{3}{4}$ x $14\frac{5}{8}''$ (82 x 73 x 37 cm)
Inscr. 6/6, Alberto Giacometti. Private collection, Geneva

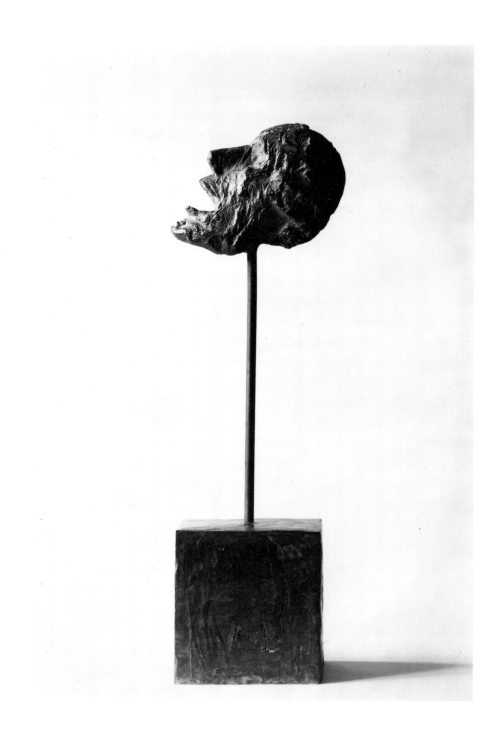

45 HEAD ON A ROD 1947, TÊTE D'HOMME SUR TIGE
Bronze, height 23½'' (59.7 cm), base 6¼ x 5⅞ x 6'' (16 x 14.9 x 15.1 cm)
Inscr. on front of base: Susse Fondeur Paris; on right of base:
Alberto Giacometti; on left of base: 5/6
The Museum of Modern Art, New York, Gift of Mrs George Acheson, 1976

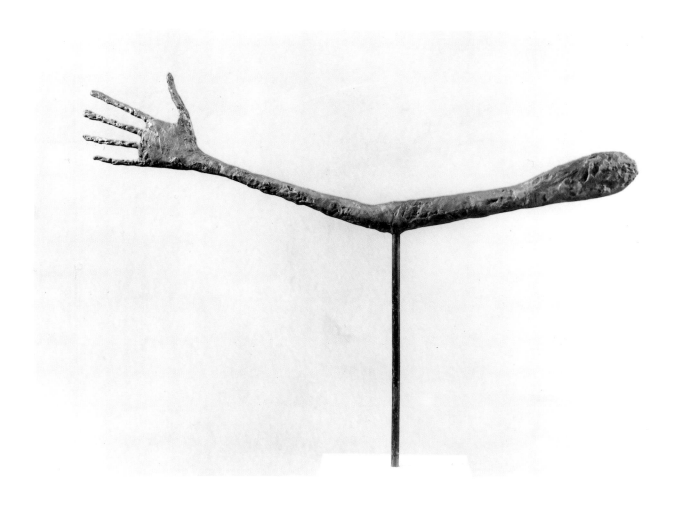

46 THE HAND 1947, LA MAIN. Bronze, 22½ x 28⅜ x 1⅜″ (57 x 72 x 3.5 cm)
Inscr. on the shoulder: AG 5/6. Alberto-Giacometti-Stiftung, Zurich

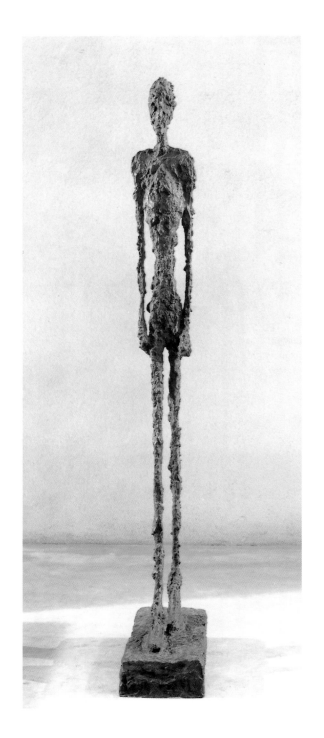 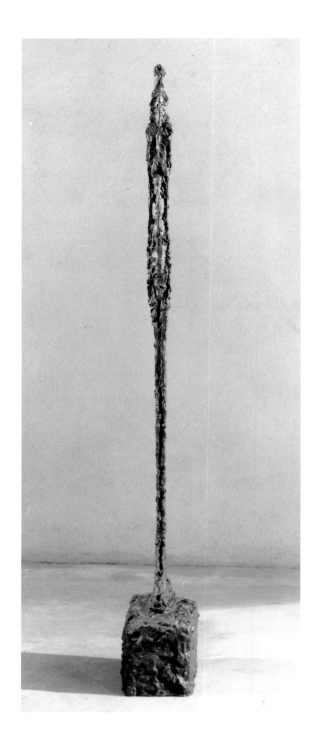

47 MAN WALKING 1947, HOMME QUI MARCHE. Bronze, 67¼ x 9¼ x 13″ (171 x 23.5 x 33 cm)
Inscr. on back of base: A. Giacometti 1/6 1947;
on lower front of base: Alexis Rudier Fondeur Paris. Alberto-Giacometti-Stiftung, Zurich

48 STANDING WOMAN 1948, FEMME DEBOUT
Bronze, 71⅝ x 9 x 13¾″ (182 x 23 x 35 cm)
Inscr. at right on front of base: A. Giacometti 1/5; at lower left on front of base: Alexis Rudier
Fondeur Paris. Alberto-Giacometti-Stiftung, Zurich

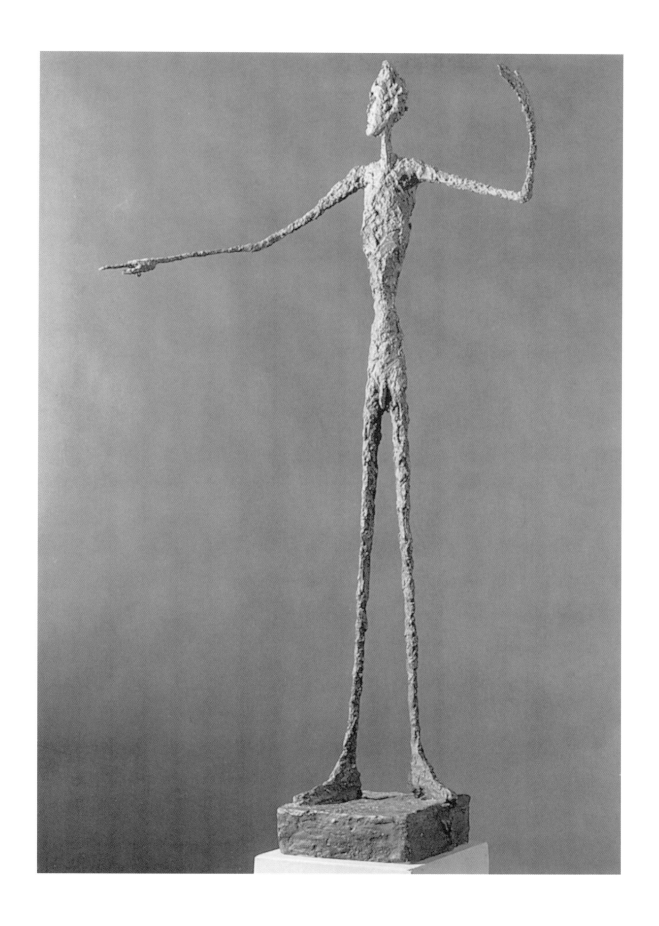

49 MAN WITH POINTING OUTSTRETCHED HAND 1947, L'HOMME AU DOIGT
Bronze, 69½ x 35½ x 24½″ (176.5 x 90.2 x 62.2 cm). The Trustees of the Tate Gallery, London

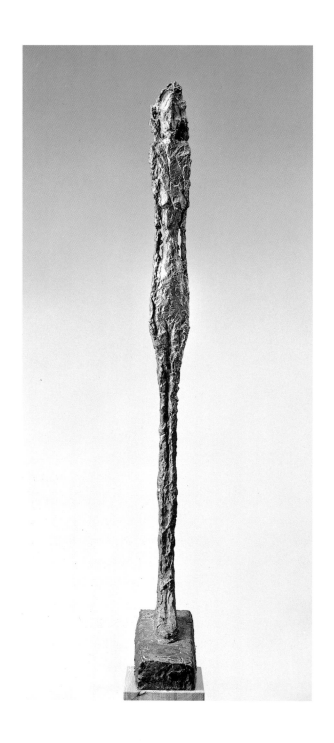

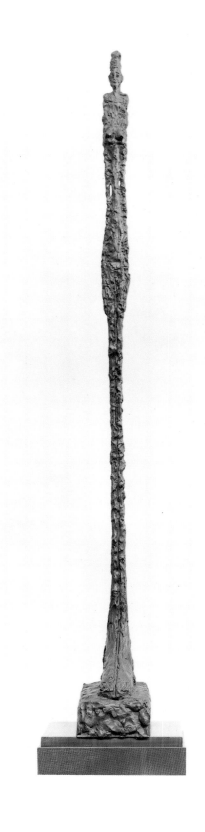

50 STANDING WOMAN (LEONI) 1947,
FEMME DEBOUT (LEONI)
Bronze, 53⅛ x 5¾ x 14″ (135 x 14.5 x 35.5 cm)
Inscr. at right on base: 6/6 Alberto Giacometti.
Franz Meyer, Zurich

51 STANDING WOMAN 1948, FEMME DEBOUT
Bronze, 66 x 6¼ x 13⅜″ (167.5 x 16 x 34 cm)
Inscr. at left on front of base: A. Giacometti 1/6;
on back of base: Alexis Rudier Fondeur Paris
Alberto-Giacometti-Stiftung, Zurich

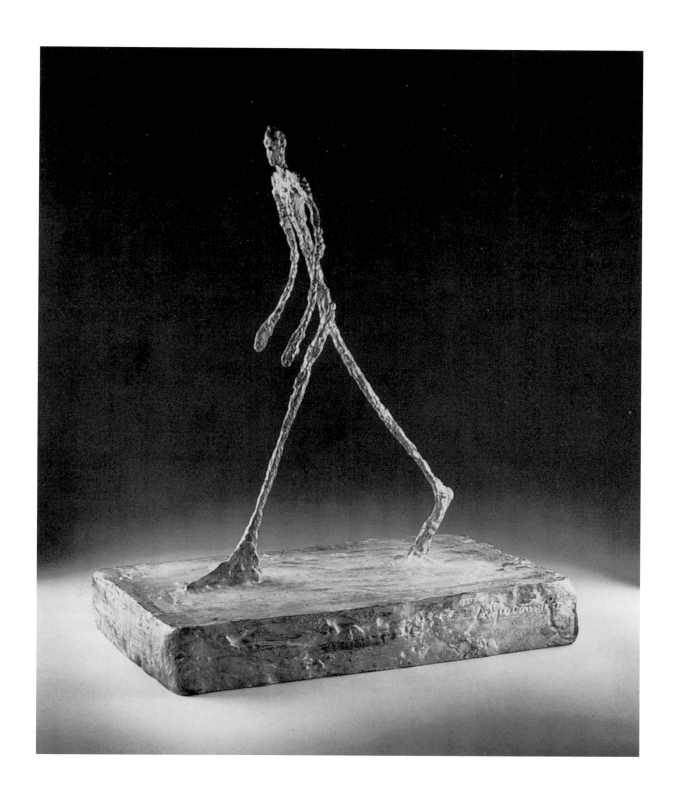

52 MAN CROSSING A SQUARE ON A SUNNY MORNING 1948–49
Bronze, 18 x 8¼ x 14⅜″ (46 x 21 x 36.5 cm). The Detroit Institute of Arts

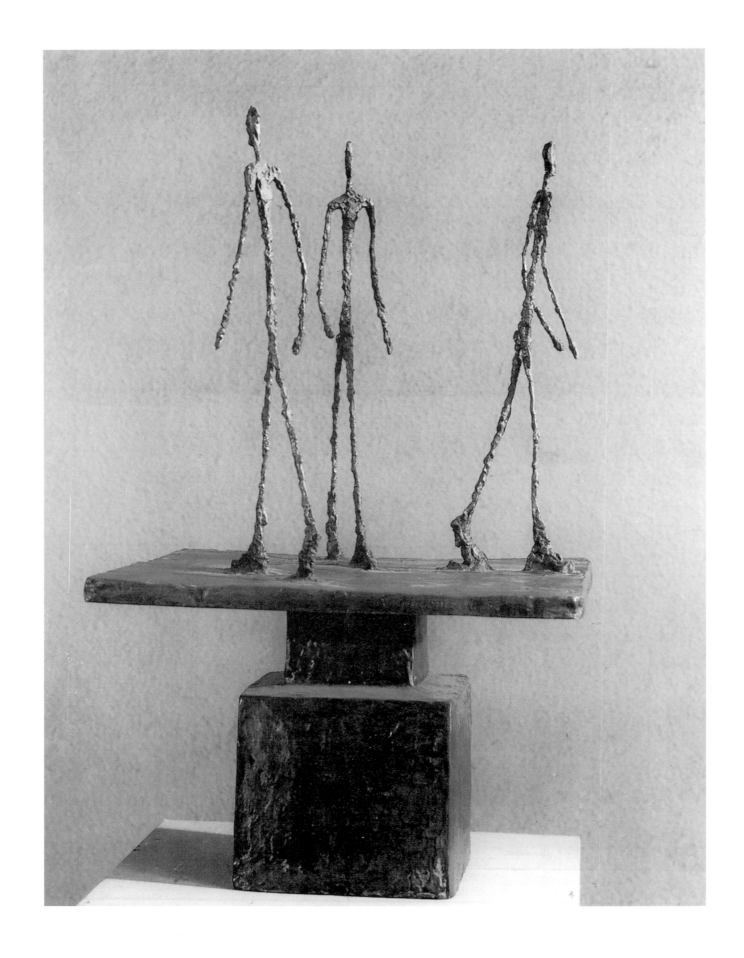

53 THREE MEN WALKING 1948, TROIS HOMMES QUI MARCHENT. Bronze, 28⅜ x 17 x 16⅜″ (72 x 43 x 41.5 cm)
Alberto-Giacometti-Stiftung, Zurich

54 STANDING WOMAN 1948–49, FEMME DEBOUT
Bronze, 49¼ x 7⅞ x 13⅜" (125 x 20 x 34 cm)
Inscr. at left on base: Alberto Giacometti; at
lower right on back of base: Alexis Rudier
Staatsgalerie, Stuttgart

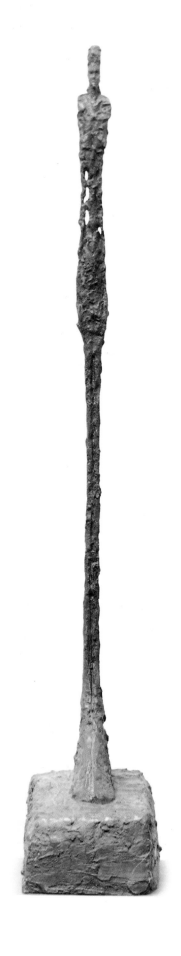

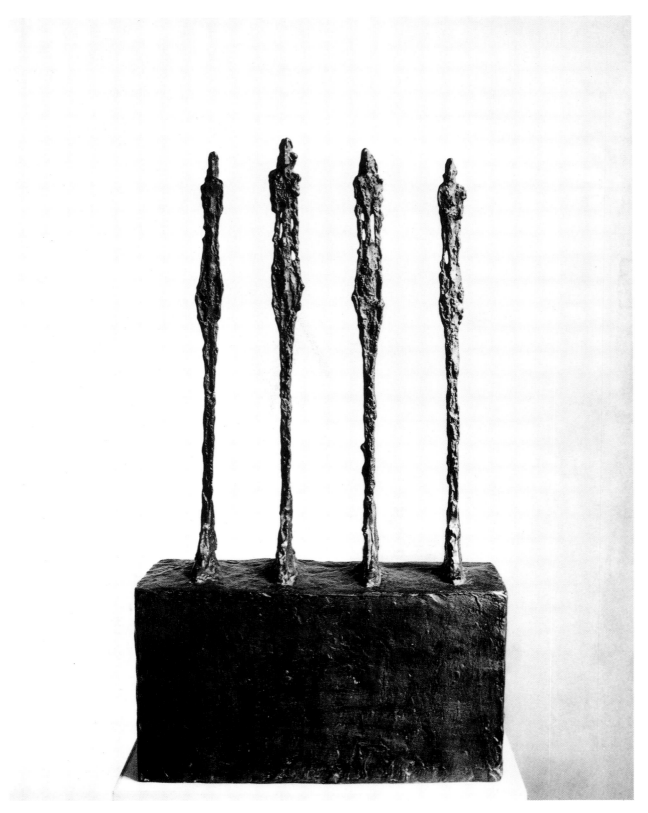

55 FOUR WOMEN ON A PEDESTAL 1950, QUATRE FEMMES SUR SOCLE
Painted bronze, 30 x 16⅜ x 6¾″ (76 x 41.5 x 17 cm)
Inscr. at right on front of base: 1/6 A. Giacometti; on back of base: Alexis Rudier Fondeur Paris
Alberto-Giacometti-Stiftung, Zurich

Right:
56 FOUR FIGURES ON A HIGH BASE 1950, QUATRE FIGURINES SUR BASE
Painted bronze, 63¾ x 16½ x 12⅝″ (162 x 42 x 32 cm)
Inscr. on right edge of base-plate: 1/6 A. Giacometti; on back edge of base-plate: Alexis Rudier Fondeur Paris
Alberto-Giacometti-Stiftung, Zurich

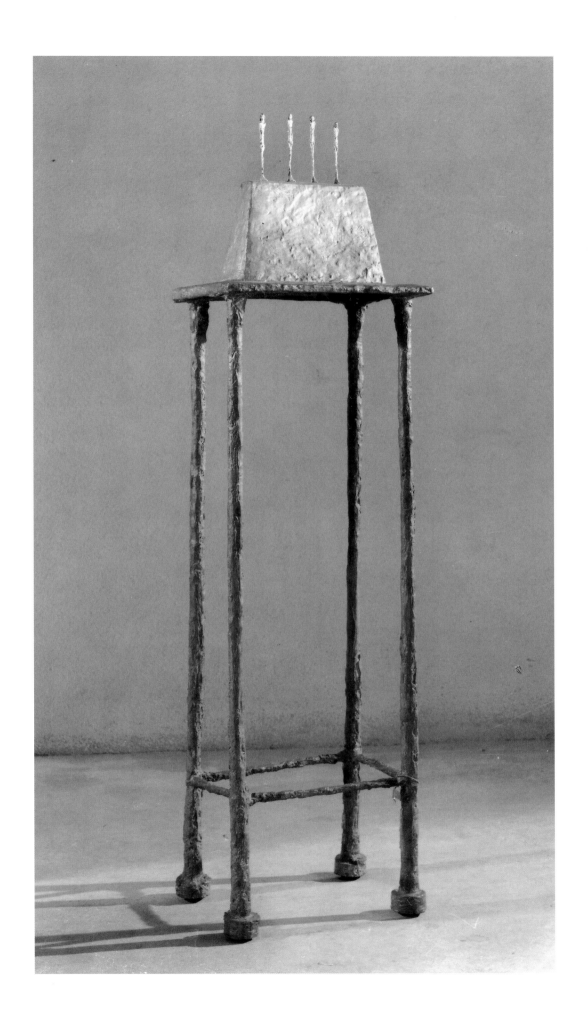

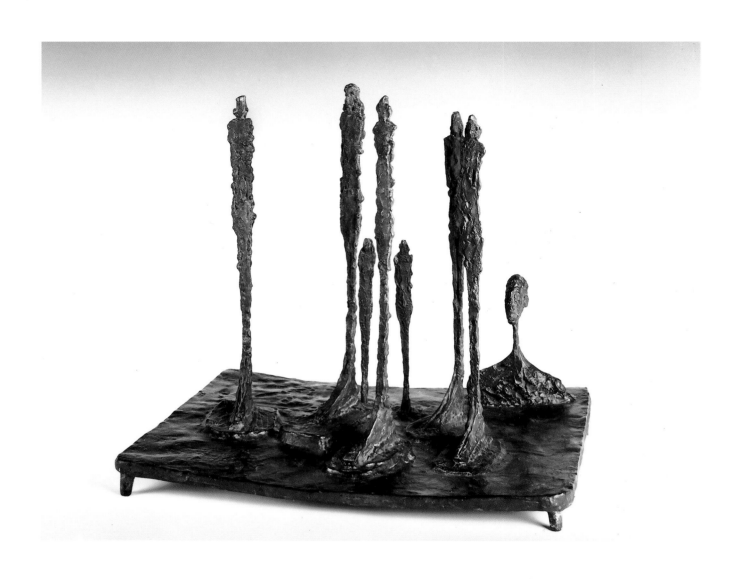

57 THE FOREST (SEVEN FIGURES, ONE HEAD) 1950, LA FORÊT (SEPT FIGURES, UNE TÊTE)
Bronze, 22⅞ x 25⅜ x 23⅝″ (58 x 64.5 x 60 cm). Wilhelm-Lehmbruck-Museum, Duisburg

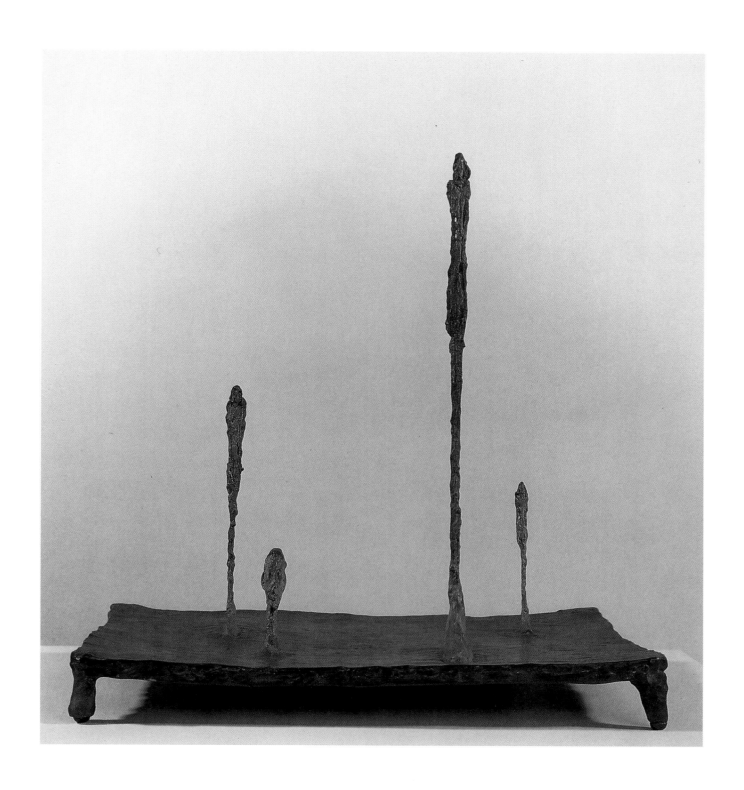

58 THE CITY SQUARE (COMPOSITION WITH THREE FIGURES AND A HEAD) 1950, PLACE (COMPOSITION AVEC TROIS FIGURES ET UNE TÊTE). Painted bronze, 22 x 2 x 1½″ (56 x 5 x 4 cm). Inscr. 5/6. Städtische Kunsthalle, Mannheim

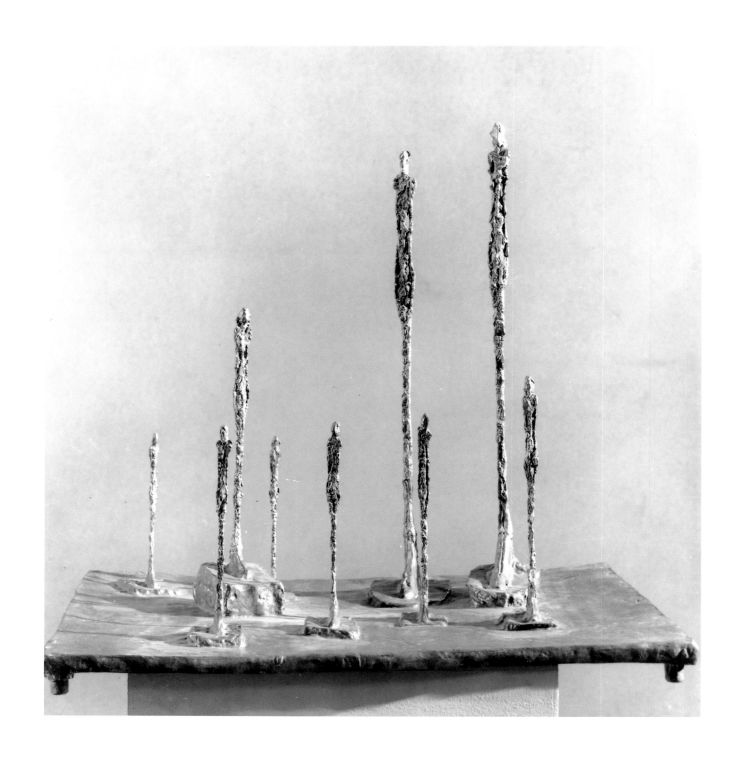

59 THE GLADE (COMPOSITION WITH NINE FIGURES) 1950, LA CLAIRIÈRE (COMPOSITION AVEC NEUF FIGURES)
Bronze, 23½ x 25¾ x 20½" (59.5 x 65.5 x 52 cm)
Inscr. on right edge of base-plate: A. Giacometti 2/6; on back edge of base-plate:
Alexis Rudier Fondeur Paris. Alberto-Giacometti-Stiftung, Zurich

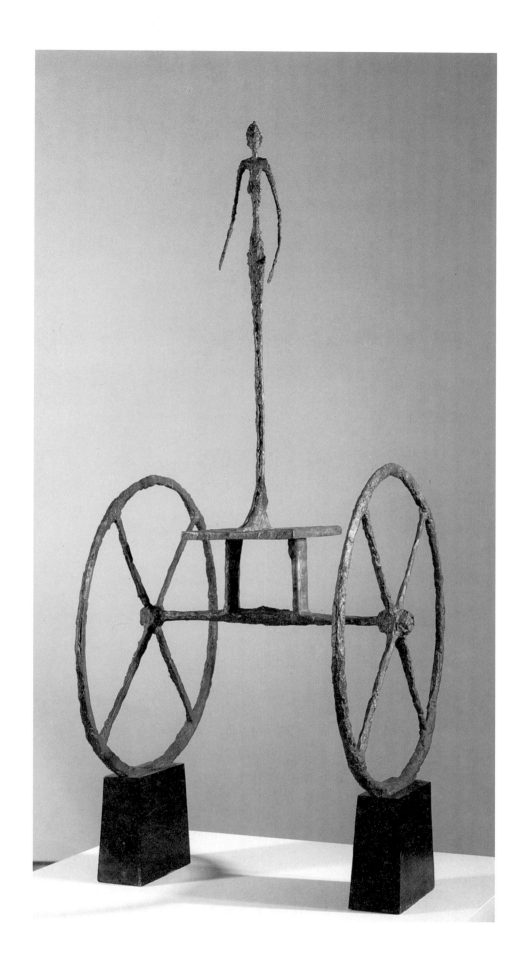

60 THE CHARIOT 1950, LE CHARIOT. Bronze, 65¾ x 24⅜ x 27⅝″ (167 x 62 x 70 cm)
Inscr. at right edge of plate supporting the figure: 3/6 A. Giacometti. Alberto-Giacometti-Stiftung, Zurich

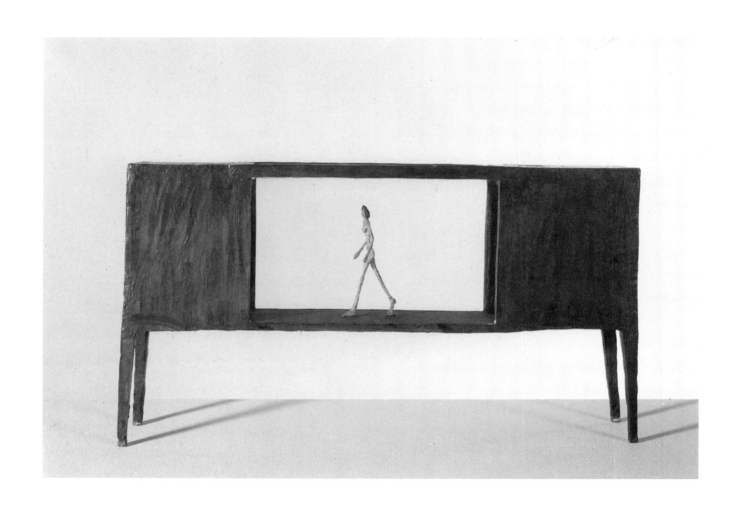

61　SMALL FIGURE BETWEEN TWO BOXES REPRESENTING HOUSES　1950, FIGURINE ENTRE DEUX BOÎTES QUI SONT DES MAISONS
Painted bronze, glass, 11¾ x 21¼ x 3¾″ (30 x 54 x 9.5 cm)
Inscr. on right side: A. Giacometti 1/6; at left on back: Alexis Rudier Fondeur Paris 1/6
Alberto-Giacometti-Stiftung, Zurich

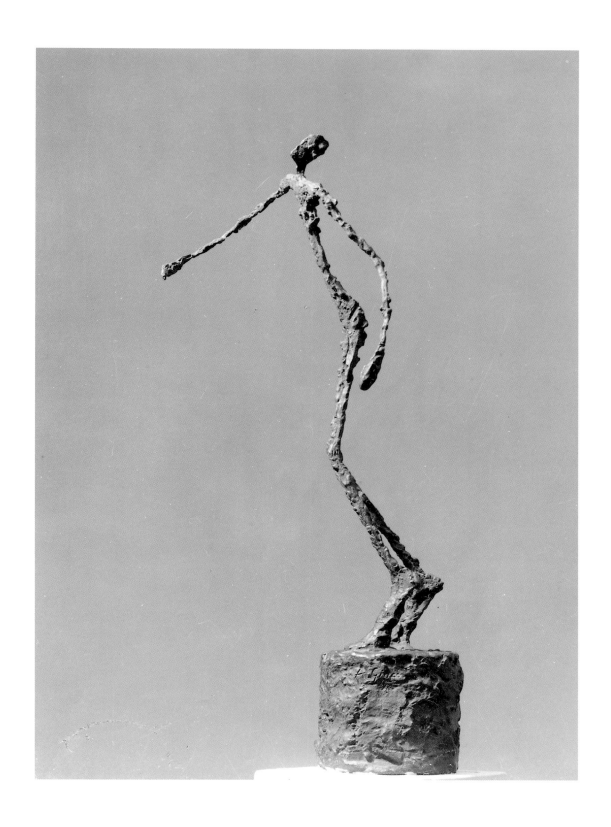

62 MAN STAGGERING 1950, L'HOMME QUI CHAVIRE. Bronze, 23⅝ x 5½ x 12⅝″ (60 x 14 x 32 cm)
Kunsthaus, Zurich, Vereinigung Zürcher Kunstfreunde

63 INTERIOR 1940, INTÉRIEUR. Pencil, 12¼ x 9½″ (31 x 24 cm)
Inscr. at lower right: Alberto Giacometti 1940. Private collection, Switzerland

64 DIEGO 1948. Pencil, 25⅛ x 18¾″ (64 x 47.8 cm)
Inscr. in pencil at lower right: Alberto Giacometti 1948. Kunstmuseum, Berne

Left:
65 PORTRAIT OF LOUIS ARAGON 1946.
Pencil, 20⅝ x 14½″ (52.5 x 37 cm)
Inscr. lower right:
Alberto Giacometti 1946
Collection of Annick and Pierre
Berès, Paris

66 PORTRAIT OF JEAN-PAUL SARTRE 1946. Pencil,
11¾ x 8⅞″ (30 x 22.5 cm)
Inscr. lower right: Alberto Giacometti
Private collection, New York

67 PORTRAIT OF GEORGES BATAILLE
1947. Pencil, 6¾ x 5¼″ (17 x 13.5 cm)
Private collection

68 HOMAGE TO BALZAC 1946, HOMMAGE À BALZAC. Pencil, 17⅞ x 12″ (45.4 x 30.5 cm)
Inscr. in pencil at lower right: Alberto Giacometti 1946
Robert and Lisa Sainsbury Collection, University of East Anglia

69 PORTRAIT OF THE ARTIST'S MOTHER 1946, PORTRAIT DE LA MÈRE DE L'ARTISTE
Pencil, 19½ x 13¾″ (49.5 x 35 cm)
Inscr. lower right: Alberto Giacometti 1946. Private collection

70 TWO STANDING FIGURES AND A HEAD 1947, DEUX FIGURES DEBOUT ET TÊTE
Pencil on uncoated paper, 19¾ x 25⅜″ (50 x 64.5 cm)
Inscr. lower centre: Alberto Giacometti 1947
Graphische Sammlung, Staatsgalerie, Stuttgart

71 FIGURES IN A CITY SQUARE 1947, FIGURES SUR UNE PLACE. Pencil, 12⅞ x 16½″ (32.7 x 41.7 cm)
Inscr. lower right: Alberto Giacometti 1947. Collection of Mrs John Levy, St Louis

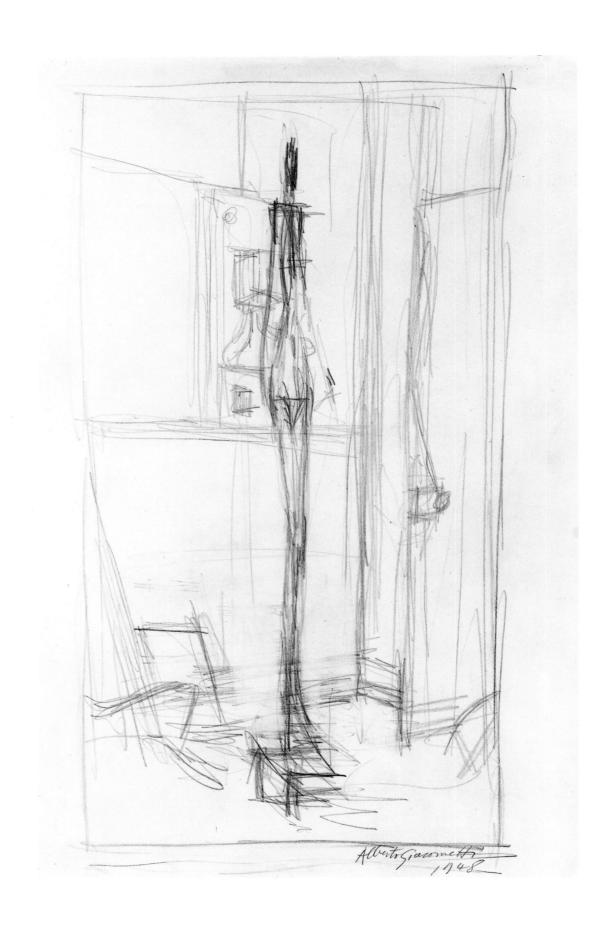

72　LARGE FIGURE IN THE STUDIO　1948, GRANDE FIGURE DANS L'ATELIER
Pencil, 19¾ x 12⅜″ (50 x 31.5 cm)
Inscr. lower right: Alberto Giacometti 1948. Kupferstichkabinett Berlin, Staatliche Museen zu Berlin

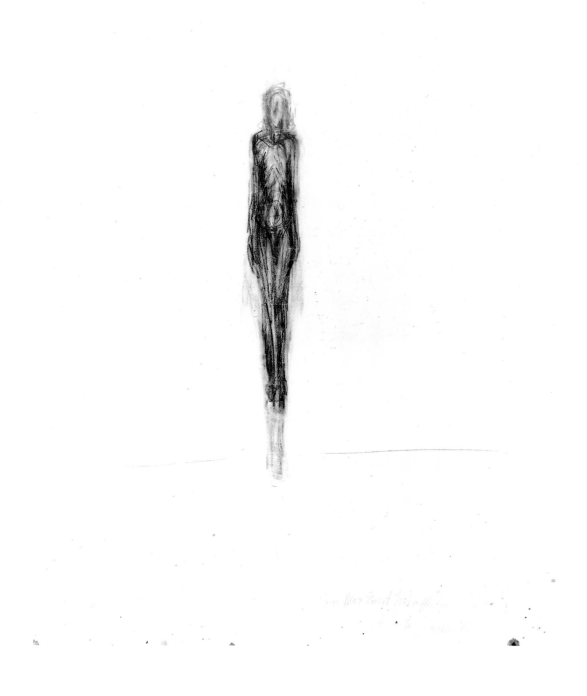

73 STANDING NUDE 1950, FEMME DEBOUT. Verso: Group of Figures. Crayon on paper,
24 x 18½″ (61 x 47 cm). Inscr. lower left: Pour Max Ernst, très affectueusement, Alberto Giacometti
Collection of Duncan MacGuigan, New York

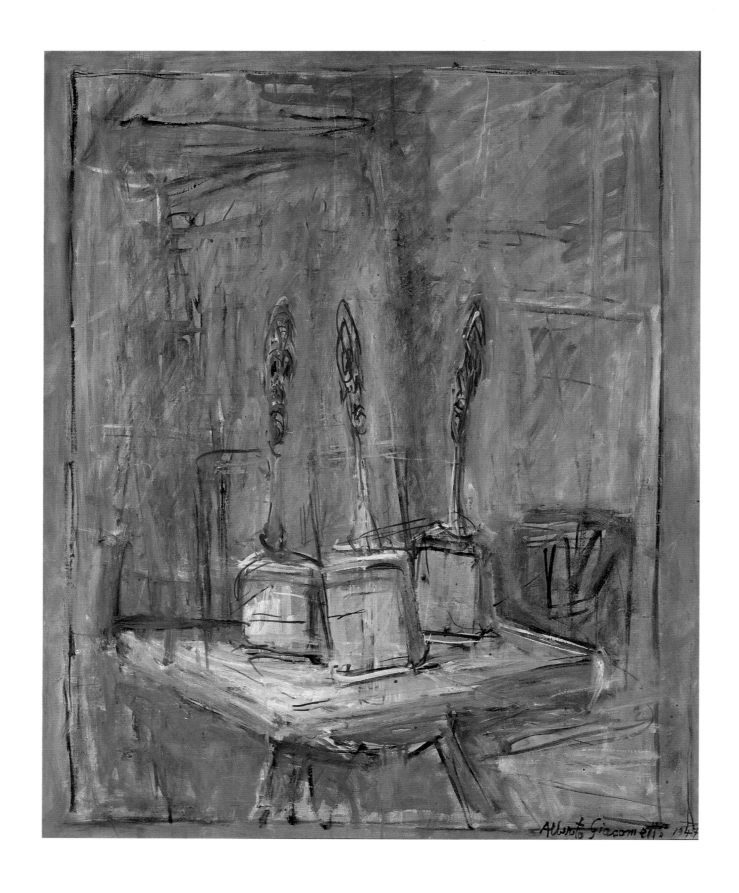

74 THREE PLASTER HEADS 1947, TROIS TÊTES DE PLÂTRE
Oil on canvas, 28¾ x 23½" (73 x 59.5 cm)
Inscr. lower right: Alberto Giacometti 1947. Alberto-Giacometti-Stiftung, Zurich

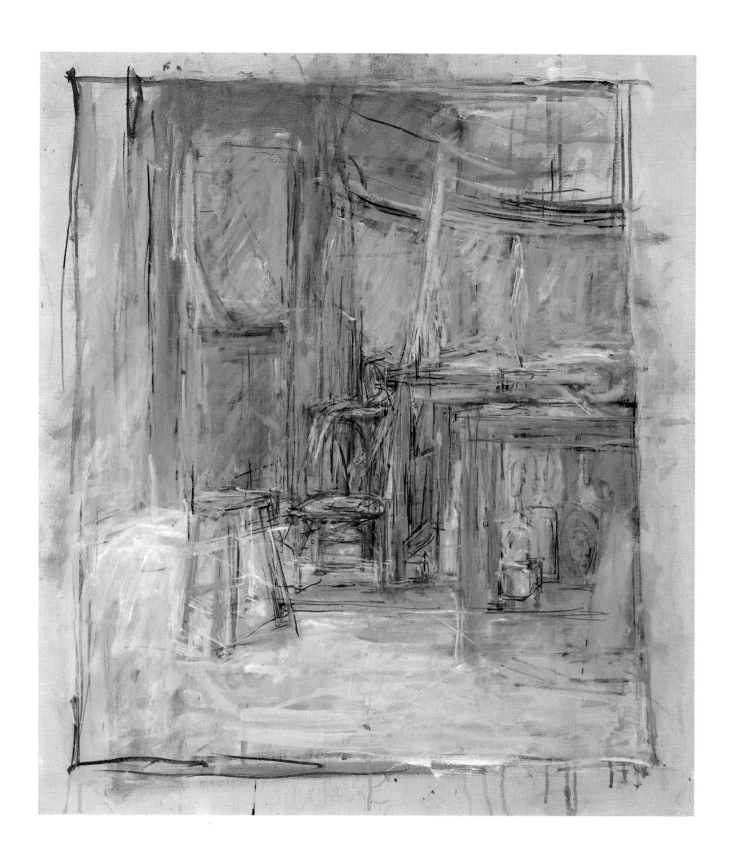

75 INTERIOR 1949, INTÉRIEUR. Oil on canvas, 25½ x 21¼″ (65 x 54 cm)
Inscr. on verso: Alberto Giacometti 1949. The Trustees of the Tate Gallery, London

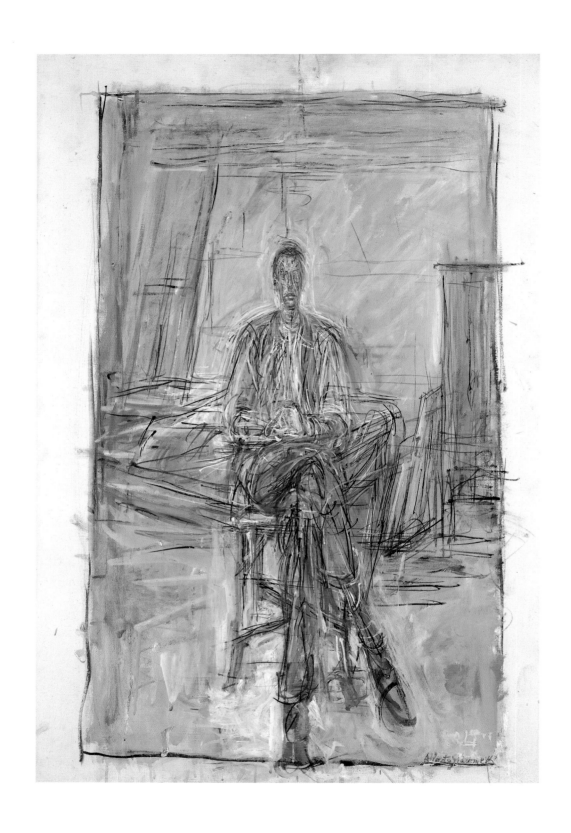

76 SEATED MAN (DIEGO) 1949, HOMME ASSIS (DIEGO)
Oil on canvas, 31½ x 21¼″ (80 x 54 cm). Inscr. lower right: Alberto Giacometti;
on verso: Alberto Giacometti 1949. The Trustees of the Tate Gallery, London

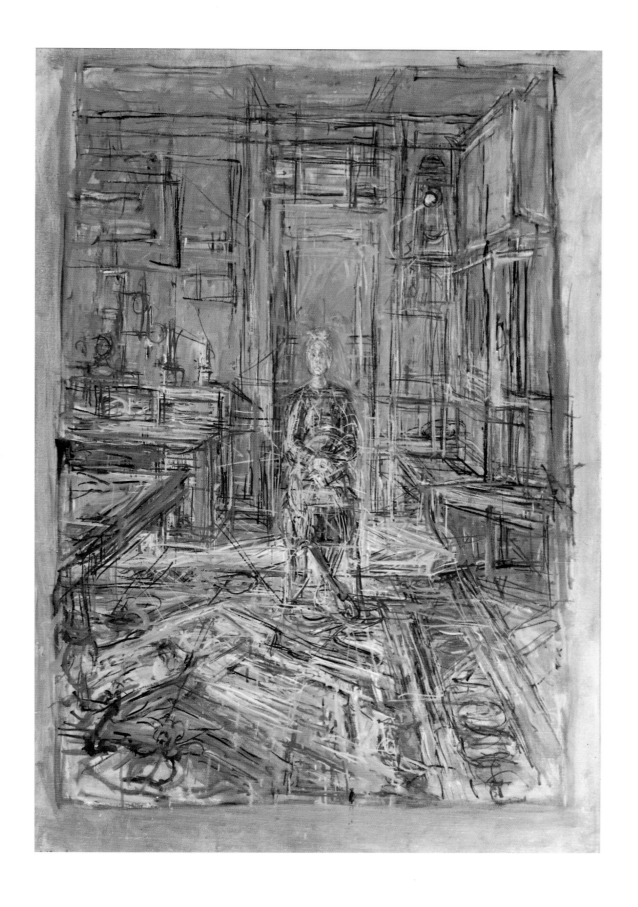

77 THE ARTIST'S MOTHER 1950, PORTRAIT DE LA MÈRE DE L'ARTISTE
Oil on canvas, 35⅜ x 24″ (89.9 x 61 cm). Inscr. lower left: Alberto Giacometti 1950
The Museum of Modern Art, New York, acquired through the Lillie P. Bliss Bequest

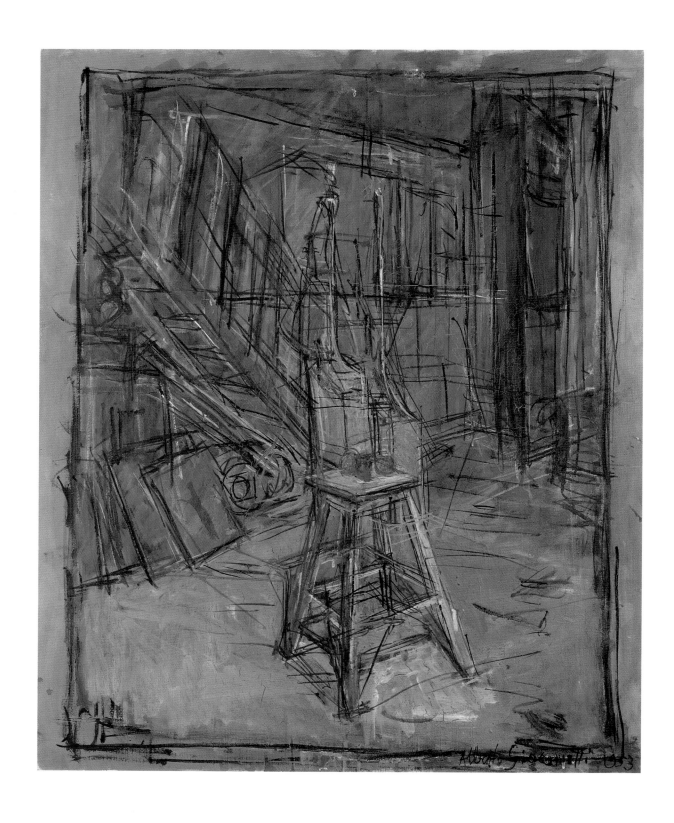

78 APPLES IN THE STUDIO 1953, POMMES DANS L'ATELIER. Oil on canvas, 28½ x 23⅝″ (72.5 x 60 cm)
Inscr. lower right: Alberto Giacometti 1953. Sprengel Museum, Hanover

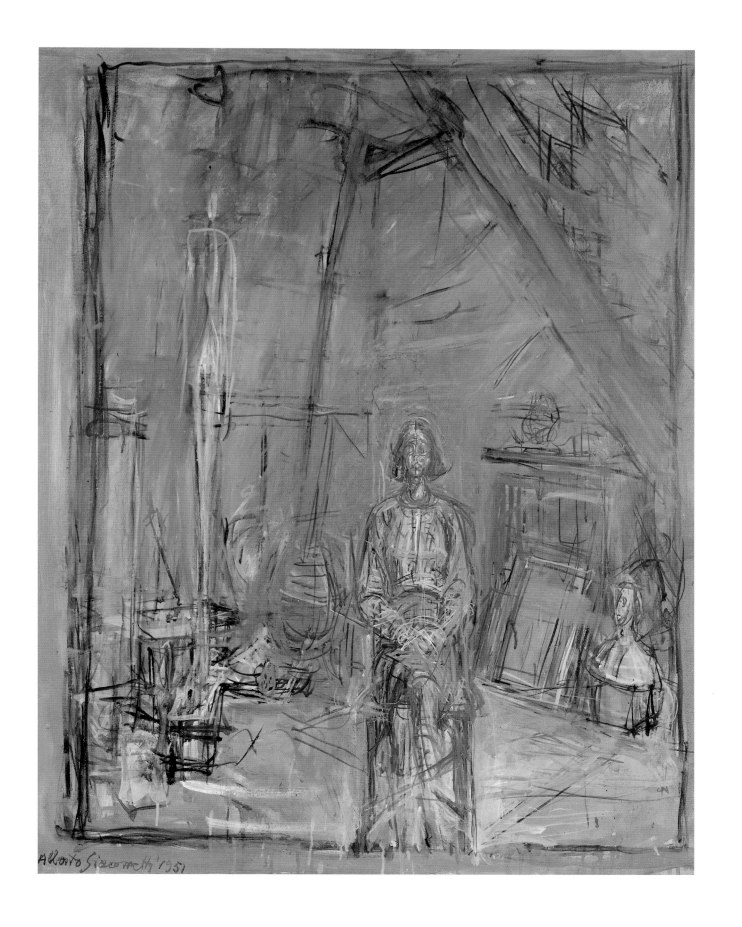

79 ANNETTE 1951. Oil on canvas, 31⅞ x 25½″ (81 x 65 cm)
Inscr. lower left: Alberto Giacometti 1951. Alberto-Giacometti-Stiftung, Zurich

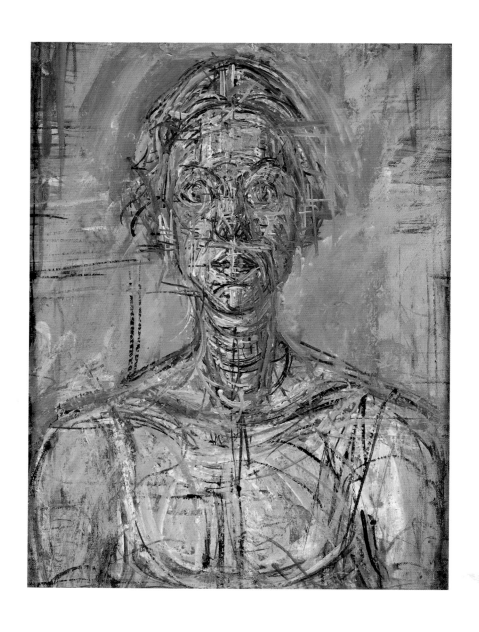

80 BUST OF ANNETTE 1954, BUSTE D'ANNETTE. Oil on canvas,
11⅜ x 8⅝″ (29 x 22 cm). Private collection

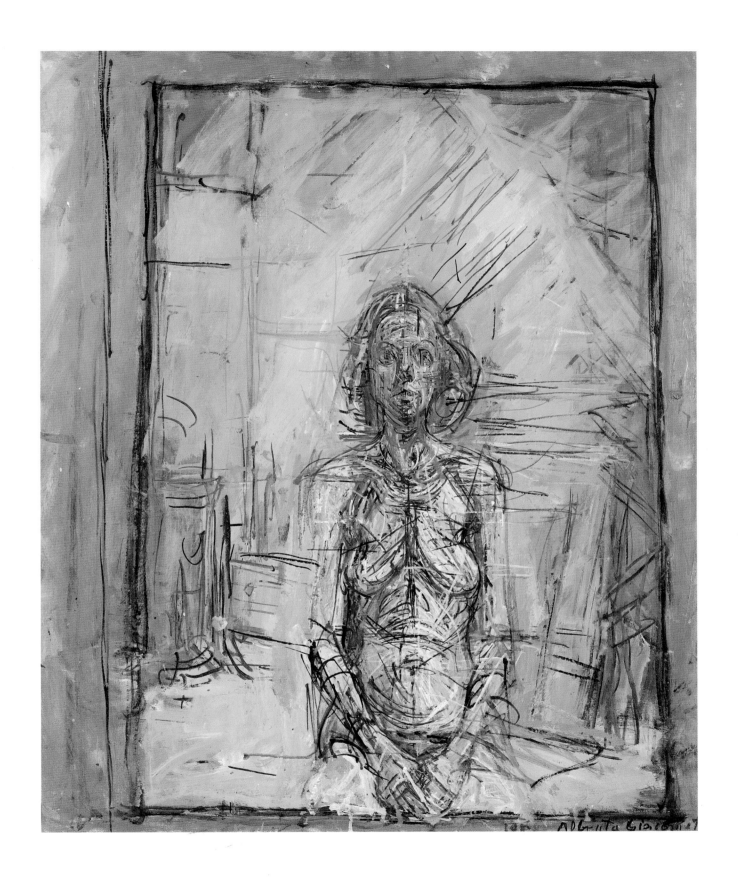

81 PORTRAIT OF ANNETTE 1954. Oil on canvas, 25⅛ x 21½″ (64 x 54.5 cm)
Inscr. lower right: Alberto Giacometti, Staatsgalerie, Stuttgart

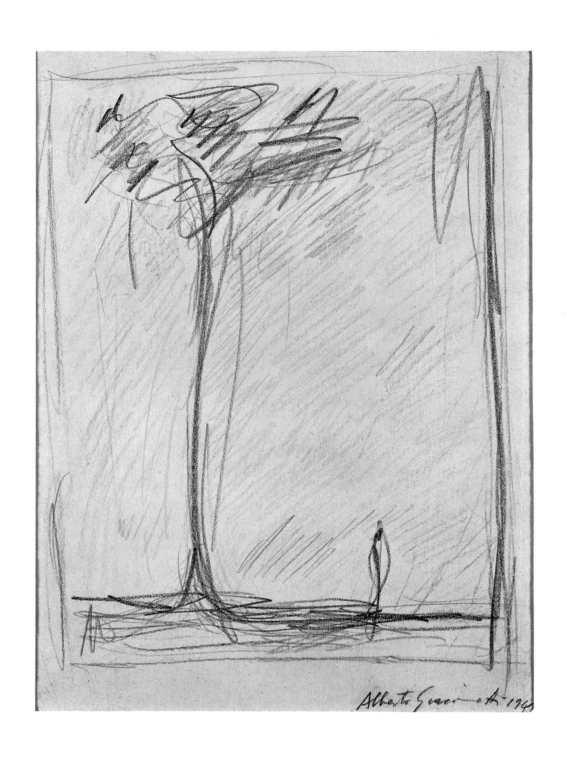

82　FIGURE UNDER A TREE　1949, FIGURE SOUS ARBRE. Verso: Figure under a tree
Crayon, 13¾ x 10″ (35 x 25.5 cm)
Inscr. lower right: Alberto Giacometti 1949. Collection of Gérald Cramer, Geneva

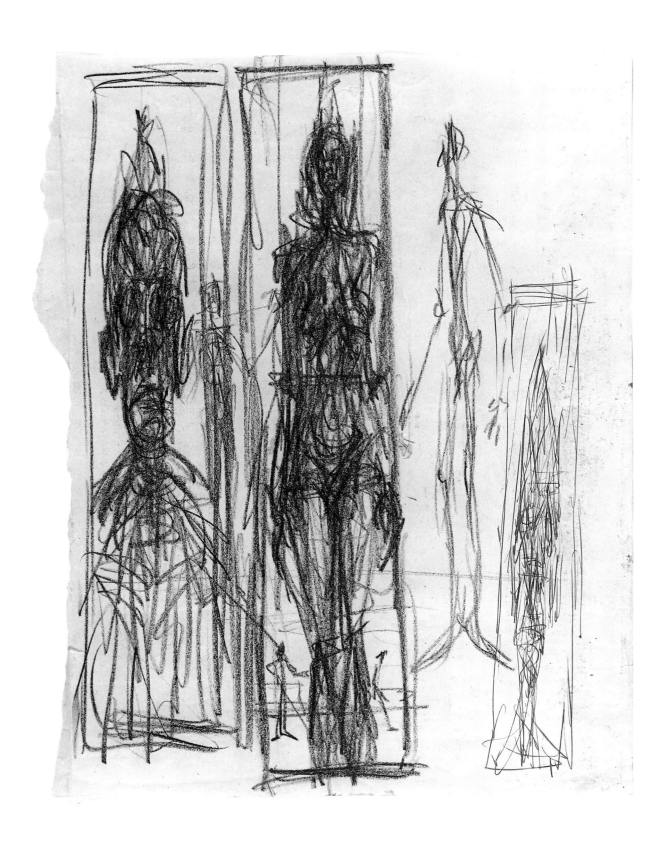

83 SHEET OF STUDIES WITH NUDES AND BUSTS 1951, ETUDES DE NUS ET BUSTE.
Verso: Three figure studies
Black wax crayon and blue ink, 15⅜ x 10¼″ (39 x 26 cm)
Kunsthandel Wolfgang Werner KG, Bremen

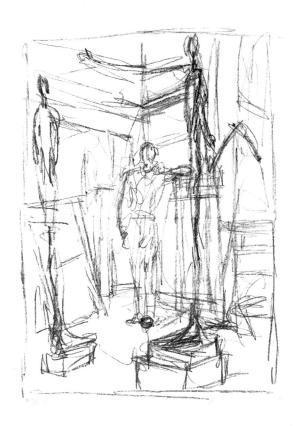

84　PERSON IN THE STUDIO　1954, PERSONNAGE DANS
L'ATELIER. Lithograph, 25⅝ x 19⅝″ (65.2 x 50 cm)
Inscr. lower right: A. Giacometti; lower left: 25/30
Lust 8, Kupferstichkabinett Berlin,
Staatliche Museen zu Berlin

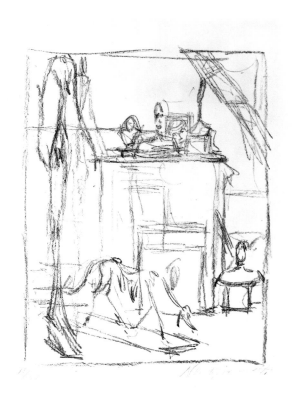

85　THE DOG　1954, LE CHIEN
Lithograph, 21⅛ x 17″ (53.8 x 43.3 cm)
Inscr. lower right: Alberto Giacometti; lower left: 18/30
Lust 21, Kupferstichkabinett Berlin,
Staatliche Museen zu Berlin

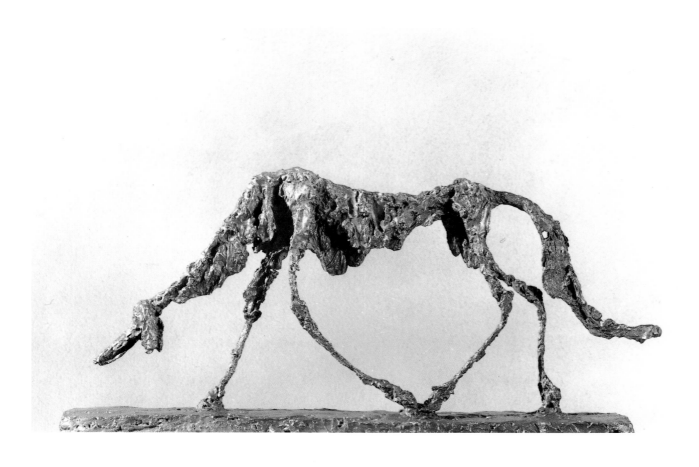

86 THE DOG 1951, LE CHIEN. Bronze, 17¾ x 38⅝ x 5⅞″ (45 x 98 x 15 cm)
Inscr. on the base-plate below the head: Alberto Giacometti 1/8, Alberto-Giacometti-Stiftung, Zurich

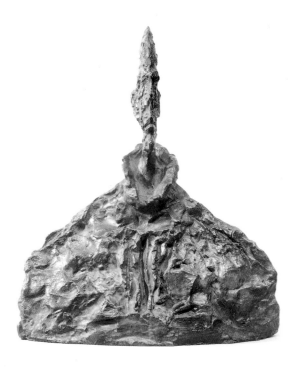

87 DIEGO IN A BLOUSON JACKET 1953,
DIEGO AU BLOUSON
Bronze, 14 x 11 x 4⅛″ (35.5 x 28 x 10.5 cm)
Inscr. at left on back: 1953, 3/6 Alberto Giaco-
metti; at right on back: Susse Fondeur Paris
Alberto-Giacometti-Stiftung, Zurich

88 HEAD OF DIEGO 1955, TÊTE DE DIEGO
Bronze, 22¼ x 8½ x 5⅞″
(56.5 x 21.5 x 15 cm)
Inscr. at left on back: 1/6 Giacometti;
at right on back: Susse Fondeur Paris
Alberto-Giacometti-Stiftung, Zurich

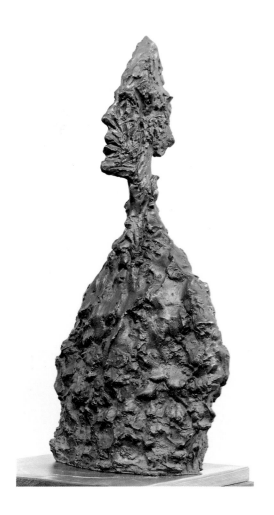

Right:
89 LARGE HEAD OF DIEGO 1954, GRANDE TÊTE DE DIEGO
Bronze, 25⅝ x 15⅜ x 8⅝″ (65 x 39 x 22 cm)
Inscr. at right on back on the shoulder:
Alberto Giacometti 4/6; at left on back on the shoulder:
Susse Fondeur Paris
Alberto-Giacometti-Stiftung, Zurich

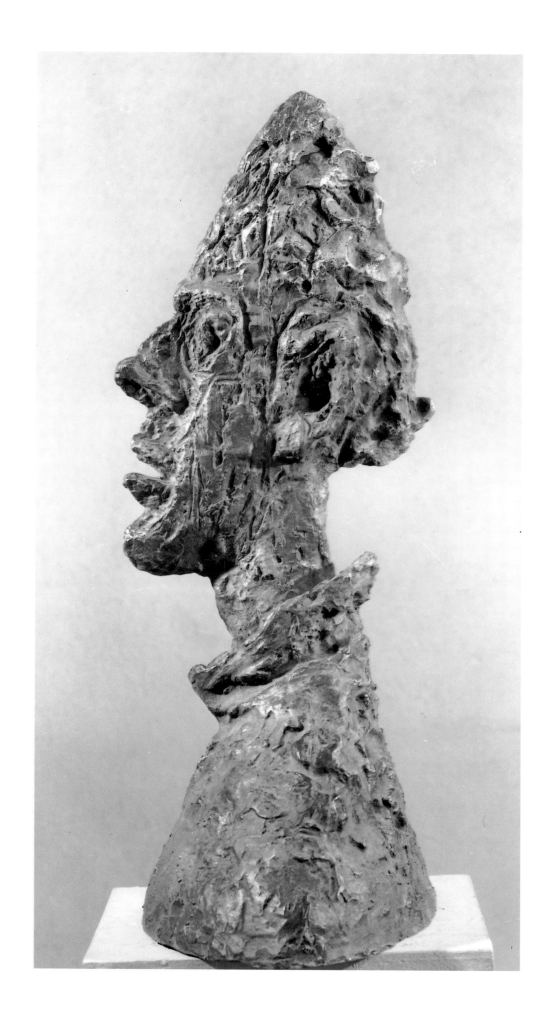

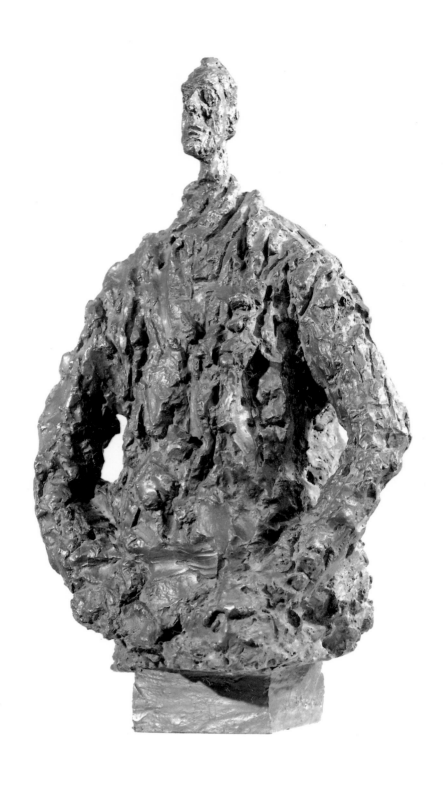

90 DIEGO IN A JACKET 1954, DIEGO AU CHANDAIL
Bronze, 19¼ x 10⅝ x 8¼″ (49 x 27 x 21 cm)
Inscr. at right on base: 1/6 Alberto Giacometti; on lower back of base: Susse Fondeur Paris
Alberto-Giacometti-Stiftung, Zurich

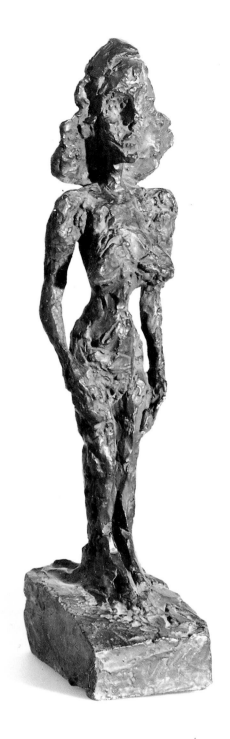

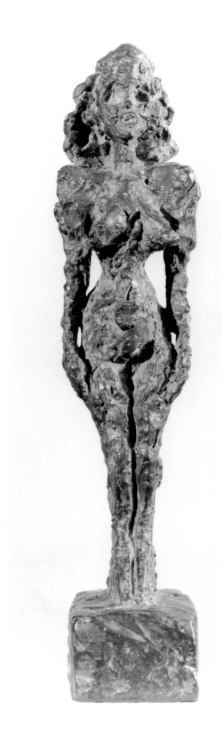

91 STANDING NUDE II 1953, NU DEBOUT II
Bronze, 19⅝ x 4¾ x 5⅞″ (50 x 12 x 15 cm)
Inscr. at right on base: Alberto Giacometti 1953 6/6: at left on base:
Susse Fondeur. EWK, Berne

92 STANDING NUDE III 1953, NU DEBOUT III
Bronze, 21½ x 4¾ x 6½″ (54.5 x 12 x 16.5 cm)
Inscr. at right on base: 1/6 1953 Alberto Giacometti
Alberto-Giacometti-Stiftung, Zurich

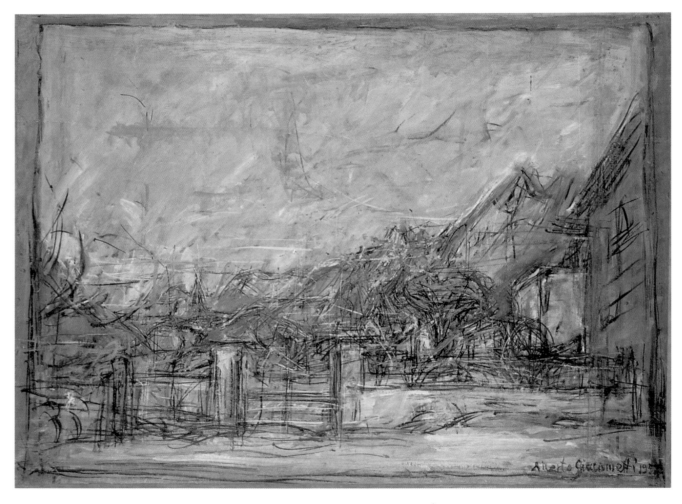

93 LANDSCAPE AT STAMPA 1952, PAYSAGE À STAMPA
Oil on canvas, 21⅝ x 28¾″ (55 x 73 cm)
Inscr. lower right: Alberto Giacometti 1952, Bündner Kunstmuseum,
Chur, Switzerland

Right:
94 MOUNTAIN AT MALOJA 1957, MONTAGNE À MALOJA. Lithograph, 19⅞ x 19¾″ (50.5 x 65.5 cm)
Inscr. lower right: Alberto Giacometti; lower left: 34/65
Lust 28, Kupferstichkabinett Berlin, Staatliche Museen zu Berlin

95 THE GIACOMETTI HOUSE AT MALOJA 1957, MAISON DE GIACOMETTI À MALOJA. Lithograph, 19⅞ x 26″ (50.5 x 66 cm)
Inscr. lower right: Alberto Giacometti; lower left: 27/65
Lust 27, Kupferstichkabinett Berlin, Staatliche Museen zu Berlin

96 PORTRAIT OF JEAN GENET 1954. Pencil, 19⅜ x 12¾″ (49.3 x 32.5 cm)
Inscr. lower right: Alberto Giacometti 1 septembre 1954. EWK, Berne

97 PORTRAIT OF HENRI MATISSE 1954
Pencil, 19¼ x 12⅝″ (49 x 32 cm)
Inscr. lower right: Alberto Giacometti;
lower left: mercredi 30 juin 54
Private collection, Paris

98 PORTRAIT OF HENRI MATISSE 1954
Pencil on ivory-coloured handmade paper, 19¼ x 12⅞″
(48.8 x 32.6 cm)
Verso: Portrait of Henri Matisse.
Inscr. lower right: Alberto Giacometti.
Graphische Sammlung, Staatsgalerie, Stuttgart

99 SEATED MAN (PORTRAIT OF JAMES LORD) 1955–57, HOMME ASSIS (PORTRAIT DE JAMES LORD)
Pencil, 19⅝ x 12⅝″ (50 x 32 cm). Fondation Pierre Gianadda, Martigny

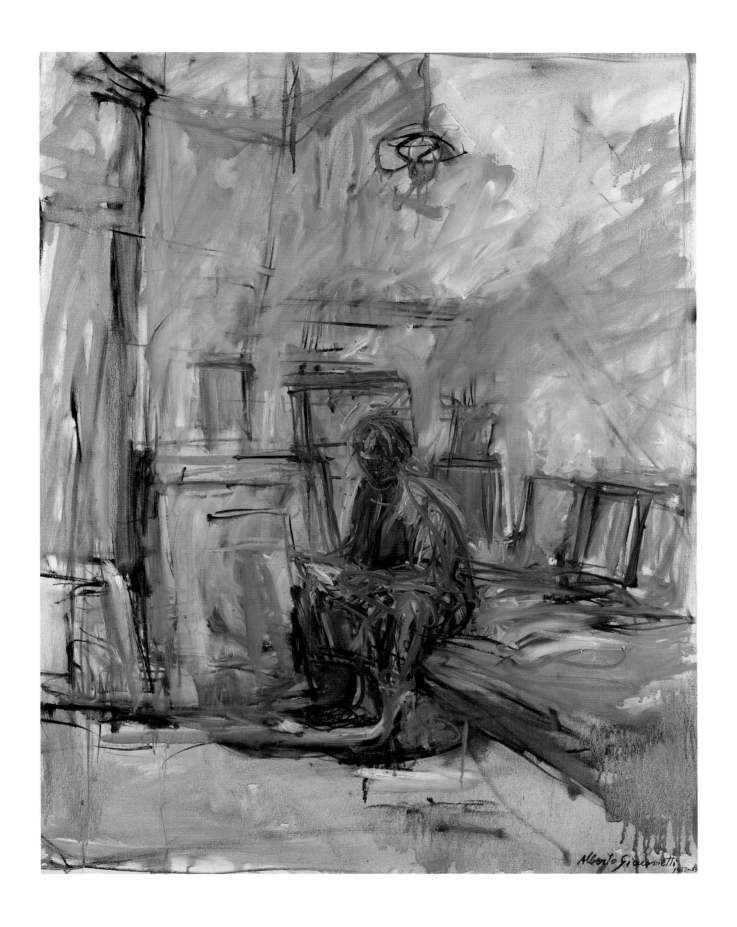

100 SEATED FIGURE IN THE STUDIO 1954, FIGURE ASSISE DANS L'ATELIER
Oil on canvas, 36¼ x 28″ (92 x 71 cm)
Inscribed lower right: Alberto Giacometti. Kunstmuseum, Winterthur

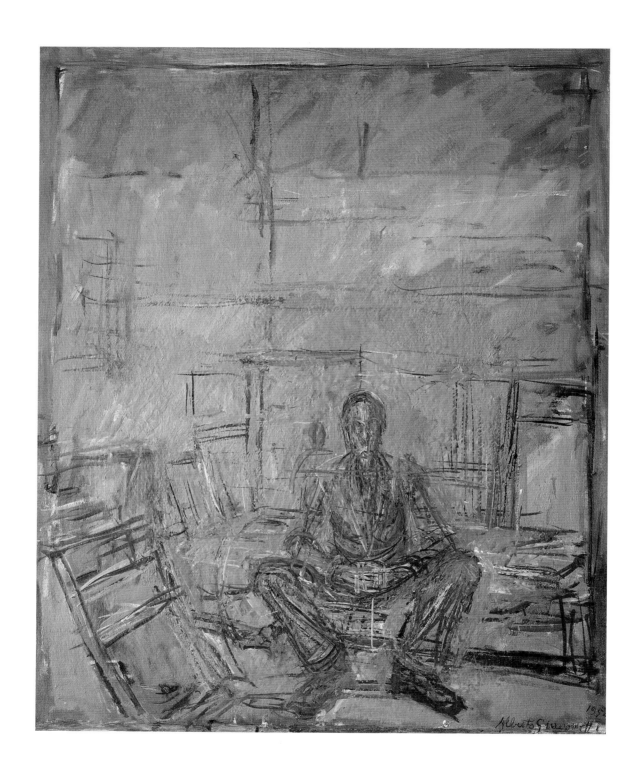

101 PORTRAIT OF PETER WATSON 1954. Oil on canvas, $28\frac{3}{4}$ x $23\frac{5}{8}$'' (73 x 60 cm)
Inscr. lower right: Alberto Giacometti 1954. Alberto-Giacometti-Stiftung, Zurich

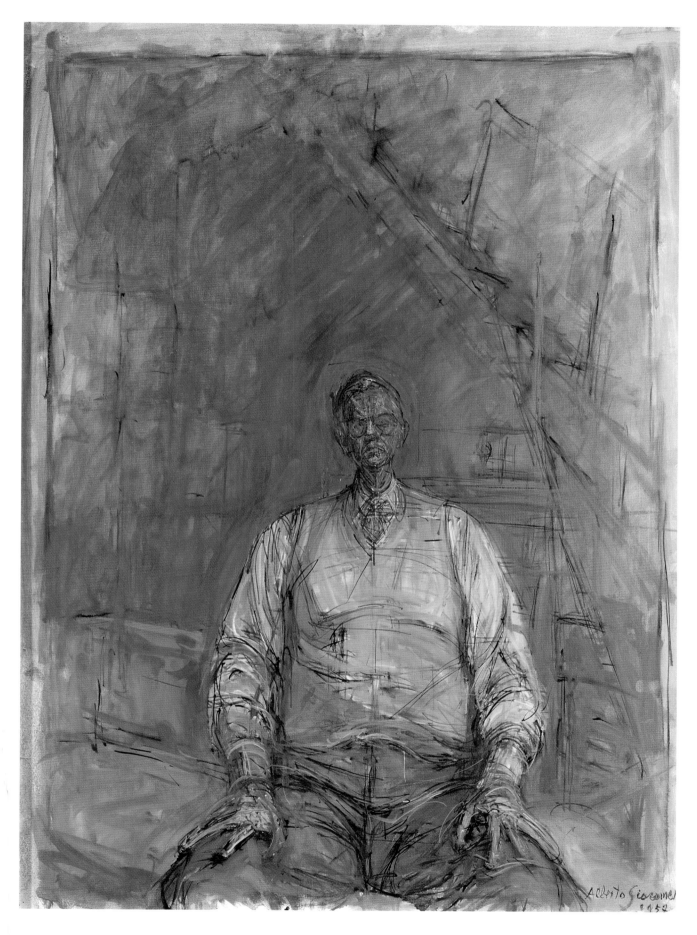

102 PORTRAIT OF G. DAVID THOMPSON 1957. Oil on canvas, 39⅜ x 28¾″ (100 x 73 cm)
Inscr. lower right: Alberto Giacometti 1957. Alberto-Giacometti-Stiftung, Zurich

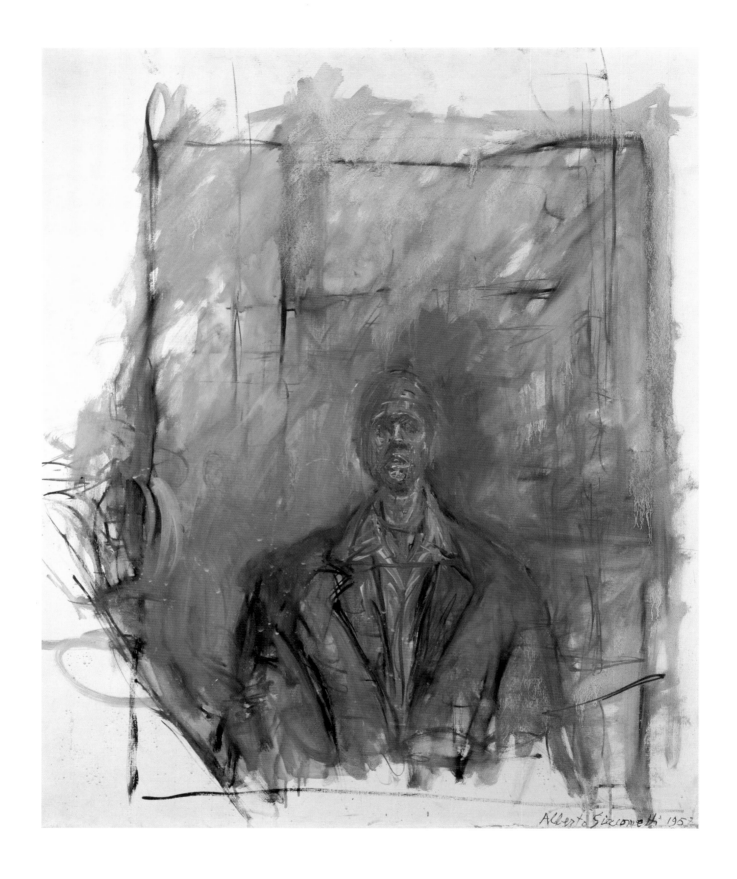

103 JEAN GENET 1957. Oil on canvas, 30⅞ x 23⅝" (78.5 x 60 cm)
Inscr. lower right: Alberto Giacometti 1957. Galerie Beyeler, Basle

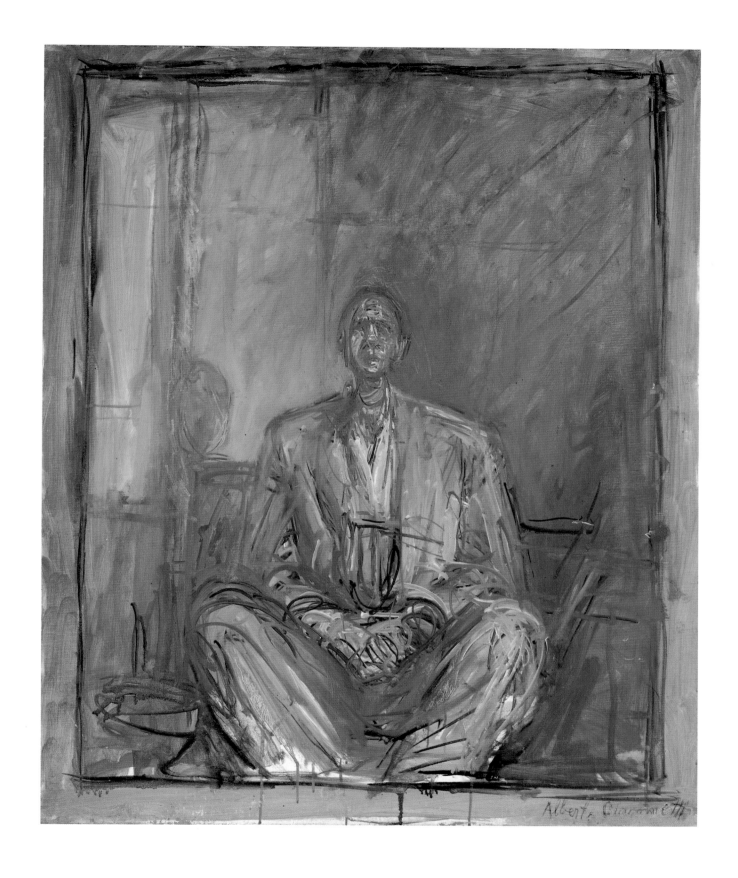

104 PORTRAIT OF JEAN GENET 1955. Oil on canvas, 28¾ x 23⅝″ (73 x 60 cm)
Inscr. lower right: Alberto Giacometti. Musée national d'art moderne, Centre Georges Pompidou, Paris

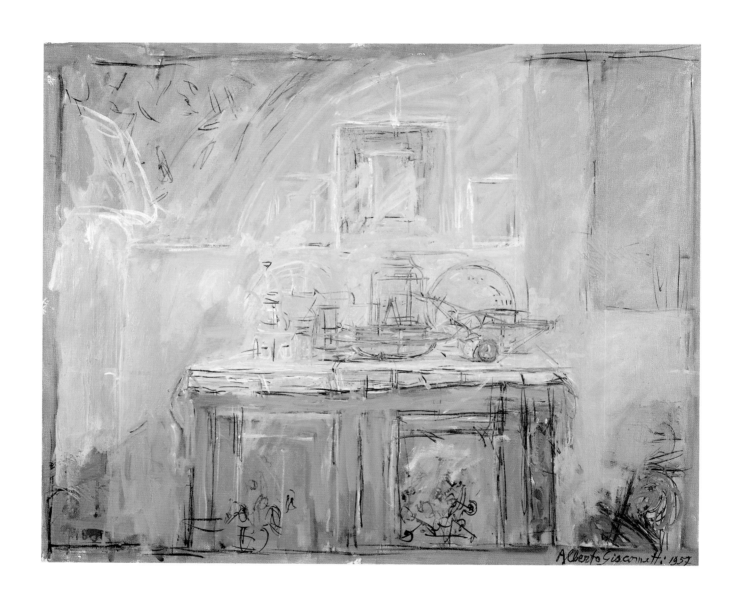

105 THE SIDEBOARD 1957, LE BUFFET. Oil on canvas, 19⅝ x 24″ (50 x 61 cm)
Inscr. lower right: Alberto Giacometti 1957
Fogg Art Museum, Harvard University Art Museums, Cambridge, Mass.

106 INTERIOR 1959, INTÉRIEUR
Pencil, 19⅝ x 18¼″ (50 x 46.5 cm)
Inscr. lower right: Alberto Giacometti 1959.
Städtische Kunsthalle, Mannheim

107 INTERIOR WITH APPLES ON A TABLE
1956, INTÉRIEUR AVEC POMMES
SUR UN TABLE
Pencil, 25½ x 19½″ (64.8 x 49.8 cm)
Inscr. lower right: Alberto Giacometti 1956.
Kunsthalle, Bremen

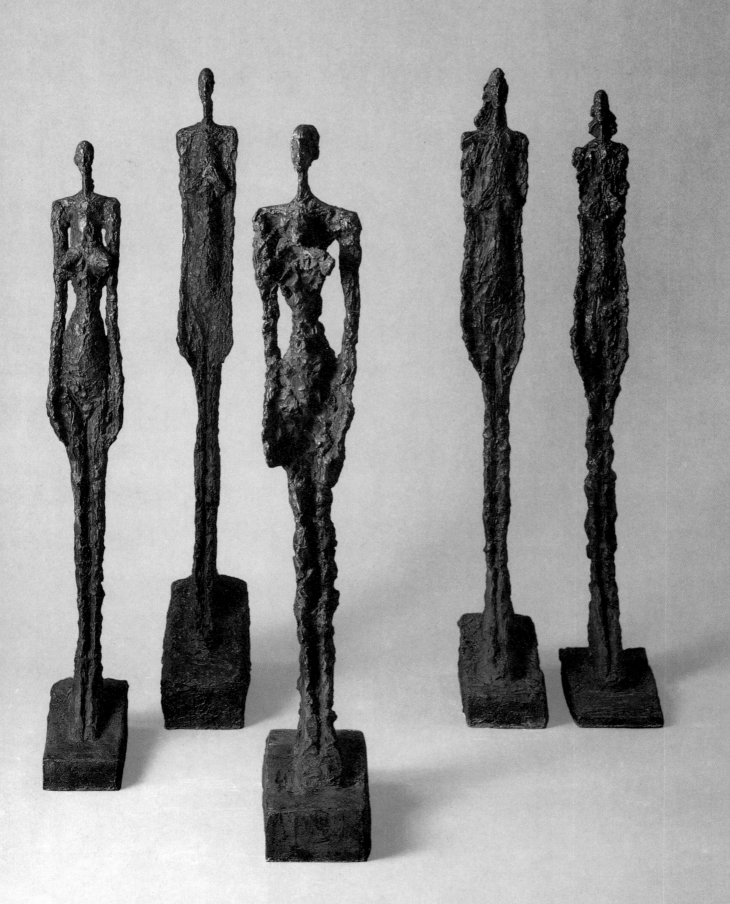

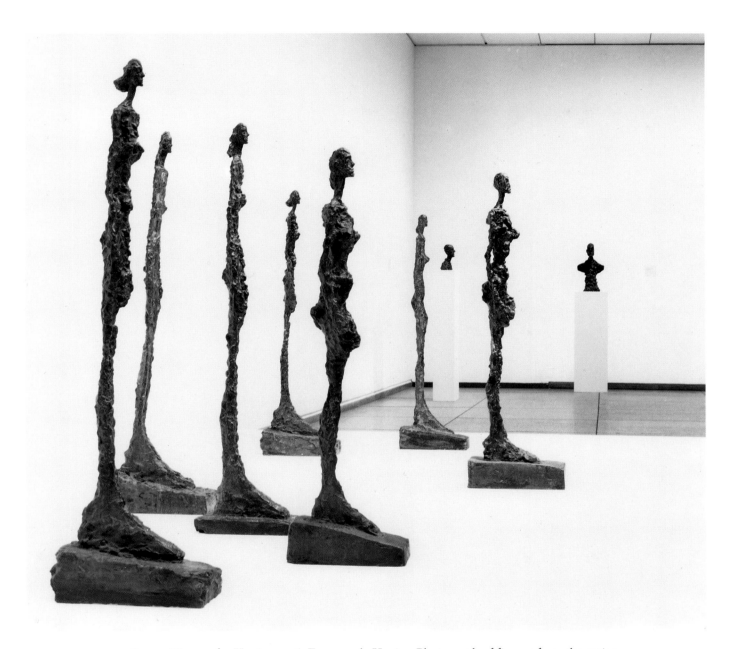

108-114 Women for Venice 1956, Femmes de Venise. Photograph of figures from the series

Left:
108-114 Women for Venice II, IV, V, VII, VIII 1956, Femmes de Venise. Photograph of figures from the series

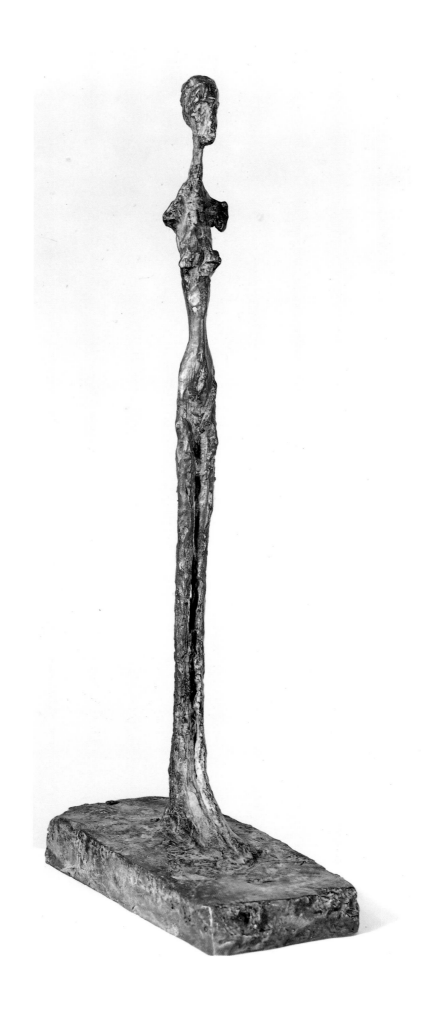

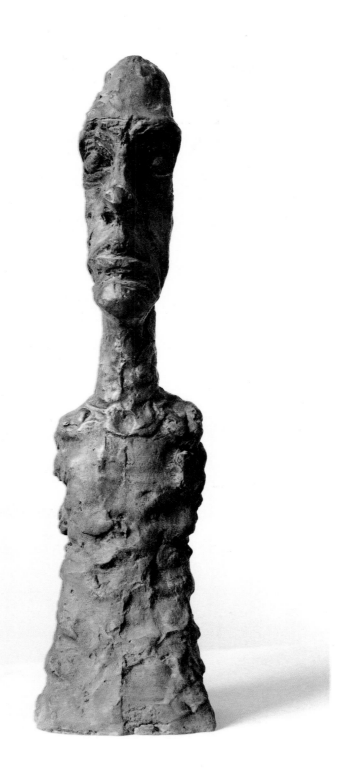

116 BUST WITH LARGE EYES (DIEGO) 1957, BUSTE AUX GRANDS YEUX (DIEGO)
Bronze, 21¼ x 5½ x 4¾″ (54 x 14 x 12 cm)
Signed on the back. Private collection, Paris

Left:
115 SLENDER WOMAN WITHOUT ARMS 1958–60, FEMME MINCE SANS BRAS
Bronze, 27½ x 7⅞ x 5⅛″ (70 x 20 x 13 cm)
Inscr. on front of base: 2/6 Alberto Giacometti; below on back of base: Susse Fondeur Paris
Nationalgalerie Berlin, Staatliche Museen zu Berlin

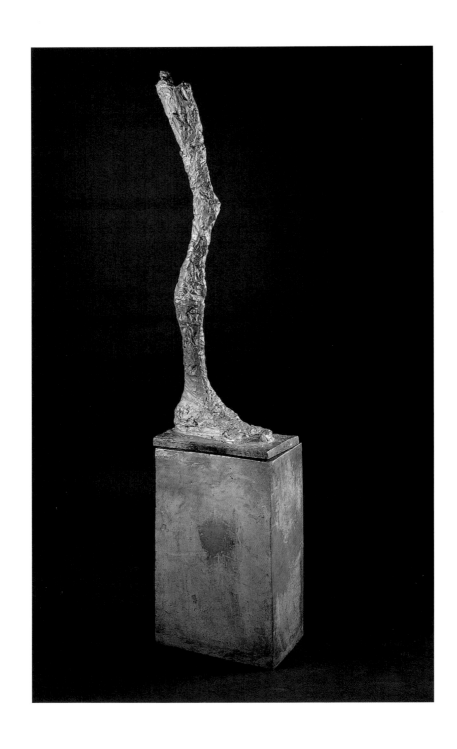

117 THE LEG 1958, LA JAMBE
Bronze, 86⅝ x 11¾ x 18¼″ (220 x 30 x 46.5 cm)
Inscr. on plinth: 2/6 Alberto Giacometti; on edge at
back: Susse Fondeur Paris
Wilhelm-Lehmbruck-Museum, Duisburg

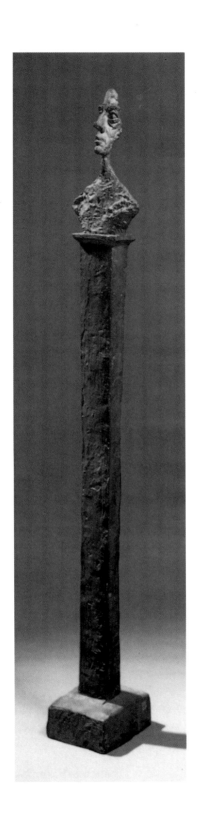

118 BUST OF DIEGO ON A STELE (STELE II) 1958,
BUSTE DE DIEGO SUR STÈLE (STÈLE II)
Bronze, 65 x 8¾ x 7⅞″ (165.1 x 22.2 x 18.8 cm)
Inscr. on back at lower right: A. Giacometti 1/6.
The Hirshhorn Museum and Sculpture Garden,
Smithsonian Institution, Washington, D.C. Gift
of Joseph H. Hirshhorn, 1966

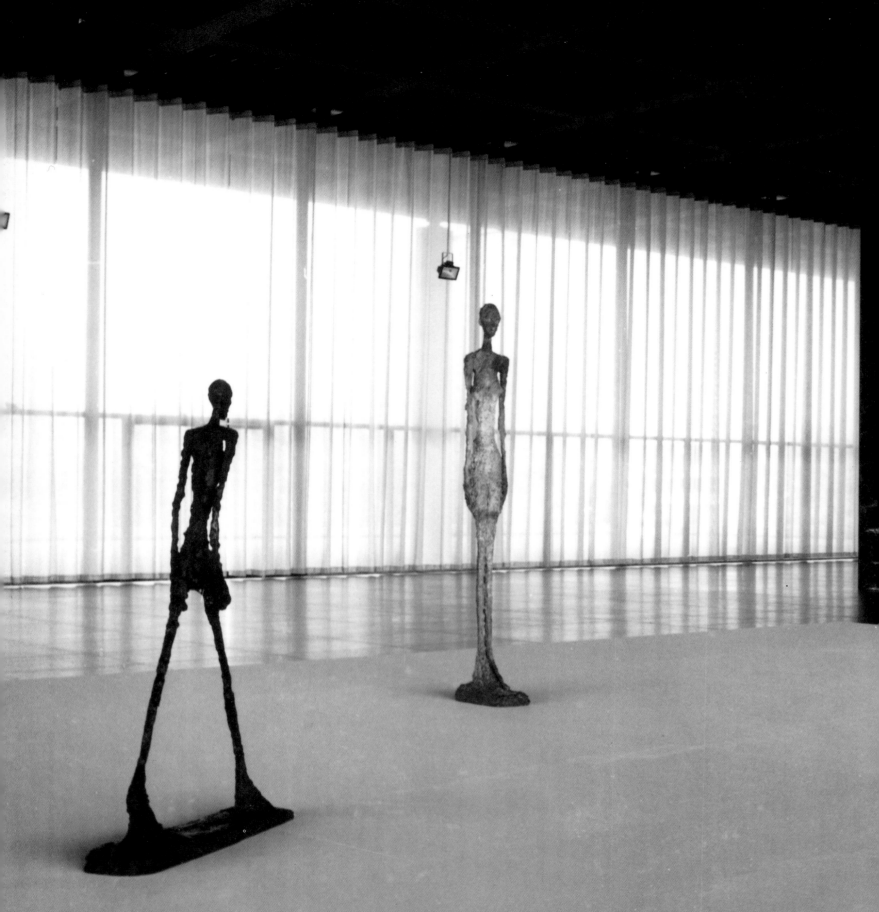

119 MAN WALKING II 1960
HOMME QUI MARCHE II
Bronze, 73⅝ x 10⅝ x 43¼″ (187 x 27 x 110 cm)
Incr. on base at right:
Alberto Giacometti, Susse Fondeur Paris 6/6
Rijksmuseum Kröller-Müller, Otterlo

120 STANDING WOMAN II 1960
FEMME DEBOUT II
Painted bronze, height 109½″ (278 cm)
Fondation Maeght, Saint-Paul-de-Vence

121 STANDING WOMAN I 1960
FEMME DEBOUT I
Painted bronze, height 106¼″ (270 cm)
Fondation Maeght, Saint-Paul-de-Vence

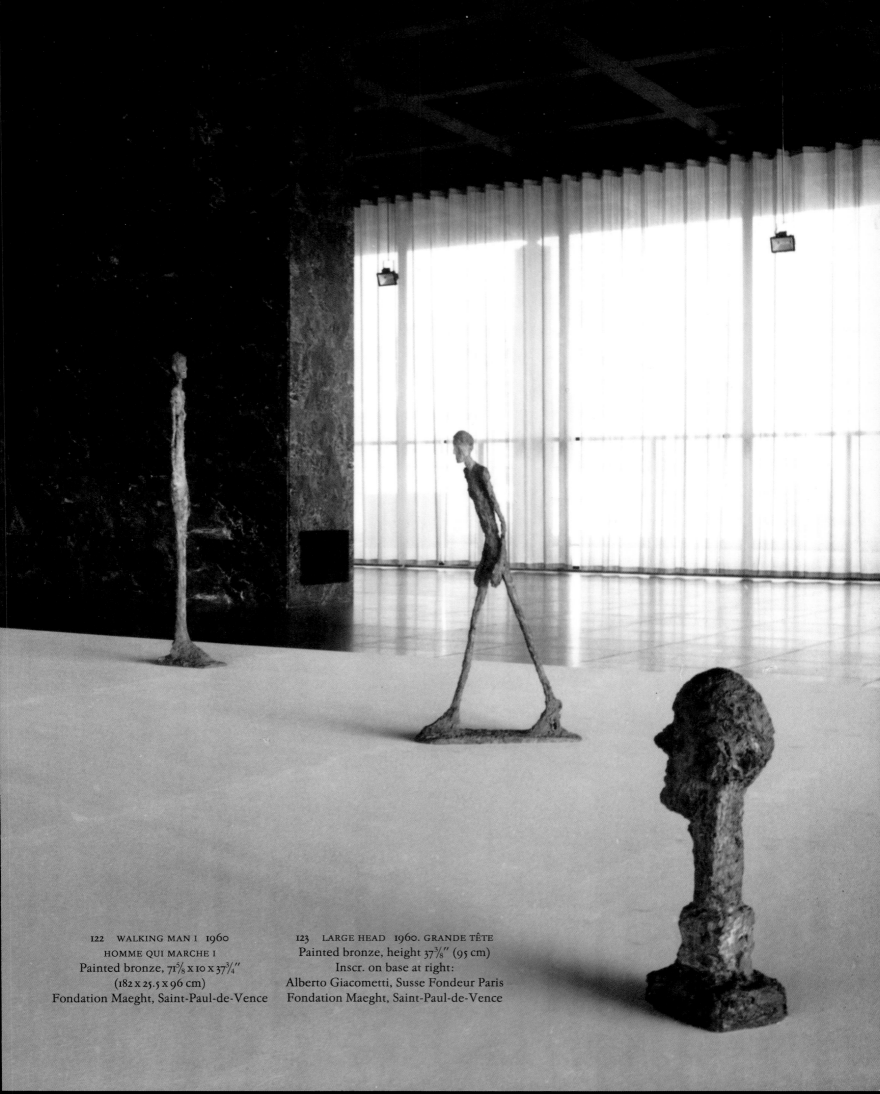

122 WALKING MAN I 1960
HOMME QUI MARCHE I
Painted bronze, 71⅝ x 10 x 37¾"
(182 x 25.5 x 96 cm)
Fondation Maeght, Saint-Paul-de-Vence

123 LARGE HEAD 1960. GRANDE TÊTE
Painted bronze, height 37⅜" (95 cm)
Inscr. on base at right:
Alberto Giacometti, Susse Fondeur Paris
Fondation Maeght, Saint-Paul-de-Vence

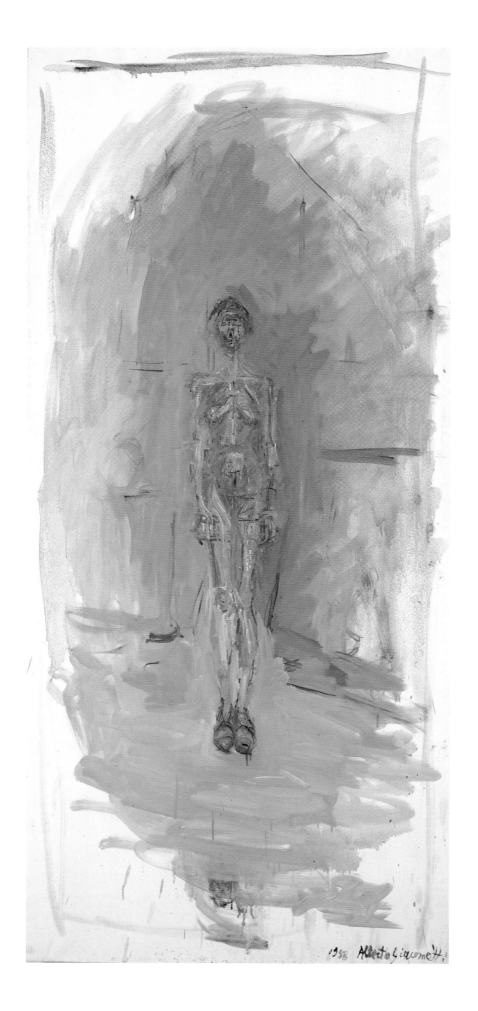

1958 Alberto Giacometti

124 STANDING NUDE 1958, NU DEBOUT
Oil on canvas, 61 x 27⅜″ (155 x 69.5 cm)
Inscr. lower right: 1958 Alberto Giacometti
Galerie Jan Krugier, Geneva

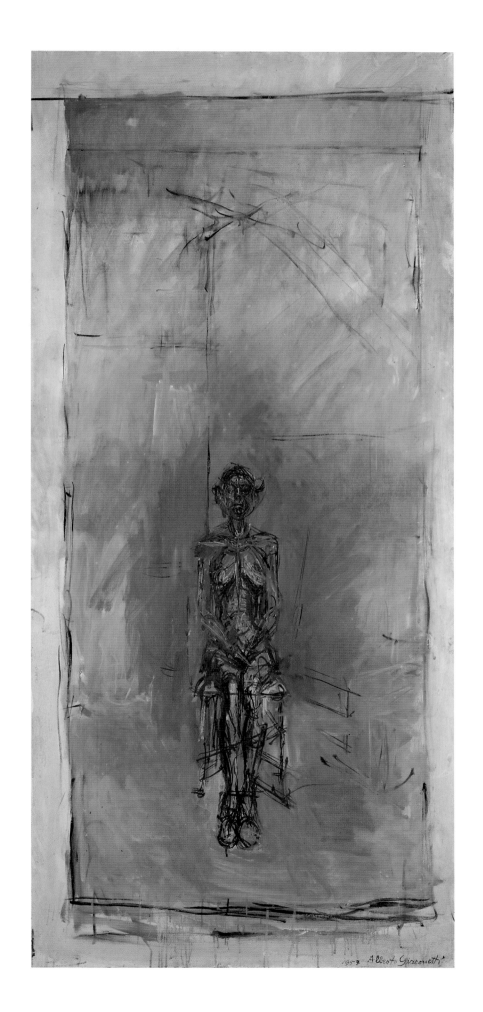

125 LARGE SEATED NUDE 1957,
GRAND NU, ASSIS
Oil on canvas, 60⅝ x 23¼″ (154 x 59 cm)
Inscr. lower right: Alberto Giacometti
Städelsches Kunstinstitut und
Städtische Galerie, Frankfurt am Main

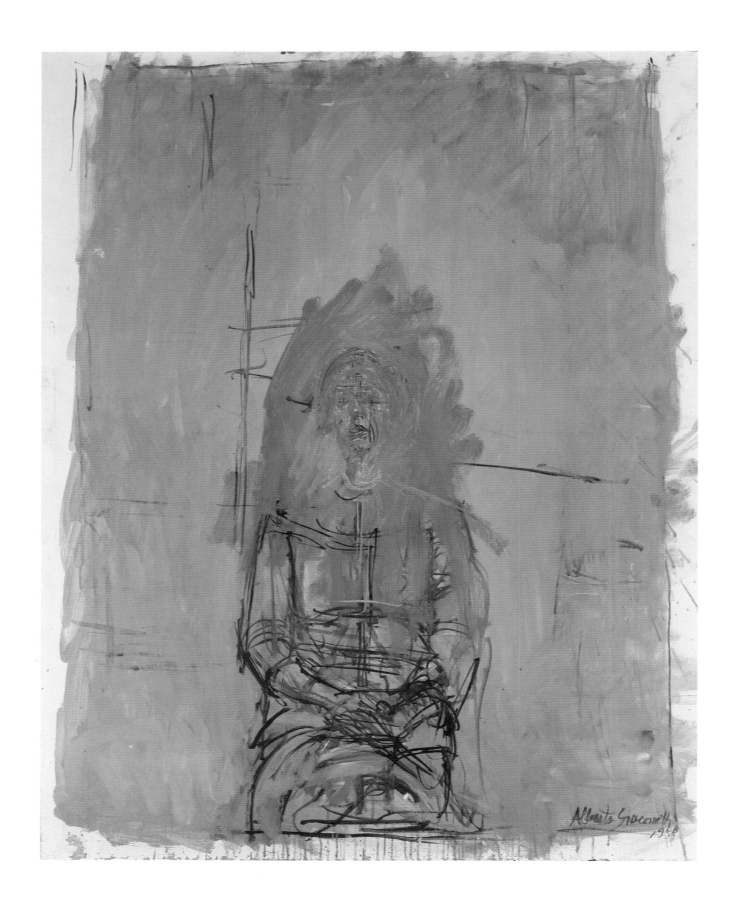

126 PORTRAIT OF ANNETTE 1958. Oil on canvas, 36¼ x 28½″ (92 x 72.5 cm)
Inscr. lower right: Alberto Giacometti 1958. Galerie Beyeler, Basle

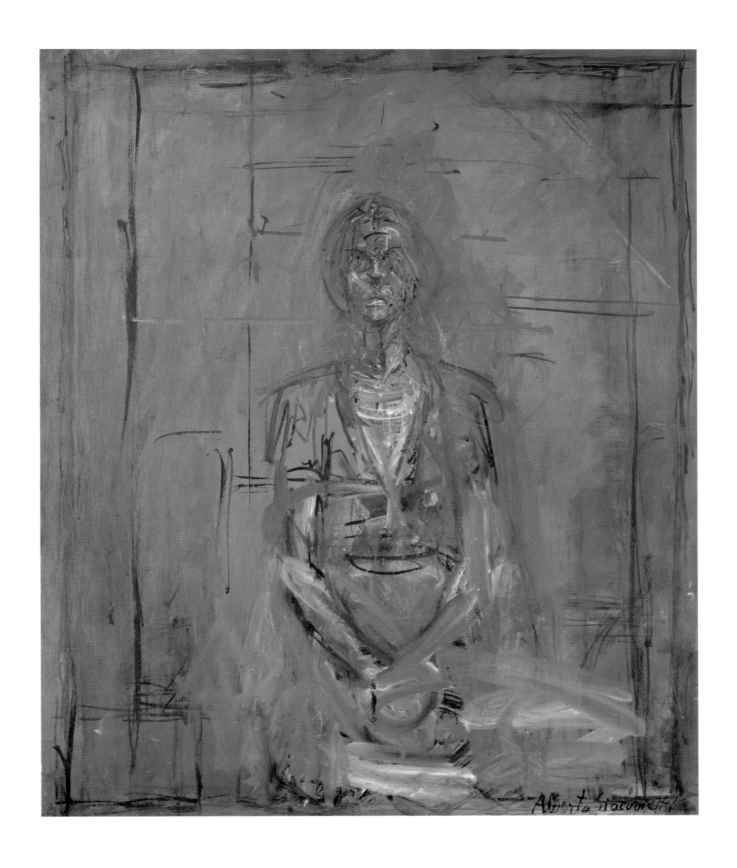

127 PORTRAIT OF ANNETTE 1958. Oil on canvas, 25⅝ x 21½″ (65 x 54.5 cm)
Inscr. lower right: Alberto Giacometti. Galerie Beyeler, Basle

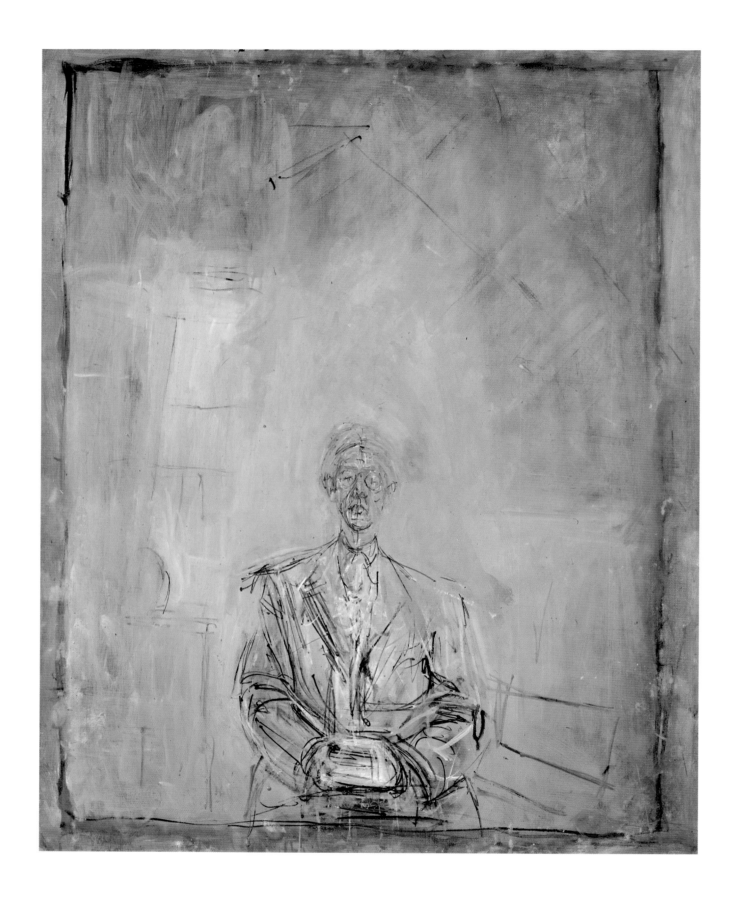

128 ISAKU YANAIHARA 1956. Oil on canvas, 32⅛ x 25¾″ (81.5 x 65.5 cm)
Musée national d'art moderne, Centre Georges Pompidou, Paris

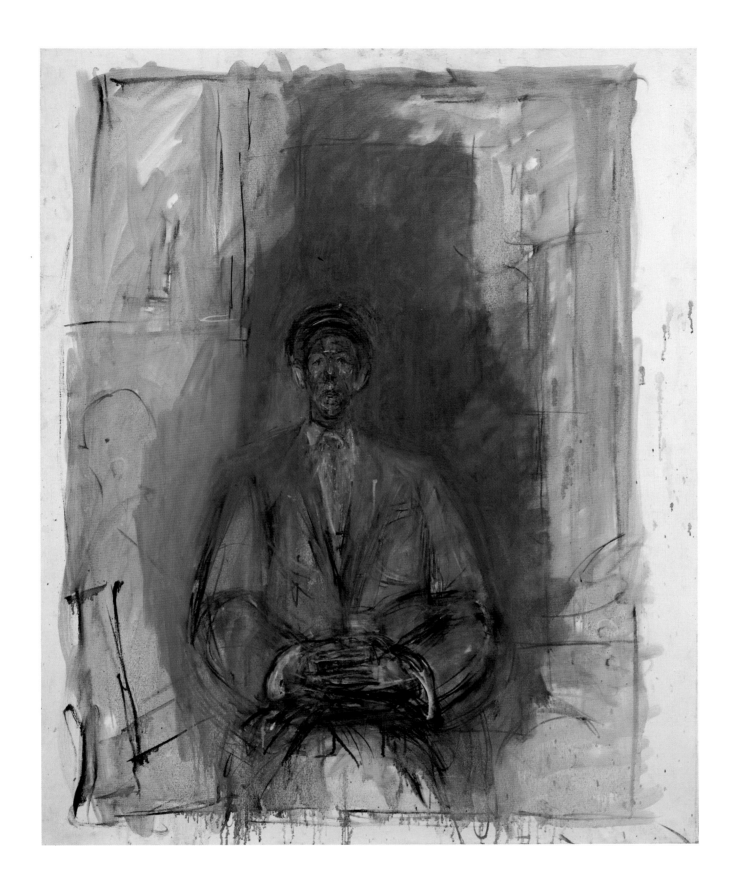

129 PORTRAIT OF YANAIHARA 1959. Oil on canvas, $36\frac{1}{4}$ x $28\frac{3}{4}''$ (92 x 73 cm)
Collection of M. et Mme Adrien Maeght, Paris

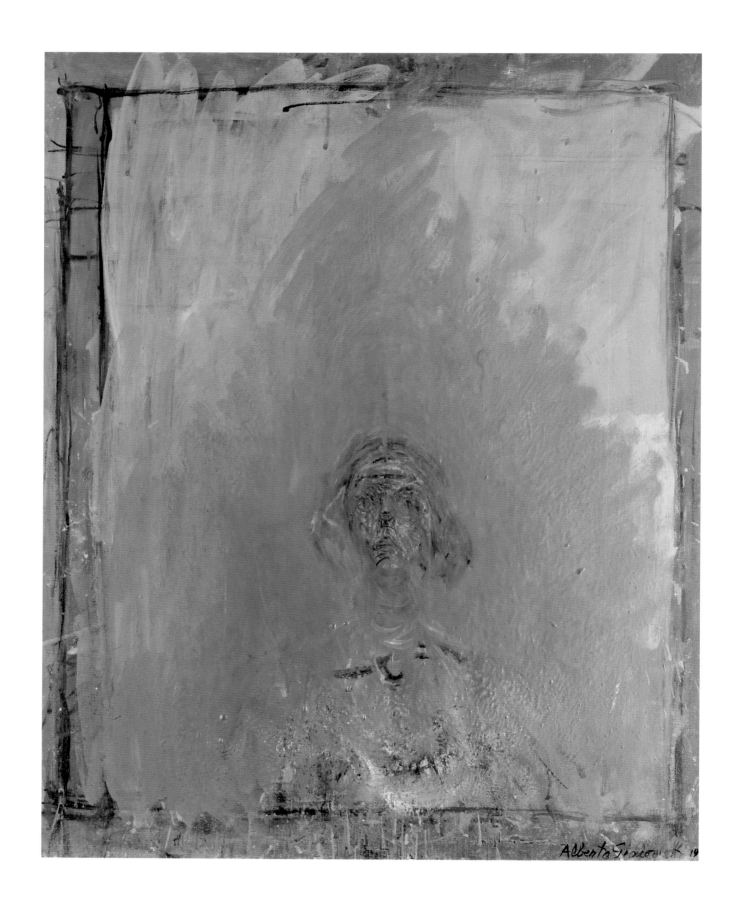

130 SKETCH 1957, ESQUISSE. Oil on canvas, 28¾ x 23⅝″ (73 x 60 cm). Kunsthaus, Zurich

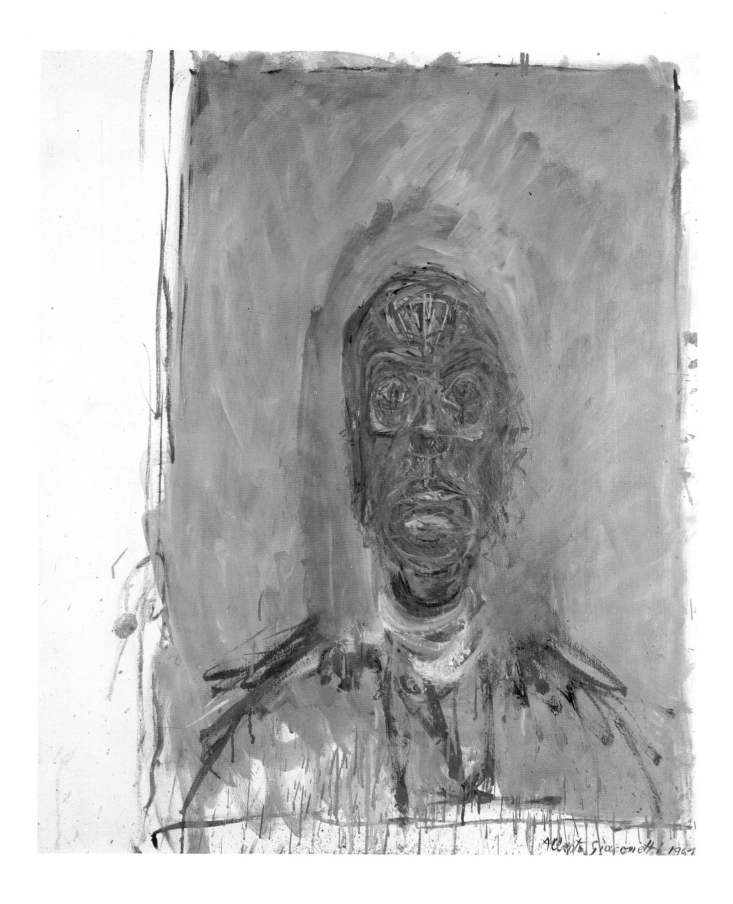

131 LARGE BLACK HEAD 1961, GRANDE TÊTE NOIRE. Oil on canvas, 31⅞ x 25⅝″ (81 x 65 cm). Private collection

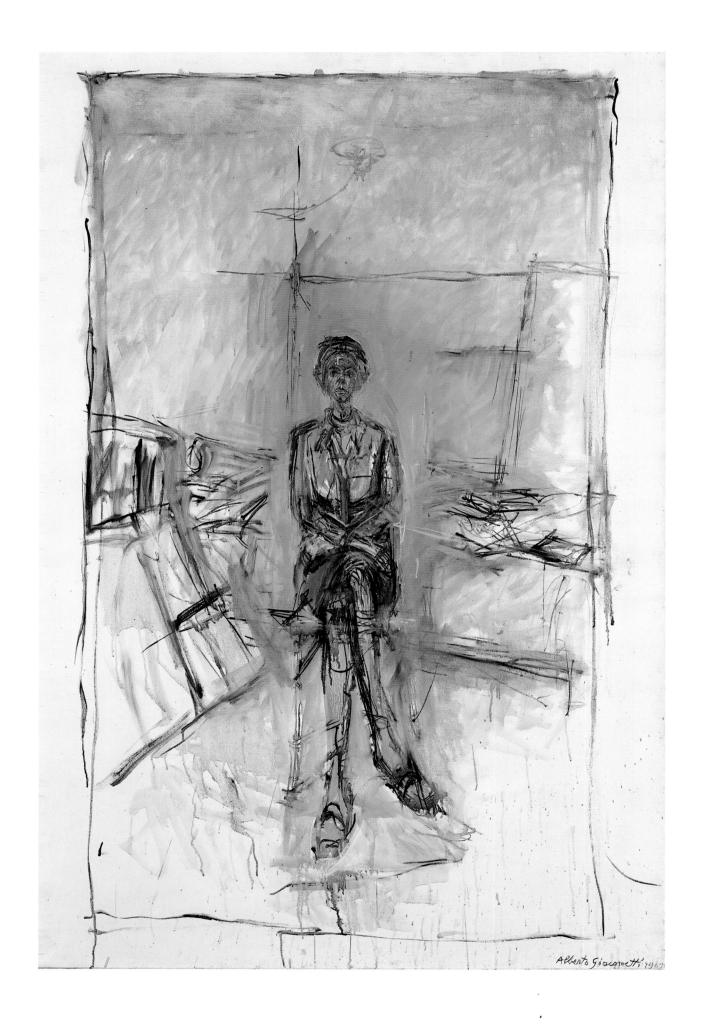

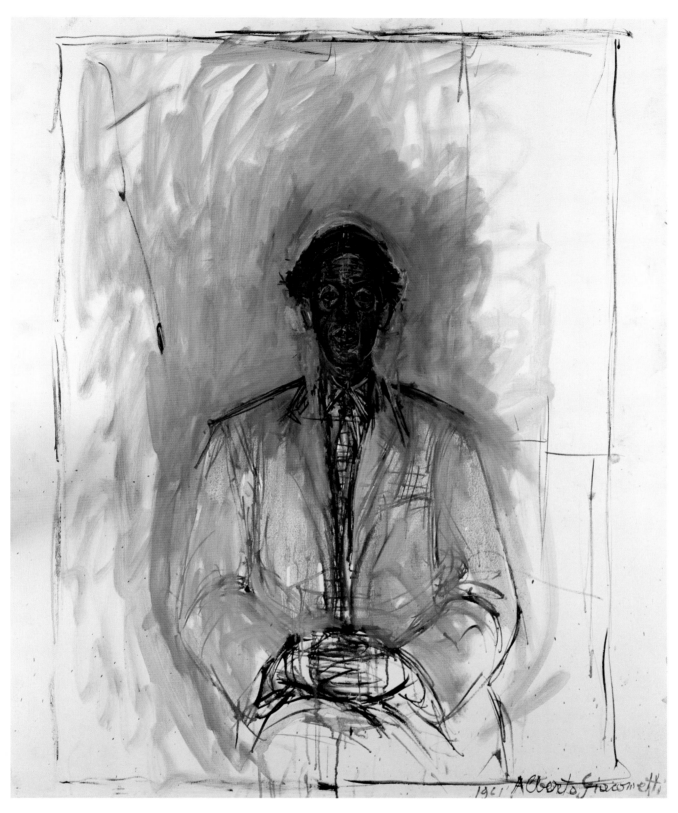

133 PORTRAIT OF YANAIHARA 1961. Oil on canvas, 39⅜ x 31⅞″ (100 x 81 cm)
Inscr. lower right: Alberto Giacometti 1961. Collection of Ernst Beyeler, Basle

Left:
132 ANNETTE IN THE STUDIO 1961, ANNETTE DANS L'ATELIER. Oil on canvas, 57½ x 38¼″ (146 x 97 cm)
Inscr. lower right: Alberto Giacometti 1961. Hamburger Kunsthalle

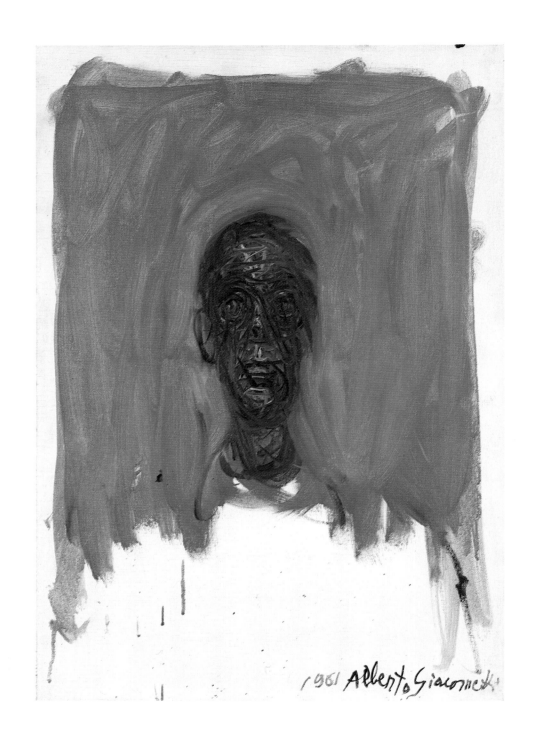

134 HEAD OF DIEGO 1961, TÊTE DE DIEGO. Oil on canvas, 21⅝ x 15″ (54.9 x 38 cm)
Inscr. lower right: 1961 Alberto Giacometti
The Hirshhorn Museum and Sculpture Garden, Smithsonian Institution, Washington, D.C.
Gift of Joseph H. Hirshhorn, 1966

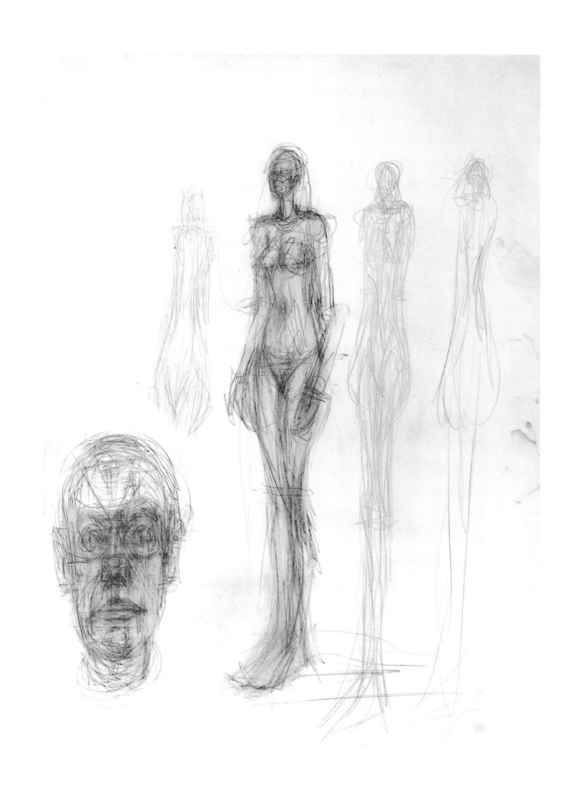

135 HEAD AND FOUR LARGE STANDING WOMEN 1960,
TÊTE ET QUATRE FEMMES GRANDES DEBOUT
Pencil, 19⅝ x 14″ (50 x 35.5 cm)
Private collection, Switzerland

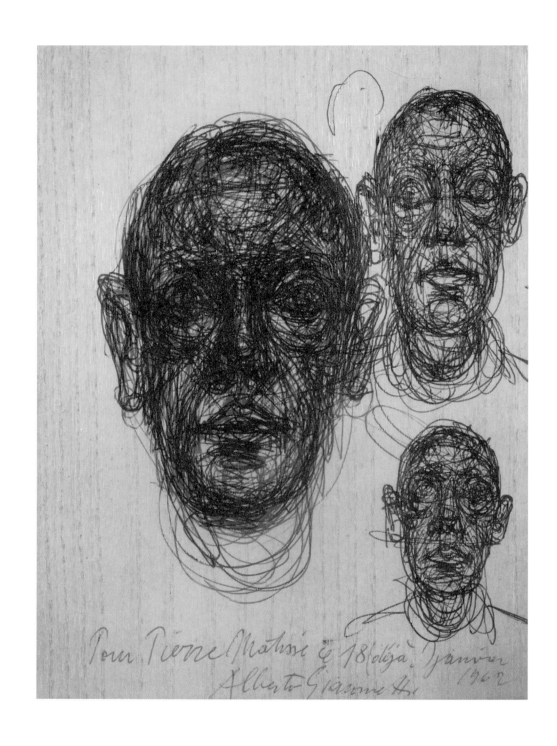

136 THREE HEADS 1962, TROIS TÊTES. Ball-point pen, 8⅛ x 6″ (20.7 x 15.2 cm)
Inscr. lower right: Alberto Giacometti 1962, Pour Pierre Matisse le 18 (déjà)
janvier 1962. Private collection

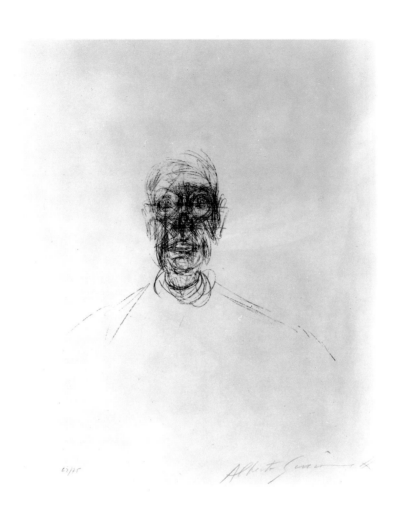

137 HEAD OF A MAN 1963–64, TÊTE D'HOMME
Lithograph, 25¾ x 18⅞" (65.5 x 48 cm)
Inscr. lower right: Alberto Giacometti; lower left: 62/75
Lust 47, Kupferstichkabinett Berlin, Staatliche Museen zu Berlin

138 HEADS *c.* 1962, TÊTES. Ball-point pen, 18⅛ x 10¼″ (46 x 26 cm). Galerie Scheidegger, Zurich

Right:
139 SELF-PORTRAIT 1963, AUTOPORTRAIT. Pencil, 19⅞ x 12¾″ (50.5 x 32.5 cm). Alberto-Giacometti-Stiftung, Zurich

140 HOTEL ROOM IV 1963, CHAMBRE D'HÔTEL.
Pencil, 19⅝ x 13″ (50 x 33 cm)
Alberto-Giacometti-Stiftung, Zurich

141 STUDIO WITH BUST 1964, ATELIER AVEC BUSTE
Pencil, 21⅝ x 16⅛″ (55 x 41 cm)
Inscr. lower right: Alberto Giacometti 1964
Bündner Kunstmuseum, Chur

142 THE STUDIO 1964, ATELIER, Oil on canvas, 22⅞ x 21⅝" (58 x 55 cm)
Inscr. lower right: Alberto Giacometti
Alberto-Giacometti-Stiftung, Zurich

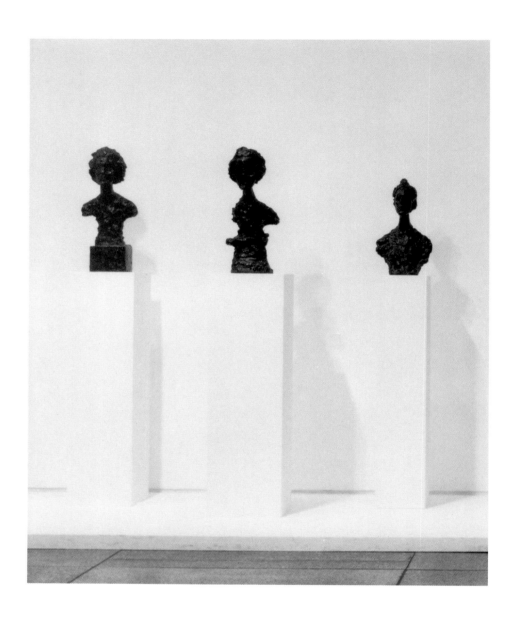

143 ANNETTE VII 1962
Bronze, height 23⅜″ (59.5 cm)
Inscr. on top left of base:
Alberto Giacometti, 2/6
San Francisco Museum of Modern Art
Gift of Mr and Mrs Louis Honig

145 ANNETTE 1961
Painted bronze, 18⅛ x 5⅛ x 4¾″
(46 x 13 x 12 cm)
Inscr. on back: Alberto Giaco-
metti; underneath: 0/6
Bündner Kunstmuseum, Chur

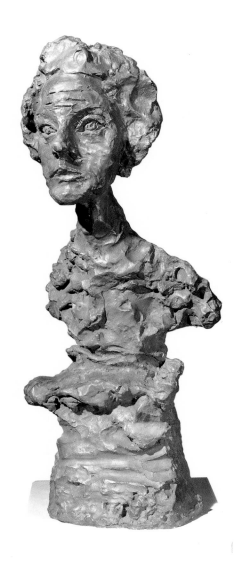

144 *See right:*
144 ANNETTE IV 1962, Bronze, 23 x 9¼ x 9″ (58.4 x 23.5 x 22.9 cm)
Inscr. lower right: Alberto Giacometti o/6, Susse Fondeur Paris
The Trustes of the Tate Gallery, London

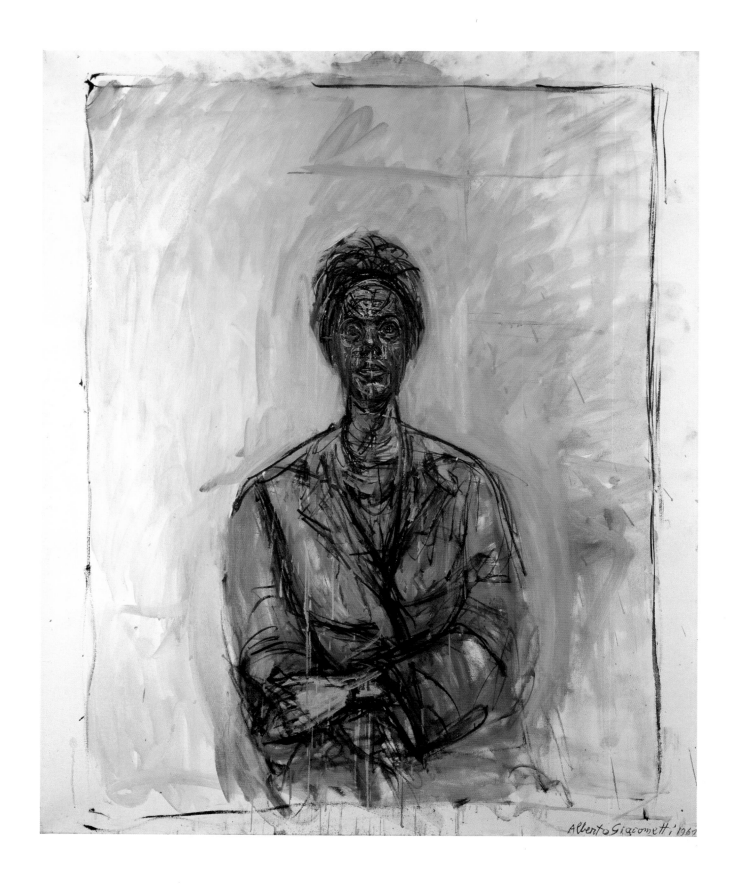

146 CAROLINE 1961. Oil on canvas, 39⅜ x 31⅞″ (100 x 81 cm)
Inscr. lower right: Alberto Giacometti 1961. Galerie Beyeler, Basle

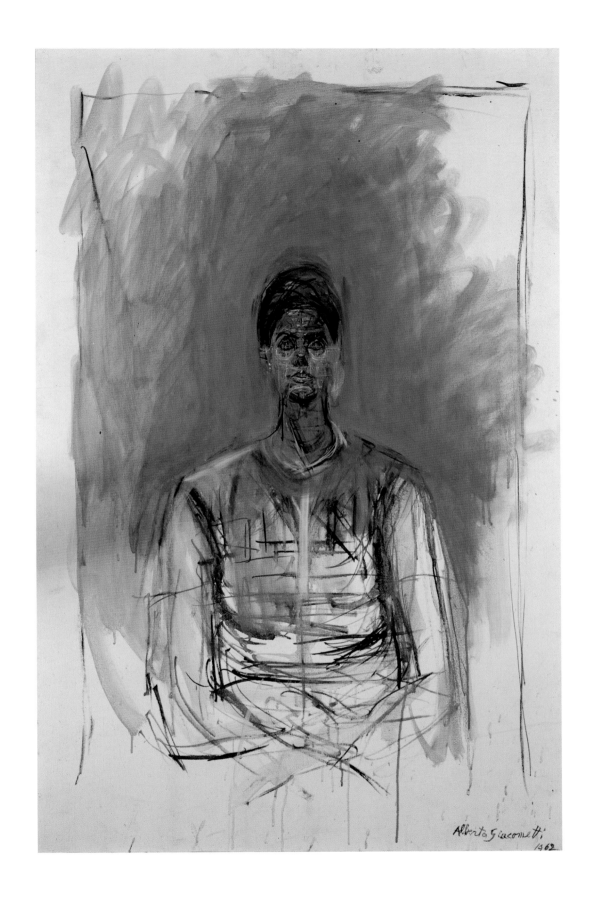

147 CAROLINE 1962. Oil on canvas, 39⅜ x 25⅝″ (100 x 65 cm)
Inscr. lower right: Alberto Giacometti 1962. Von der Heydt-Museum, Wuppertal

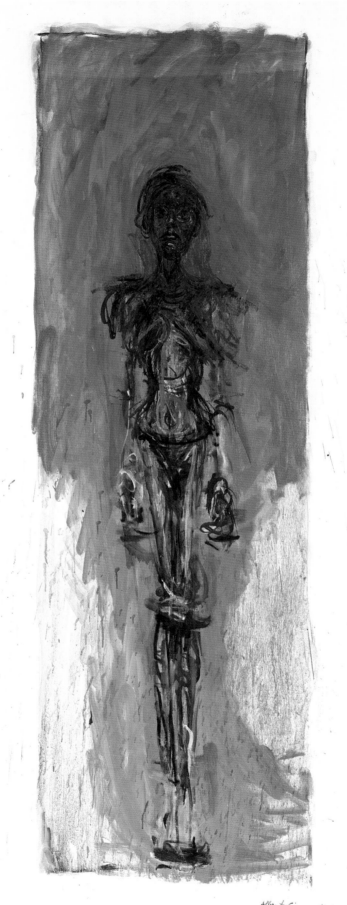

Alberto Giacometti 1962

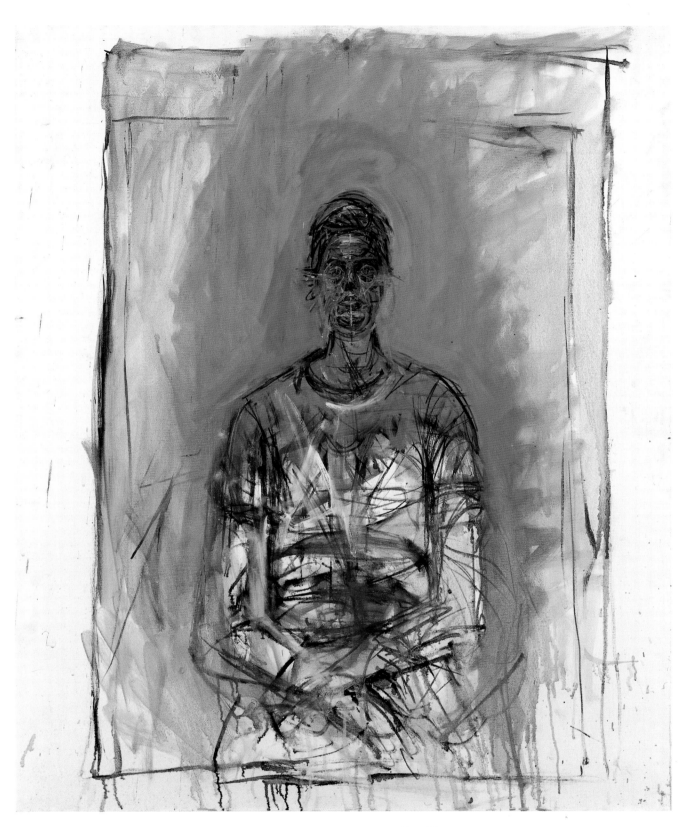

149 CAROLINE II 1962. Oil on canvas, 39⅜ x 31⅞″ (100 x 81 cm)
Öffentliche Kunstsammlungen (Kunstmuseum), Basle

Left:
148 LARGE NUDE 1962, GRAND NU. Oil on canvas, 69 x 27½″ (175.3 x 70 cm)
Inscr. lower right: Alberto Giacometti 1962. Private collection

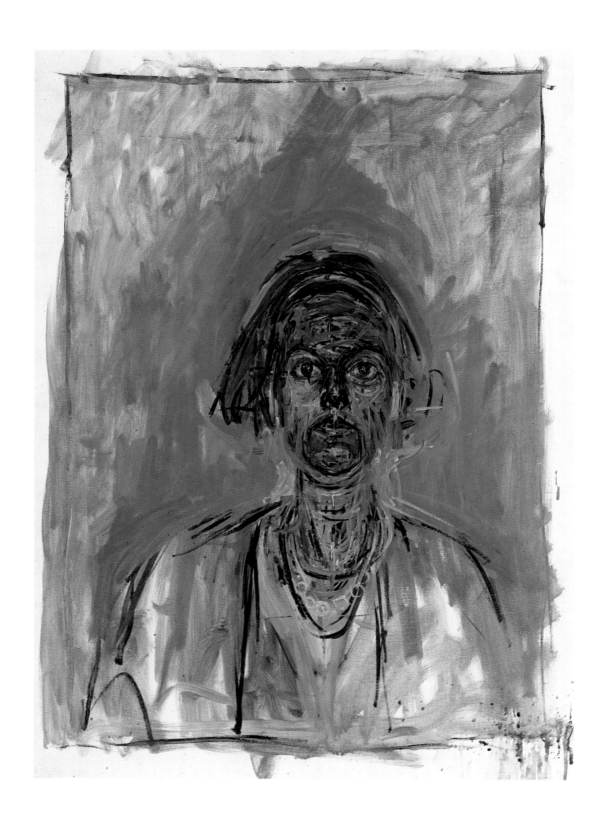

150 PORTRAIT OF ANNETTE 1964. Oil on canvas, $27\frac{1}{2}$ x $19\frac{5}{8}$″ (70 x 50 cm)
Alberto-Giacometti-Stiftung, Zurich

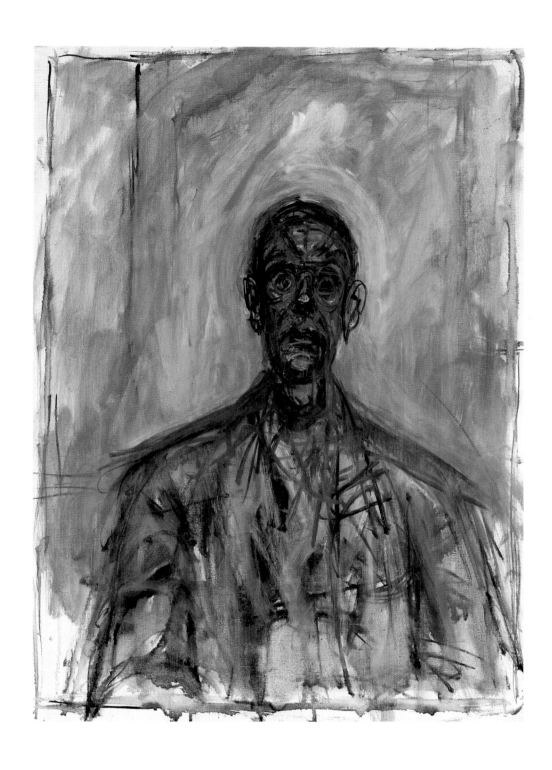

151 HEAD OF A MAN III (DIEGO) 1964, TÊTE D'HOMME III (DIEGO). Oil on canvas, 25⅝ x 17⅞″ (65 x 45.5 cm)
Alberto-Giacometti-Stiftung, Zurich

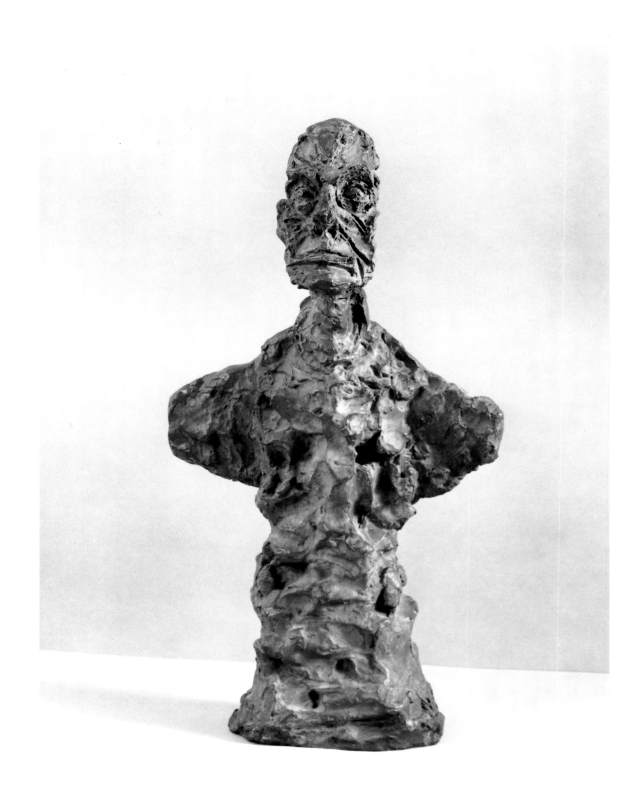

152 BUST OF A MAN (DIEGO) NEW YORK I 1965, BUSTE D'UN HOMME (DIEGO) NEW YORK I
Bronze, 21⅝ x 11⅜ x 5½" (55 x 29 x 14 cm)
Inscr. Alberto Giacometti, Susse Fondeur Paris 4/8
Private collection, Switzerland

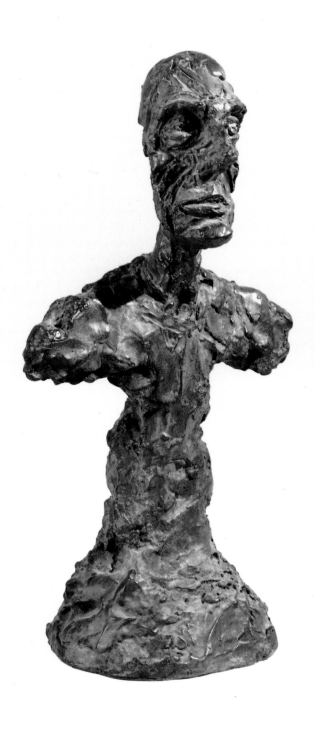

153 BUST OF A MAN (DIEGO) NEW YORK II 1965, BUSTE D'UN HOMME (DIEGO) NEW YORK II
Bronze, 18½ x 9⅞ x 7⅛" (47 x 25 x 18 cm). Inscr. Alberto Giacometti 4/8
Private collection, Geneva

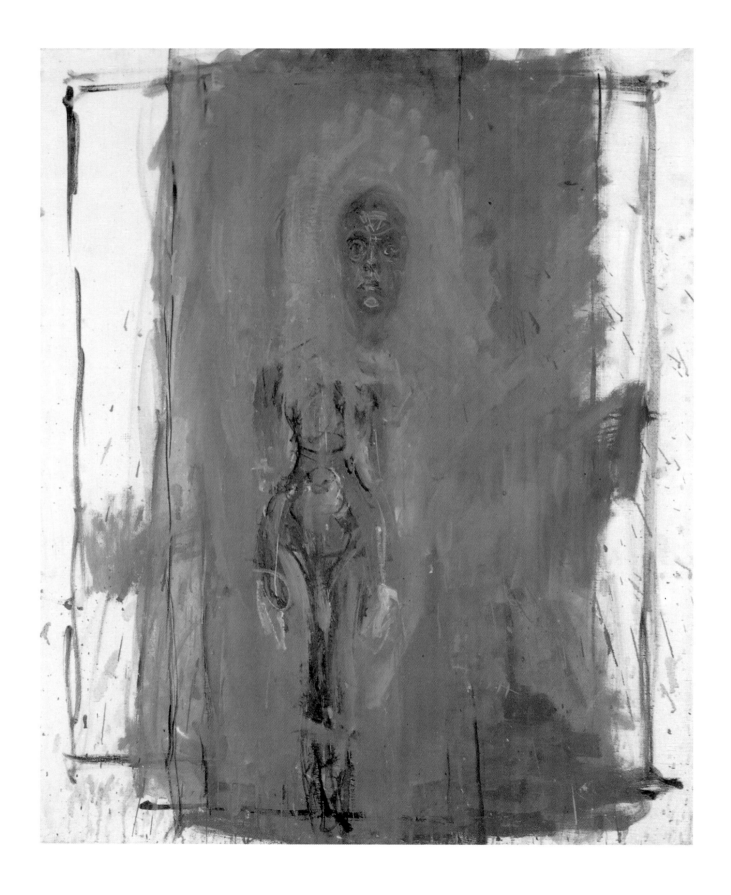

154 WOMAN AND HEAD 1965, FEMME ET TÊTE. Oil on canvas, 35⅜ x 28⅜″ (90 x 72 cm). Private collection, Switzerland

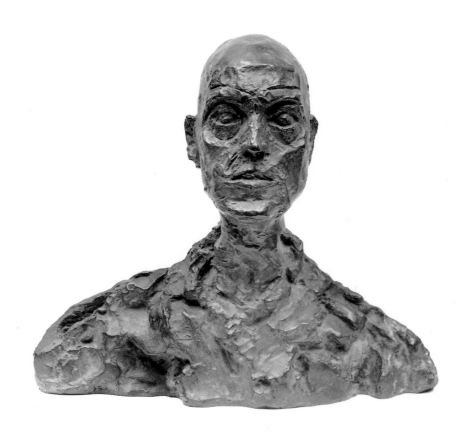

155 ELIE LOTAR I 1965. Bronze, 10¼ x 11⅜ x 3⅞″ (26 x 29 x 10 cm)
Inscr. Alberto Giacometti, Susse Fondeur Paris 4/8. Private collection, Switzerland

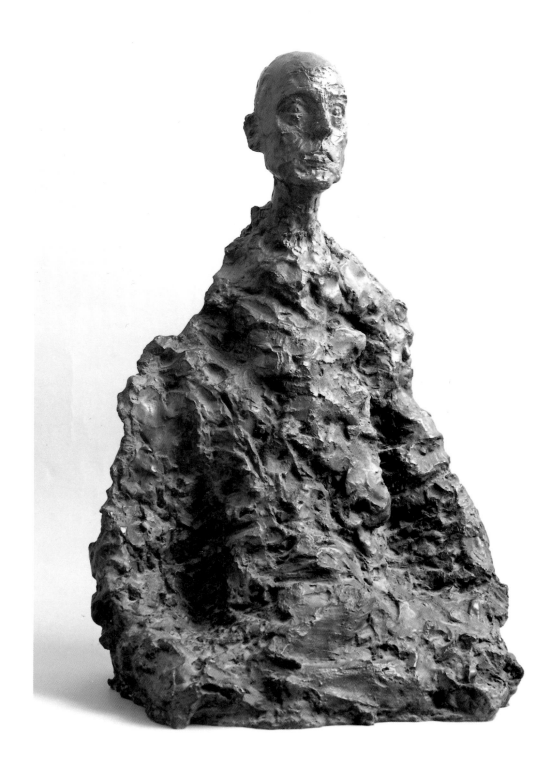

156 ELIE LOTAR II 1965. Bronze, 23¼ x 15 x 9⅞" (59 x 38 x 25 cm)
Inscr. Alberto Giacometti, Susse Fondeur Paris 4/8. Private collection, Geneva

Right:
157 ELIE LOTAR III 1965. Bronze, 25⅝ x 9⅞ x 13¾" (65 x 25 x 35 cm)
Inscr. Alberto Giacometti, Susse Fondeur Paris 5/8. Private collection, Switzerland

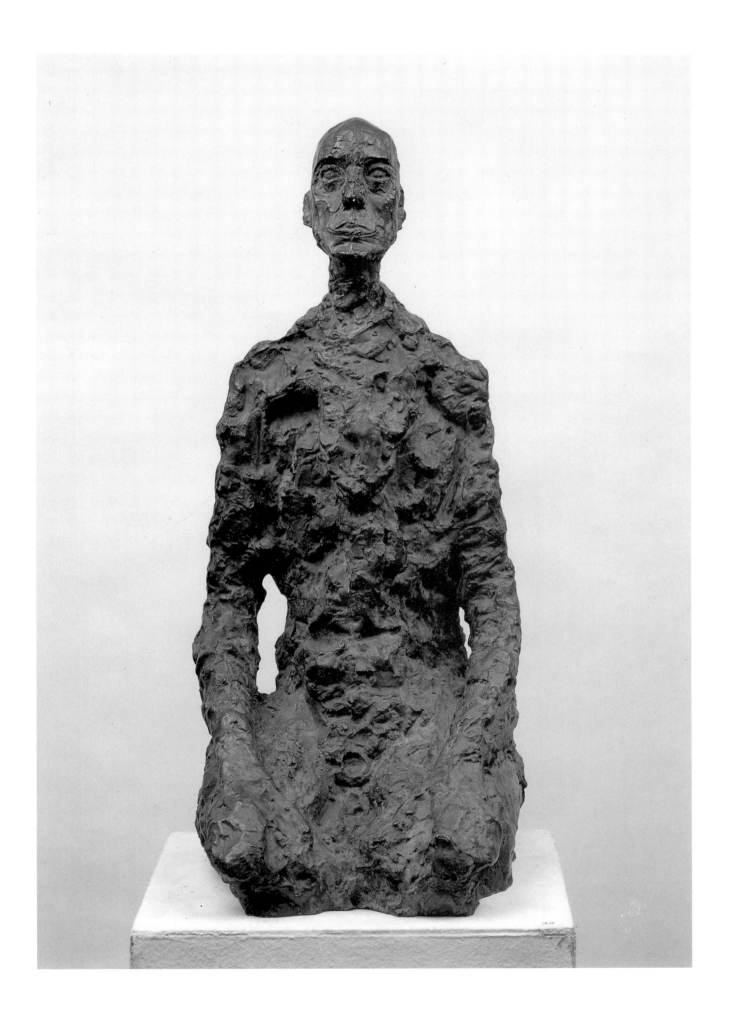

Selected Bibliography

An extensive bibliography, including writings by the artist and interviews with him, is contained in Reinhold Hohl, *Alberto Giacometti* (London, 1972). The following is a selection of the most important publications to have appeared since 1972.

Monographs

Bernoulli, Christoph, *Alberto Giacometti 1901–1906: Erinnerungen und Aufsätze,* Berne, 1974.

Bovi, Arturo, *Alberto Giacometti,* Florence, 1974.

Breicha, Otto, and Reinhold Hohl (eds.), *Alberto Giacometti: 'Paris sans fin',* Salzburg, 1985.

Brenson, Michael, 'The Early Works of Alberto Giacometti: 1925–1935', Ph. D. thesis, Johns Hopkins University, Baltimore, Maryland, 1974 (Ann Arbor, University Microfilms, 1986).

Evans, Tamara S. (ed.), *Alberto Giacometti and America,* New York, 1984.

Giacometti, Alberto, *Ecrits,* Paris, 1990.

Hall, Douglas, *Alberto Giacometti's 'Woman with Her Throat Cut',* Edinburgh, 1980

Julier, Charles, *Giacometti,* New York, 1986.

Lamarche-Vadel, Bernard, *Alberto Giacometti,* Paris, 1984.

Lord, James, *A Giacometti Portrait,* New York, 1965; rev. edn, 1980.

Lord, James, *Giacometti: A Biography,* New York, 1986.

Matter, Herbert and Mercedes, *Giacometti,* New York, 1987.

Megged, Matti, *Dialogue in the Void: Beckett and Giacometti,* New York, 1985.

Rotzler, Willy, *Die Geschichte der Alberto-Giacometti-Stiftung: Eine Dokumentation,* Berne, 1982.

Soavi, Giorgio, *Disegni di Giacometti,* Milan and Rome, 1973.

Exhibition Catalogues

Ascona, Museo Communale, *Alberto Giacometti,* 1985. With a text by Reinhold Hohl.

Berlin, Nationalgalerie, and Stuttgart, Staatsgalerie, *Alberto Giacometti,* 1987/88. With texts by the artist, Alexander Dückers, Jean Genet, Lucius Grisebach, Reinhold Hohl, Dieter Honisch, Gudrun Inboden, Karin von Maur, Jean-Paul Sartre, Angela Schneider, Werner Schnell and Vladimir Vogelsang.

Chur, Bündner Kunstmuseum, and Vienna, Museum des 20. Jahrhunderts, *Alberto Giacometti: Ein Klassiker der Moderne 1901–1966 (Skulpturen, Gemälde, Zeichnungen, Bücher),* 1978/79. With a text by Jacques Dupin and Giacometti's 'Lettre à Pierre Matisse' in facsimile and German translation.

Chur, Bündner Kunstmuseum, *The Photographer's View: Alberto Giacometti,* 1986. With a text by Franz Meyer. English, French and German edns.

Duisburg, Wilhelm-Lehmbruck-Museum, and Mannheim, Städtische Kunsthalle, *Alberto Giacometti: Plastiken, Gemälde, Zeichnungen,* 1977. With texts by Jean-Christophe Amman, Michael Brenson, Heinz Fuchs, Ernst-Gerhard Güse, Reinhold Hohl, Max Imdahl, Norbert Kricke, James Lord, Karlheinz Nowald, Siegfried Salzmann and Edward Trier.

Geneva, Musée Rath, and Paris, Musée national d'art moderne, Centre Georges Pompidou, *Alberto Giacometti: Retour à la figuration 1933–1947,* 1986/87. With texts by Pierre Brugière, Christian Derouet, Bruno Giacometti, Jean Starobinski and Hendel Teicher.

London, Thomas Gibson Fine Art Ltd, *Alberto Giacometti: Thirteen Bronzes,* 1977. With an interview with the artist by David Sylvester (1964).

Madrid, Fundación Juan March, *Giacometti: Colección de la Fundación Maeght,* 1976. With texts by Jacques Dupin, Jean Genet and Jean-Paul Sartre.

Manchester, University of Manchester, Whitworth Art Gallery; Bristol, City of Bristol Museum and Art Gallery; and London, Serpentine Gallery, *Giacometti: Sculptures, Paintings, Drawings,* 1981. With an interview with the artist by David Sylvester (1964).

Martigny, Fondation Pierre Gianadda, *Alberto Giacometti,* 1986. Edited by André Kuenzi with texts by the artist, Michel Butor, Jacques Dupin, Jean Genet, Bruno Giacometti, Guido Giacometti, Reinhold Hohl, E. W. Kornfeld, James Lord, Chiara Negri, Jean Soldini and Hugo Weber.

Martigny, Fondation Pierre Giannada, *Alberto Giacometti Sculptures,* 1986. With a text by Pierre Schneider and photographs by Marcel Imsand.

Mexico City, Centro cultural arte contemporáneo, and Barcelona, Fundación Joan Miró, *Giacometti: Giovanni 1868-1933, Augusto 1877-1947, Alberto 1901-1966,* 1987. With texts by Reinhold Hohl, Daniel Marchesseau, Pierre Schneider and Beat Stutzer.

New York, Solomon R. Guggenheim Museum; Minneapolis, Walker Art Center; Cleveland Museum of Art; Ottawa, National Gallery of Canada; and Des Moines Art Center, *Alberto Giacometti: A Retrospective Exhibition,* 1974/75. With a text by Reinhold Hohl.

Norwich, Sainsbury Centre for the Visual Arts, *Alberto Giacometti: The Last Two Decades,* 1984.

Paris, Galerie Adrien Maeght, *Alberto Giacometti: Plâtres peints,* 1984. With a text by Alain Kirili.

Paris, Galerie Claude Bernard, *Alberto Giacometti: Dessins,* 1975. With texts by Francis Bacon, Balthus, Louis Clayeux, Diego Giacometti and Michel Leiris, and an interview with the artist by David Sylvester (1964).

Paris, Galerie Claude Bernard, *Alberto Giacometti: Dessins,* 1985. With a text by Pierre Schneider and photographs by Henri Cartier-Bresson.

Paris, Galerie Maeght, *Alberto Giacometti: Les Murs de l'atelier et de la chambre,* 1979. With texts by Michel S. Bourbon and Michel Leiris.

Saint-Etienne, Musée d'art et d'industrie, *Alberto Giacometti,* 1981.

Saint-Paul-de-Vence, Fondation Maeght, *Alberto Giacometti,* 1978. With texts by Jacques Dupin and Michel Leiris.

Tübingen, Kunsthalle; Hamburg, Kunstverein; Basle, Kunstmuseum; Krefeld, Kaiser Wilhelm Museum; and Nijmegen, Museum Commanderie van Sint Jan, *Alberto Giacometti: Zeichnungen und Druckgraphik,* 1981/82. With texts by Reinhold Hohl and Dieter Koepplin.

Washington, Hirshhorn Museum and Sculpture Garden, Smithsonian Institution; San Francisco Museum of Modern Art, *Alberto Giacometti 1901-1966,* 1988. Valerie J. Fletcher, with essays by Silvio Berthoud and Reinhold Hohl.

Articles

Bach, Friedrich Teja, 'Giacomettis "Grande figure abstraite" und seine Platzprojekte: Überlegungen zum Verhältnis Betrachter und Figur', *Pantheon* 38, no. 3, 1980, pp. 269-80.

Barilli, R., 'La prospettiva di Giacometti', in idem, *L'Informale e altri studi di arte contemporanea,* Milan, 1964, pp. 119-37.

Bonnefoy, Yves, 'Etudes comparées de la fonction poétique', *Annuaire du Collège de France,* 1982, pp. 643-53.

Brenson, Michael, 'Looking at Giacometti', *Art in America* 67, no. 1, 1979, pp. 118-20.

Clair, Jean, 'Alberto Giacometti, *La Pointe à l'œil', Cahiers du Musée national d'art moderne* 11, 1983, pp. 62-99.

Feist, Peter H., 'Giacometti oder die Schwierigkeit des Sehens', *Bildende Kunst,* no. 6, 1987, pp. 273-6.

Flint, Lucy, and Elizabeth C. Childs, 'Alberto Giacometti: *Woman Walking,* 1932; *Woman with Her Throat Cut,* 1932; *Standing Woman ("Leoni"),* 1947; *Piazza,* 1947-48', in idem, *Peggy Guggenheim Collection: Handbook,* New York, 1986, pp. 162-9.

Forge, Andrew, 'On Giacometti', *Artforum* 13, 1974, pp. 39-45.

Francblin, Catherine, 'Alberto Giacometti: Un Art de cruauté', *Art Press,* no. 49, 1981, pp. 4-7.

'Giacometti's Graffiti', *Artnews,* no. 1, 1980, pp. 8-10.

Giger, Romeo, 'Alberto Giacometti and Ernest Hemingway: Eine geistige Verwandtschaft', *Schweizer Monatshefte,* no. 4, 1984, pp. 285-91.

Graevenitz, Antje von, 'De bedreining van hat oog: Obsessionele zinnebeelden van Giacometti', *Archis,* no. 3, 1986, pp. 11-16.

Grenier, Jean, 'Alberto Giacometti vu par Sartre', *Cahiers du Musée national d'art moderne* 9, 1982, pp. 32-3.

Hill, Edward, 'The Inherent Phenomenology of Alberto Giacometti's Drawings', *Drawing* 3, no. 5, 1982, pp. 97-102.

Hohl, Reinhold, 'Odysseus und Kalypso: Der Mythos der existenziellen Impotenz bei Arnold Böcklin und Alberto Giacometti', in *Arnold Böcklin 1827-1901,* exhibition catalogue, Basle, Kunstmuseum, 1977, pp. 115-18.

Hohl, Reinhold, 'Giacometti rejoint l'avant-garde', 'Les Psychodrames de Giacometti' and 'Giacometti renouvelle les données de la représentation', in Jean-Luc Daval (ed.), *Histoire d'un art: La Sculpture XIXᵉ et XXᵉ siècles,* Geneva, 1986, pp. 166-7, 170-1 and 188-91.

Holländer, Hans, 'Das Problem Alberto Giacometti', *Wallraf-Richartz-Jahrbuch* 33, 1971, pp. 259-84.

Huber, Carlo, 'Alberto Giacometti: *Palais à quatre heures du matin,* 1932', *Jahresbericht 1967-1973 der Öffentlichen Kunstsammlung Basel,* 1975, pp. 180-8.

Hüttinger, Eduard, and Alain Jouffroy, 'Rétrospective 1978 à la Fondation Maeght: l'œuvre impossible de Giacometti', *XXᵉ Siècle,* no. 51, 1978, pp. 4-8.

Kesting, Marianne, 'Die Eternisierung der Fluktuation: Über den Prozess der Wahrnehmung bei Beckett und Giacometti', *Das Kunstwerk*, no. 2, 1981, pp. 33-45.

Kirili, Alain, 'Giacometti's Plasters', *Art in America* 67, no. 1, 1979, pp. 121-3.

Koepplin, Dieter, 'Alberto Giacometti: *Les Pieds dans le plat*, 1933', *Bericht der Gottfried-Keller-Stiftung Bern 1973–1976*, 1976, pp. 181-95.

Koepplin, Dieter, 'Surrealistische Raum-Zeit-Modelle von Alberto Giacometti', in *Neue Sachlichkeit und Surrealismus in der Schweiz*, exhibition catalogue, Winterthur, Kunstmuseum, 1979, pp. 133-41.

Krauss, Rosalind, 'Giacometti', in William Rubin (ed.), *'Primitivism' in 20th Century Art*, exhibition catalogue, New York, The Museum of Modern Art, 1984, vol. 2, pp. 502-33. Repr. in Rosalind Krauss, *The Originality of the Avant-Garde and Other Modernist Myths*, Cambridge, Mass., 1985, pp. 42-85.

Lord, James, 'Giacometti and Picasso: Chronicle of a Friendship', *New Criterion*, no. 10, 1983, pp. 16-24.

Lord, James, 'Sartre and Giacometti: Words Between Friends', *New Criterion*, no. 10, 1985, pp. 45-55.

Lord, James, '*Caresse*, 1932, d'Alberto Giacometti', *Cahiers du Musée national d'art moderne* 15, 1985, pp. 22-5.

Negri, Mario, 'Frammenti per Alberto Giacometti 1956' and 'Si fa ció che più ci sfugge: In memoriam Alberto Giacometti 1966', in idem, *All'ombra della scultura: Scritti 1950-1982 – All'insegna del pesce d'oro*, Milan, 1985, pp. 70-82 and 92-III.

Nugent, C., 'Sculpture et théâtre: L'Influence de Giacometti sur Genet', *Obliques*, no. 2, 1972, pp. 65-9.

Pleynet, Marcelin, 'Le Sujet invisible d'Alberto Giacometti', *Tel Quel*, no. 93, 1982, pp. 32-48.

Poley, Stefanie, 'Alberto Giacomettis Umsetzung archaischer Gestaltungsformen in seinem Werk zwischen 1925 und 1936', *Jahrbuch der Hamburger Kunstsammlungen* 22, 1977, pp. 175-86.

Quirot, Chantal, '*La Table surréaliste* de Giacometti', *Cahiers du Musée national d'art moderne* II, 1983, pp. 170-1.

Riese, Renée Hubert, 'Lecture de Giacometti: Sartre, Ponge, du Bouchet, Bonnefoy sur Giacometti', *Revue d'Esthétique*, 1971, pp. 75-90.

Rowell, Margit, 'Giacometti', in *Qu'est-ce qe la sculpture moderne?*, exhibition catalogue, Paris, Musée national d'art moderne, 1986, pp. 160-87.

Salzmann, Siegfried, 'Zu den Spiegel-Bildern von Alberto Giacometti', in *Spiegel-Bilder*, Hanover, Kunstverein; Duisburg, Wilhelm-Lehmbruck-Museum; and Berlin, Haus am Waldsee, 1982, pp. 90-3.

Scheidegger, Ernst, 'Begegnungen mit Alberto Giacometti', *Du* 4, 1986, pp. 96-106.

Silver, Jonathan, 'Giacometti, Frontality and Cubism', *Artnews* 73, no. 6, 1974, pp. 40-2.

Wolf, Marion, 'Giacometti as a Poet', *Arts* 48, no. 8, 1974, pp. 38-41.

Photographic Acknowledgments

Acquavella Galleries Inc., New York: plate 73

Jörg P. Anders, Berlin: plates 25, 72, 84, 85, 94, 95, 137

James Austin, Cambridge: plate 68

Ch. Bahier, Ph. Migeat et le Service Photographique du Musée national d'art moderne, Centre Georges Pompidou, Paris: plates 21, 33, 104, 128

Galerie Beyeler, Basle: plates 126, 127, 133, 146

Bündner Kunstmuseum, Chur: plates 93, 141

Gérald Cramer, Geneva: plate 82

Walter Dräyer, Zurich: plates 2-7, 10, 14-17, 19, 20, 32, 46-49, 51, 53, 56, 59-62, 74, 79, 86-90, 92, 101, 102, 130, 131, 135, 139, 140, 142, 148, 150-152, 154, 155, 157

Fogg Art Museum, Harvard University Art Museums, Cambridge: plate 105

Reinhard Friedrich, Berlin: plates 108-114, 115, 119-123, 143-146

Claude Gaspari, Fondation Maeght, Saint-Paul-de-Vence: plate 22

Fondation Pierre Gianadda, Martigny: plate 99

The Greenberg Gallery, St. Louis: plate 71

Foto Hinz, Allschwill: plate 149

Hirshhorn Museum and Sculpture Garden, Smithsonian Institution, Washington, D.C.: plates 11, 118, 134

Ralph Kleinhempel, Hamburg: plate 132

E. W. Kornfeld, Bern: plates 91, 96

Galerie Jan Krugier, Geneva: plate 124

Kunsthaus Zurich: plates 24, 27

Kunstmuseum Winterthur: plate 100

Britta Lauer, Duisburg: plates 57, 117

Galerie Maeght, Paris: plate 129

Pierre Matisse Gallery, New York: plates 36, 37, 67

Claude Mercier, Geneva: plates 12, 13, 44, 153, 156

National Gallery of Art, Washington, D.C.: plate 35

O. E. Nelson, New York: plate 69

Öffentliche Kunstsammlung Basel, Kupferstichkabinett: plates 1, 30, 31

Eric Pollitzer, New York: plate 136

Pro Litteris, Zurich: plate 64

Peter Schächli, Zurich: plate 63

Galerie Scheidegger, Zurich: plate 138

Sprengel Museum, Hanover: plate 78

Staatsgalerie Stuttgart und Graphische Sammlung: plates 54, 70, 81, 98

Städelsches Kunstinstitut und Städtische Galerie, Frankfurt a. M.: plate 125

Städtische Kunsthalle Mannheim: plates 58, 106

Statens Konstmuseer, Stockholm: plate 26

Stichelmann, Bremen: plate 107

The Detroit Institute of Arts: plate 52

The Museum of Modern Art, New York: plates 45, 77

The Trustees of the Tate Gallery, London: plates 49, 75, 76, 145

Commune de Vézelay: plates 39, 40

Von der Heydt-Museum, Wuppertal: plate 147

Sabine Weiss, Paris: plates 18, 38, 42, 43, 97, 116

W. Werner, Graphisches Kabinett und Kunsthandel, Bremen: plate 83

D. Widmer, Basle: plate 50

Wilhelm Lehmbruck Museum, Duisburg: plates 41, 117

Ole Woldbye, Kopenhagen: plate 34

Photographs not listed here were kindly provided by the respective authors and collectors.

Index of Names